# CONCEPTS OF BEAUTY IN RENAISSANCE ART

In the bonfire of the vanities that took place in Florence on the last day of *Carnevale* in 1497 and 1498, portrayals of female beauties, cosmetics and ornaments, volumes of Latin and Italian poetry were ceremonially burnt. At the urging of the Dominican prophet Savonarola, beauty was consigned to the flames as excess, as cosmetic ornament, as dissolute and wanton.

For Jacob Burckhardt, writing *The Civilisation of the Renaissance in Italy* in 1860, artistic purpose and commitment to beauty were defining characteristics of Italian Renaissance culture. Burckhardt's analysis has been widely accepted but little has been done to define the Renaissance concept of beauty. In this volume, fifteen scholars reveal that ways of perceiving, conceiving and creating beauty were as diverse as the cultural influences at work at the time, deriving from antique, medieval and more recent literature and philosophy, and from contemporary notions of morality and courtly behaviour.

Approaches include discussion of contemporary critical terms and how these determined wrtiers' appreciation of paintings, sculpture, architecture and costume; studies of the quest to create beauty in the work of artists such as Botticelli, Leonardo, Raphael, Parmigianino and Vasari; and the investigation of changes in the concept relating to the biological functioning of the eye and brain, or to technical innovations like those found in Venetian glass.

The volume is introduced by Elizabeth Cropper who offers an historical overview of art historians' study of the Renaissance concept of beauty.

FRANCIS AMES-LEWIS is Reader in History of Art at the University of London.

ELIZABETH CROPPER is Professor of History of Art and Director of the Villa Spelman at Johns Hopkins University.

MARY ROGERS is a lect ᵗʰᵉ History of Art Department, Bristol University.

D1439613

# Concepts of Beauty
# in Renaissance Art

Edited by Francis Ames-Lewis and Mary Rogers

ASHGATE

First published in hardback 1998 by Ashgate Publishing Limited.

This paperback edition published 1999 by
Ashgate Publishing Limited        Ashgate Publishing Company
Gower House                       Old Post Road
Croft Road                        Brookfield
Aldershot                         Vermont 05036-9704
Hants GU11 3HR                    USA
England

British Library Cataloguing-in-Publication data

Concepts of beauty in Renaissance art
  1. Aesthetics – History 2. Feminine beauty (Aesthetics) –
  History 3. Art, Renaissance
  I. Ames-Lewis, Francis II. Rogers, Mary Ruth
  701.1'7'094

Library of Congress Cataloging-in-Publication data

Concepts of beauty in Renaissance art/edited by
Francis Ames-Lewis and Mary Rogers.
  1. Feminine beauty (Aesthetics) 2. Arts, Italian. 3. Arts,
  Renaissance—Italy. I. Ames-Lewis, Francis II. Rogers,
  Mary (Mary Ruth)
  NX650.F45C66 1997
  700 – dc21        97-17021
              CIP

ISBN 0 7546 0061 0

Printed on acid-free paper

Typeset in Palatino by Photoprint, Torquay, Devon
and Printed in Great Britain by Hobbs Limited, Totton.

# Contents

# Contributors

FRANCIS AMES-LEWIS is Reader in History of Art at Birkbeck College, University of London. He has published books and articles on Italian Renaissance drawing, including *Drawing in Early Renaissance Italy*, New Haven & London 1981, on the art and patronage of the early Medici, and most recently on *Tuscan Marble Carving 1250–1350*, Aldershot (Ashgate) 1997. In 1992 he edited a sister collection of papers entitled *Decorum in Renaissance Narrative Art* (London, Birkbeck College Department of History of Art).

JANE BRIDGEMAN has a B.A. in Italian (University of Birmingham) and a Ph.D. in History of Art from the Courtauld Institute of Art. She is especially interested in interpreting formal ceremonial and the role of dress in public life. Recent publications include ' "Belle considerazioni": Dress in the work of Piero della Francesca', *Apollo*, 136, 1992; 'Dress in Southern Europe, 14th to 16th centuries', *Macmillan Dictionary of Art*, London 1996; and ' "Pagar le pompe": why the sumptuary laws did not work', in *Women in Italian Renaissance Culture and Society*, ed. L. Panizza, Oxford 1997.

LIANA DE GIROLAMI CHENEY is Professor of Art History, University of Massachusetts Lowell. She has written books on *Botticelli's Neoplatonic Images*, on *The Paintings of the Casa Vasari*, on *Readings in Italian Mannerism*, and on *The Symbolism of Vanitas in the Arts, Literature and Music*. Among her principal articles are studies on Giorgio Vasari's decorative cycles, and on Mannerist female self-portraits.

GEORGIA CLARKE is Lecturer in Renaissance and Baroque Architecture at the Courtauld Institute of Art, University of London. Her recent research has focused on the textual presentation of fifteenth-century architecture and the complexity of its relationship with classical antiquity. 'Ambrogio Traversari: Artistic Advisor in Fifteenth-Century Florence?', *Renaissance Studies* XI, 1997

(forthcoming) considers some early fifteenth-century descriptions of architecture in the context of religious and humanist interests.

ALISON COLE wrote her M.Phil thesis at the Warburg Institute, University of London, on *Aspects of Quattrocento Landscape Painting*. She is author of *Virtue and Magnificence: Art of the Italian Renaissance Courts*, London (Weidenfeld and Nicolson) 1996, and is currently writing a book on Renaissance landscape painting for Yale University Press. She is Head of Communications and Education at the National Art Collections Fund.

ELIZABETH CROPPER is Professor of History of Art and Director of the Villa Spelman at The Johns Hopkins University. Her interest in questions of beauty and gender was first announced in the much-cited article 'On Beautiful Women, Parmigianino, Petrarchismo, and the Vernacular Style', (*Art Bulletin*, 58, 1976). Her most recent essay in this field is 'The Place of Beauty in the High Renaissance and its Displacement in the History of Art', in *Place and Displacement in the Renaissance*, ed. A. Vos, Binghampton, NY, 1995.

SHARON FERMOR is Curator of Paintings at the Victoria and Albert Museum. She has a particular interest in the representation of movement in Italian Renaissance art and theory, and in issues of decorum. Her publications on the subject include 'Movement and Gender in Sixteenth-Century Italian Painting', in *The Body Imaged*, eds K. Adler and M. Pointon, Cambridge 1993, pp.129–43.

THOMAS FRANGENBERG is Lecturer in History of Art at the University of Leicester. His main research areas are fifteenth- to eighteenth-century art theory and perspective theory. He places particular emphasis on sixteenth-century Florentine art theory, written by and for non-artists, that allows the reader to arrive at value judgements about art works; and on seventeenth-century texts about contemporary ceiling paintings.

DAVID HEMSOLL is a lecturer at the Barber Institute of Fine Art, University of Birmingham. He is a specialist in Renaissance art and architecture who has also written on the aesthetics and ideology of ancient Roman architecture. He is the co-author of a forthcoming monograph on the early sixteenth-century architect Michele Sanmicheli, a study which will deal extensively with theoretical approaches towards architecture at this time.

PAUL HILLS is Senior Lecturer in History of Art at the University of Warwick, and author of *The Light of Early Italian Painting*, New Haven and London 1987. His interest in Venetian glass arose out of research for his book *Venetian*

*Colour, 1200–1580*, New Haven and London (forthcoming). Recently he edited *David Jones, Artist and Poet* for Ashgate.

ANDREW MORRALL is Lecturer at Christie's Education, London, and teaches Northern Renaissance art at the University of London. He wrote his doctoral thesis on the Augsburg artist Jörg Breu the Elder and has published essays on German Renaissance classicism and on sixteenth-century glass roundel designs. He is currently preparing a book on the art and culture of Reformation Augsburg.

JOHN ONIANS is Professor and Director of the World Art Research Programme in the School of World Art Studies, University of East Anglia. His principal research interests are Renaissance architecture, Classical art, and the biological basis of artistic activity. He is author of *Bearers of Meaning. The Classical Orders in Antiquity, the Middle Ages and the Renaissance*, Princeton 1988.

MARY ROGERS is a lecturer in the History of Art Department, University of Bristol. Her publications have mainly been on the connections between literature and art in the sixteenth century, especially in relation to the representation of women.

RUPERT SHEPHERD studied history of art at the University of Essex and the Courtauld Institute of Art, University of London. He has recently completed a Ph.D. thesis at the Courtauld Institute, on Giovanni Sabadino degli Arienti's descriptions of works of art, and has published articles on Arienti in *Renaissance Studies*.

JOANNE SNOW-SMITH is Professor of Art History at the University of Washington in Seattle, specializing in the Italian Renaissance. In addition to numerous journal articles, she is the author of *The Salvator Mundi of Leonardo da Vinci*, Seattle 1982, a monograph on a painting recently attributed to Leonardo da Vinci, and *The Primavera of Sandro Botticelli: A Neoplatonic Interpretation*, New York and Bern 1993.

MARY VACCARO is Associate Professor of Art History at the University of Texas at Arlington. Her doctoral dissertation (Columbia University, 1994) explored the meaning of style in Parmigianino's art using related archival documents and preparatory drawings. Part of this research has already seen publication in journals such as the *Burlington Magazine* and *Aurea Parma*. She

is currently completing an essay on Parmigianino and Petrarchism in Parma. Her long-term projects include a book on Parmigianino and the erotics of piety.

ROBERT WILLIAMS is Associate Professor in the Department of the History of Art and Architecture at the University of California, Santa Barbara. His principal scholarly interest is Renaissance art theory. He is author of *Art, Theory and Culture in Sixteenth Century Italy,* Cambridge 1997, and is currently collaborating with Thomas Frangenberg on a translation of Francesco Bocchi's *Bellezze della città di Fiorenza.*

# Figures

della Steccata, apse (north side). (Photo: Parma, Soprintendenza per i beni artistici e storici, Gabinetto fotografico)

## 12 Michelangelo's Christian neoplatonic aesthetic of beauty in his early oeuvre: the *nuditas virtualis* image

12.1 Michelangelo, *Risen Christ*. Rome, S. Maria sopra Minerva. (Photo: Art Resource, NY)

12.2 Michelangelo, *Dying Captive*. Paris, Musée du Louvre. (Photo: Art Resource, NY)

12.3 Michelangelo, *Rebellious Captive*. Paris, Musée du Louvre. (Photo: Art Resource, NY)

12.4 *Sleeping Eros*, second-century A.D. Roman copy of an earlier prototype. Oxford, Ashmolean Museum. (Photo: Oxford, Ashmolean Museum)

12.5 Michelangelo, *Victory*. Florence, Palazzo Vecchio. (Photo: Art Resource, NY)

## 13 Venetian glass and Renaissance self-fashioning

13.1 Bowl in millefiori-glass, Venetian, c.1500. London, Victoria and Albert Museum

13.2 Goblet in chalcedony glass, Venetian, c.1480 (18 cm high). London, Wallace Collection. (Photo: London, Wallace Collection)

13.3 *Cristallo* wine glass with blue baluster stem, Venetian, mid-16th century. Murano, Museo Vetrario. (Photo: Murano, Museo Vetrario)

13.4 Bucket in ice-glass, Venetian, late 16th century. Murano, Museo Vetrario. (Photo: Murano, Museo Vetrario)

13.5 Titian, *Diana and Callisto*. Edinburgh, National Gallery of Scotland (Duke of Sutherland loan). (Photo: Edinburgh, National Gallery of Scotland)

13.6 Standing cup and cover in *vetro a fili*, Venetian, mid-16th century. London, British Museum. (Photo: London, British Museum)

13.7 Jacopo Tintoretto, *The Finding of the Body of St Mark*. Milan, Brera. (Photo: Milan, Soprintendenza per i beni artistici e storici, Laboratorio fotoradiografico)

## 14 Vasari's interpretation of female beauty

14.1 Giorgio Vasari, *The Toilet of Venus*. Stuttgart, Staatsgalerie. (Photo: Stuttgart, Staatsgalerie)

14.2 Giorgio Vasari, *The Bacchanal*. Saratov (Russia), Radiscev Museum of Fine Arts

# Preface

This book comprises edited versions of twelve papers prepared for the annual conference of the Association of Art Historians held at Newcastle-upon-Tyne in April 1996, together with three more contributions presented to us at a later date. When it was announced that the general theme of the Newcastle conference was to be 'Beauty?', it became clear to us that such a gathering could not fail to include a session exploring the diversity of the ideals of beauty current during the centuries dubbed 'the Renaissance'. It has been traditional, of course, to connect Renaissance artistic innovations with the conscious search for new standards of beauty, usually seen as derived from nature or from classical antiquity. In putting together a session entitled 'Concepts of Beauty in Renaissance Art' we hoped that these familiar art-historical ideas might be freshly developed, challenged or refined; and that contributors might ask how far we can still contrast a 'Renaissance' sense of the beautiful with a Gothic one, or distinguish Italian aesthetic preferences from those of Northern Europe.

Over the last two decades scholars have introduced both new material and new methodologies to the study of the history of Renaissance art, and these can considerably enhance our understanding of the forces that shaped aesthetic ideals in different facets of the culture of the period. One seminal study was published some twenty years ago by Elizabeth Cropper who, to our great pleasure and gratitude, consented to provide an Introduction to this collection. Her 1976 article on Petrarchism and the cult of woman's beauty has influenced many writers, of varied ideological persuasions, on the theme of the representation of women in Renaissance art – as can be gauged by its citation by several of our contributors. Perhaps the other major stimulus to innovative research has been the work of Michael Baxandall. His emphases both on the literary conventions through which ideas on art emerged and became articulate, and on the reconstruction of a Renaissance

'period eye' formed by a wide variety of social practices, have shaped the work of many of the contributors to this book.

In assembling the papers which eventually resulted in this volume, it seemed to us to be important to seek the greatest possible diversity of field and approach. We hoped that reappraisals of well-known artists or of general problems would be balanced by studies of less familiar works and texts, and that daring speculation would lie alongside close and careful scholarship. We sought essays that would examine Renaissance perceptions of the beautiful in 'real life', urban or rural, and others that would look at the 'applied' as well as the traditional 'fine' arts. Although our main focus was on Italy, we also wished to include material dealing with cultural ideas north of the Alps. The response from scholars on both sides of the Atlantic exceeded our expectations. We thank them all for their efforts, and we hope that the reader will be as stimulated by this wide-ranging and well-balanced collection as we have been in assembling it. Finally, we thank Pamela Edwardes and Ellen Keeling of Ashgate Publishing who have been unstinting of their advice and encouragement throughout the production of this book.

Francis Ames-Lewis
Mary Rogers

# Introduction

*Elizabeth Cropper*

In the bonfires of the vanities that took place in Florence on the last day of *Carnevale* in 1497 and 1498, portrayals of female beauties – of Bencina and Bina, of Lucretia and Cleopatra – were placed at the very top of the burning pyres, together with ancient busts of similarly beautiful women. Below were volumes of Latin and Italian poetry, especially works of lyric content by Petrarch and Boccaccio, together with all the false hair and cosmetics and ornaments of the modern women to whom the words of such poets could be addressed, and all the musical instruments and games that were employed to divert them. At the urging of the Dominican prophet Savonarola, beauty was consigned to the flames as excess, as cosmetic ornament and, in a gesture familiar to students of ancient philosophy and rhetoric, as dissolute and wanton.[1]

Jacob Burckhardt, in *The Civilization of the Renaissance in Italy* (first published in 1860), recounts the events surrounding the bonfires of the vanities in a chapter devoted to 'Religion in Daily Life'. For Burckhardt the destruction of the representations and trappings of beauty was one more example of the power of an individual, rather than a display of misogyny, or a manifestation of the historic suspicion of excessive femininity and ornament. Despite his much-criticized blindness to the different and unequal status of women in the Renaissance, however, Burckhardt was deeply conscious of the importance of beauty in Renaissance culture. He examined the beauty of women's role and appearance, the beauty of the perfection of man and of language, of the description of and response to nature, of philosophy, and of what he called 'the outward refinement of life'.

In Burckhardt's essay, in which all aspects of Italian Renaissance civilization are viewed as works of art, artistic purpose and commitment to beauty are defining characteristics of that civilization. It was, for example, 'that universal education of the eye which rendered the judgement of the Italians

as to bodily beauty or ugliness perfect and final'.[2] The individual, whose emergence famously defined the Renaissance for Burckhardt, was compelled to shape his own demeanour in an artistic way. As a result, 'even the outward appearance of men and women and the habits of daily life were more perfect, more beautiful, and more polished than among the other nations of Europe'.[3] In this civilizing process (as Norbert Elias would later call it), many aspects of social life, from personal hygiene to recreation, and even to war, were made beautiful through conscious reflection.

Burckhardt chose not to discuss the 'artistic study of the human figure' in his book, believing that this belonged more properly to the history of art as such.[4] As William Kerrigan and Gordon Braden have noted, however, Burckhardt's *Kulturgeschichte* was informed by 'a sensibility nursed in art history'.[5] Burckhardt's belief that ways of seeing define a particular period would be taken up, they suggest, by his pupil and successor in the Chair of Art History at Basle, Heinrich Wölfflin. For Wölfflin, too, beauty was a defining characteristic of the 'Classic Art' of the Renaissance, and it had a history. The shift from the detailed, jocular and natural loveliness of the fifteenth century to the graver antique beauty of the sixteenth century that Wölfflin sought to establish was based on his understanding that stylistic change was indeed cultural change and vice versa:

> When we speak of a new style arising . . . we find that the change is not confined to the environment of man – major or minor architectural features, furniture or costume – but that man himself has changed even in his outward, bodily form; and the real kernel of a style is in the new outlook upon the human body and in new ideas about deportment and movement. This conception of style is a much more weighty one than that which obtains nowadays, when styles change like fancy dresses being tried on for a masquerade.[6]

Wölfflin's discussion of the 'New Beauty' includes one or two youthful male subjects: Verrocchio's *David* is compared to Cellini's *Perseus*, and to Raphael's *St John the Baptist*, for example. But his most telling comparisons are those between the women in Ghirlandaio's and Andrea del Sarto's frescoes of *The Birth of the Virgin*, female figures in the former's *Birth of Saint John* and Raphael's *Fire in the Borgo*, portrayals of Venus by Lorenzo di Credi and Franciabigio, and the ideal heads of women by Piero di Cosimo and Michelangelo. Beauty for Wölfflin, as for Savonarola, was more easily identified in the feminine.

The examples of Burckhardt and Wölfflin were before me in the mid-1970s when I began to investigate the theme of female beauty in Italian Renaissance painting. In thinking about Parmigianino's *Madonna of the Long Neck* in this context, however, it was also clear that certain formalist claims, especially those of classicism, had obscured their arguments. As I wrote 'On Beautiful Women: Parmigianino, *Petrarchismo*, and the Vernacular Style', I

began to see that matters of feminism and formalism, of ornament and content, were inseparable from even broader aesthetic and social distinctions.[7] These larger problems involved the misogynist suppression of beauty as vanity, and of modern mistrust of ornament itself. In a critical history traceable from Burckhardt and Wölfflin to Lessing, to Dolce, to Firenzuola and Poliziano, to Petrarch and ultimately back to Propertius, Ovid, Homer and Plato, something important was at stake. Many nineteenth-century scholars of art and literature – not only Burckhardt and Wölfflin but also Warburg, Faral and Renier, to mention only some of the most influential – had paid considerable attention to the representation of beauty, and especially female beauty, in the culture of Renaissance Italy. In their analysis of the desiring Petrarchan individual, Kerrigan and Braden point to Freud's identification of the elevation of the female object as an identifying feature of post-classical culture.[8] Somehow this thread had been lost in more recent historical inquiries. This loss is perhaps associable with a shift in twentieth-century Renaissance studies away from engagement with the conventions of romantic love (with its close ties to the late medieval tradition) towards a preoccupation with the more ideal terms of Neoplatonism and the revival of ancient theories of harmonious beauty in which women play a minor part.

The shift may also reflect a desire to uphold an idea of absolute beauty in the face of the crucial Enlightenment distinction between absolute and relative beauty, which permitted beauty a history, and allowed for the discovery of the historical perception of art. To reduce the argument to its simplest terms: the philosophical claims of aesthetics were advanced over the historical explanations of taste, judgement and poetic subjectivity. Implicit in that rejection of historical subjectivity was a suppression of the feminine, and it seems logical in retrospect that my own next step in thinking through the rhetoric and poetics of female portrayal in the Renaissance should have been prompted by an invitation to participate in a pioneering conference organized by a group of feminist scholars at Yale University in March 1982.[9] It is difficult to recall how radical this programme then seemed, and especially because it did not take up the already somewhat stale question of women in the Renaissance. Instead, the focus was on sex/gender arrangements, aesthetic and material questions, issues of class and race, production and reproduction. In the editors' introduction to the publication of those papers, my essay was characterized as concerning itself with 'the strategies by which women are rendered marginal in works by male artists and critics'.[10] The marginality that allowed female identity to be suppressed was indeed one issue under discussion, but my main interests were somewhat wider and, I believe, more fundamental. Renaissance critics, I proposed, following their understanding of ancient writers, made the portrayal

of a beautiful woman into a synecdoche of painting itself. This under-standing led me back to the poetry of Petrarch, where I had begun.

Burckhardt recognized the importance of Petrarch in the discovery of natural beauty in the Renaissance, but he belonged to a realist generation that read Petrarch's meditations on nature as direct records of his experience. Even though Burckhardt understood that Petrarch was, as he put it, 'per-fectly able to distinguish the picturesqueness from the utility of nature', his own concern was with Petrarch's views on fame and his fixing of the forms of the sonnet rather than his expression of lyrical sentiment as such.[11] The lyric poetry of Petrarch is, however, of the utmost importance for the understanding of concepts of beauty and its representation in the Renais-sance, for the poet invokes a special relationship between love and the imagination, exalting the latter as a means by which to figure memories. The capacity of the imagination to reconfigure the beloved at any time or place is fundamental to his poetry and its images. Petrarch conceives of Love itself as a painter whose many colours paint the 'bel viso leggiadro' on his heart (*Rime sparse* [RS] 71 and 96). His compelling desire to see Laura's lost beauty deprives him of his freedom, for, as he writes, 'mal si segue ciò ch'agli occhi agrada' – or 'it is bad to follow what is pleasing to the eyes' (RS 96). But that visual seduction and the desire to recover its joy is what leads the poet to write about the sweet movement of his lady, the memory of which will outlast a statue of solid diamond – or of *di-amante* (RS 108). The poet revives these memories in his heart through looking at nature, especially the landscape of Vaucluse where he seeks out the traces, or signs, of her passage (RS 108). There, amid the rocks and springs, he can figure with his thought (RS 116), wherever he looks: ' 'l pensier mio figura ovunque io sguardo'. Nature itself is marked by Laura's appearance, especially the uninhabited mountains and woods. In the key poem 'Di pensier in pensier, di monte in monte' (RS 129), Petrarch characterizes himself as a deer climbing in this wild landscape. Wherever a pine or a hillside casts a shade he is able to draw with his mind the beautiful face of Laura on the first stone (*nel primo sasso*); keeping his wandering mind fixed on this *primo pensier*, he senses the presence of Love close by, and his soul is satisfied by its own self-deception. Gazing at her, and forgetting himself, he succeeds in seeing Laura in so many places that if only the illusion (*error*) could last, he would ask for nothing more. He sees his beloved alive in clear waters, on the green grass, on the trunk of a tree, and in the white clouds. The more deserted and wild the place, the more beautiful does his thought shadow her forth until the truth dispels the illusion, leaving him a mere image of himself, who can only think and weep and write.

In nature the poet projects in both line and chiaroscuro – the word used for the latter is *adombrare* – the memory image of his beloved, just as in life Laura

covered the ground with her shadow or marked it with her foot. Love maintains him through memory, re-membering the pieces that were scattered by the vision and loss of the beloved. In the long poem that begins *In quella parte dove Amor mi sprona* (RS 127), Petrarch gives an extended version of how this remembering of the past works at different times of day and in different seasons. Whenever he sees snow on hills, whenever he sees the stars after nocturnal rain, he remembers his beloved's eyes, and the face that seen from afar makes him weep (as the sun melts the snow), but from close by dazzles him and vanquishes his heart. When spring comes he sees his *bella giovenetta* again, even as in the shortening days he sees her as the *donna* she becomes. Gazing at the leaves and the violets of the spring, he remembers the weapons of love, and remembers (or is himself re-membered by, given the reflexivity of the verb *mi rimembra*) the humble deportment of his beloved. In his interpretation of Botticelli's *Primavera*, Charles Dempsey has established how the invention of a painting that is about love may be read as an extended series of such metaphors of loss and remembrance.[12]

Petrarch indeed gave a new meaning to looking at nature, one that was founded in human experience, as Burckhardt recognized. But he further conceived his remembering as an artistic practice of drawing and shading, which could satisfy for just as long as the imaginative projection was not interrupted by the truth of loss and absence. What the imagination produced in collaboration with memory was beauty. Petrarch's search for the beautiful grace of the woman who had made his heart gentle, and his actual physical withdrawal into the mountains and valleys in order to experience moments of illusionistic remembering, in order then to write about them, had a powerful effect on the way that poets and painters looked at nature in the generations to come. The painter's experience of nature and the remembrance and representation of the absent, beautiful beloved were now inseparable. By extension, in Renaissance painting the representation of a beautiful woman and naturalism, or the representation of nature as vitally alive as a human being, were also inseparable. Painting and woman are equally desired. In both Leonardo's *Mona Lisa* and *Ginevra de' Benci* the figure is set against a landscape of water, hills and trees, with which the figure seems to be one. Leonardo's practice of projecting into random shapes in plaster walls, or in clouds, is famous. There is an important connection between these two phenomena, between such imaginative projections and the Petrarchan sequence of being seized by beauty through the eyes, followed by loss of the beloved object, followed by the desire to remember through drawing with the mind in nature: that is the connection, again, between the naturalism of these images and their subjects. It was through the portrayal of the beloved that the beauty and value, or meaning, of nature could be unlocked. As Leonardo challenged in his defence of painting, 'What

poet with words will put before you, O lover, the true effigy of your idea with such truth as will the painter? Who is it that will show you the sites of rivers, woods, valleys and fields wherein are represented your bygone pleasures with more truth than the painter?'[13]

Vasari records that among the first of Leonardo's works on joining the studio of Verrocchio were some gesso heads of putti, and of *femmine che ridono*. These images of smiling women Freud associated with the mysterious smiling women who come later in Leonardo's career – with Mona Lisa, St Anne and, in turn, with Leonardo's sublimation of his memory of the smile of his excessively tender mother, Caterina. Without entering into Freud's claims about that repression, I would propose that the phenomenon of Petrarchan lyricism at least helps to account for the presence of so many smiling, graceful, beautiful and natural female heads in Leonardo's work. For there is nothing at all speculative about the claim that in a Petrarchan culture the image of a beautiful laughing woman was the primary figure for the expression of desire for the lost beloved, for the discovery of beauty in nature, and, again, as the means by which the artist could pursue and eventually embrace his own art. Searching out the signs of the beloved in nature, Leonardo's hand might design the flow of water and braids of hair with the same marks. The hair and fluttering drapery of a smiling nymph are one with the landscape. Hair could also come alive like vegetation. Eventually, the projective technique of Leonardo's inventive drawings, discovering his thought through the very process of drawing in shadow on paper, becomes a kind of analogue for the process of discovering the signs of the beloved in nature. And as the desire for beautiful painting grew, the expression of desire for it was no longer limited to a single subject. The aesthetic of painted *dolcezza* in the sixteenth century is one of femininity without respect to sex.[14]

That a session was devoted to the topic of 'Concepts of Beauty in Renaissance Art' at the Association of Art Historians Conference in 1996 is another marker in the recuperation of the role of beauty in Renaissance culture. The range of the papers published here reflects the direction of the debate towards topics at once more varied and more detailed than Burckhardt could have imagined. As a result, his optimistic individualism is sometimes challenged. For example, Burckhardt celebrated the variety in dress he believed to be documented in painting, and praised those exceptional people who, in contrast to his own contemporaries, had the courage to dress as they pleased even after uniformity closed in. By contrast, Jane Bridgeman points to the overriding importance of *convenevolezza*, appropriateness, in Italian Renaissance discussions of dress. In the treatises on comportment and costume that she analyses (the very existence of which Burckhardt would probably have seen as a sign of decline), individualism is

subordinate to social standing and decorum. Like Burckhardt, however, she notes an emphasis on cleanliness of clothing and body.

The story of the recovery of Vitruvius' text appears briefly in Burckhardt's section on 'The Revival of Antiquity'. Georgia Clarke's essay on beauty and design in Italian Renaissance architecture, while noting that *venustas* is just one part of the Vitruvian triad that also included *firmitas* and *utilitas*, is more truly a contribution to an assessment of the new importance of beauty for its own sake than of Vitruvius' text as such. Especially significant is the reminder that *bellezza* is more closely associated with *grazia* than with simple proportion or symmetry in sixteenth-century commentaries on Vitruvius. Clarke's study of drawings by Peruzzi and Antonio da Sangallo the Younger elucidates through specific examples the special importance placed by these architects on the quality of *bellezza*. Good workmanship and skill could contribute more to such beauty than canonical correctness or magnificence, and beauty of workmanship was not necessarily to be linked to a particular style. Large and expensive, on the other hand, was the preference of Giovanni Sabadino degli Arienti in the last decade of the fifteenth century, according to Rupert Shepherd. His analysis of Arienti's description of buildings created by Ercole I d'Este, Duke of Ferrara, yields precise information about the practice of magnificence at court, as opposed to its now familiar theory.

Burckhardt believed that the Italians were 'the first among modern peoples by whom the outward world was seen and felt as something beautiful'.[15] Neither Alison Cole nor David Hemsoll would probably wish to defend that absolute claim, but their papers reflect its implications. Cole underscores how Botticelli, usually uninterested in landscape, chose to endow the garden of the *Primavera* with varied and detailed beauty. Following Dempsey's association of the invention of Botticelli's *Primavera* with the poetic inventions of Petrarchan vernacular poetry by Lorenzo de' Medici and Poliziano, she relates the artist's special concern with landscape here to the theme of the springtime as paradise, and of the haunt of the beloved as perpetual springtime. Andrea Mantegna and Cosmè Tura, on the other hand, exploited opportunities to paint landscape settings as a way of demonstrating their personal styles and inventive ability. In the criticism of Vasari such individualism was to be subordinated to a standard of *grazia*, *morbidezza*, and *facilità*.

That a change took place in the representation of nature around 1500 (echoing Wölfflin's 'New Beauty' and 'New Pictorial Form') is the starting point for David Hemsoll's assessment of the role of Ficino's aesthetic theories in promoting a new ideal of beauty, one associated with 'forms' and 'ideas' rather than observation. Botticelli's later work (including the *Birth of Venus*) with its linear emphasis and flattened surfaces provides the example

here, as does the sculpture of Bertoldo. The shift comes with Leonardo's return to Florence, according to Hemsoll, who reads Leonardo's treatise on painting as a deliberate denial of Ficino's views. Various of Leonardo's works, including the *Leda* and the *Mona Lisa*, he argues, developed in direct response to Botticelli and to 'philosophical' beauty.

The change that Andrew Morrall traces puts Burckhardt's view on beauty in a new perspective. Starting out with familiar Italianate criticisms of Northern art, Morrall looks at the courtly origins of the vernacular tradition of beauty in Germany, where the word for attractive allure (as opposed to ideal beauty) is still *hübsch* (relating to the Middle High German *hübesch*, or courtly). As in Italy, the same ideals of beauty characterized the Madonna and the courtly Lady. This ideal was, however, already challenged in Germany in the fifteenth century by the popular practice of the *Devotio Moderna*, according to which qualities of ugliness and habits of inward seeing gained new importance. Most intriguing in Morrall's account, however, is his suggestion that classical qualities of Italian art were eventually adopted in Germany for their rhetorical signification, rather than their affective power. The classical style became just one more expressive tool in the depiction of an image that was intended to be seen through, rather than looked at.

Mary Vaccaro and Sharon Fermor both return to the subject of the language of description of female beauty in Italy, to which they have made important contributions in the past. Vaccaro's analysis of the frescoes in Santa Maria della Steccata poses the question of how the Petrarchan poetics of desire might be combined with sacramental and liturgical content. She associates Parmigianino's capturing of his own wandering thoughts in drawing with the *vaghezza* of the beauty of his figures that sets the heart of the beholder wandering. Complementing my observations about the *Madonna of the Long Neck*, Vaccaro shows how the grace of the wise and foolish Virgins, whose arrangement invites comparison with the Graces, may be associated with their religious meaning. And in a further move that folds this new aesthetic back into the festivals of daily religion that so appealed to Burckhardt, she proposes a connection between the Steccata maidens and the poor young women who entered the church on the feast of the Annunciation to receive a dowry. Fermor's identification of beauty in movement as *leggiadrìa* provides a further dimension to this discussion, for the wise and foolish Virgins of the Steccata are her prime example of such movement as described by Vasari (who associates it with women and young men especially). Art, Fermor proposes, might require different movements from those expressed in life, and here she calls attention to Vasari's criticism of the twisted and overwrought lines of Pontormo's *Annunciation* in Santa Felicità. Like Vaccaro, Fermor points to the importance of light in connection with

movement. In papers that return to the issue of Neoplatonism Liana Cheney and Joanne Snow-Smith also consider the expression of beauty as light. Cheney, in connection with Vasari's *Toilet of Venus*, contemplates the meaning of Venus as the luminous one (*phosphorous*). Snow-Smith revisits the question of the role of Neoplatonism in Michelangelo's formation.

Parmigianino included a self-portrait in one of his drawings of the graceful Steccata maidens, and Mary Rogers takes up the issue of this new type of artist-as-beauty appearing in the Renaissance. Not only Parmigianino, but also Leonardo, Raphael, Rosso Fiorentino, Giulio Romano, Perino del Vaga and Jacopo Sansovino fall into this category, in which artists embody the very grace and beauty they portray. The beautiful artist might be a product of nature or of self-fashioning, or both, but in any case his courtly graces bore witness to the graceful art he produced: his creations bore a family resemblance to him, as did those of his graceful artistic followers.

That the cultivation of beauty was part of Renaissance statecraft was clear to Burckhardt. The two papers by Thomas Frangenberg and Robert Williams deal with a text, *Le Bellezze della città di Fiorenza*, and an author, Francesco Bocchi, that for Burckhardt would have belonged to the decline of the Renaissance: Bocchi's book was published in 1591. Yet this important work, in which the encomium and the guidebook are combined, provides support for the view that sixteenth-century Florentines expected a consensus on the question of beauty as much as their predecessors, and that beauty continued to be encouraged as a civic asset. Frangenberg shows that whereas in his earlier *Eccellenza del San Giorgio di Donatello* (1571) Bocchi set forth a very limited Florentine canon (identifying only Michelangelo's *Notte*, Sarto's *Madonna del Sacco*, the cupola of Santa Maria del Fiore and Donatello's *St George* as truly perfect), in the *Bellezze* he introduces the reader to many beauties scattered throughout the city. If the notion of 'scattered beauty' suggests Petrarch, we should note that Bocchi's purpose, according to Williams, is to establish a relationship between beauty and virtue, rather than beauty and desire. Even the game of *calcio* played in Piazza Santa Croce could exemplify this noble and virtuous beauty. In Bocchi's praise of Michelangelo's windows for Palazzo Medici and of the cupola, Williams identifies the same validation of natural and unadorned beauty found in contemporary praise of Duke Cosimo himself. Though many familiar metaphors and comparisons to the beauty of women are to be found in Bocchi's text, Williams suggests that the replacement of desire by a sort of objectification of beauty is central to Bocchi's enterprise.

Bocchi's encomium of Florence (whose very name, *Fiorenza*, implies the beauty of springtime), must be set in the context of political rivalry with other states, especially Ferrara. Williams sees a parallel between Cosimo I's own policy of appropriating the virtues of individualism that Burckhardt

would celebrate, if now in the service of a courtly and feudal ideal, and the morality of beauty expressed by Bocchi. In his attempt to understand the social value of the beauty of glass Paul Hills approaches the particular aesthetic culture of a different political centre, Venice, in a quite different way. Following Richard Goldthwaite's work on maiolica, Hills asks how the increased production of a luxury item may have contributed to a refinement in sensibility on the part of consumers. He traces how changes in demand for lightness, combined with increase in value, demanded new manners on the part of those using table glassware: in a telling phrase he suggests that 'owning and using glass was more a statement about manners than about wealth'. After identifying pieces of glass in familiar works by Titian and Veronese, Hills proposes a deeper connection between the aesthetics and techniques of glassmaking and painting. The rough quality of Titian's later style appeals, he suggests, to the same aesthetic as the deliberately induced roughness of ice-glass. Tintoretto's curvilinear spaces, on the other hand, are compared to the evanescent circling highlights of filigree glass. As glass became worldly and common, Hills suggests, it lost that association with purity that had led Parmigianino to pose a transparent crystal vase in the hands of an angel in the *Madonna of the Long Neck* as an analogy for the grace and purity of the Virgin.

Hills looks to a structural relationship between the qualities prized by glassmakers, painters and patrons, and only hints at an economic cause. John Onians makes more radical claims, explaining stylistic change and difference in relation to the evolution of neural development: perspective and interest in mathematical projection developed in Florence, he proposes, because it was there that such straight lines and grids could be experienced. In outlining a natural history of art Onians is not, strictly speaking, providing an explanation of the Renaissance, nor of the beauty that characterized it. He does, however, make several provocative applications of that theory here. The hypotheses that both Alberti and Leonardo succeeded through a Darwinian drive for survival conditioned by their illegitimacy, and that late fifteenth-century fantasies were provoked by fear of the apocalypse, rather than consciously representing the latter, allow for historical expansion. On the other hand, his view that Leonardo's paintings of women are 'increasingly warm and attractive', reflecting the artist's awareness of the biological basis of beauty, and that properties of vision were selected genetically, challenges fundamentally the history of art as the history of culture. It remains to be seen how Onians' theories allow for all the issues of taste, economy, religion and philosophy that the authors of these papers have brought to bear on the topic of beauty that he seeks to re-naturalize. Burckhardt saw nothing unnatural in culture, after all, and Petrarch's deferral of desire, which led him to solitude as a way of cherishing the

absence that fed his imagination, if individual, is surely founded in nature. In the bonfires of the vanities both apocalyptic and puritanical instincts came together, not against an enemy, but against representations of beauty, of women, and of their ornaments. Only through the sort of historical discussions collected here can we begin to comprehend such cultural destruction.

## Notes

1. For the notion of 'a dissoluteness which is that of femininity itself', see Lichtenstein (1989): esp. 79.

2. Burckhardt (1958): II, 338.

3. *Ibid.*: II, 361.

4. *Ibid.*: II, 338.

5. Kerrigan and Braden (1989): 4.

6. Wölfflin (1952): 231.

7. *Art Bulletin* 58 (1976): 374–94.

8. Kerrigan and Braden: 157.

9. The conference, entitled 'Renaissance Woman/Renaissance Man: Studies in the Creation of Culture and Society', was subsequently published as *Rewriting the Renaissance: The Discourses of Sexual Difference in Early Modern Europe*, ed. M.W. Ferguson, M. Quilligan, N.J. Vickers (Chicago and London, 1986). For my essay, 'The Beauty of Woman: Problems in the rhetoric of female portraiture', see 175–90, 355–59.

10. *Ibid.*: xxvii.

11. Burckhardt, *op. cit.*: II, 296.

12. Dempsey (1992).

13. As translated by Dempsey, *ibid.*: 148, n. 17.

14. For an extended discussion of this, see Cropper (1995).

15. Burckhardt, *op. cit.*: II, 293.

# The biological basis of Renaissance aesthetics

## John Onians

We are used to thinking of the Renaissance as an emphatically 'cultural' phenomenon. The new values, new approaches and new patterns of behaviour with which it is associated are understood typically in terms of the new roles acquired by book-learning, by education and other types of social formation. This is as true of aesthetics as of other areas. New artistic theories and new practices tend to be related above all to the increasing influence of Greek and Roman examples and ideas and of contemporary texts, rules and teachers. Even when the decisive input of a single individual seems to jeopardize such explanations, we often see them only as the privileged beneficiaries of a unique convergence of cultural forces. The cultural basis of the art and ideas of Brunelleschi and Masaccio, of Leonardo and Michelangelo is well understood. What is less appreciated is the extent to which their achievements may also be the product of the operation of mechanisms which are better understood in natural than cultural terms – that is, as biologically driven.

Some will object to the word 'biological' in this context. What, after all, is the place of the language of science in the study of the humanities? The answer, however, must surely be that in the search for explanations the scholar should turn down no appropriate approach and, since the humanities involve the study of human activities, they should take account of the human biology which makes such activities possible. Since all our actions, from looking and thinking to walking and painting, are supported by our physiology and above all by our neurology, then we should surely understand them. In the context of the present paper this means understanding the physiology and neurology which make possible the sensory, motor and cognitive acts involved in the making, looking, commissioning, purchasing, talking and writing that, broadly interpreted, constitute Renaissance aesthetics.

This is not the place to review the full sweep either of these aesthetics or of the complex and often conflicting views which make up current knowledge of neurology. Rather, what will be presented here are some limited general claims about three features of the neuropsychology of vision which are fairly uncontentious and which have a clear importance for the history of art. These are (1) the tendency of the brain's neural structures dealing with sense data to develop differently in different environments; (2) the tendency of the brain to attend selectively to its surroundings, looking for particular features or objects, and, especially under the influence of the emotions, to over-interpret incomplete data and imagine such features or objects even when they are not actually there; and (3) the tendency of innate mental templates, especially those related to the human body, to affect visual preferences.

Each represents a specific evolutionary adaptation. The first tendency is apparent in many animals, but is most highly developed in humans because the human brain is least complete at birth, being only fifty per cent formed at that stage, unlike that of chimpanzees in whom the brain is sixty-six per cent formed or of other creatures in which it is virtually complete. Experiments with other animals demonstrate that the neurones of which the brain is composed and which in the visual cortex are specifically adapted to respond-ing to such elements in the visual field as horizontal or vertical lines, dots or colours, multiply if exposed to such elements and form networks that become better at dealing with them. Similarly, if there is no exposure, they die back and atrophy. Such detailed experiments cannot be carried out on humans, but studies of people who have experienced injury and sensory deprivation show that the human brain also reacts in the same way.[1] This means that individuals who are brought up in an environment rich in particular elements, such as straight or curved lines, strong colours or soft tones, will develop neural networks which make them good at working with those elements. The more limited the presence of an element the less developed will be the networks needed to deal with it. The principles governing the growth of the brain ensure that people have neural networks which are appropriate to their environments. To the extent that the members of a single community share a visual environment they will also share a similarly adapted visual cortex.

This first neuropsychological predisposition operates largely passively. The second, that involving feature detection, is more active in its operation and is formed by more active pressures. All animals have brains that are adapted by the process of evolutionary selection to enable them to identify and distinguish between objects around them which are either beneficial or damaging, being attractive or dangerous, edible or poisonous, friendly or hostile, potential mates or potential rivals.[2] In some animals the neural networks which provide for this are inherited and ensure instinctive

reactions to particular stimuli, such as the smell or shape of a particular food or a particular predator. The more complex the animal, however, the more likely it is that the networks will be formed as a result of a process of learning. A young bird will automatically cower at the silhouette of a hawk, but a human being has to learn that a bomb is dangerous. Whichever way the networks are formed they ensure that visual attention operates selectively to search for shapes which correspond to the thing to be sought or avoided. This selectivity is also directly influenced by the emotions. When we are afraid we look for dangers. When we are secure we are freer to seek for attractions. In the wood at night we are more likely to look for dangerous animals and during the day we tend to look for ones we like. In either case we often only imagine we see them because our brain is predisposed to complete silhouettes on the basis of too little information, such a predisposition making it more likely that we shall get an early warning of the presence of the thing we need to see and thus favouring our survival. Imagining things are there when they are not is an essential adaptation of the visual cortex.

The final adaptation is closely related to the second. Some forms of feature detection and projection, as noted, are inherited, which means that the brain must be born with something like a template of the relevant object or life-form. Typically such templates are those of predators to be avoided, food to be sought or members of the same species whose company is desirable. The more social the animal the more important will be templates of the last kind. In the case of homo sapiens the templates for the face and body of conspecifics are very strong and the areas of the brain in which they are located can even be identified. It is these which enable us to identify other humans and to react to them appropriately, distinguishing males and females, adults and children.[3] The authority of these templates means that things in our environment which have sufficient features in common with a human will elicit from us the same reaction as would the real thing. The tendency of people to see figures, faces or other body parts in rock formations is one example of this process in operation. Our preference for objects which, like us, possess bilateral symmetry is another. The power of the templates for humans is so extraordinary that they have an overriding influence on our response to what we see and especially on our aesthetic predilections.

These three neuropsychological traits constitute a limited selection from among the adaptations of our visual cortex, but they are distinctive enough and have a clear enough potential relevance to the history of art to form the starting point for an enquiry into the biological basis of Renaissance aesthetics. The first trait thus has obvious implications for our understanding of the way regional or local styles develop. It almost allows us to construct a

theory that we might use when predicting in which place a particular style should develop, thus building on the important concept of the 'urban subconscious' developed by Elisabeth de Bièvre in her discussion of the art of Delft and Leiden.[4] If, for example, we were to try to predict in which city a preference might develop for pictures configured around lines parallel to the picture plane and receding orthogonals, then a theory that assumes that neural networks are passively formed by environmental exposure would prepare us to look neither to Rome with its jumbled rounded ruins, nor to Venice with its sinuous Grand Canal and irregular alleys, nor to Siena with its curved piazza and meandering streets, nor to Bruges or Ghent with their winding waterways and steep gables. The place in which we would expect this preference to emerge would be Florence with its river, straight as a canal, its quadrilateral Roman core, and its medieval periphery built around a network of straight roads. Also, in trying to predict the period at which such a style might appear we should expect the build-up of the visual preferences on which it must be based to be accelerated as the straight streets became lined with an increasing number of rectangular buildings, their walls marked with the repeated horizontals of coursed masonry. And this is exactly what happened in the fourteenth and fifteenth centuries. A knowledge of earlier texts on optics and on surveying was available in many towns. Only in Florence, however, did the principles governing brain development ensure that individuals brought up there would enjoy such an intensive growth of neural networks designed to deal with receding orthogonals that they were biologically better prepared to apply existing theory on the geometry of optics to the representation of pictorial space. That Brunelleschi demonstrated his system in paintings of two of the city's most striking angular buildings, the Palazzo Vecchio and the Baptistery, from familiar viewpoints is also no more than we might expect.

If the neural networks in the visual cortex of the typical Florentine were especially adapted for dealing with straight lines meeting at right angles, those in the cortex of Venetians would have developed rather in response to the repeated experience of light reflected from water and of the similar effects produced by polished coloured marbles, gold glass mosaics and oriental silks. Venetian patrons would always have had a biologically based positive response to reflected lights and would always have preferred paintings which included them, whether they were the golden flashes from an Antonio Vivarini or the more elusive highlights of a Bellini or Titian. The same factors would also have given them a biological preference for oil paint, with its greater capacity for capturing brilliance and refulgence. It was not necessary for foreigners such as Tiziano da Cadore and Giorgio da Castelfranco actually to share the neural structures of native Venetians. All that was required was that they should respond to the preferences such

structures encouraged in their paymasters. At one level the point made here is no more than common sense and has often been prefigured in many celebrations of the difference between Florentine and Venetian art. All that modern knowledge of the brain enables us to do is to appreciate the extent to which such classic differences between the schools of Florentine and Venetian painting are biologically based.

The stress here on modern knowledge of the brain should not lead us to minimize the understanding of the brain available in the fifteenth and sixteenth centuries. The use of scanners and electron microscopes may help us to know more about its inner mechanisms, but many people in the past already had an awareness of specific mental tendencies including that associated with our second neuropsychological trait, feature detection. One such person was Alberti who begins his *De statua* with the familiar statement:

I believe that the arts of those who attempt to create images and likenesses from bodies produced by Nature, originated in the following way. They probably occasionally observed in a tree trunk or a clod of earth and other similar inanimate objects certain outlines in which, with slight alterations, something very similar to the real faces of Nature was represented. They began therefore, by diligently observing and studying such things, to try to see whether they could not add, take away or otherwise supply whatever seemed lacking to effect and complete the true likeness. So by correcting and refining the lines and surfaces as the particular object required, they achieved their intention and at the same time experienced pleasure in doing so.[5]

The phenomenon of people imagining seeing things that are not there had been treated before.[6] What is new is the understanding of the importance of the phenomenon for the history of art. Alberti is in fact the first person to provide what is probably the correct explanation for the origin of artistic activity and he must do so on the basis principally of his own experience. He apparently noticed that when he tried to make sculptures he began by looking in his raw material for the thing he wished to represent and that he experienced a natural tendency to see shapes when they were only vaguely suggested. The mechanism to which Alberti is drawing our attention is precisely that noted earlier. Natural selection has predisposed us to such projective feature detection because it favoured those members of our species who were able to pick out leaves, fruits, nuts, animals and so on even when they were concealed by camouflage. Even the pleasure Alberti refers to on the completion of the image is biologically driven, as those individuals who got more pleasure from actually 'completing' the leaf or nut by getting close to it would also be the most likely to survive. Alberti's awareness of the importance of man's genetically driven neurology also underlies his observation in the *De pictura* that if we witness an emotion we are liable to share it:

'A *historia* will move spectators when the men painted in the picture outwardly demonstrate their feelings as clearly as possible. Nature' – and here we would nowadays say biology – 'provides . . . that we mourn with the mourners, laugh with those who laugh and grieve with the grief stricken'.[7] Since those humans who shared the emotions of those around them were more likely to survive, the tendency to do so was also selected for and was there, as Alberti realized, to be exploited by artists. A similar exploitation of a natural, or biologically controlled, human response also lies behind his recommendation in favour of the use of naturalistic portrayals because of the observable tendency of people to pay attention to likenesses of particular known individuals in paintings, whether or not they are well painted.[8] Similarly, Alberti's privileged understanding of the operations of the brain is again revealed when he describes how the artist should work things out and correct them in the mind before he puts them on panel: 'For it is safer to remove errors from the mind than to erase them from the work itself.'[9] He evidently realized that we can visualize things as well in the brain as we can on an external surface, which means that we can virtually sketch in our heads. The extent to which all Alberti's observations are based on autobiographical experience is clearly suggested by his recommendation that we look at sculptures with half-closed eyes, because that renders the nuances of shading more visible.[10] All this implies that Alberti paid more attention to the operations both of the eye and the brain than anyone previously, but why?

It would be easy to say that it was because of his humanistic education, but the truth is that learning from books, even great Greek and Roman works, could hardly have led him to these new perceptions. The real reason for his reflection on his mental resources probably lies in a combination of the self-consciousness such books encouraged and the more prosaic attribute of illegitimacy. While legitimate members of the Alberti family owed their wealth and position to the legal system and its documents, Leon Battista was actually disenfranchised by such apparatus and as a natural son had to rely on his natural, or biological, resources. His illegitimacy drove him to explore these, as it also drove him to develop them by the study of an exceptionally wide range of skills. The extent to which Alberti's study of the visual arts was driven by a Darwinian drive to survive is well illustrated by his dedicatory preface to the *De pictura* in which he tells Gian Francesco Gonzaga that if he wants to discover more of his abilities he should invite him to spend time at his court. Alberti's knowledge of the linkages between eye and hand through the mind was his meal-ticket.

The suspicion that the root of Alberti's self-awareness lies in his distress at being denied by law his rightful place in society is strengthened by the extraordinary parallel with Leonardo. Leonardo too was the natural son of a

relatively high-class father and he too first wrote a job-begging letter boasting of his talents and then went on to write another major account of the rules of nature as they affected artistic activity. Indeed he went even closer to the biological roots of art, as in the remarkable passage in which he demonstrates the superiority of the eye over the ear by pointing out that the former is much more essential than the latter for survival.

Animals receive worse injury by the loss of vision rather than hearing, for many reasons: firstly, by means of sight, they find food with which to nourish themselves, as is necessary for all animals; secondly, through sight, they can appreciate the beauty of all created things, more especially those that arouse love.[11]

Leonardo here acknowledges that humans and other animals all depend on sight for the two necessities of life, nourishment and procreation; although he could not realize that he was coming close to describing the reasons why the particular properties of vision were selected genetically. An important point of his argument is that the sense of beauty is based on sexual desire and this is implied again in another passage:

... human beauty will stimulate love in you, and will make your senses envious, as if they wished to emulate the eye – as if the mouth would wish to suck it into the body, as if the ear would seek its pleasure in being able to hear visual beauty, as if the sense of touch would wish it to be infused through the pores, and as if the nose would wish to inhale it with the air that it continually exhales.[12]

There can be little doubt that Leonardo's awareness of the biological basis of beauty was an essential precondition of his success. His paintings of women, for example, become increasingly warm and attractive until he reaches the intensity of acknowledged desire in the smile of Mona Lisa.

Another source of Leonardo's success is, of course, his development of elaborate preparatory methods. He realized more clearly than Alberti that the exploitation of the projective feature-detection faculty could be one of the best ways for any painter to improve his technique:

... if you look at any walls soiled with a variety of stains or stones with variegated patterns, when you have to invent some location, you will therein be able to see a resemblance to various landscapes ... or again you will be able to see various battles and figures darting about ... and an endless number of things which you can distil into finely rendered forms. And what happens with regard to such walls and variegated stones is just as with the sound of bells, in whose peal you will find any name or word you care to imagine.[13]

As with his extension of the discussion of aesthetic preference to animals, Leonardo's recognition that he is talking about a general phenomenon and that our mind's response to wall stains and bell peals is the same demonstrates an even keener awareness of the universality and thus the biological

nature of our responses. More important for his art, though, is his recognition that even chance marks can suggest landscape and figure details. It was his alertness to the suggestiveness of every stain on the paper which enabled him to select from the many marks he made in exploring a composition the very best for his purpose. As he says in urging other painters to cross out and improve any charcoal mark they find less than fully satisfying, just as poets keep crossing out and improving their verses, 'I have in the past seen in clouds and walls stains which have inspired me to beautiful invention of many things. These stains, while wholly in themselves deprived of perfection in any part, did not lack perfection in regard to their movements or other actions.'[14] Leonardo's exploitation of a genetically driven projective faculty helped him to make paintings that were more satisfying than any made earlier. His aesthetic, like that of Alberti, was largely biologically based.

Leonardo and Alberti, the two natural children who insistently urged others too to look at nature rather than turn to books or to masters, were the most articulate on the subject of biologically rooted mechanisms, but they were not alone in experiencing the phenomena they discuss. Botticelli, according to Leonardo himself, looked down on landscape painting because he could easily see landscapes in the impact mark of a paint-soaked sponge thrown at a wall. Piero di Cosimo too, according to Vasari, was in the habit of staring at clouds and spotted walls, 'imagining that he saw there equestrian combats and the most fantastic cities and the grandest landscapes ever beheld', and there are several suggestions of faces in the landscape elements of his paintings, as there are in other fifteenth-century paintings. An intriguing example is the dark cloud behind the light head of Piero di Cosimo's beautiful Simonetta Vespucci (Figure 2.1). The suggestion of the profile of an ugly old man in the cloud contrasts with the head of the young woman just as that which one dislikes contrasts with that which one desires. A similar contrast underlies one of the most remarkable fifteenth-century heavenly visions, that in Enguerrand Quarton's famous *Coronation of the Virgin* in Villeneuve-les-Avignon. There in the sky an angel and devil wrestle for a soul (Figure 2.2). Each is clearly made out of the same substance as the dark and light clouds found elsewhere in the sky and there is a clear suggestion that dark clouds encourage the projection of diabolic images and light clouds angelic ones. If so, this is exactly what we would expect from the adaptive history of the human perceptual system. As noted earlier, when we are afraid or depressed we tend to see or imagine dangers and when we are secure we imagine delights. What, though, would have caused the alternation of fear and hope implicit in these figures? The answer lies almost certainly in their date, 1453. The work was commissioned at the time of the Fall of Constantinople to the Turks, an event that was widely seen as one of the

disasters which would, according to Revelation, announce the end of the world. Those who waited to discover their fate at Judgement would have alternately feared being seized by devils and hoped to be rescued by angels. They would also have kept their eyes on the skies where St John warned them to expect visions, whether of evil forces such as the four horsemen or of benevolent ones such as angels. That others too looked at the skies in this way is demonstrated by Mantegna's early *St Sebastian* of about 1460 in Vienna. There the image of a horseman who emerges from the clouds is almost certainly the crowned rider on a white horse envisaged at Revelation 6:2. Following the Fall of Constantinople apocalyptic fears only increased.

Indeed, as the year 1500 with its millennial associations approached they reached a new peak. Savonarola traded on them for political advantage in Florence and Dürer traded on them financially in Nürnberg, publishing in 1498 his great *Apocalypse* in which he filled the skies above a familiar German landscape with visions that were alternately terrifying and reassuring. If we think his prints are purely artistic inventions we are wrong. A series of broadsheets, published from around this date, show that people all over Germany had apocalyptic visions, seeing in the chance effects of cloud and sun and displays of the Northern Lights battles and manifestations of the divine presence (Figure 2.3). That these broadsheets appeared in even larger numbers in the mid-sixteenth century indicates that the strife between Pope and Luther, which was at its fiercest in Germany, and which recalled for both sides the conflict of Christ and Anti-Christ, kept the popular imagination there more alive than elsewhere. The uneasy battle between hopes and fears affected the minds of the whole frontier area between Catholic and Protestant. That there was so much agreement about what was seen in each community, as is testified to in the texts accompanying the broadsheets, can be explained by the way common anxieties were affecting people who also shared similar neural structures. The biological basis of the vision is an important aspect of Renaissance aesthetics. It may seem strange to compare what German peasants saw in the sky with what Leonardo painted, but the experience of both relies on the same mechanism.

Another more delicate link between German peasants and Florentine artists is provided by a small architectural drawing by Michelangelo (Figure 2.4a). This, one of a number made in connection with the Medici Chapel commission, uniquely shows a face emerging from the moulding of an Ionic base. If we are to look for the origin of this vision we should probably see it in the Turkish flavour of the profile's beard and turban. Made during the 1520s when there was a fear of a Turkish attack on Rome itself, it shows how terror preyed on the mind of even the divine Michelangelo. It also draws attention to the biological basis of a whole trend in architectural aesthetics, the change from the more mathematically defined forms of the fifteenth and

early sixteenth centuries to the more organic forms of the later sixteenth and seventeenth. What the drawing suggests is that the main reason why architects began to use forms which were increasingly organic and specifically anthropomorphic, was that as they drew more freely they naturally tended to select preferentially from the charcoal and ink marks those forms which the brain recognised as corresponding to human templates. This tendency is already clear in Michelangelo, as Ackerman observed,[15] and directly underlies much that is new in his architecture, especially of the Medici Chapel. One such feature is the cornice in which eggs and darts become masks and another the series of face capitals on the pilasters, but perhaps the most significant is the baluster-like element in the attic. This abandons the traditional form with symmetrical enlargements about a central element, still found in the vault of the Sistine Ceiling of 1508–12 (Figure 2.4b), in favour of one swelling upwards towards the top. The reason for Michelangelo's preference for this shape is almost certainly its correspondence with the template for man in his – and all men's – neural networks made it more meaningful and so more satisfying. A similar reason would also lie behind his invention of another form of baluster, with a reverse swelling towards the base in the adjoining Medici Library vestibule. The main difference was that the template matched was probably rather that of a female. Students of human ethology have long noted that an essential feature of human sexual dimorphism is that women appear widest at their hips and men at their shoulders and that inborn programming in the form of templates helps us to react quickly and appropriately to the different silhouettes. As Michelangelo covered his pages with drawings, mixing figures and buildings with a new freedom, it was these templates which came to shape his preferences in architecture. He also in some way knew what he was doing. Although he did not write about his activities at such length as did Leonardo, he does allude to the processes involved. It is thus in this light that we should understand Michelangelo's statements both that the compasses should be in the head, not in the hands, and his observations in a late letter that: 'It is an established fact that the members of architecture resemble the members of man. Whoever neither has been nor is a master at figures, and especially at anatomy, cannot really understand architecture'.[16] The architecture that he writes of is above all his own, since he had gone further than his predecessors in evaluating architectural designs using the part of the brain adapted to dealing with people, but others soon followed his practice and his theory. Some went far beyond him, like the designers of the face-façades at Bomarzo and at the Palazzetto Zuccaro in Rome. Many simply allowed their drawings to be gently distorted by the unconscious pressures emanating from the universal human neurology, producing, like

Bernini and Borromini, more and more organic forms. All, though, collaborated in giving architectural aesthetics a new biological basis.

This study is not a critique of existing approaches to Renaissance art. Rather it is an attempt to provide new support for what might otherwise be only aperçus. It is also a cautious attempt. The knowledge of neuropsychology presented here is still elementary. As it becomes refined and adjusted the conclusions offered here will also need to be corrected. The only conclusion that will not change is the one which follows from the initial attempt to explore the biological basis of Renaissance aesthetics. This is the recognition that the greatness of some of the most celebrated Renaissance artists is due to their responsiveness to their genetically encoded animal nature.

## Notes

1. Kolb and Whishaw (1996): 499–502.
2. McFarland (1992): 259–63.
3. Kolb and Whishaw: 290.
4. de Bièvre (1995).
5. Alberti, *De statua*, 1, trans. and ed. Grayson (1972): 121.
6. Parronchi (1959); Janson (1961).
7. Alberti, *De pictura*: II, 41, trans. and ed. Grayson (1972): 81.
8. Alberti, *De pictura*: III, 56, *ibid.*: 101.
9. Alberti, *De pictura*: III, 59, *ibid.*: 103.
10. Alberti, *De pictura*: III, 58, *ibid.*: 101.
11. da Vinci, *Cod. Urb.*, 7 r.v., in *Leonardo on Painting*, trans. and ed. Kemp and Walker (1989): 22.
12. *Cod. Urb.*, 11 r.v., *ibid.*: 24.
13. *Cod. Urb.*, 35 v., *ibid.*: 222.
14. *Cod. Urb.*, 61 v., 62 r., *ibid.*: 222.
15. Ackerman (1986): 1–40.
16. *Ibid.*: 37.

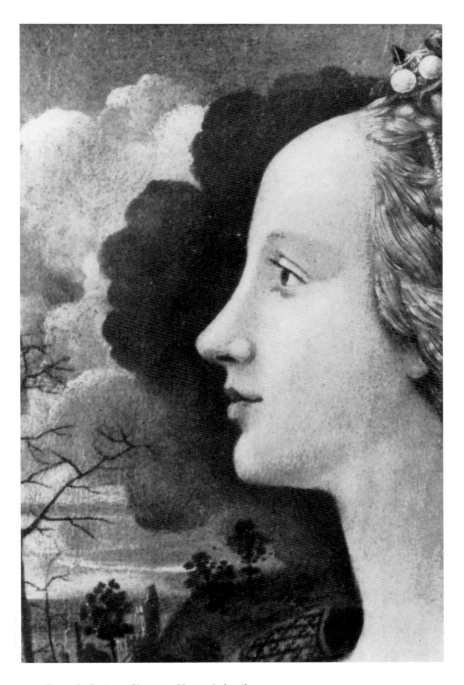

2.1   Piero di Cosimo, *Simonetta Vespucci*, detail

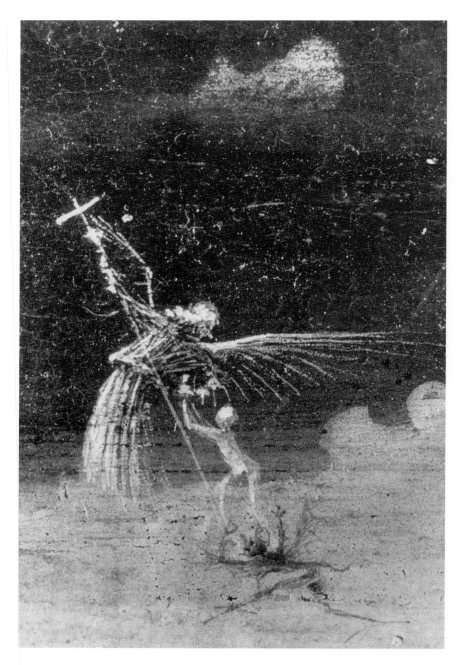

2.2   Enguerrand Quarton, *Coronation of the Virgin*, detail

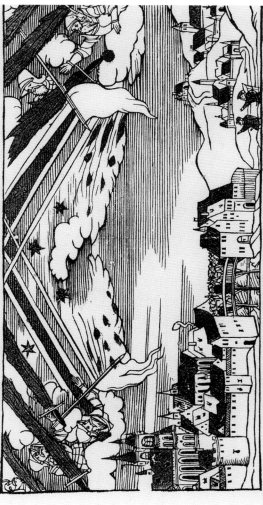

2.3  *Vision over Bamberg* (woodcut), 28 December 1560

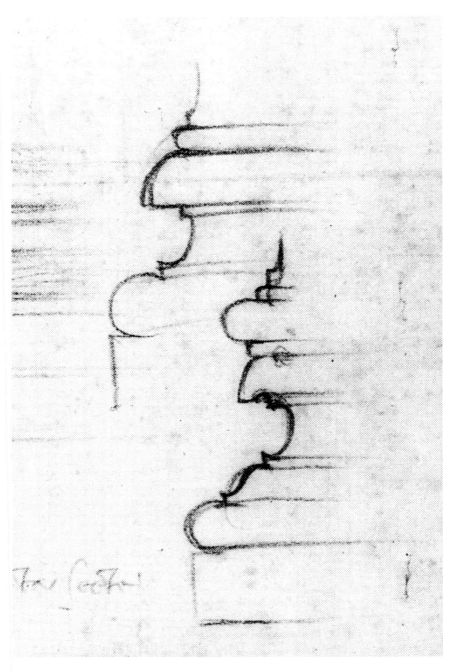

2.4   Michelangelo, sketches of base profiles

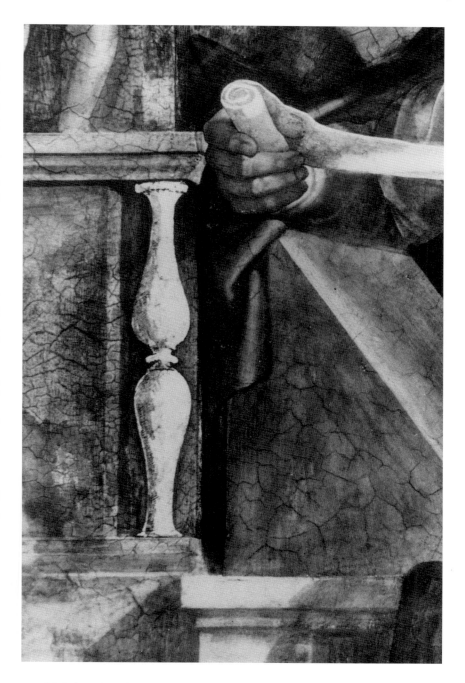

2.5   Michelangelo, *Balusters*, to left of *Isaiah*

# The perception of beauty in landscape in the quattrocento

*Alison Cole*

Any discussion of the elusive concept of beauty in fifteenth-century land-scape depiction must confront the limited critical vocabulary used in con-temporary descriptions. The main responses to painted landscape exist as poetic or rhetorical pieces, often polished exercises in the 'florid' style. These elaborate descriptions, with their 'smiling meadows',[1] give frustratingly little idea of how people truly responded to representations of nature. It is even more difficult to try to pin down the painter's own aesthetic response to the landscape elements that he often so painstakingly portrayed on panel or canvas. This paper attempts to establish what both painter and beholder considered to be beautiful in fifteenth-century landscape depiction, looking first at the contemporary standard for a 'beautiful' landscape before delving into the more complex realms of artistic style, content and technique.

## A landscape of universal beauty

In medieval and early Renaissance culture the most pervasively beautiful landscape is the garden of delight, with all its literary connotations of love, innocent pleasure or desire. This garden may be enclosed – a piece of 'paradise' sheltered and protected from the wild forests and mountains beyond. Or it can take the form of a flowery meadow or shady grove, within safe reach of the city walls. In such a garden, beauty not only resides in the visual loveliness of 'the many flowers which with their various colours compose harmonies for the eyes' (Leonardo da Vinci).[2] It also springs from the material amenities of the place: the sweet-scented shade provided by spreading pine trees or a hedge of roses, the cool refreshment of sparkling fountains, the abundance of nature's fruits – oranges, cherries, pears – waiting to be 'grasped' (most fifteenth-century gardens had eating corners),

and in the restorative properties of medicinal herbs.[3] The garden's beauty also dwells in its peaceful, sometimes secret, seclusion.

This 'locus amoenus', whose character is so vividly described in the writings of Virgil, Homer and, later, Dante, is a favourite literary setting throughout the Renaissance.[4] Shady gardens, delicious retreats from the fierce heat of the afternoon, set the scene for the narration of the amorous tales of Boccaccio's *Decameron* (1348–53);[5] and a sun-drenched garden, with laurels and cypress trees, provides the setting for Firenzuola's Neoplatonic dialogue on beauty in his famous treatise 'On the Beauty of Women' (1548).[6]

From c.1400, the garden emerges as a favourite motif in art, expanding into an exquisite ornamental world of flowers, fountains and birds. Here the Virgin nurses her child, her virginity protected and enclosed, or courtly lovers weave wreaths of violets, dance and sing. By the late fifteenth century the real-life garden had itself become a work of art. Giovanni Sabadino degli Arienti, walking around his patron Ercole d'Este's 'heavenly' garden at the Castello of Ferrara, compared the 'diverse artifice' of the plots of salad vegetables and the orchards of exotic fruit trees with the work of the 'finest painters'.[7] For a literary figure like Sabadino, this courtly 'giardino d'amore', reminiscent of the apocryphal garden of Susanna, had clearly been designed according to an artistic and poetic ideal.

The educated Renaissance viewer, as contemporary descriptions by travellers and chroniclers bear witness, looked at real scenery and painted imagery alike through a filmy gauze of poetic description. Thus the humanist Leon Battista Alberti, demonstrating the miraculous painted and mirrored 'peep-box' with which he obtained spatial images of the Italian landscape, managed to capture images by day which reminded him of Homer's vistas, tinged with the light of dawn.[8] And the humanist Guarino da Verona, admiring Pisanello's pictures, with their empirical study of animals, birds and plants, imagined them quivering – just as in Virgil's descriptions – with breezes and bird-song.[9] Pisanello may well have designed his detailed landscape backgrounds to inspire just such a response.

However, there are problems in looking for too close a correlation between literary ideals and the painted landscape elements employed in the fourteenth and fifteenth centuries. The artist's experience of real landscape – be it the cultivated garden, the well-ordered rural estate, or more remote scenery – was articulated in imagery dictated largely by pre-existing visual conventions. His scenic world included the typical components – seas, sites, plants, mountains, buildings, animals, grass, flowers – embraced by the simple word *paese* in fifteenth-century texts. Selecting and including any of these diverse elements brought with it a whole set of new concerns: for instance, how the landscape could emphasize the main figure configurations or

provide an iconographically appropriate setting. Poetic beauty was not, generally speaking, of paramount concern.

In Sandro Botticelli's *Primavera* (c.1478, Uffizi; Figure 3.1), however, we can find a crystallization of the seductive idea of poetic beauty in a painted landscape. What is helpful here is that the painting's theme of love and regeneration is expressed through the metaphor of 'springtime', of which the landscape is an essential part. In his recent study, Charles Dempsey has sensitively related Botticelli's particular brand of poetic invention in the *Primavera* to the literary milieu of Lorenzo de' Medici and his circle.[10] Lorenzo's and Angelo Poliziano's descriptions of a 'paradise on earth', shaped by the conventions of vernacular love poetry and infused with imagery from a rich variety of classical sources, provide the context for a reading of the grove of *Primavera*.

The landscape expresses an idea of beauty woven out of literary allusion – it is as much an image of beauty as the figures of Venus, Flora and the three Graces, individually or combined. It is the landscape of Spring: 'the whole world [is] more beautiful and ornamented in this season than any other' (Lorenzo de' Medici).[11] Yet it is also a 'paradise':

> ... 'paradise', for whomever wishes to define it correctly, means nothing more than an exceedingly agreeable garden, teeming with everything that is delightful, trees, fruits, flowers, living and running waters, birdsong, and in effect all the amenities of which the heart can think. One can verify by this that it was Paradise wherever a lady so beautiful was, because there was the fullness of every amenity and sweetness that the gentle heart can desire.[12]

Botticelli's landscape meticulously describes the ornamental and sensual beauties of such a paradise. The grass is carpeted with copious flowers, which are keenly observed and delicately painted. Scented shade is provided by a dense grove of orange trees, simultaneously blossoming and fruiting. These symmetrically frame an arched opening, filled with the dark radiating foliage of myrtle – the tree sacred to Venus. The setting is gracious and gentle – as befits the garden of Venus. It is also as elaborately rich and decorative as the Netherlandish tapestries so prized by the Medici. This ornamental naturalism, so in tune with contemporary Florentine taste, is part of the landscape's general attractiveness and appropriateness (as a painted panel used to decorate a room).

Alberti recommended in his *De pictura* (1435) that the artist's settings should exhibit both plentiful variety and decorum.[13] In Botticelli's landscape, such variety and decorous harmony are evoked specifically through the architectural symmetry of forms and the felicitous combination and contrast of colours. Alberti responded to colour in purely aesthetic terms: 'I should like, as far as possible, all the genera and species of colour to appear in

painting with a certain grace and amenity.'[14] This 'grace' is nothing to do with subtle tonal transitions, but with an aesthetic ideal of juxtaposition ('sympathy among colours') and contrast – with clear bright colours placed near different darker colours. 'This combining of colours will enhance the attractiveness of the painting by its variety, and its beauty by its comparisons.'[15]

Botticelli, who rarely devoted much energy to his landscape settings, seems to have endeavoured to give his garden an aesthetic beauty. The rhythmic variation of colour and form in the surging meadow, like the proportions and movements of the figures in *Primavera*, are expressive of both nature's variety and the artist's own fertility of invention. Yet this 'paradise' is something of an isolated phenomenon in Botticelli's output: Leonardo da Vinci described most of Botticelli's landscapes, with their bland suggestions of grass, hills and watery distances, as 'tristissimi' – 'extremely poor'.[16]

Leonardo was particularly scathing about Botticelli's lack of detail, describing how his friend scorned the study of landscape: in Botticelli's opinion, Leonardo relates, a sponge soaked in a variety of colours and thrown at a wall (an ancient practice ascribed to Protogenes) could create as lovely a landscape as anyone could wish for. Leonardo acknowledges the power of such suggestive forms in his *Trattato*, but he insists that the creator of beautiful landscapes must first be equipped with a detailed knowledge of 'le membri de paesi' – rocks, plants and the like.[17] This insistence on the study of the 'parts' of nature, as preliminary to the exercising of the imagination, has its roots in the practice of the early Quattrocento workshop.

## The 'imitation of nature'

The Quattrocento workshop, both out of preference and necessity, tended towards simplification. Ideas and images were translated into straightforward workshop procedures that could be followed by assistants or elaborated by masters. The early workshop practice of creating landscape settings from 'nature' is clearly set out in the manual of the artist Cennino Cennini.[18]

Writing early in the fifteenth century, Cennini instructs the master in the practice of the painter's craft – particularly fresco – basing his guide on the practice of Giotto's school. Fruit, flowers, fishes and birds are the ornaments of nature (embraced by the term *ornamenti* or 'usual (*consueto*) decoration' in Quattrocento contracts), and landscapes can be embellished with these as and when the painter sees fit. But mountains and rocks are of greater importance. This is not because they were considered beautiful or sublime, but because from Byzantine times onwards they denoted the biblical *locus* in

general and because with little variation – denuded or sparsely vegetated – they could represent a specific site like Mount Verna or a wilderness. Here, as in all fifteenth-century painting, appropriateness or general iconographic suitability of setting is a key consideration.

What is interesting is Cennini's suggestion that the artist should achieve a natural effect by copying 'pietre grande' from nature, concentrating on the contrasts between 'i lumi e schuro' (to achieve a maximum sense of relief).[19] The stones should be dirty – 'scogliosi e non pulite' – so that the effect is as naturalistic as possible. From these humble objects, the painter can create huge mountains and rocky plateaus, and 'cose non vedute'. It is inappropriate in this connection to speak in terms of the inspiration of natural beauty. Giotto's landscape elements serve almost as symbols of the natural world, and are as much a product of his *fantasia* ('imagination') – a term used by Cennini[20] – as his hands. But it is this quality of *invenzione*, the transformation of a stone into a rock or a mountain, a lump of wood into a bulbous tree, that the Quattrocento eye would be particularly receptive to and which could give immense aesthetic pleasure to the beholder (Figures 3.2, 3.3).

One cannot underestimate the enthusiasm of Quattrocento painters for 'inventing' and demonstrating new areas of expertise. Landscape settings (free for the most part from contractual stipulation) allowed painters to transform *siti*, *monti* or *verdure* (the term used in contracts to denote ornamental greenery of a generalized nature) into something novel and individual, fantastic yet plausible. Leonardo's 'word-paintings', written during his sojourn at the Sforza court in Milan, reveal a taste for such delights. His imaginary 'picture' of Mount Taurus, soaring from 'eternal snows' a mile high into the clouds and emerging to expose a peak of pure white rock, was long thought to be a real description.[21] It finds its equivalent in the haunting Alpine backgrounds of Leonardo's paintings.

With the emergence of the idea of 'a personal artistic style', so valued in humanist and courtly circles, the Northern Italian painters Andrea Mantegna and Cosimo Tura could create volcanic mountains, grottoes and rocky outcrops, even foregrounds littered with pebbles, that must have given keen delight because of their imaginative or idiosyncratic recreation of the natural world. For viewers well-versed in the Byzantine landscape of spiralling rock, such settings must have also given pleasure because of their novel and sophisticated elaboration of established visual convention.

Yet Mantegna, like Leonardo da Vinci, had a keen understanding of the rocky formations he painted. His fantastic rocks are founded in scientific observation: their stratified, weather-eroded forms have the ring of geological truth. The Quattrocento artists' marvellous powers of natural description, born of intellectual curiosity and nurtured by study and diligence, were

regarded as remarkable well into the sixteenth century. The Spaniard Fernandez de Oviedo (writing in 1535) found words insufficient to conjure in the mind's eye a plant newly discovered in America – there were no literary formulas to which he could resort; the plant, he wrote, 'needs to be painted by the hand of a Berruguete or some other excellent painter like him, or by Leonardo da Vinci or Andrea Mantegna, famous artists whom I knew in Italy.'[22]

For humanist writers on art, beauty could be found specifically in the 'life-likeness' of painted images. Thus a life-like representation of an object (a plant or a person) could be regarded as beautiful because of the marvels wrought by the artist, even if the object itself was rather unremarkable.[23] The great preacher Girolamo Savonarola, a close friend of Botticelli's, seems to suggest that this *similitudine* was equally appreciated by ordinary people: 'The closer they [painters] imitate nature, the more pleasure they give. And so people who praise any pictures say: look these animals seem as if they are alive, and these flowers seem natural ones.'[24] This prizing of illusion, sanctioned by the ancients, opened up a whole new realm of aesthetic responses for the artist to address.

### New techniques, new skills

The creation of illusionistic vistas on to deep space, facilitated by technical innovation, brought an extra dimension to the ideal of 'the imitation of nature'. The technique of one-point perspective, invented by the architect Brunelleschi and formulated for painters by Alberti, helped create the ultimate illusion: the picture surface was now a transparent window onto a painted world, miraculously mirroring one's own. The actual painted view through a window was a Flemish innovation: but Albertian perspective views were constructed according to a mathematical rationale.[25] This meant that Quattrocento landscapes and townscapes, organized along calm horizontals and orthogonals, could conform to an Aristotelian ideal of beauty, conveying order and symmetry and definiteness.

Yet in aesthetic terms, there is plenty of evidence to suggest that the panoramic vistas of Northern artists, created empirically, with their unparalleled suggestion of light and distance (painted in the newly refined oil technique), were considered even more breathtaking in their illusion of reality. The humanist Bartolommeo Fazio, historian and secretary to King Alfonso of Naples, described the effect of a Jan van Eyck vista in his *De viris illustribus* (1456):'. . . there [are] . . . horses, minute figures of men, mountains, groves, hamlets, and castles, carried out with such skill you would believe one was fifty miles distant from another.'[26] Some artists, like Antonio Pollaiuolo and Antonello da Messina, tried to combine the aesthetic appeal

and sophistication of both Italian and Flemish methods, creating symmetrical foregrounds, yielding onto sweeping light-filled vistas.[27] Alesso Baldovinetti, depicted the Arno valley, partly because its coiling riverbanks seemed to converge naturally in accordance with Albertian perspective rules.

Technique and medium had an enormous impact on the types of landscape that artists chose to depict. For the Florentine painter and art historian Giorgio Vasari, writing in the mid-sixteenth century, it was clear that Quattrocento painters could not be as receptive to the more beautiful aspects of scenery because they were limited either by their medium (predominantly tempera or fresco) or by their determination to master certain technical difficulties.[28] This is very much the case with the Florentine artist Paolo Uccello, who, Vasari tells us, in landscapes (*paesi*), 'was the first among the old masters to make a name for himself . . .'.[29]

Vasari mentions a series of scenes on canvas executed for the house of Medici, and some drawings relating to them, in which there were 'certain very lifelike shepherds, and a landscape (*paese*) which was considered something very beautiful in its time' (*che fu tenuto cosa molto bella nel suo tempo*).[30] It is worth examining this notion of what was held to be 'very beautiful' in Uccello's landscapes, even at the risk of ignoring the obvious iconographic appeal of such scenes – rural idylls in the bucolic mode.

Vasari, writing his *Lives*, clearly had some difficulty in finding beauty in Uccello's landscapes. One of the reasons for this is that they offend his sense of decorum. In the *Scenes from the Monastic Legends* in the cloister of S. Miniato (Florence), Vasari describes how Uccello 'paid little regard to effecting harmony by painting with one colour, as should be done in painting stories, for he made the fields blue, the cities red, and the buildings varied according to his pleasure . . .'.[31] Such obvious delight in pattern and flagrant disregard for local colour or carefully gradated tones accords with the pronounced aesthetic taste in fifteenth-century Florence for combining elements of empirical naturalism with ornamental stylization and decorative colouring (encountered also in Botticelli's *Primavera*).

Vasari's attitude to Uccello's landscape is summed up in his illuminating discussion of the now damaged Creation cycle in the *Chiostro Verde*, S. Maria Novella, Florence:

. . . in this work [Uccello] took delight in making the trees with colours, which the
painters of those times were not wont to do very well; and in the landscapes,
likewise, he was the first among the old masters to make a name for himself by his
work, executing them well and with greater perfection than the painters before him
had done; although afterwards there came men who made them more perfect, for
with all his labour he was never able to give them that softness (*morbidezza*) and
harmony (*unione*) which have been given to them in our own day by painting them

in oil colours (*colorirli a olio*). It was enough for Paolo to go on, according to the rules of perspective, drawing and foreshortening them exactly as they are (*come stanno quivi appunto*), making in them all that he saw (*tutto quel che vedeva*) – namely ploughed fields, ditches and other minutenesses of nature – with that dry (*secca*) and hard (*tagliente*) manner of his, whereas, if he had picked out the best from everything and had made use of those parts that come out well in painting, they would have been absolutely perfect.[32]

Vasari's idea of what makes for a 'perfect' painted landscape is codified in this assessment of the ways in which Uccello fails. He is looking for a pleasing vista, with soft fluid forms, harmoniously coloured and composed with a sense of 'design' (according to an intellectual perception of beauty). Uccello should have selected only those things which 'come out well' in painting. This does not include ploughed fields and ditches – associated with peasants and mud. Yet for Uccello's contemporaries, the painter's skill in recording these 'minutiae' of the everyday landscape must have been a source of pleasure. The decorative patterns and linear harmonies created by the ordered furrows and ditches, combined with their use as novel devices for creating convincing spatial recession could even be 'held' to be of beauty.

The opposition of *morbidezza/secca* and *unione/tagliente* in the discussion of the 'Creation' cycle, reveals Vasari's sensitivity to the different media of tempera and oil. The potential of Jan Van Eyck's and Memling's refined oil technique, with its dark resonance and light-reflecting properties, had a huge impact on the painting of landscape and on the aesthetic appreciation of it.

Vasari's term *tagliente* – literally 'cutting' – vividly evokes Uccello's practice of incising lines at the underdrawing stage, in order to crisply transfer his design. This process often went hand in hand with perspective techniques (particularly in defining the orthogonals) as in Uccello's *Unhorsing of Bernardino della Carda* (1450s, Uffizi, Florence; Figure 3.4). *Secca*, meaning 'dry', suggests the consistency and qualities of tempera which, due to the nature of its egg medium, dries too quickly to allow colours to fuse. In landscape, oil colours could be easily blended to create *morbidezza* and *unione* – Leonardo created especially soft tonal transitions by working the oil paint with his fingertips. The tempera process was extremely precise – perfect for counterfeiting the *minuzie* of nature. Vasari admires its qualities in Mantegna's *Madonna of the Stonecutters* (1488–90, Uffizi, Florence; Figure 3.3), made 'with such subtlety and patience that it does not seem possible that it could have been executed so well with the slender point of a brush.'[33]

The terms *secca* and *tagliente* also vividly evoke the substance of Uccello's landscapes: his ploughed fields with deep irrigation ditches seem to be furrowed into the canvas and painted with dry earth. Vasari however finds

these features – perfectly suited as they are to the rather arid temperament of Uccello – too literal and prosaic. The painter's manner is dry, too, in that he is starting from a theoretical base and does not have the technical accomplishment to go beyond the rules he has devised. Uccello should have selected the 'good things' and then used only 'the parts which turn out best in painting' – presumably the trees, grottoes, skies turbid and serene, that Vasari admires in Raphael's compositions.[34] But to Uccello's contemporaries, thrilled by the novelty of the perspective technique, Uccello would have depicted these things precisely because they 'came out well'.

The standard by which landscape beauty should be judged, according to Vasari, is set by the landscape backgrounds of the Umbrian painter Pietro Perugino: 'For the nuns of S. Chiara,' Vasari tells us, 'he painted a "Dead Christ" on a panel . . . [and] he made therein a landscape that was then held most beautiful, because the true method of making them, such as it appeared later, had not yet been seen.'[35]

Earlier in his description of this painting (1495, Palazzo Pitti, Florence) Vasari mentions 'delightful and novel colouring', no doubt referring to Perugino's use of oil colours as well as the subtle range of his palette. This personal colour style is summed up by the term *grazia*, a favourite word for the type of beauty which cannot be defined by rules. Later, describing the scene of *Pope Boniface Confirming the Habit of his Order*, painted for the Convent of the Ingesuati, Vasari mentions 'a most beautiful view receding in perspective' (*una prospettiva bellissima che sfuggiva*). Thus he suggests that Perugino discovered the real way to paint beautiful landscapes – through a charm and loveliness of colour and a method of creating distances that recede gracefully from the eye.

Perugino's landscapes are highly artful, with their filigree trees, silhouetted against the sky like flowering grasses on long slender stems, gently undulating hills and hazy distances (Figure 3.5). They set the perfect contemplative tone for his pious (occasionally poetic) subjects, and have a unifying light and spatial clarity that give his figures real air to breathe. These qualities are described in the courtly, Neoplatonic terms that were so familiar in the society within which Giorgio Vasari moved: *facilità*, for instance, in the effortless rendering of landscape space, and *vaghezza* (charm) of colouring. Nature is idealized and generalized, displaying only its finer features: rolling hills, distant mountain ranges and wisps of cloud.

The landscapes of Perugino and his pupil Raphael, which mark the turn and beginning of the new century, form part of a painted world which breathes the relaxed air of *grazia*. Refusing to be reduced to readily identifiable rules, these lovely vistas are made up of a balanced combination of the most individually pleasing parts, just like the perfect idea of female beauty arrived at in Firenzuola's dialogue. For Firenzuola this beauty comes from a

'mysterious' order in Nature that the human intellect cannot begin to fathom.[36] Botticelli's dense ornament, Uccello's innovative perspective patterns and Mantegna's wondrously painstaking descriptions of rock and stone have little place in this new aesthetic. The melting distances, pleasing forms and atmospheric skies of the landscapes of the late fifteenth and early sixteenth centuries are where this new indefinable beauty resides.

## Notes

1.  For the rhetorical exercise 'ekphrasis' and humanist ways of describing painted landscapes to set the 'reality' before the eyes, see Baxandall (1971): chap. II, 3, 85ff., in particular, Guarino da Verona on Pisanello, 92–3.

2.  Leonardo da Vinci, *Trattato della Pittura*, ed. and trans. McMahon (1956): para. T.42.

3.  See Piero de' Crescenzi, *De Agricultura* (before 1305), (Venice, 1495): Book VIII on the medieval viridiarium; also Alberti, *De re aedificatoria*, ed. Orlandi (1966): IX, chap. IV.

4.  See Curtius (1979): chap. 10, 183ff., especially on Homer's flowery mead in the *Hymn to Demeter* and Virgil's description of the Elysian fields in the *Aeneid*. See also Dante's description of Purgatorio in the *Divina Commedia* (c. 1306–21).

5.  Giovanni Boccaccio, *Decameron*: III, introduction.

6.  Firenzuola, ed. Eisenbichler and Murray (1992): 8.

7.  Quoted in Hale (1993): 20. For full text, see Gundersheimer (1972): 52–3.

8.  Anon., *Vita di Leon Battista Alberti*, in L.B. Alberti, *Opere Volgari*, ed. Bonucci (1843–49), 5 vols, Florence: I, XCI–CXVII.

9.  Baxandall, *op. cit.*: 93.

10.  Dempsey (1992): esp. chap. 5, 140ff.

11.  Lorenzo de' Medici, *Comento sopra alcuni de' suoi sonetti*, 448, quoted in Dempsey (1992): 150. See also Angelo Poliziano, *Stanze*, I, 55.

12.  Lorenzo de' Medici, *Comento . . .*, 368, quoted Dempsey (1992): 152.

13.  Alberti, *De pictura* (1435), trans. and ed. Grayson (1972): Book II, 40, 79.

14.  *Ibid.*: Book II, 48, 90.

15.  *Ibid.*: 93.

16.  Leonardo, ed. McMahon: para. T.93.

17.  *Ibid.*: para. T.76.

18.  Cennino Cennini (1933): 57.

19.  *Ibid.*: chap. LXXXVII.

20.  *Ibid.*: chap. I.

21.  Leonardo da Vinci, *Codex Atlanticus*, 145a, quoted in Kemp (1981): 159.

22.  Quoted in Hale, *op. cit.*: 218.

23.  See Baxandall, *op. cit.*: 81.

24.  Savonarola, *Prediche e scritti*, quoted in Burke (1986): 144.

25.  For Alberti's perspective construction, see Alberti, ed. and trans. Grayson (1972): Book I, 37–59. For Aristotle, *Metaphysics*, see R. McKeon (ed.), 1941.

26.  Quoted in Baxandall, *op. cit.*: 107.

27.  See for example Antonio Pollaiuolo's *Martyrdom of St Sebastian* (1475), National Gallery, London.

28.  Vasari, *Le vite*, ed. Milanesi (1878–85).

29. Life of Paolo Uccello, *Vite* . . .: III, 66.

30. *Ibid.*: 65.

31. *Ibid.*

32. *Ibid.*: 66.

33. Life of Mantegna, *Vite*: III, 554.

34. Life of Raphael, *Vite*: IV, 375.

35. Life of Perugino, *Vite*: III, 569.

36. Firenzuola, ed. Eisenbichler and Murray: 14.

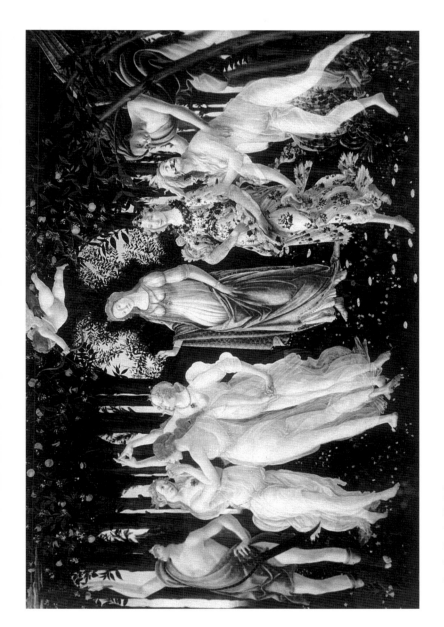

3.1   Sandro Botticelli, *Primavera*

3.2   Andrea Mantegna, *The Virgin and Child with the Magdalen and St John the Baptist*, detail of stony foreground

Andrea Mantegna, *Madonna of the Stonecutters*

3.4 Paolo Uccello, *The Unhorsing of Bernardino della Carda*

3.5   Pietro Perugino, *The Virgin and Child with an Angel*, detail of landscape vista

# 'Condecenti et netti ...': beauty, dress and gender in Italian Renaissance art

*Jane Bridgeman*

The clothes worn in fifteenth- and sixteenth-century Italy were significant enough to merit frequent, detailed description by contemporary diarists, letter-writers, diplomats and bureaucrats, but there is little evidence that considerations of beauty played any part in their expositions. Dressing correctly was certainly an important aspect of polite behaviour which identified status and informed social and political relationships, but in art, as in everyday life, the most essential feature of dress was not its beauty, but its appropriateness. Indeed, except for commonplace recommendations that painters depict clothing suited to the age and status of the subject, the representation of dress is rarely mentioned.[1]

Giovanni della Casa, the author of *Galateo*, an influential manual of etiquette written between 1551–55, offers a common definition of beauty when he notes human beings are attracted to and delighted by symmetry and proportion. Beauty exists, says della Casa, where '... there is an appropriate harmony (*convenevole misura*) between each element and between all the elements and the whole; whenever this said harmony (*la detta misura*) is found, there truly is beauty ...'.[2] This recalls Pietro Bembo's definition in Castiglione's *Courtier* (1516) although (since he is discussing etiquette) della Casa defines appropriate or harmonious *behaviour* as beautiful and discordant or inappropriate behaviour as ugly.[3] It was harmonious behaviour to be dressed correctly: inappropriate clothing was deemed impolite, even insulting. Della Casa recommends garments be of good material and well-cut, appropriate to the wearer's age and status and worn properly – for whatever their quality a slovenly or dishevelled appearance was inexcusable. To neglect one's appearance or wear unsuitable garments demonstrated that, '... the wearer is either careless about pleasing or offending others or he has no idea of elegance or harmony (*che si sia né grazia né misura alcuna)'.*[4]

A decade earlier, Alessandro Piccolomini's *Istituzion morale* (1542) offered one of the clearest definitions of this socially defined concept of beauty in dress.

... it would be ugly and distasteful for a nobleman's wife to appear publicly wearing garments suitable for a duchess or a queen – in brocades and cloth of gold, ornamented and embroidered with pearls, gems, or other decoration inappropriate to her rank. For, as beauty in all things results from a due proportion between the elements themselves and between them and the whole, lack of proportion and an ill-conceived relationship between elements results in ugliness. Dress unsuited to the wearer, creates a discord that is not just unattractive, but irksome and distasteful to all who see it. A lady therefore has to dress and adorn herself according to the dictates of rank and wealth ...[5]

Piccolomini's view that dress had to be congruent with social mores to be considered beautiful, approaches Agnolo Firenzuola's criterion for female beauty. This, too, depended upon collective consensus rather than personal taste. In *Della Bellezza delle donne* (1541), Firenzuola comments '... when one speaks of a beautiful woman, one means a woman generally *liked* by everyone, not just by this man or that ...'.[6]

Concepts of beauty were thus influenced by strongly expressed social conventions and expressions of personal taste were clearly subordinated to the demands of etiquette. Depending upon rank, enhancement of dignity was admirable in male dress but in female attire a restrained beauty was desirable. These perceptions echo Cicero:

... there are two orders of beauty; in the one loveliness predominates; in the other, dignity. Of these, we ought to regard loveliness as the attribute of woman, and dignity as the attribute of man. Therefore let all finery not suitable to a man's dignity be kept off his person ...[7]

Giovanni Pontano, in his *I trattati delle virtù sociale* (1493–98), advised the dignity of a mature man (over thirty) be enhanced by clothes chosen according to age and rank, and the garments of young men (between twenty and thirty) be vivacious and elegant. Such recommendations were unsuitable for females; the garments of nubile girls (aged twelve to eighteen) should be neat and attractive and those of married women reflect matronly virtue.[8]

Similar sentiments were expressed in Leon Battista Alberti's *Libri Della Famiglia* (1432–33). Asked how the members of his household should be dressed, 'Gianozzo Alberti' replies:

Just well. In plain clothes, especially those which are clean, appropriate and well-made; where suitable in bright and lively colours, in good cloth ... For formal occasions wear a new garment, at other times clothes previously worn and at home, those which are the most worn out. Garments confer respect Lionardo, isn't that true? You then, must respect your clothes.[9]

Matteo Palmieri (like Pontano, influenced by Cicero) in *Della Vita Civile* (c.1433) stresses a man should take care to keep clean and to avoid uncouth and coarse behaviour. In addition, '. . . the attained authority of a mature man is enhanced by appropriate adornment. That is by clean and decent garments, but not those so lavish and fancy that they attract rebuke; for one should always be careful to preserve one's dignity . . .'.[10]

Francesco Sansovino presented similar arguments in his *Arte d'Amore* (1545) where 'Panfilo' advises 'Silio', a young bachelor of about twenty-five, on various aspects of behaviour and how to dress to find favour with his would-be (married) mistress:

. . . taking account of your status, the income, rank and honour of your family, you should dress according to what is expected of a polite and well educated person, that is simply, avoiding all pomp and affectation. If it is true that intrinsic attitudes are revealed by extrinsic action then the plain and neat adornment of the body identifies a prudent, wise and calm temperament.[11]

Clothes must be plain and unadorned lest a man appear pretentious;[12] '. . . above all they should be so suited to the wearer that they cannot offend the gaze of those who see him in any way'.[13] Panfilo recommends Silio imitate his mistress's attire – not in colour (impossible in Venice where, as Silio notes, all gentlemen not in office had to wear black), but in its quality – wearing (silk) velvet or damask whenever she does.[14]

The dress of unmarried men in their twenties was usually regulated by their fathers. Alberti advised: 'If a son wishes to choose his own clothes he should consult his father who will grant permission if the son is sufficiently sensible and mature, but he should never allow his son to dress ostentatiously or with frivolity . . .'.[15] Similar warnings were given by Matteo Palmieri:

. . . young men should not be allowed clothing which is too fine, overly neat, or embroidered or multi-coloured. All feminine ornament should be avoided – bushy mops of hair, tight curls or fancy haircuts are not required for the well-born. A refined beauty is sought in girls, but what is praiseworthy in males is that decorum which enhances mutual respect.[16]

When youths wore eccentric clothes it was sometimes interpreted as a sign of being in love – of the sort of erratic behaviour not encouraged in a society where arranged marriages were usual.[17] Gaudily ostentatious clothes, on the other hand, were associated with mercenary soldiers, itinerant musicians and entertainers, as well as with homosexuals.[18] Sansovino points out: '. . . lavishly embroidered or slashed garments, or those that are too effeminate or indecent are never admired: the wearer acquires the reputation of being fickle and scatter-brained and – if young – of being shameless and disreputable, or if elderly, of being ludicrous.'[19]

Quattrocento and Cinquecento writers frequently emphasized the impropriety of what was regarded as effeminate dress. This antipathy was sometimes rationalized: della Casa argued it created inconsistencies between the person and the adornment.[20] For various reasons therefore it was undesirable for men, especially when young, to dress in unusual or slightly unconventional attire.

There were clear differences between the dress of unmarried girls and married women. The clothes of nubile girls reflected their unmarried status and the rank of their family: '. . . Adornment should not concern you since it is not in your power, and how you dress is at the discretion of your father, but make sure that what you do wear fits you properly'.[21] Once married (generally by the age of eighteen) a young woman's appearance advertised her adult status or, more accurately, her married state and her husband's social position.[22] Thus in August 1465 Alessandra Strozzi, writing to her son Filippo about a potential wife, remarked, 'that she will turn out to be good-looking – particularly when dressed as a young woman rather than as a girl . . .'.[23]

Treatises or essays on female etiquette were usually written for young married women of good family (not necessarily aristocrats) aged between eighteen and thirty-two; '. . . after that time, it is necessary to stand back a bit and not everything will be suitable . . .'.[24] In Alessandro Piccolomini's *Rafaella o Dialogo de la Bella Crianza de le Donne* (1538), the young wife of a Sienese merchant of good family is recommended clothes of fine woollen cloth (silks were inappropriate). These were to be roomy, but not over-ample, with a variety of decoration, some being quite ornamented, others plain. They should not be multi-coloured, or of clashing colours like green and yellow, or red and pale blue, and flag-like combinations must be avoided. Devices or emblems worn on clothing should be of two or three colours, one the same as the garment and the bodice of a gown ought always to be of a single colour flattering the wearer. The same garment ought not to be worn continously for months; nor must 'new' clothes be made from old by being turned, dyed, or otherwise treated. Jewellery should consist of a rope of pearls, an enamelled necklace, a diamond ring.[25] Most importantly, a young woman should observe moderation in all things and behave with great circumspection and modesty in public.[26]

Similar views are found in Castiglione's *Cortegiano*. Giuliano de' Medici recommends the ideal court lady invited to dance or to play any kind of music, show '. . . a certain shyness, demonstrating a reserve which is the opposite of pertness. Her clothes should reflect this, and not suggest she is vain or flighty . . .'. She is also expected to have the judgement to choose garments which, in an unstudied manner, best enhance her looks and character.[27]

The views of fifteenth- and sixteenth-century Italian writers on etiquette are very similar, and contemporary evidence suggests that most people showed considerable sensitivity to the nuances of meaning in dress. At the same time non-conformity or displays of individualism in dress were deemed disrespectful and ill-mannered and might provoke social ostracism.[28] In some circumstances, being dressed in the wrong clothes was considered an insult to others. Della Casa records how affronted the Paduans were if they saw a Venetian strolling around their city in informal and not very smart clothing; such dress implied the Venetians thought the ancient city (incorporated into the Republic in 1405) little more than a holiday retreat.[29] It was not surprising that Matteo Palmieri advised: 'In behaviour the best rule is to observe the generally approved practices of society – those followed by custom – with such correctness and decorum that you cannot be faulted . . .'.[30]

In the hierarchical society of Renaissance Europe, these conventions of dress and etiquette were founded upon a belief that outward beauty symbolized an inner grace. Pietro Bembo could argue '. . . there is no beauty without goodness, it is rare to find an evil soul in a beautiful body . . .'.[31] But besides this there was a long tradition associating moral worth with high rank; epitomized by the tenth century Byzantine axiom 'those who are unique in the grace of their virtue should be unique in the beauty of their raiment . . .'.[32] Proper adornment was required for rank because such ornament was the outward symbol of intrinsic virtue. Thus rulers and aristocrats were entitled to silks and rare furs, gold, silver and gems which commanded respect from equals and inspired awe in inferiors. No Italian merchant, however rich, might dress like Borso d'Este (1450–71) who, as ruler of Ferrara, exploited to the utmost the prerogatives of rank which permitted him to wear, every day, garments made of cloth-of-gold. This was the most ostentatious and costly textile available: it was reserved to rulers although few wore it daily. Borso's delight in ostentation was made acceptable by his position. Anyone of lower status had to conform to more mundane expectations, exercising a limited personal choice in apparel (especially if they were wealthy but not noble). Rulers might wear garments of cloth-of-gold, nobles those of silk: anyone of lesser estate had to be content with wool and linen. Conceptually all were equally beautiful when worn by those to whom they were proper.

The intrinsic beauty of a garment was of little significance – unless it was worn by someone entitled to it and of a singular and exceptional richness. A garment adorned with a skilfully worked embroidery, or made of a silk velvet in several heights of pile, lined with a sumptuous fur, was of course admired. But a clear distinction existed between personal taste and social propriety: the social function of dress, not its beauty, was all important.

Gian Paolo Lomazzo in his *Trattato dell'arte della pittura, scoltura et archi-tettura* (1584) emphasized the need for a painter to identify a character or sitter with attributes of rank, appropriate garments, jewellery and accoutre-ments. He castigated Parmigianino for improperly adorning the Virgin with gems and pearls and criticized other artists for portraying the Emperor '. . . wearing a cap which makes him look more like a merchant than an imperial figure . . .' and for depicting merchants and bankers in the guise of military leaders.[33] But Lomazzo's concerns themselves signal changes in society's attitude to the role of dress at the end of the sixteenth century.

## Notes

1. Alberti (1950): II, 90, 'Poi appresso ogni cosa seguiti ad una dignità: sarebbe cosa non conveniente vestire Venere o Minerva con uno capperone da saccomano; simile sarebbe vestire Marte o Giove con una vesta di femina . . .'. (Then pay attention to the dignity of every subject; it would be improper to dress Venus or Minerva in a heavy military cloak or likewise Mars or Jove in a woman's gown . . .). da Vinci (1956): II, v, 573, 'Osserva il decoro co'che tu vesti le figure secondo li loro gradi et le loro età . . .'. (Follow convention in dressing figures according to their status and age . . .). All translations are the author's unless stated.

2. della Casa (1977): xxvi, 123, '. . . voglio che sappi che, dove ha convenevole misura fra le parti verso di sé e fra le parti e 'l tutto, quivi è la bellezza; e quella cosa veramente bella si può chiamare, in cui la detta misura si truova'.

3. Castiglione (1972–81): IV, li, 331, '. . . il nome universal della quale si conviene a tutte le cose o naturali o artificiali che son composte con bona proporzione e debito temperamento . . .' (that universal concept suited to everything natural or man-made created with good proportion and proper harmony).

4. della Casa (1977), vii, 69–70, 'Ben vestito dee andar ciascuno secondo sua condizione e secondo sua età, perciocché altrimenti facendo pare che egli sprezzi la gente . . . Vogliono essere ancora le veste assettate e che bene stiano alla persona, perché coloro, che hanno le robe ricche e nobili ma in maniera sconce che elle non paiono fatte a lor dosso, fanno segno dell'una delle due cose: o che eglino niuna considerazione abbiano di dover piacere né dispiacere alle genti, o che non conoscano che si sia né grazia né misura alcuna.'

5. Piccolomini, 'Istituzion Morale', in della Casa (1970): 556–7, '. . . se la donna fusse a nobil gentiluomo congiunta in consorte, bruttissima cosa e odiosa saria di veder ch'ella con vesti apparisse fuori più a Duchessa o a Regina che a gran gentildonna sì convenienti, come sarebbe vestendo brocati e tele d'oro, di perle e di gemme ricamate e fregiate, e simili altri ornamenti alla sua condizion disdicevoli. Percioché, sì come la bellezza in tute le cose consiste nella proporzion delle parti tra loro e col tutto loro, così la bruttezza dalla disproporzione dipende e mal comportamento di dette parti. Onde ogni volta che, non proporzionando le vesti con chi le porta, faranno una certa disagguaglianza di parti, sarà forza che tal cosa non sol non apparisca dilettevole, ma noiosa e incomportabile universalmente a chiunque la vede.'

6. My italics. Firenzuola (1763): 258, '. . . quando e' si parla d'una bella, e' si parla d'una che piaccia a ognuno universalmente, e non particolarmente a questo e a quello . . .'.

7. Cicero (1975): I. xxxvi, 131–3, 'Cum autem pulchritudinis duo genera sint, in altero venustas sit, in altero dignitas . . .'.

8. Pontano (1965): 275 and 134, '. . . in viris pro aetate atque auctoritate dignitatem, in iuvenibus nitorem elegantiamque, quae tamen minime muliebris videatur, in puellis venustatem et comptum, in matronis decus quoddam matronale.' It should be noted that when Renaissance authors refer to females/women they mean *married* women only, not unmarried girls or widows.

9. Alberti *I Libri della Famiglia* (1969): 247, 'Pur bene: civili vestimenti, sopratutto puliti, atti e bene fatti: colori lieti, aperti quali piú s'afacesse loro (vivace quanto piú loro s'addicesse); buoni panni . . . In dí solenni la vesta nuova, gli altri dí la vesta usata, in casa la vesta piú logora. Le veste, Lionardo mio, onorano te. Vero? Onora tu adunque, onora le veste.'

10. Palmieri (1982): 97, '. . . il conveniente ornamento servi la degna auctorità dell huomo virile. A questo conrispondano i vestimenti condecenti et netti, non di troppa abbondanza in modo ornati che meritino riprehensione; et sempre s'abbia riguardo a conservare la degnità propria . . .'

11. Sansovino (1970): 661, '. . . considerata la qualità del tuo stato, l'entrata, il grado e lo onor della casa, ti vestirai secondo che si ricerca a costumata e ben creata persona, cioè modestamente, fuggendo la pompa e l'affettazione. Perché lo schietto e puro adornamento del corpo dà altrui indizio di prudente e saggio e riposato intelletto, s'egli è però vero che per l'azzioni di fuori si comprendino i pensieri di dentro.'

12. *Ibid.*: 662, 'Di materia semplice, come di raso schietto, di velluto, di panno schietto, sanza tagli, sanza pennacchi, sanza medaglia, sanza catene e puntali. Perché queste sono alcune superfluità sanza garbo, imitate da color che, non essendo, voglian parer qualche cosa . . .'

13. *Ibid.*: 662, 'Le quai vestimenta sopratutto debbano esser appropriate così fattamente alla persona, che non si disconvenga in parte alcuna all'occhio di chi riguarda.'

14. *Ibid.*: 662.

15. Alberti, *I libri della Famiglia* (1972): III, 313–14, 'Se vorrà vestire, richieggane il padre, el quale, sendo facile e maturo, lo contenterà, ma non lascerà il figliuolo vestire isfoggiato, nè con alcuna leggerezza . . .'

16. Palmieri: 36, '. . . non si permetta a' giovani vestimenti dilicati, non puliti, né recamati, o veramente frappati di varii colori. Fuggasi sempre ogni femminile ornamento, però che none le pettinate zazzere, none i crespi capelli, né l'artificali dirizature si richiegono a chi è nato atto a virtù. Le fanciulle sono quelle in chi si loda la dilicata bellezza, in ne' maschi si loda la convenientia apta a dovere servare alchuna reverente auctorità fra altri huomini.'

17. Sansovino (1970): 662, '. . . tosto che s'esce col vestire fuor dell'ordine che si richiede, le persone notano e pensano agli innamoramenti . . .'. Della Casa draws similar implication 1977, xxviii, 128, 'Niuna tua vesta vuole essere molto molto leggiadra né molto fregiata, acciocché non si dica che tu porti le calze di Ganimede o che tu sii messo il farsetto di Cupido . . .'

18. Sansovino 662, 'I tagli adunque, le pompe e i ricami si convengano a' soldati di oggidì, ai gran maestri, non già a persona letterata, riputata e modesta . . .' Alberti *I libri della Famiglia*: III, 247, warned against the over-embroidered or beribboned clothes of entertainers and musicians.

19. Sansovino: 661, '. . . le vestimenta ripiene di ricami, di tagli, e più femminile e lascive che altrimenti, non furon mai lodate; perché, oltra che si acquista nome di leggieri, lo uomo, essendo giovane, è in opinione di disonesto appresso la gioventù, appresso la vechiezza, è risibile.'

20. della Casa, (1977): 127, 'Perché non si dee l'uomo ornare a guisa di femmina, acciocché l'ornamento non sia uno e la persona un altro . . .'

21. Gottifredi (1970): 592, 'Dello addobarti, non sendo in tua facoltà il vestire a tuo modo, ma in questo necessita stare alla discrezione del signore, non t'importa molto: solo che tu studii le cose che avrai indosso ti stiano attillate . . .'

22. The most usual age for girls to marry was sixteen; Herlihy & Klapisch-Zuber (1985): 210.

23. Strozzi (1877): lii, 464, '. . . che la riuscirà bella, e ancora più bella quando andrà a modo di giovane che di fanciulla . . .'

24. Piccolomini, 'Rafaella', in *della Casa* (1970): 469, 'E hai da sapere, Margherita, che tutte quelle cose, di che io t'ho ragionato e ti ragionarò appartenersi a una gentildonna, io intendo che ella sia giovine e non passi, al più, trentadue anni; perché, doppo quel tempo, bisogna che si ritiri un passo adietro e non le sta ben così ogni cosa.'

25. *Ibid.*: 448–9, 450–2; 459, 462.

26. *Ibid.*: 473, 'In ogni luogo, dove gli accada di conversare o con donne o con uomini, abbia avertenzia costei di non lassar mai trasportar a far un minimo movimento, o dir una minima parola, che passi il termine de la modestia ed onestà . . .'

27. Castiglione (1972–81): III, viii, 215, '. . . deve indurvisi con lassarsene alquanto pregare e con una certa timidità, che mostri quella nobile vergogna che è contraria della impudenzia. Deve ancor accommodar gli abiti a questa intenzione e vestirsi di sorte, che non paia vana e leggera . . .'

28. della Casa, vii, 70, '. . . Costoro adunque co' loro modi generano sospetto negli animi delle persone, con le quali usano, che poca stima facciano di loro; e perciò sono mal volentier ricevuti nel più delle brigate, e poco cari avutivi.'

29. della Casa, vii, 69, '. . . solevano i cittadini di Padova prendersi ad onta quando alcun gentiluomo viniziano andava per la loro città in saio, quasi gli fosse avviso di essere in contado.'

30. Palmieri 92, 'Sia dunque ne' costumi potissima legge seguire l'approvata consuetudine dell'uso civile: quello che secondo l'uso approvato si facessi sia con misura et tale convenentia che non meriti riprehensione . . .'

31. Castiglione (1972–81): IV, lvii, 335, '. . . e però come non po essere circulo senza centro, non po esser bellezza senza bontà; onde rare volte mala anima abita bel corpo e perciò la bellezza estrinseca è vero segno della bontà intrinseca . . .'

32. Liutprand (1881): 931, '. . . ut quibus est singularis in virtutibus gratia, sit singularis et in pulchritudine vestis . . .'

33. Lomazzo (1974): 374, 377 and 394.

# Giovanni Sabadino degli Arienti and a practical definition of magnificence in the context of Renaissance architecture

*Rupert Shepherd*

Over the period 1497–9, the Bolognese author Giovanni Sabadino degli Arienti (c.1443–1510) wrote a description of the buildings created in Ferrara and its territories by Ercole I d'Este, Duke of Ferrara.[1] Arienti frequently describes these buildings and their decorations as beautiful, using the terms *bello* and *bellezza* some thirty times, for example, in relation to the palace of Belriguardo. But his descriptions were only part of a larger project, *De triumphis religionis*, a treatise on ten religious virtues, all embodied by Ercole I. Approximately one third of the work is devoted to the virtue of magnificence. Arienti's descriptions of architecture and its decoration play a major role in this part of the work, suggesting that beauty and magnificence were, for Arienti, closely related.[2]

It is to this element of Renaissance notions of beauty, the concept of magnificence, that this paper is dedicated. Arienti's descriptions in *De triumphis religionis* can show us which qualities in buildings and other works of art should be considered magnificent. This, in turn, sharpens our understanding of Renaissance attitudes to beauty, necessary as the concept of magnificence is now a commonplace among students of Renaissance patronage. Previous contributions have concentrated upon Renaissance *theories* of magnificence.[3] The aim of this paper is to indicate some contemporary critical criteria that will allow us to assess which projects would have been perceived as magnificent in the Renaissance.

Arienti's descriptions are of buildings he considers magnificent, described in terms which reveal something of his concept of magnificent architecture. Despite the highly descriptive nature of his account, Arienti provides a useful summary of traditional Renaissance definitions of magnificence at the beginning of his section on the virtue. Magnificence is expressed in expenditure; the predominant characteristic of magnificent expenditure is its scale:

Magnificence therefore must be considered as consisting of sumptuous, large and sublime things. As [does] her name, [so] she proclaims largesse and vastness in spending gold and silver on things eminent, high and divine, as befits the magnificent, always according to the condition and state of the man. And even though she is more or less the sister of liberality, she always indulges and pardons a great expense to make excellent and memorable things . . .[4]

We must remember that here magnificence is by definition a virtue, an identification which goes back to the definitions of magnificence by Aristotle and Aquinas.[5] Given the links between beauty and magnificence in Arienti's account, it seems likely that beauty must also absorb some of the virtue of magnificence.

Although this paper retains Arienti's emphasis upon architecture and its decoration, passing references by Arienti to clothing, festivals, religious and secular performances, and so on, remind us that this was not the only form in which magnificence could be displayed.[6] But Arienti focused his interest upon four buildings, the oldest of which is the Palazzo del Corte, in the centre of Ferrara. Much of his description is related to extensive improvements and modifications carried out by Ercole I d'Este from the early 1470s (Figure 5.1).[7] Next to the Palazzo del Corte is the Castel Vecchio, built in the 1380s, and partially refurbished for Ercole I's wife Eleonora d'Aragona following an attempted coup in 1476. The large garden nearby (now a main road) was known as the Zardino de Madama.[8] Belfiore was effectively a grand suburban hunting lodge. Begun in the late fourteenth century by Alberto d'Este, it was situated in a large hunting-park just outside the city walls until its inclusion within the Herculean Addition to Ferrara in the 1490s. It is now completely destroyed, and the site built over.[9] Finally, Belriguardo is situated at Voghiera, about eleven miles south-east of Ferrara. It was begun in 1435, and extensively decorated by Ercole d'Este. It now survives only in part, in a largely derelict state. An idea of its former glory can be gained from the sixteenth-century view and ground-plan which Gundersheimer included in his edition of Arienti's text (cf. Figure 5.2).[10]

Given the eulogistic intent of Arienti's descriptions, the extent of his accuracy is an important question. However, in the few cases when we can compare surviving details with his descriptions, they are proven reliable. Moreover, Arienti states that he gathered much of his information either from, or in the company of, ducal officials. Inaccuracies would surely have provoked the derision of his patron and the work's dedicatee, Ercole I, who would have known his own buildings well.[11]

A useful framework within which to examine Arienti's descriptions is provided by another Renaissance commentator upon magnificence, Giovanni Giuniano Pontano, in his short work *De magnificentia*.[12] Although there is no evidence that Arienti knew Pontano's treatise, or vice versa, they did

have friends in common.[13] They both considered magnificence to be expressed in architecture in similar terms, summarized by Pontano when he states that, to be magnificent, an architectural project must be expensive, but done with worthiness (*dignitas*). This important aspect of magnificence is explained: 'For worthiness itself is principally comprised of these things: ornament, scale, excellence of materials, and the perpetual duration of the work'.[14] The following account of Arienti's concept of magnificence is largely organized around Pontano's criteria, although, as we shall see, Arienti omits any discussion of durability and adds categories of his own.

Examining Arienti, we see that the forms taken by ornament might be subdivided. One aspect is the use of specifically architectural features, such as the landing, columns and vaulted roof which adorn the covered staircase he described in the courtyard of the Palazzo del Corte (Figure 5.1);[15] or architectural mouldings, such as 'a cornice of branches and carved heads of the antique Roman princes' on the Palazzo's Torre di Rigobello.[16] In Belriguardo, Arienti mentions the window archivolts and tracery in the first courtyard (Figure 5.2),[17] and the upper entablature in the second, 'cloister', courtyard: 'Above the square and round columns are placed marble squares in the form of beams, which outside make a beautiful elaborate cornice, above which is drawn a beautiful wall up to the top of the roof'.[18] (This may refer to the triglyphs of a very early Doric frieze; or perhaps to modillions.)

However, when discussing ornament and decoration, Arienti's main interest lies in the decoration of rooms, 'painted', in his words, 'in various ways with moral and amorous exemplars'.[19] The most notable example, which Arienti described at great length, was the extensive cycle of the *Legend of Cupid and Psyche*, painted in a first-floor hall in Belriguardo, probably by Ercole de' Roberti c.1493.[20] Arienti also describes many other cycles in varying degrees of detail. The most popular seem to have been hunting scenes. Many of these were found in Belfiore, and several included portraits of members of the Estense court.[21] There were more straightforward mural portraits of Ercole I and his courtiers in several rooms on the first floor of Belriguardo.[22] Other murals depicted notable events in the life of the court, such as jousts, processions and celebrations.[23] Although none of these frescoes survive, comparable examples include the decorations of the Salone dei mesi in the Palazzo Schifanoia, painted c.1470–1 for Ercole d'Este's predecessor, Borso d'Este, by Francesco del Cossa and others; and Mantegna's *Camera picta* in Mantua.[24]

Another form of painted ornament which Arienti considered significant is painted polychromy. For example, the courtyard of the Palazzo del Corte was surrounded by 'high walls crowned with beautiful merlons, in which are painted your ducal arms and insignia, and then the chequered walls are

painted in the guise of green, white and red marbles, the colours of your device'.[25] At Belriguardo, the gardens were enclosed by whitewashed walls with the merlons picked out with red, while the exterior walls bore Ercole's arms on the merlons.[26] This type of polychromy can be seen in the frescoes in the Salone dei Mesi in the Palazzo Schifanoia. Between the fields for *Libra* (*September*) and *Scorpio* (*October*), a very damaged section seems to represent a Ferrarese palace: traces of white and red paint can still be seen on the merlons (Figure 5.3).[27] Walls 'painted in the guise of green, white and red marbles' also recall the façade of the Palazzo Schifanoia itself, where areas of the external polychromy, applied during Borso d'Este's extension of the palace in the late 1460s, were walled in and preserved when Ercole I extended it further in the 1490s.[28]

Another form of decoration mentioned by Arienti only in passing, but which was nevertheless very lavish, and very expensive, is carved stucco and wooden ceilings: the surviving Sala degli Stucchi in the Palazzo Schifanoia, created in 1467, gives some idea of the richness involved.[29]

Like Pontano, Arienti considered scale important for magnificence. On first seeing Belriguardo, Arienti was struck by its scale, recalling: 'I gazed at its size'.[30] He lists the measurements of a whole series of rooms in his description of Belriguardo. In Belfiore, he measured the entrance courtyard, two loggias and two *salotti*.[31] But there is little in Arienti's recording of room-sizes that indicates an interest in their proportions.

Arienti's precise enumeration of the columns which he saw in loggias, staircases and so on also shows his concern with scale. Thus, in the Palazzo del Corte, he counted the columns on the Torre di Rigobello's balconies, and the Scala coperta;[32] while in Belriguardo he did the same for the first courtyard,[33] and for both storeys of the second, 'cloister', courtyard. He described the upper storey of the 'cloister' courtyard as follows:

And we arrived at the loggia above the lower one, as beautiful, eighty-three paces long, having on that side twenty-five square columns of white marble and the two sides each have seventeen square columns of similar marble and sixty-three paces long, and the other side opposite as long as the first, eighty-three paces, but it has eleven round marble columns and the width beginning from the wall of the large hall nine paces.[34]

Finally, Arienti's interest in scale is surely displayed in his description of a project still recognized today for its ambition, the Herculean Addition to Ferrara.[35]

One of Pontano's few references to a specific contemporary building is due to the unsuitable materials used in its construction. He describes how Roberto da Sanseverino was criticized for not using marble when it was fitting to do so. This refers to the rusticated stone façade of the palace in

Naples built for Roberto in 1470 by Novello da San Lucano, and now incorporated into the façade of the Chiesa del Gesù Nuovo (Figure 5.4). Roberto's son Antonello often mentioned his own intention to set the matter right.[36]

Arienti is also concerned with materials. His most frequent references, unsurprisingly, are to the use of marble – although Tuohy notes that much of what he calls marble is in fact Istrian stone.[37] For example, Arienti records the marble columns of the balconies on the Torre di Rigobello in the Palazzo del Corte,[38] and describes marble colonnettes on the balcony of the great hall and in the northern grand staircase in Belriguardo.[39] He also notes the extensive use of marble – some of which appears to have been book-cut – in the pavilion in the Zardino de Madama.[40]

Although brick might seem too common a material to be recorded, Arienti refers to it as a contrast with marble. The most sustained example appears in his description of the entrance and first courtyard in Belriguardo:

Opposite this bridge there is the great door of the palace, in front of which there is a roof of brick, vaulted above four columns, two of brick beside the door and two of white marble towards the bridge and with benches for sitting, and beneath the vault above the door there is your ducal insignia. Fixed to the wall above this vaulted roof there are the fortunate Estense arms carved in marble. Within the door, above, it is again vaulted with brick. . . . We pass within into a large loggia, which has forty-eight columns of brick with bases and capitals of decorated white marble, and has a ceiling of beautiful panels decorated with squares of painted lines.[41]

The contrast between marble and brick is finally made clear when Arienti compares Ercole to Augustus, expanding upon Augustus:

. . . as Augustus Caesar himself said: that he had found Rome made of clay and he would leave it [made] of marble. Thus your Highness, by virtue of magnificence, will be praised to posterity with the greatest glory, that you found Ferrara of painted clay, and you will have left it of marble, of adamantine carved with your indomitable device.[42]

But Arienti also describes further criteria for magnificence, which were not considered by Pontano. He is very much aware of the importance of the comforts which the Estense buildings provided, noting the glazed windows in Belriguardo and Belfiore, and the boards used to close up the upper 'cloister' loggias in Belriguardo in inclement weather. Fireplaces are mentioned, as is the cool breeze which can be enjoyed at Belfiore.[43]

Arienti also saw magnificence in forms which Pontano did not discuss. He mentions the resources of the Estense palaces, paying particular attention to the gardens of the Castel Vecchio (the Zardino de Madama) and Belriguardo. He describes the fountains and cisterns – thereby stressing the convenience and quality of the water supplies – as well as the fish-ponds. In addition, the agricultural resources and hunting at Belriguardo are praised.[44]

Arienti's apparent reticence on questions of style is disappointing, but not surprising: his writings on art, including *De triumphis religionis*, are notable for the lack of developed technical vocabulary, including technical terms, with which to discuss the subject. He seems to have lacked either the talent, or the inclination, to pursue such tools. However, several of his references to architectural features – mouldings and so on – seem to refer to classicizing motifs. Likewise, his few specific mentions of style all refer to work done *all'antica*. Thus, it seems likely that magnificence might also be displayed in this form. So, the covered staircase in the courtyard of the Palazzo del Corte (Figure 5.1) has a roof specifically described as 'vaulted *all'antica*', while the letters which identify Ercole's courtiers in one of the court-portrait murals are 'Roman'.[45] Equally, as we have seen, Ercole I's patronage is compared to that of Augustus.[46]

Although geographical centres of interest in magnificence changed over time, and opinions varied as to the forms of building on which the virtue was most suitably displayed, other late-medieval and Renaissance texts on magnificence echo the concerns displayed by Arienti and Pontano. These range from works by Galvano Fiamma (Milan, late 1330s), to those by Timoteo Maffei (Florence, probably c.1454–6) or Gianozzo Manetti (1455–8).[47] But *De triumphis religionis* remains the most extensive practical, rather than theoretical, discussion of magnificence, and the one which most clearly indicates the forms in which the virtue is best displayed. Of Renaissance architectural treatises, only Filarete's seems to discuss architecture in terms which reflect those of these commentators upon magnificence.[48] But such treatises were written for very different reasons from the encomiastic or philosophical works which deal with magnificence: the exceptional nature of Filarete's treatise is a result of the specific context within which he was writing.

Following our examination of Arienti's text, we are able to reconstruct something of late-fifteenth-century attitudes to magnificence in architecture, which, by now, had gravitated towards court circles. These can be illustrated by the Palazzo dei Diamanti, built by Biagio Rossetti from about 1492, and which has survived rather better than the buildings referred to above (Figure 5.5).[49]

A magnificent building should, first of all, be large: on an imposing scale, and with many rooms of a reasonable size. It should be built of expensive materials: ideally marble, preferably worked stone. (However, in areas such as Ferrara with little local stone, brick would be acceptable, albeit painted either to resemble coloured marble arranged in geometric patterns, or with arms and devices.) Carved stone should ideally be used for architectural features, and for sculptural ornamentation. The interiors should be decorated, with mural paintings of mythological stories, or scenes from everyday

court life, or one's portrait, or arms and devices. The building should also be comfortable, equipped with baths and fireplaces, the windows glazed. It should have an adequate supply of good water, large gardens and, ideally, a fish-pond. If outside the city, extensive grounds should include agricultural land, and somewhere to hunt. Ideally, it should be in a modern style, that is *all'antica*. But the most important criterion, fundamental to all definitions of magnificence, is that it should be very expensive.

## Notes

This paper is based upon part of my PhD thesis on Arienti's descriptions of works of art and architecture, in preparation at the Courtauld Institute.

1.  Arienti is best known today as an author in the vernacular. For his life and career, see Chandler (1952) and James (1996), which list the previous bibliography. Having studied at the University in Bologna and served as a secretary in the service of a branch of the Bentivoglio family, he sought patronage from contacts in the Ferrarese and Mantuan courts, spending up to two years in Ferrara in 1497–99.

2.  *De triumphis religionis* was published in 1972, by Gundersheimer, as *Art and Life at the Court of Ercole I d'Este: The 'De triumphis religionis' of Giovanni Sabadino degli Arienti* (hereafter *De triumphis religionis*). Book V, *Del triumpho e dignità della magnificentia, in cui se recorda le nuptie ducale et la gloria deli edificati templi e deli palaci, zardini e acrescimento dela bella città de Ferrara*, occupies pp. 50–79 of this edition. Although the text twice contains the date 1497, it must have been completed by Arienti in Bologna c.1499: *De triumphis religionis*: 75, 79, 90 and 93; cf. James (1996): 60–3. For the frequency of references to beauty, see *De triumphis religionis*: 56–66; the richest sections are 58, 60 and 65–6. (*Vaghe* and *vaghezza* are used once each, 62 and 64, and *leggiadrìa* once only, 65.)

3.  Previous discussions of magnificence can be found in Gombrich (1978): 35–57 and 142–4, esp. 39–40; Fraser Jenkins (1970); Green (1990); Rubin (1995).

4.  'La magnificentia dunque considerare si debbe che in cose sumptuose grande et sublime consiste. Come il nome de epsa suona largheza et amplitudine in expendere auro et argento in cose eminente, alte e dive ala convenientia del magnifico, secondo sempre la conditione e stato del'huomo. E benchè ella sia sorella circa della liberalitate, lei mai indulge e perdona ad spensa grande per fare cose excelse et memorande, . . .': *De triumphis religionis*: 50; cf. the even shorter definition of liberality, 46: '. . . che consiste in dare como e quando e a cui è necessario'.

5.  Aristotle (1926), *The Nicomachean Ethics*, trans. Rackham, II, vii, 6 and IV, ii, 1–19; Aquinas (1964–81), *Summa theologiae*, 2a2ae, q.134.

6.  For these see, for example, Brown R. G. (1982); Kruse (1993); Tuohy (1996): 154–63 and 234–77.

7.  *De triumphis religionis*: 51–2. For the Palazzo, see Tuohy: 53–95.

8.  *De triumphis religionis*: 52–5; cf. Tuohy: 95–117.

9.  *De triumphis religionis*: 67–72; cf. Varese (1991): 187–201, and Tuohy (1996): 342–52.

10.  *De triumphis religionis*: figs 4 and 5.

11.  For the presence of ducal officials, *ibid*.: 55–6. For Arienti's accuracy, see Gundersheimer's comments, *ibid*.: 18–19, and my own, in Shepherd (1995): 24–5.

12.  Pontano (1965), *I trattati delle virtù sociali: De Liberalitate, De Beneficentia, De Magnificentia, De Splendore, De Conviventia*, ed. Tateo: 83–121. Pontano seems to have begun the work in or after 1486, and to have continued revising it at intervals up until its publication in Naples in 1498: see *ibid*.: xvi–xvii and xxi, and Kidwell (1991): 268–73.

13.  Notably in the Mantuan poet and Carmelite friar Battista Spagnoli. For his connections with Arienti, see James (1996): 32–3. For his connections with Pontano, see Mustard's introduction to his edition of Spagnoli (1911): 24.

14.  'Dignitas autem ipsa rebus his praecipue comparatur: ornatu, amplitudine, materiae praestantia, operis perennitate.' Pontano (1965): 95.

15. 'Et instaurato lì per ascendere il tuo ducal palacio una magna scala de quaranta et septe gradi de bianchi marmi, con optimo et bene inteso possamento nel mezo. Sopra la quale al sinistro lato glie sono sei colomne de simili marmi, che sustengono de piombo el bel coperto voltato al'antiqua, de pietra, che sarebbe degna essere scesa da tutti li principi et rei del mondo.' *De triumphis religionis*: 52. For the Scala coperta, completed under the supervision of Pietro Benvenuto degli Ordini by April 1481, Tuohy: 73–5.

16. '. . . con cornice de fronde e capi deli antiqui principi Romani sculpti, . . .'. *De triumphis religionis*: 51. For the twelve marble heads of emperors given by Ercole I to the civic administration in October 1472, for incorporation into the set of balconies added to the tower prior to Ercole's wedding in June 1473, see Venturi (1887–9): 113; Tuohy: 63–5.

17. *De triumphis religionis*: 58. See also Pavan's comments in Malagù (1972): 158–9, and Tuohy: 354.

18. 'Sopra le quadre e tonde colomne li sono posti quadri marmorei in forma de travi, che fano fuori bella cornice elaborata, sopra la quale è tirato bel muro sino ala sumità del cuperto . . .'. *De triumphis religionis*: 60. Tuohy: 355.

19. '. . . pincti in varii modi de morali et amorosi exempli . . .'. *De triumphis religionis*: 68 (in fact a description of courtyards, which it seems Arienti did not visit, in Belfiore). Mural cycles described by Arienti are discussed in Shepherd; cf. Tuohy: 210–20.

20. *De triumphis religionis*: 62–5; see also Gundersheimer (1976): 8–17; Manca (1992): 34–7 and 213–14; Tuohy (1996): 353–4 and 356.

21. *De triumphis religionis*: respectively 68, 69 and 70–2.

22. *Ibid.*: 61–2.

23. *Ibid.*: 69–71.

24. For illustrations, see Varese (1989) and Signorini (1985).

25. '. . . del cortile cinto da alte mura coronate de belli merli, in li quali sono pincte le arme et insigne tue ducale, e le mura poi a quadri sono pincte in figura de marmi verdi, bianchi e rossi, colori della tua divisia.' *De triumphis religionis*: 51. This may be related to the painting of the façade of this wing of the Palazzo which faced the Cathedral, by Giovanni Trullo in 1472: cf. Cittadella (1864): 322; Tuohy: 65.

26. *De triumphis religionis*: 57, 60 and 66. The merlons of the entrance courtyard at Belfiore were similarly decorated, *ibid.*: 67.

27. The appearance of a whole building is also indicated by the rural palace painted in the lower field of *Virgo* (*August*). Varese (1989): 430, pl. 4.

28. See Varese (1978): 44–66; Visser Travagli (1994): 27–9; more generally, Tuohy: 195–6. Cf. the decoration of the Bentivoglio palace at Ponte Poledrano (Gennari (1957): 173–7 and figs 2–3), and the fifteenth-century polychromy in, e.g., Botter (1979) and Valcanover (1991).

29. *De triumphis religionis*: 52. Rosenberg (1973): 33–4; *id.* (1979): 377–84. Cf. Tuohy, pp. 201–5.

30. '. . . mirai la sua magnitudine . . .'. *De triumphis religionis*: 56. An understandable reaction, when compared with the late-sixteenth century plan reproduced *ibid.*, plate 4.

31. *Ibid.*: 67–9.

32. *Ibid.*: 51–2. Cf. nn. 15 and 16 above.

33. *Ibid.*: 58.

34. 'E giunsemo ala logia sopra la inferiore tanto bella, longa passi octantatri, havendo questo lato vintecinque colomne de bianco marmo quadre e dali duo lati ciascuno ha colomne XVII quadre de simil marmo e longo passi sexantatri e l'altro lato opposito de longheza come il primo passi octantatri, ma ha undece colomne tonde de marmo et largo incominciando dal muro dela grande sala passi nove.' *Ibid.*: 60.

35. *Ibid.*: 72–5; cf. now Tuohy: 122–40 and 173–4.

36. Pontano (1965), *Trattati*: 95–6; Ceci (1898); Pane (1937): 37–44. Arienti may well have known of the building, as his friend Giovambattista Refrigerio was secretary to Roberto da Sanseverino from 1482 until 1484. Frati (1888): 332–6; cf. James: 30–4.

37. Tuohy: 75 and 189–93.

38. *De triumphis religionis*: 51. Cf. n. 16 above.

39.   *Ibid.*: 58, 60 and 65.

40.   *Ibid.*: 52–3. Cf. Tuohy (1996): 106–7.

41.   'In opposito a questo ponte li è la magna porta del palazo, avanti la quale gli è uno coperto de pietra cotta voltato sopra quatro colomne, due de pietra cotta alato la porta e due di marmo bianco verso il ponte e con banche per sedere, e sotto la volta sopra la porta gli è la tua insignia ducale. Sopra questo voltato coperto affixo nel muro gli è l'arma felice extense sculpta in marmo. Dentro ala porta sopra gli è voltato de pietra cotta anchora. [. . .] Passiamo dentro in una grande logia, che ha quarantaocto colomne de cotta pietra con basse e capitelli de bianco marmo elaborati, et ha il cielo de belle tabule ornato a quadri de righe pincte.' *De triumphis religionis*: 57. For brick, see Tuohy (1996): 187–8.

42.   '. . . come di se istesso Cesare Augusto disse: che havea trovata Roma di terra et ella lassarebbe di marmo. Così la tua Celsitudine per virtù de magnificentia serà preconizata ala posterità con grandissima gloria, chè Ferrara de terra pincta trovasti, et di marmo, de adamanti sculpta tua indomita divisia haverai lassata.' *De triumphis religionis*: 75, cf. *Suetonius* (1914), trans. Rolfe, *Divus Augustus*: 28.

43.   *De triumphis religionis*: 60–1, 65–7 and 71–2. Cf. Tuohy: 206–8.

44.   *De triumphis religionis*: 52–8 and 65–7, respectively; for the Zardino de Madama, Tuohy (1996): 104–17.

45.   '. . . voltato all'antiqua . . .'. *De triumphis religionis*: 52 (cf. n. 15 above); '. . . romane lettere . . .', *ibid.*: 61.

46.   *Ibid.*: 75. Cf. n. 42 above.

47.   This is not the place for detailed comparisons; the reader is referred to Fiamma (1938), *Opusculum de rebus gestis ab Azone, Luchino et Johanne Vicecomitibus* . . ., ed. Castiglioni: cap. xv–xx, xxiii–xxv, xxvii–xxix and xxiii (pp. 15–24) (see also Green (1990)); Timoteo Maffei's *In magnificentiae Cosimi Medicei detractores libellus*, and Alberto Avogadro's hyperbolic *De religione et magnificentia . . . Cosmi Medicis* (both discussed in Fraser Jenkins, Avogadro published in part in Gombrich (1962)), and Manetti (1734), *Vita Nicolai V Summi Pontificis auctore Jannotio Manetto Florentino*, ed. Muratori, cols 928E–940D.

48.   Filarete (1965).

49.   Zevi (1960): 165–71 and 260–77.

5.1 Ferrara, Palazzo del Corte, Scala coperta

5.2    Voghiera, Belriguardo, entrance courtyard, central block, ground-floor window

5.3  Anonymous Ferrarese, *View of a city*. Ferrara, Palazzo Schifanoia, Salone dei Mesi, north wall

5.4  Naples, Chiesa del Gesù Nuovo (formerly Palazzo Sanseverino), west façade

5.5   Ferrara, Palazzo dei Diamanti

# Beauty as an aesthetic and artistic ideal in late fifteenth-century Florence

*David Hemsoll*

> *But as in all the arts, what pleases is harmony, through which alone all things are wholesome and beautiful.*
>
> St Augustine, *De vera religione*, 30, 55

The late-fifteenth century was a period of considerable ferment in Florentine art. As Vasari noted, it was a time when certain artists, notably Verrocchio and Pollaiuolo, began to pay more attention to the precise appearance of the natural world. This new outlook, in Vasari's view, was eventually to culminate in the career of Leonardo da Vinci, who succeeded in laying the foundations for the third and final phase of artistic renewal on the basis, in good part, of his 'very subtly imitating all of nature's minutiae'. On the other hand, it was also a time when other artists, especially Botticelli, seem to have become increasingly indifferent to such concerns. In Vasari's opinion, such artists had succumbed to 'excessive study', and this had caused their style to become 'dry, crude and sharp'.[1]

Although it may be tempting to regard these artists as less competent and forward looking than some of their contemporaries, it is perhaps more fitting to see them as embracing a different aesthetic outlook. In fact, it becomes a good deal easier to understand the artistic complexities of this period once it is recognized that all artists were in the position of having to choose between two competing outlooks which had become increasingly incompatible with each other. The first of these was based, of course, on the time-honoured premise that art should imitate nature, an ideal enshrined in art theory since the time of Cennino Cennini (c.1400).[2] The other, itself a perfectly respectable aesthetic position, was based on the premise that art should concern itself with metaphysical concepts such as beauty. Both these aims were to a degree recognized by Alberti (1435), who advised the artist to be 'attentive not only to the likeness of things but also and especially to beauty'.[3] However, the

ideal of imitating nature increasingly came to predominate, as can be seen in works from the 1470s by Pollaiuolo and more especially by Verrocchio and the young Leonardo, and then perhaps most adventurously in the frescoes produced by Perugino and others for the Sistine Chapel (1481 onwards). It may even now have been further reinforced by the notion that painting was *scientia* (literally 'knowledge'), the principle later developed by Leonardo who used the term to encapsulate the whole ethos – and justification – of representing the natural world 'as nature's legitimate daughter' in an ever more exhaustive and exacting manner.[4] Meanwhile, the more other-worldly approach was not entirely neglected, as can be seen in the works of Pollaiuolo and perhaps the early paintings of Botticelli, even those by him in the Sistine Chapel, but it remained subordinated to the doctrine of naturalistic imitation until the early 1480s. Then, all of a sudden, matters completely changed.

This change could have been prompted by a host of different reasons. In the first place, Florence was now entering a new phase of introspective calm following the recent ending of the war with Rome in 1480. In the second place, the artists who had once been at the forefront of 'scientific' naturalism were now leaving Florence – Leonardo departing in 1482, Verrocchio in 1483, and Pollaiuolo in 1484 – or were rarely there for any length of time, as in the case of Perugino, while others were now coming to greater prominence, Botticelli perhaps most notably. In the third place, and most significantly, a new aesthetic outlook had been propounded in the philosophical writings of Marsilio Ficino, which was to make the most substantial and coherent contribution to art theory since the time of Alberti.[5] By placing new emphasis on aesthetic objectives such as beauty, and renewed emphasis on the stylistic considerations of form, line and colour, this outlook not only challenged prevailing views, but also provided a theoretical basis for a new approach which was shortly to be developed in both painting and sculpture.

It is not so surprising that Ficino's views were taken up at this period. His main philosophical works were in circulation well before they were published, and his popular commentary on Plato's *Symposium* was even available in an Italian translation. They would certainly have been of considerable interest to artists. Although never dealing directly with art itself, Ficino nevertheless often referred to art and often explored principles that were directly applicable to art. He also addressed themes, such as the expressive powers of the human body, that were of particular fascination to artists even during the 1470s, and so he may well have been an influence on Pollaiuolo, who knew Ficino,[6] and who was especially preoccupied with such matters. At this time, Ficino's writings may not have been regarded as being particularly at odds with the developing ideal of imitating nature. By the early 1480s, however, as they finally began to be published, they would have

been regarded as having become wholly incompatible. In other words, they would have been seen as providing artists with both a theoretical basis and a set of key formal and stylistic principles for an entirely different approach.

Ficino's outlook was itself rooted firmly in the philosophy of Plato, which he had translated into Latin (and eventually published in 1484), and it was founded in part on Plato's belief that art should, if possible, represent not the superficial appearance of an object as visible in nature but instead its essential truth, or 'image'.[7] In short, Plato meant that the artist should respect the true proportions and colours of an object, and that he should not distort them for illusionistic effect.[8] The fact that Plato seemed to conceive of objects and their truthful 'images' in terms of line and colour was certainly not lost on Ficino, who inserted his own more explicit comment into a passage of Plato's, stating that 'we are against those who do not represent distinct lines and colours (*singula lineamenta coloresque*)'.[9] This remark, of course, was considerably at odds with the prevailing views held by artists that art should imitate the natural appearance of objects as precisely as possible.

Ficino's own aesthetic outlook was embedded in his *Theologiae platonicae* (finally published in 1482) and his 'commentary' on Plato's *Symposium* otherwise known as *De amore* (finally published with his Plato edition of 1484), and was largely developed in connection with his broader concerns with the metaphysical significance of the human body.[10] These concerns, which owed their origins to Plato and the speculations of his neoplatonist followers, depended in particular on Ficino's understanding of the human body as a prime receptacle of beauty and as an outward expression of the inner soul.[11] For as Ficino saw it, such considerations were directly related to the form and animation of the body, which he consequently discussed in considerable detail and, indeed, with frequent reference to painting, sculpture and even architecture. In his view, the shape and appearance of the body could be construed in some sense as a measure of spiritual beauty, while the deportment of the body, as well as the expression of the face and especially of the eyes and the other features,[12] could be regarded in some sense as a reflection of spiritual condition.

Particularly relevant to current artistic concerns were some of the specific theories Ficino advanced in connection with his investigations into beauty and other related matters, not least because of their obvious similarities with some of art's established procedures. For instance, despite equating the body's beauty with its 'movement, vivacity and grace', he still argued that it was associable with its formal properties of 'arrangement, measure and appearance' (*ordo, modus, species*), which he explained as its organization, its proportions, and its colour and surface enhancement.[13] He thus envisaged the body, rather as Plato had done, as an object defined in the first place by

lines (*lineae*), so that in doing so he viewed it in much the same way that Alberti and others had discussed the depiction of objects in paintings as being primarily dependent on a process of formal delineation.[14] In a similar vein, he also argued that all worldly objects were in fact the corporeal equivalents of higher 'forms' or 'ideas', which themselves were perceivable to the human soul,[15] from which principle he then reasoned that an artist produced works of art on the basis of 'forms' or 'ideas' which were imprinted within him.[16] He appears, in this instance, to have concluded that these 'forms' or 'ideas' were themselves rather like the preliminary designs for works of art, for he specifically compared them to the plans conceived by architects for their buildings,[17] and so he seems likely to have been aware of the process of preparatory drawing, and thus familiar with the long cherished concept of *disegno*.[18]

The chief significance of Ficino's aesthetic theories for the art of the period is perhaps that they provided a sound basis upon which the recently emerged doctrine of 'scientific' imitation could be effectively challenged. They would certainly have offered artists a means of freeing themselves from the slavish copying of nature, for instance by promoting the notions that artists were motivated by their inner beings,[19] and that works of art then expressed these inner beings.[20] Above all, they would have offered them a theoretical justification as to why the imitation of nature was not as noble an objective as the search for beauty. In the first place, Ficino very much denigrated the general concept of nature by regarding earthly nature as hierarchically inferior to 'forms' and 'ideas', which he believed were more closely associated with the divine.[21] By such reasoning, he was able to conclude that a renowned artist such as Zeuxis or Apelles was not nature's slave but her rival, because he 'imitates all the works of the divine nature, and perfects, corrects and amends all the works of the lower nature'.[22] In the second place, Ficino very much re-enhanced the general concept of beauty by identifying its pursuit as a prime spiritual and aesthetic objective,[23] and indeed as a prime artistic objective,[24] while at the same time linking it explicitly with the formal properties of line and also colour. By doing this, and by also associating beauty with the 'forms' and 'ideas' that exist in an artist's mind, he thus would have forged an implicit but inevitable connection not between beauty and nature but between beauty and *disegno*.

Ficino's ideals would certainly seem to have influenced Botticelli, who may already have been predisposed towards such an outlook, and they would certainly seem to have played a key role in the changes that occur in his art during the early 1480s. Very generally, they would be reflected in Botticelli's changed attitude towards nature, in that during the 1470s he had been a confirmed believer in the doctrine of 'scientific' imitation, but by the mid-1480s he had abandoned this approach almost entirely. Much more

specifically, they would also be reflected in the precise approach that he now appears to have taken. This approach seems to have been founded on the related premises that art should be based more resolutely on the achievements of past artists, and that it should be attuned more attentively to the pursuit of beauty.[25] In short, it seems to have been envisaged on the basis of adapting past prototypes to the formal principles of beauty that had been laid down by Ficino.

This new approach can be exemplified by Botticelli's Raczynski tondo in Berlin (Figure 6.1). On the one hand, the painting seems to be thoroughly purged of the concept of naturalistic imitation, and thus to be disassociated from the realities of everyday life. On the other hand, it resembles works by previous artists, such as Filippo Lippi's Washington *Madonna* (early 1440s), or even Bernardo Daddi's much earlier Or S. Michele *Madonna* (1347; Figure 6.2), but in a way that suggests they have been modified, or reinterpreted, in accordance with Ficino's various precepts and preferences. The composition is thus conceived with deliberate recourse to *disegno* as an animated and harmonious arrangement of lines, which are visibly expressed as such and which define areas of bright and fairly unmodulated colour. The transcendental figure of the Virgin is thus presented in a flat-on and flattened manner, with the result that distortions due to foreshortening are largely avoided, and with the further advantage that her face acquires an alluring emphasis, and her steadfast eyes gain a searching power.

In other paintings of the period Botticelli used similar means in order, so it would appear, to achieve new and ambitious pictorial objectives. In the incomparable *Birth of Venus*, for example, he depicted the goddess of love emerging from the sea and thus still naked, presenting her in a similarly flat-on and flattened manner, with clearly defined outlines and smoothly applied coloration, and as though caught in graceful movement.[26] By these means, he must have intended to call conspicuous attention to her beauty, and thus to her identity as the personification of divine love as a philosophical ideal, and as a metaphorical embodiment of the most noble of all earthly desires.[27] In his portraits, to turn to another of his areas of activity, he almost always presented his subjects from a near frontal viewpoint, stressing outline and colour, divesting them of superficial naturalism, and placing special emphasis on the facial features. In this way, he was presumably intending to record not so much the external appearance of his sitters but rather their inner being, and thus to accomplish in a more calculated way the aim of representing 'mood' that Ficino had earlier praised in the portraits of Pollaiuolo.[28]

While Ficino's outlook may have affected other painters of the period such as Ghirlandaio or Signorelli more sporadically or to a more limited extent, it appears to have had a very considerable and sustained effect upon the development of sculpture. As with painting, Ficino regarded sculpture as the

final outcome of a creative act, and he seems to have been thinking chiefly of sculpture when he referred to the divine act of creation through the analogy of a 'form' that exists 'firstly in the artist's mind, secondly in the tools that he wields, and thirdly in the material thus formed'.[29] He was specifically thinking of sculpture on other occasions, such as when discussing 'forms' with reference to both bronze and marble statuary, and he even entertained the notion that the form of a sculpture was potentially present within a stone block.[30] In fact, he may have regarded sculpture as in some ways the most effective means of representing what he saw as the most beautiful of all earthly creations, the body of man.[31] He certainly described the male body in a way that would have been readily understood by sculptors, calling attention not only to its ideal proportions,[32] but also to the inherent expressiveness of its stance. He considered that the soul itself was reflected in the body's 'free and general movement',[33] and he even associated particular spiritual conditions with particular bodily postures, describing, for example, how the nobility of the soul was expressed by an erect posture and by 'not looking at the ground' but up towards heaven.[34] That a similar approach was soon to be explored by sculptors seems already apparent in the small-scale statuettes produced by Bertoldo di Giovanni in the early 1480s of young and naked men in dynamic and evocative poses, such as his Vienna *Bellerophon* or his Bargello *Apollo* (Figure 6.3), just as it is later apparent, of course, in the early works of Bertoldo's youthful protégé, Michelangelo.

The crucial notion at the heart of this approach, that the form of the body, especially the male body, could possess a metaphorical as well as a literal significance was expressed perhaps most eloquently by Ficino himself in a letter addressed to his friends and titled *A picture of a beautiful body and a beautiful mind*.[35] After referring to the 'beautiful form' of a young woman and remarking that beauty was more effective than words at 'calling forth love', Ficino requested his readers to 'picture a man endowed with the most vigorous and acute faculties'. This mental image, which would seem to foreshadow so closely the sculptural concerns of Bertoldo and his contemporaries, he then explained as follows:

Now, in order to reflect more easily upon the divine aspect of the mind from the corresponding likeness of the beautiful body, refer each aspect of the body to an aspect of the mind. For the body is the shadow of the soul; the form of the body, as best it can, represents the form of the soul; thus liveliness and acuteness of perception in the body represent, in a measure, the wisdom and far-sightedness of the mind; strength of body represents strength of mind; health of body, which consists in the tempering of the humours, signifies a temperate mind. Beauty, which is determined by the proportions of the body and a becoming complexion, shows us the harmony and splendour of justice; also, size shows us liberality and nobility; and stature magnanimity . . .

It remains now to consider how Leonardo finally responded to these various ideas. After returning to Florence in 1500, he found himself in an artistic environment which, in the aftermath of the rise and fall of Savonarola, had become diminished to a point of virtual non-existence. Yet in the continued writing of his intended treatise he appears not to have been content with simply reasserting his own unwavering faith in the 'scientific' imitation of nature.[36] He seems instead to have felt a need to reinforce and re-elaborate his own position by way of countering some of the more daring claims that had been made for art by those of differing outlook, as well as by denigrating the achievements of many of his contemporaries: hence his summary dismissal of Botticelli as a painter of 'very sorry landscapes'[37] and his more concerted attacks on sculpture. He thus seems to have felt compelled to challenge the whole basis of Ficino's aesthetic philosophy. It is certainly the case that in the treatise he was openly dismissive of philosophers and men of letters, whom he described as 'inflated and pompous' (among other things), and as having derived their knowledge merely from books rather than directly from nature.[38] However, it is also the case that he himself conceived large parts of his treatise in a notably philosophical way, making use of similar ideas that had been put forward by Ficino but then adapting and manipulating them to suit his own ends.

By way of the treatise, Leonardo set out a theoretical framework for the systematic denial or dismissal of most of Ficino's aesthetic speculations. In the first place, he implicitly contradicted Ficino's claim that art was dependent on metaphysical 'forms' or 'ideas' through the exposition of his own basic premise that painting was the 'daughter' of nature,[39] and by specifically asserting that what the mind might be capable of imagining was in many ways inferior to what the eye was capable of seeing and the painter thus capable of depicting.[40] He further undermined Ficino's views of the generative and receptive functions of the artist's soul by continually stressing the intellectual powers of the artist's mind, so that when he referred to the eye as supposedly being the 'window of the soul',[41] he simply meant, as he explained, that it was the prime sensory organ by which the mind could perceive 'the infinite works of nature'.[42] He similarly undermined Ficino's views of the metaphysical expressiveness of the human body by arguing that bodily movement should be appropriate to a particular behavioural or mental state,[43] and by pointedly remarking that irrational movement was an outward sign of madness or of 'buffoonery' and similar dancing.[44] Finally, in regarding painting as 'science', and indeed as 'philosophy' or as a form of 'truth' in its most literal sense,[45] capable of reproducing the visual appearance of each and every kind of natural object – and in some ways even of superseding nature[46] – he was now in a strong position to attack the primacy of line and colour which had been upheld by Ficino and reaffirmed by

Botticelli and other artists. For he specifically condemned the practice of surrounding the edges of figures and objects with visibly drawn contours[47] and he expressly chided those persons who valued 'beauty of colour' over modelling in light and shade,[48] an aim which, together with foreshortening, he now declared to be the painter's greatest accomplishment.[49]

In one of his paintings from this period, the now-lost *Leda* (begun c.1505), Leonardo even appears to have confronted directly the key concept of beauty, intending to re-establish it once more as a central artistic concern although now very much in his own terms.[50] In fact, there can be little doubt that he intended his picture, which takes the form of an idealized female nude standing in an expansive landscape, as a calculated critique of paintings of comparable subject produced beforehand, and perhaps above all of Botticelli's *Birth of Venus*. The differences between these two paintings are revealing, for they suggest that Leonardo may have hoped not only to reinvent Botticelli's picture but also to expropriate some of its high-flown ambition. Whereas Botticelli's female figure is represented in a style that is seemingly consistent with Ficino's outlook, Leonardo's is arguably just as graceful, but it is represented in accordance with his own aesthetic preferences, with a pose that is suggestive of a rather more particularized state of mind, with a much greater degree of naturalistic verisimilitude and with much more attention to foreshortening and modelling in light and shade. Whereas Botticelli's female figure appears stylistically well suited to its identity as Venus, the personification of divine love and the object of human desire, Leonardo's rather resembles a Venus, but it is much better suited to its identity as Leda, a paradigm of earthly beauty which, even according to Leonardo, had the power to 'stimulate love',[51] and a terrestrial mortal who, according to mythology, was the unwitting object of divine desire.[52]

In another of his paintings, the celebrated *Mona Lisa* (begun c.1505), Leonardo appears to have turned very deliberately to the question of representing a person's state of mind, and to have thus tackled Ficino's general notion that outward appearance was in some sense a manifestation of inner being.[53] In this instance, there can be little doubt that he intended the work, at least in part, as a critique of the portraits by previous artists, particularly Botticelli, who had presumably pursued similar objectives in rarifying their subjects' appearance, and in placing special emphasis on their eyes as if they really were 'the windows of the soul'.[54] Initially, like some of his other contemporaries (such as Ghirlandaio), Leonardo may not have believed this to be possible, for he specifically remarked in an early poem that he could reproduce the likeness of a woman he was then painting (a mistress of the duke of Milan) but not the soul.[55] By the time, however, of the *Mona Lisa*, a picture that was apparently begun as a portrait of the lady Elisabetta del Giocondo, he had undoubtedly changed his view. Perhaps

prompted by the associations of the name *La Gioconda* ('the joyful woman'), he said by Vasari to have gone to extraordinary lengths in preparing her for the picture, by having her entertained by musicians and jesters to put her into a cheerful mood, and then to have set about depicting her facial features, especially her mouth and eyes, with unprecedented attention to detail.[56] By these means, he would seem to have been intent on conveying the joyful state of her mind, if not her soul, through the meticulous representation of her features, but on doing so according to the guidance of nature rather than the mere precepts of philosophy. Perhaps the success of this strategy should be judged by the reputation of the resulting portrait (assuming that it really is the one discussed by Vasari), or at least by the undoubted effectiveness of the captivating eyes and the famously enigmatic smile.

In conclusion, it is instructive to turn again to Vasari and his verdict on Leonardo. In addition to applauding Leonardo's abilities in imitating 'nature's minutiae' as a prelude to his initiating the third phase of art, Vasari also saw him as having mastered other challenges. In particular, he regarded him as having demonstrated a 'vigour and cleverness in *disegno*', so that with 'perfect *disegno* and divine grace' he was truly able to give his figures 'movement and breath'. Yet concerns with grace and even with *disegno* never really formed part of Leonardo's artistic philosophy, inasmuch as they were never treated to any great consideration in his writings. In fact, they would seem instead to have been the preoccupations of those rivalling artists, in particular Botticelli, who were dismissed by Vasari as having been blighted by 'excessive study' and as having worked in a 'dry, crude and sharp' style. In the light of what has been said, it becomes clear that Leonardo's achievement, at least in part, relied on his ability in eclipsing his rivals by assimilating their ideals and obscuring their accomplishments. It is also clear, however, that even this achievement was not sufficient to prevent the ideas of his early competitors from eventually being reformulated and reinvigorated by his arch-rival Michelangelo.

## Notes

1. Vasari, *Le Vite*, ed. Milanesi (1878–85): IV, 9–11.

2. Cennini, XXVIII, ed. and trans. Thompson (1933): 15. See Barasch (1985): 114–30; and also E. Panofsky (1968): 197–8, 202–4.

3. Alberti, *De pictura*, III, 55, ed. and trans. Grayson (1972): 98–99. See also e.g. Barasch (1985): 120–7; Blunt (1962): 1–22.

4. Leonardo da Vinci, *Trattato*, ed. and trans. McMahon (1956): 6; eds Kemp and Walker (1989): 13. Cf. Ghiberti, *I commentari*, I, 3 and I, 21, ed. Morisani (1947): 7–8 and 24. Note also the criticism of Verrocchio's *Colleoni monument* in Gauricus, *De sculptura*, eds Chastel and Klein (1969): 202–7. For Leonardo's outlook in general see Barasch (1985): 132–41; Blunt (1962): 23–38.

5. As previously discussed in Chastel (1954; 1959): my intention here is to make some of the various possible connections between Ficino's theories and contemporary art much more explicit.

For Ficino's general conception of art, see Kristeller (1943): 305–7 and in particular Allen (1989): 117–67.

6. Chastel (1954): 32.

7. On Plato, see Barasch (1985): 4–9, and Keuls (1978).

8. As expressed most succinctly in *Sophist*, 235D–236B, and in *Republic*, 10, 602C–E.

9. *Critias*, 107D, as represented in Ficino's (1548) *Platonis opera omnia*: 498: 'sumus adversus eum qui non singula lineamenta coloresque expresserit'. For Plato's conception of painting as outline and colouration, see e.g. *Statesman*, 277B–C and *Philebus*, 51C–D.

10. Ficino, *Theologiae platonicae*, ed. Marcel (1964–70); *In convivium Platonis de amore commentarium*, trans. and ed. Jayne (1985).

11. See e.g. Chastel (1954): 87–114; (1959): 279–88 and 299–319, and also Trinkaus (1970): 2, 461–504.

12. Chastel (1954): 94; (1959): 311.

13. *In convivium Platonis*: V, 6, ed. Jayne (1985): 93–5. Ficino's terminology probably derives from St Augustine, *De natura boni*, 3.

14. *De pictura*, II, 30; *De statua*, V; ed. Grayson (1972): 66–7 and 122–3.

15. *In convivium Platonis*, V, 5, ed. Jayne (1968): 91–3. See also Panofsky, 56–7 and passim.

16. *Theologiae platonicae*, XI, 5 and X, 4, ed. Marcel: II, 133 and 68. See Allen (1989): 120–1, 142–3 and 158.

17. *In convivium Platonis*, V, 5, see Chastel (1954): 71–2 and 1959, 131–3. See, in addition, *Theologiae platonicae*, II, 11, ed. Marcel: I, 108–9.

18. Petrarch, *De remediis utriusque fortunae*, 41 quoted in Baxandall (1971): 56 and 61; Cennini, IV, ed. Thompson (1933): 3; Ghiberti, I, 2–3, ed. Morisani: 3 and 6.

19. *Theologiae platonicae*, III, 1, ed. Marcel: I, 135–6. See e.g. Chastel (1954): 65; (1959): 94.

20. *Theologiae platonicae*, X, 4; ed. Marcel: II, 68–70. See Chastel, (1954): 65–6; (1959): 102–3; 398; and Allen (1989): 161–2. See also Kemp (1976): 311–23.

21. Panofsky (1968): 56–7; Allen (1989): 142.

22. *Theologiae platonicae*, XIII, 3, ed. Marcel: II, 223. See Allen (1989): 148–50.

23. See e.g. *In convivium Platonis*, I, 4; II, 9; V, 1–8; ed. Jayne: 40–3, 58, 83–98.

24. *Theologiae platonicae*, XII, 5, ed. Marcel: II, 175; quoting St Augustine, *De vera religione*, 30, 55. Cf. Chastel (1959): 282–3.

25. As I shall describe more fully in a future article to be entitled 'Botticelli's Theory of Art'.

26. Baxandall (1972): 78–81. See also Chastel (1959): 310–11.

27. As expressed, for example, in a letter by Ficino himself, Book V, n. 46, *The Letters of Marsilio Ficino* (1975): 4, 61–3. See Gombrich (1972): 41–2.

28. *Letters*, Book VII, cited in Chastel (1954): 32.

29. *Theologiae platonicae*, X, 4, ed. Marcel: II, 68. See Allen (1989): 157–61.

30. *Theologiae platonicae*, V, 8 and V, 13, ed. Marcel: I, 187, 205. On this last point, which was also taken up by Alberti (*De Statua*, II, ed. Grayson): 120–21, see also Chastel (1959): 282. Panofsky (1968): 29–31 and 188–9 and Summers (1981): 101 and 531.

31. *Theologiae platonicae*, V, 13, ed. Marcel: I, 208.

32. *In convivium Platonis*, V, 6, ed. Jayne: 93–5. Cf. Alberti, *De Statua*, 12–13, ed. Grayson: 132–9.

33. *Theologiae platonicae*, III, 1, ed. Marcel: I, 134, as cited by Chastel (1959): 309.

34. *Theologiae platonicae*, X, 2, ed. Marcel: II, 59–60, cited by Trinkaus: 2, 474–5.

35. *Letters*, Book V, n. 51, *ed. cit.*, IV (1988): 66–7.

36. For the dating of all the various parts of Leonardo's treatise, see Pedretti (1965): 95–221.

37. *Trattato*, ed. McMahon: para. 93; eds Kemp and Walker: 201–2.

38. Richter, ed. (1939): paras 10–12, 1153 and 1159, and *Trattato*: ed. McMahon: para. 19 and 78; ed. Kemp and Walker: 9–10 and 195.

39. *Trattato*, ed. McMahon: para. 6 (as n. 14 above). Cf. para. 30, and ed. Richter, para. 660; ed. Kemp and Walker, 13 and 193, perhaps recalling Dante's idea that art is the 'grandchild' of God (*Inferno*, 11, 99–105); cf. Summers (1981): 298–9.

40. *Trattato*, ed. McMahon: para. 23; ed. Kemp and Walker: 22–3.

41. Perhaps recalling Dante's idea of the eyes as the 'balconies' of the soul (*Convivio*, 3, 8); see Kemp (1981): 267 and below n. 54. For a similar manipulation of ideas earlier explored by Ficino, see Kemp (1976).

42. *Trattato*, ed. McMahon: paras 30 and 42; ed. Kemp and Walker: 20 and 32.

43. *Trattato*, ed. McMahon: paras 395, 401 and 261; ed. Kemp and Walker: 144–6 and 222.

44. *Trattato*, ed. McMahon: para. 408; ed. Kemp and Walker: 146.

45. *Trattato*, ed. McMahon: paras 10, 30 and 17; ed. Kemp and Walker: 18, 34 and 19.

46. See e.g. *Trattato*, ed. McMahon: para. 34; ed. Kemp and Walker: 21.

47. *Trattato*, ed. McMahon: para. 156, 501 and 506, ed. Richter: para. 49, ed. Kemp and Walker: 210, 88, 86–87 and 53.

48. *Trattato*, ed. McMahon: para. 434; ed. Kemp and Walker: 15–16.

49. *Trattato*, *ibid.* and ed. McMahon: para. 840; ed. Kemp and Walker: 88.

50. On Leonardo's *Leda*, see Heydenreich (1954): 1, 52–4; Kemp (1981): 270–77, and also Clark (1969): 18–21.

51. *Trattato*, ed. McMahon: paras 42 and 26; ed. Kemp and Walker: 23–4 and 35.

52. On Leda in art, see Bober and Rubinstein, (1986): 52–4.

53. For the *Mona Lisa* in general, see Heydenreich (1954): 48–52; Kemp (1981): 263–70 and more recently Zöllner (1993). The identity of the sitter is corroborated by Shell and Sironi (1991).

54. Gauricus, *De Sculptura*, ed. Chastel and Klein: 136, which suggests a source to be Lactantius, *De opificio Dei*, VIII, 11 and IX, 2. See also Albertus Magnus, *De animalibus*, I, 1. For similar opinions about representing a person's character or soul, see Xenophon, *Memorabilia*, III, 10, 1–8; Philostratus the Younger, *Imagines*, preface (cf. Baxandall (1971): 98–103); Gauricus, *De Sculptura*, ed. Chastel and Klein: 128.

55. Richter: para. 1560. Ghirlandaio included an inscription to this effect on his portrait of Giovanna Tornabuoni (1488), an inscription itself based on an epigram by Martial, for which see Shearman (1992): 108–48, and Dempsey (1992): 63–4, 147–9.

56. *Le Vite . . .*, ed. Milanesi: IV, 39–40.

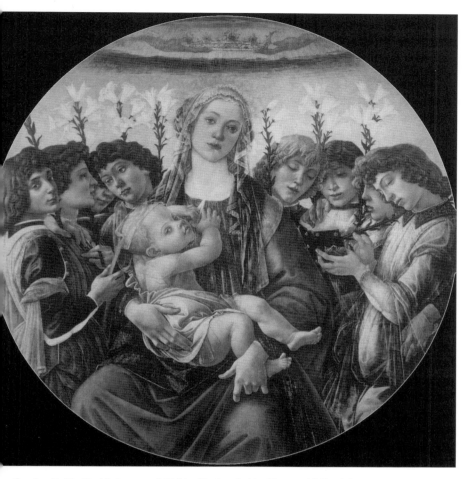

Sandro Botticelli, *Madonna and Child with Angels* (the Raczynski Tondo)

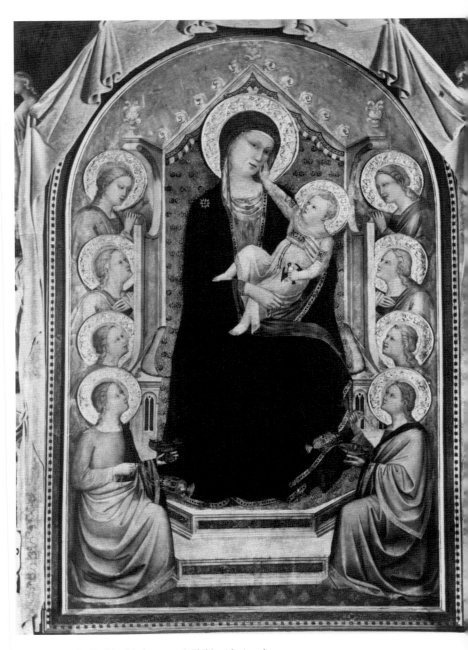

6.2    Bernardo Daddi, *Madonna and Child with Angels*

6.3   Bertoldo di Giovanni, *Apollo*

# Defining the beautiful in early Renaissance Germany

*Andrew Morrall*

Within the discipline of art history, German art of the late fifteenth and early sixteenth centuries has tended to be perceived as somewhat awkward and difficult to categorize. During this period the arts were undergoing profound change as their traditional functions and forms came into question during the Reformation and as artists and their patrons were increasingly drawn to Italian art. If the subject has been marginalized, it is not least because German art lacks the aesthetic qualities associated with Italian art.

The origins of the bias against Northern art lie in the sixteenth century. Michelangelo, in his account of Northern painting, as recounted by Francisco da Hollanda, famously criticized the Northern predilection for the particularity of things:

They paint stuff and masonry, the green grass of the fields, the shadows of trees and rivers and bridges which they call landscapes, with many figures on this side and many on that; and all this, though it pleases some persons, is done without reason or art, without symmetry or proportion, without skilful choice or boldness and finally, without substance or vigour.[1]

Hostile reaction to similar qualities of style is to be found in Vasari's condemnation of Northern Gothic architecture as:

... a malediction of tiny niches, one above the other, with no end of pinnacles and points and leaves, so that, not to speak of the whole erection seeming insecure, it seems impossible that the parts should not topple over at any moment ... In these works they made endless projections and breaks and corbellings and flourishes that throw their works all out of proportion ...[2]

For both great classicists, Northern art lacked what Michelangelo called 'harmony', that is to say, the underlying and unifying aesthetic principle of 'ratio', governed by symmetry, proportion, synthesis and overall unity of

conception. Behind this closed system of form lay the idea that harmonious beauty expressed the moral qualities of truth and goodness. This idea, drawn from classical thought,[3] was reiterated frequently in sixteenth-century Italian treatises.[4]

To the classicist, works of art that lacked these aesthetic and ethical qualities were therefore ipso facto bad. Yet the very qualities that Vasari condemns, of particularity and variety at the service of an overall material splendour of effect, are celebrated in a description of Strassburg Minster by the Alsatian humanist Jacob Wimpheling who, in an attempt to assert German cultural achievements against those of Italy, exclaimed:

Who can fail to admire and praise the Strassburg tower, which with its statues, paintings and variety of elements easily surpasses every building in Europe? Its height exceeds 415 cubits. It is a wonder that such a massive edifice could be raised to such height.[5]

Wimpheling's distance from the aesthetic theory of Italy and of the classical ideal are demonstrated in his avowal that Phidias himself would have admired it.[6]

As the relative poverty of Wimpheling's critical apparatus might indicate, the Germans lacked a theoretical foundation for their art and possessed no general theory of aesthetic beauty. Yet in architecture, as in landscape and indeed the other genres, it might be said that the Northern gothic aesthetic was dependent upon a formal system that was open, variegated, irregular, and complex in its sum of particularities; and that its chief organizing principle lay in the building up of aggregative structures of discrete elements of relatively equal importance.

If, in general, such aesthetic principles underlie the structures of Northern art, particular notions of beauty could evolve out of conventions surrounding the object involved, based on values that were not necessarily aesthetic. Throughout the high and later Middle Ages and continuing into the early modern period, the manner of expressing ideal human physical beauty was determined as much by social as by purely aesthetic criteria. The roots of this conception lie in the literary and artistic conventions of thirteenth-century courtly art. Beauty was defined in terms of the conventions of decorum and behaviour of the court. A passage describing the heroine, Isolde, in Gottfried von Strassburg's *Tristan* (fl. 1210), may serve as a particularly vivid literary parallel to the ideal of female beauty as it evolved in Gothic art, and articulates a number of its meanings. The young Isolde is being led into the court by her mother:

The girl glided gently forward . . . exquisitely formed in every part, tall, well-moulded, and slender, and shaped in her attire as if Love had formed her to be her own falcon, an ultimate, unsurpassable perfection![7]

Expressed here is a general notion of ideal proportions: not in the classical sense of a universally applicable harmonic theorem, but an ideal specific to her age, gender and social status: of a young woman of marriageable age and of high social class. It is an ideal of Woman in fact, informed by the courtly notion of Love, as something both deliciously sensual and unattainably chaste.

This notion of beauty is grasped through a lengthy and minutely detailed itemizing of the different elements of her clothing and of her bearing – a poetic form, in fact, that mirrors the paratactic structures found in the visual arts, discussed above. This list is enlivened by rhetorical ornament, in particular by chiasmus (lost in the prose translation), and is charged with sexual innuendo and social observation. The emphasis on clothing reveals the overriding importance in the courtly perception of beauty of correct and decorous outward display in dress and demeanour – a socially conditioned notion of value:

Her mantle was set off by a lining of white ermine with the spots arranged diaper-fashion. For length it was just right, neither dragging nor lifting at the hem. At the front it was trimmed with fine sable cut to perfect measure, neither too broad nor too narrow, and mottled black and grey – black and grey were so blended together as to be indistinguishable.[8]

A further important element in the understanding of courtly beauty is found towards the end of the passage:

One saw [the mantle] inside and out, and, hidden away within – the image that Love had shaped so rarely *in body and in spirit*! These two things – lathe and needle – had never made a living image more perfect![9]

In the equation between body and inner being (the German word is 'Sinn') is a version of the Platonic association between outward beauty and beauty of soul, which pervaded the medieval courtly aesthetic. Courtly poetry knew only beautiful people and beauty was a mark of their inherent nobility; accordingly, the ugly represented the opposite pole to the sincere and true soul.[10] This idea, allied to the same convention of the *descriptio puellae*, continued into the Renaissance, North and South, as the conventional means of portraying Beauty Adored.[11]

As an aesthetic of naturalism developed in the course of the fourteenth and fifteenth centuries, the same socially conditioned notion of beauty became increasingly released from metaphysical association. Beauty continued to be bound up with connotations of class. It was to remain embedded in the language. The word 'hübsch', meaning 'beautiful' or 'attractive', contained a distinct social value, being closely linked with the Middle High German 'hübesch'/'hövisch', i.e. of the court ('Hof') or 'courtly'.[12] In the

visual arts, the persistence of this ideal may be seen in the late fifteenth-century works of the so-called Housebook Master, where aristocratic richness of costume and idealization of feature and mien form a corollary of the literary ideal.[13] Yet in a print by the Master MZ of a courtly dance of 1500 (Figure 7.1), the extreme stylization of dress and bearing now registers social exclusivity alone – a meaning reinforced by the servant on the left, who forcibly closes the door on the lesser estates. The element of satire, introduced by the leering fool in the right-hand upper gallery, effectively dispels any connection with poetic idea. This new literalism allied to parody in prints such as this signals the decline of medieval courtly idealism and its gradual replacement by the values of the increasingly influential urban middle classes.[14]

The medieval courtly ideal that exalted Woman as the mystical expression of Love, also pervaded the religious art of the later Middle Ages. Aristocratic decorum allied to a style of detailed material description and richness of decoration combined to create a metaphysical equation between Beauty and Goodness that was powerfully applied to the Madonnas and saints of fourteenth- and fifteenth-century court art. The material splendour of the individual saints and their collective setting in the richly carved and decorated retables, provided an earthly metaphor for heavenly beauty. Yet in the course of the fifteenth century, the metaphysical idea embodied in this courtly image became increasingly sullied by the biblical literalism of popular religious movements such as the Devotio Moderna. In the decades immediately preceding the Reformation, as disillusionment with the Church's liturgical practices and distaste for the materiality of church decorations and furnishings grew, so too did the saints and Virgins, gorgeously attired in their costly and sensual vestments, seem an increasing breach of religious decorum. As Karsthans, the Lutheran peasant narrator of the broadsheet *Neu-Karsthans*, published in Strassburg in c.1520 expressed it:

I often had base thoughts when I looked at the female images on the altars. For no courtesan can dress or adorn herself more sumptuously and shamelessly than they nowadays fashion the Mother of God, Saint Barbara, Katherine and other saints.[15]

Implicit in such criticisms lay an attitude according to which outward beauty of appearance was seen as a *negative* factor, diverting attention away from the image's proper function: to enable the pious beholder to pray *through* the image to the saint or holy personage represented.[16] According to this brand of piety, the image should serve merely as a cipher of the spiritual reality behind it. Such a manner of looking at paintings and sculptures, formed by habits of devotion widespread throughout the Middle Ages, was fundamental in determining the Northern idea of the beautiful. It presupposes an

attitude towards images that does not address the aesthetic sense first and foremost. According to St Augustine's influential formulation, three kinds of seeing are involved in the exercise of prayer – the bodily, the spiritual and the intellectual. The pious contemplation of an image might lead from a purely 'physical' act of seeing, to a devotional form of 'inner seeing', culminating ultimately in the direct apprehension of the Divine, grasped through the intellect.[17] This mystical form of 'inward seeing' was therefore very different from the dispassionate activity of objective looking, of regarding an image as something separate, upon which the aesthetic attitude depends; rather, it involved an intensely emotional and affective relationship with the sacred person represented.

To a large extent, images in Northern Europe were defined as much by affective response as by any inherent aesthetic qualities. Indeed, surveying the religious art of the fifteenth century that may be said to belong to this tradition, one is struck not so much by what one may conventionally call 'beauty', but rather by a cult of deliberate and exaggerated ugliness. Behind such imagery was a widely practised tradition of affective meditation upon the Passion, which by this period had become, in the words of Eamon Duffy, 'the central devotional activity of all seriously-minded Christians'.[18] This process was one in which the individual identified and empathized with the sufferings of Christ, in a step-by-step mental re-enactment of the Passion, a phenomenon that led to a morbid preoccupation with Christ's wounds, blood and specific instruments of torture. The extraordinary violence and malevolence of the tormentors and the graphic literalness of Christ's sufferings in an image such as the *Flagellation of Christ* by Jörg Breu the Elder, from the Aggsbach Altarpiece of 1501 (Figure 7.2), find close parallels in the many vernacular handbooks on meditation that followed thirteenth- and fourteenth-century Latin models.[19] Behind its popular appeal lay a christology which found in Christ's torments evidence of his human nature, of a divine identification with suffering humanity. As Ludolph of Saxony wrote in his *Vita Christi*:

O Good Jesus . . . I am not able to fully understand how it is . . . sweeter to view you as dying before the Jews on a tree than as holding sway over the angels in heaven; to see you as a man bearing every aspect of human nature to the end, than as God manifesting divine nature.[20]

The paradoxical result of this form of devotion was to find in the abject, the defiled, the broken and degraded, a suitable image of the Divine. In ugliness lay a symbol of ultimate transcendence.

Furthermore, as the crudity of the many printed meditational aids of the period demonstrate, the simplest and most schematic of images were

sufficient to stimulate intense devotion. Painted imagery involving a developed aesthetic sense could have been supererogatory to the meditational process for both practised, literate mystics like Gailer von Kaisersberg, and his *unlettered* congregation, whom he advised to buy cheap prints and use thus:

If you cannot read, then take a picture of paper where Mary and Elizabeth are depicted as they meet each other; you buy it for a penny. Look at it and think how happy they had been, and of good things . . . Thereafter show yourself to them and in an outer reveration, kiss the image on the paper, bow in front of it, kneel before it.[21]

This ingrained habit of inward seeing did not abruptly cease with the advent of the Reformation. That it continued in the Protestant tradition may be seen in the figure of Martin Luther. That he threw his inkpot at the devil is well known; less familiar is his description of a vision he experienced, while engaged in prayer and mystical exercises, which he recorded in his *Tischreden*. His account also reveals the self-sufficiency of this 'inner sight', without recourse to external imagery:

. . . On Good Friday last, I being in my chamber in fervent prayer, contemplating with myself, how Christ, my Saviour on the cross, suffered and died for our sins, there suddenly appeared on the wall a bright vision of our Saviour Christ, with five wounds, steadfastly looking at me, as if it had been Christ himself corporeally.[22]

Of all the Protestant reformers, Luther was the most tolerant of the use of painted and sculpted images in religious worship. He in fact justified the latter's use by using the analogy of 'mental pictures', saying that since everyone possessed an inner image of God and the saints, painters in creating their images were doing no more than realizing their own images, something that could be of general benefit.[23] Nonetheless he disapproved of the emotionalism and the tenor of brutish violence of these late medieval passion scenes. He advocated a more sober, neutral type of image, through which the central theological lesson of the redemptive significance of Christ's sacrifice, and its importance for all mankind, should be made manifest.[24]

Outward beauty had little place within this attitude to images. In fact, by the third and fourth decades of the sixteenth century, through the twin impulses of the Reformation mistrust of the image and the increasing interest in and adoption of Italian Renaissance forms, the emotion-laden, affective image had died out. The process of its gradual demise can be witnessed in a later rendition of the *Mocking of Christ* by the same artist, Jörg Breu, dateable to the early 1520s (Figure 7.3).[25] In sharpest contrast to the expressive qualities of his earlier Aggsbach altarpiece, theological significance is now expressed in largely emblematic terms. The violence has evaporated. The

evil of Christ's tormentors is still registered in the grotesque faces and wildly flailing gestures. Yet their actions *as narrative* are neutralized by the figure of Christ, who is no longer the reduced, tortured figure but stands open-eyed, in a posture of seeming repose, as if oblivious to his tormentors. A stream of golden light issuing from the mouth of God falls upon him, signifying his status as the *Verbum Dei*, the vehicle through which God communicates his plan for mankind in the Divine Order.[26] The pillar on the left, a reference to the column of Christ's Flagellation, as well as the two figures before it, who possibly allude to Judas's betrayal and collusion with the High Priests, act ideogrammatically as further cues within the process of meditation. The written inscription on the tablet at the back, drawn from Job 16, associates Christ's torments with his Old Testament antetype and prompts further reflection upon the theme by equally rational means.

In every sense of the word, this is a *reformed* image. It has been purged of all expressive means of affective relationship. In its place is a kind of aesthetic neutrality. Both outward beauty and ugliness have become irrelevant to a process of purely intellectual cognition that seeks to recognize the *idea* behind the image. Like the method of meditation outlined above, this image depends upon a relationship with the viewer that involves inner reflection and cogitation upon a specific theme, a *looking through* the theme represented to its intended meaning: in this case, the salvatory significance of Christ's suffering for mankind's redemption. Any notion of beauty is apprehended by the intellect and mediated through the prism of moral understanding. This image, conforming as it does to Luther's prescription for a reformed imagery, shows that the habits of 'inner seeing' did not disappear with the taste for the ecstatic and the affective. What is of particular interest in this period is to consider how these continuing habits affected the adoption and reception of Italian art.

With the great exception of Dürer, the majority of German artists who were influenced by Italianate form remained unreceptive to the aesthetic and expressive values of their adopted style. This is overridingly so in the case of the products of the Augsburg school of painting.[27] Here, classicism took greatest root in the field of allegory and exemplary imagery (the themes themselves often drawn from classical literature). The late style of Jörg Breu the Elder, represented in his 1528 *Story of Lucretia*, displays a developed classicism in costume and architecture (Figure 7.4).[28] These elements are built up from Italianate motifs, garnered principally from prints. They were understood, not in their expressive nature, but decoratively, as a kind of outward rhetorical clothing, which dressed the idea represented with an aura of antique authority. Style, through its 'elevated' nature, does honour to the subject and the idea behind that subject through its semantic references to antiquity, rather than by expressive means. It was a way, in other words,

by which the habit of seeing through the outer, physical world, inherited from medieval habits of contemplation, was continued. Beauty, as in the mystical religious tradition, remained an inward, moral quality, to be grasped by the inner eye; the outward, bodily appearance was but its signifier. Stylistically, moreover, in Breu's piecemeal application of the classical elements is to be seen an interest in variety, fantasy and conglomerative application – a use in fact of the *Classical* that is strikingly close to Vasari's hostile characterization of the *Gothic* with which this paper began. The Augsburg school brand of classical idealism, as exemplified in Breu, therefore ensured the continuation, in new secular guise, of older habits of metaphysical contemplation within the Northern tradition. The classical, as an expressive ideal, found no satisfactory purchase.

## Notes

1. da Hollanda (1928): 16.

2. Vasari (1878): I, 138; Maclehose (1907): 83.

3. Thus, for example, Aristotle (following Pythagoras): '. . evil is a form of the Unlimited and good of the Limited', *The Nicomachean Ethics*: Bk 2, 101.

4. See Lomazzo, *Scritti* (1974): II, 38–9, on proportionate beauty and religious art: '. . sì che de la maestà e bellezza de le sacre immagini, causata in loro da questa euritmia e simmetria, maravigliosa cosa è quanto s'accresca ne gl'animi nostri la pietà, la religione e la riverenza verso Dio et i santi suoi . . .'

5. 'Wer kann den Straßburger Thurm, der mit seinen Statuen, seinen Bildern und mannigfalten Dingen alle Gebäude Europas leicht übertrifft, dessen Höhe über 4515 Füß beträgt, nicht bewundern oder loben? Ein Wunder ist es, daß man eine solche Masse in solche Höhe erheben kann.' Wimpheling (1505): chap. LXVII.

6. *Ibid.*

7. See von Strassburg, *Tristan* (1978): Part 2, chap. xiv, 29; trans. and ed. Hatto (1967): 185–6.

8. *Ibid.*: 185.

9. *Ibid.*: 185; the italics are mine.

10. On the medieval inheritance of the Greek ideal of the identity of the beautiful and the good, see Brinkmann (1928): 19 and Ehrismann (1995): 189ff., *schoene unde guot: zur Kalokagathie*.

11. Thus the description of the heroine of Aeneas Silvius Piccolomini's *Historia de duobus amantibus* of 1444, concludes (in an English translation of 1567): 'Nothyng was in that bodye not to be praysed as the outwarde aparaunces shewed token of that that was inward'. Aeneas Silvius Piccolomini, Pius II, ed. Morrall, (1996): 4. Aeneas Silvius gives the medieval tradition a characteristically humanist gloss by including in his list of virtues the quality of her speech, comparing her to women of antiquity famous for their eloquence; *ibid.*: note 4/6–7.

12. Ehrismann (1995): s.v. *hövesch*, 103–14.

13. See Moxey (1985): 39–51.

14. See Hess (1996); for the satirizing of courtly style see Moxey (1980): 125–48; also Vignau-Wilberg (1984): 43–52.

15. Cited in Baxandall (1980): 88.

16. See for instance the passage in the 1475 tract *Der spiegel des Sünders*: '. . if you honour a beautiful and modern image more than one crudely made and old, then you are guilty of the sin of idolatry'; the German text cited in Baxandall (1980): 54.

17. See Scribner (1989): 457–8.

18. Duffy (1992): 235.

19. Marrow (1979): 33–170; for Breu's Aggsbach altarpiece, see Menz (1982).

20. Cited in Duffy (1992): 237.

21. Cited in Freedberg (1989): 177.

22. Cited in Forde (1984): 15.

23. For Luther's views on images, see Christensen (1970): 147–65.

24. Luther 'Sermon von der Betrachtung des heiligen leydens Christi', in *Martin Luthers Werke* (1883–): II, 136.

25. Oil on panel, Innsbruck, Tiroler Landesmuseum, Ferdinandeum.

26. Krämer (1980): III, 125.

27. See Baer (1993).

28. For a full discussion of the painting, today in the Alte Pinakothek, Munich, see Morrall (1996): chapter 4.

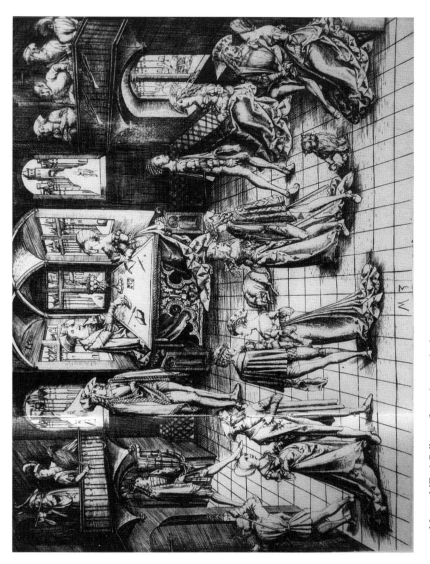

7.1　Master MZ, *A Ballroom Scene* (engraving)

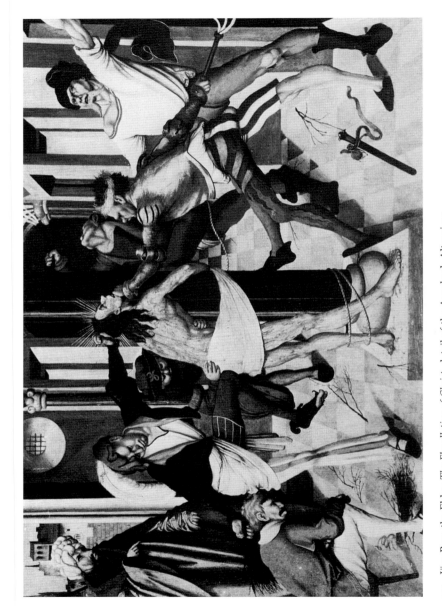

7.2  Jörg Breu the Elder, *The Flagellation of Christ*, detail of the Aggsbach Altarpiece

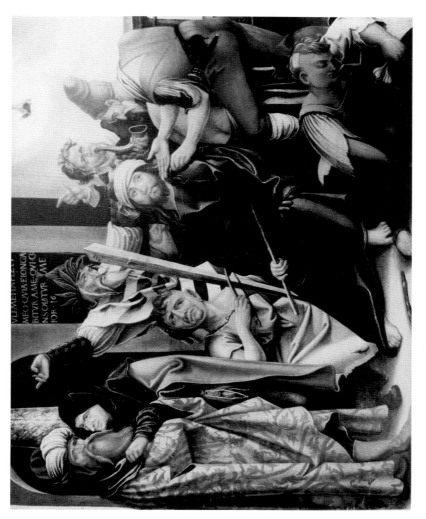

7.3  Jörg Breu the Elder, *The Mocking of Christ*

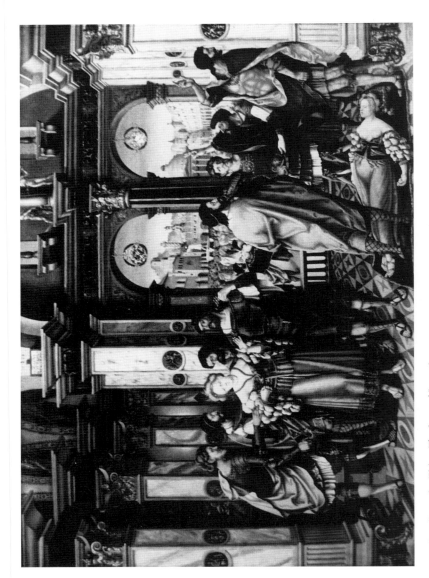

7.4  Jörg Breu the Elder, *The Story of Lucretia*

# The artist as beauty

*Mary Rogers*

In the *Life* that opens his discussion of his third and final stage in the development of the arts, Giorgio Vasari introduces a new type of artist: the artist as beauty. Not only could this genius endow his figures with a superhuman grace, his actual person possessed an angelic beauty suggesting divine favour. Among Leonardo's abundant heaven-sent gifts, the author tells us, were:

> ... beauty, grace, and ability, so that, whatever he turns himself to, each action is so divine that he surpasses all other men, thus making it evident that it is a gift from God, and not acquired through human skill. This men saw in Leonardo da Vinci, who apart from physical beauty, which could not be praised enough, displayed infinite grace in every action ....[1]

This type of artist, beautiful in physique and graceful in behaviour, was anticipated by some of the painters in Vasari's preceding stage. Signorelli, whom Vasari knew as an old man, was 'gracious and refined', 'gentle, pleasing and courteous'; Francia was 'of handsome appearance, in speech and conversation very gentle and charming'.[2] But they were limited, as dramatically demonstrated when Francia was literally extinguished by the beauty of Raphael's creation: at the sight of the *St Cecilia altarpiece* he took to his bed and died.[3] With the supremely graceful Leonardo, however, a new stage begins, in which Vasari's reader encounters several major artists who are either physically beautiful or possess an attractive demeanour: Leonardo, Raphael, Rosso, Parmigianino, Giulio Romano, Perino del Vaga and Jacopo Sansovino.[4] Thus the advent of the beautiful artist in life seems to serve as a metaphor for the arrival of a perfected beauty in art, and Vasari's treatment of the motif registers some of his key concerns as to the nature of artistic

talent and the ways in which it should be nurtured, developed and deployed.

In the first sentence of his *Life* of Leonardo, Vasari uses the phrase 'celesti influssi' to explain Leonardo's physical grace, revealing a Neoplatonic origin for his belief that exterior beauty signals God's favour and thus an elevated interior.[5] Another explicit linking of physical with moral perfection would come when, in a later passage discussing the head of Christ in the *Last Supper*, he wrote about Leonardo's struggle to realize 'that beauty and celestial grace which must have been present in the Divinity Incarnate'.[6] The notion that beauty came from God was, of course, a commonplace in the culture of the mid-sixteenth century, when Vasari wrote the *Life*, tracing back to Ficino's commentary on Plato's *Symposium*.[7] So, too, was the idea of the artist as 'divine' because heavenly inspiration enabled him to create beauty (an idea to which Leonardo himself subscribed).[8] It is hardly surprising, then, that when suitable real-life material presented itself, the two concepts, of personal beauty signalling divine favour and of artistic inspiration as signalling divinity, should have become elided. Yet Paolo Giovio, whose short *Life of Leonardo* of 1525 provided the basic ingredients of beauty, charisma and diverse gifts found in Vasari's biography, failed to emphasize their divine origin.[9] The German humanist Joachim Camerarius linked Dürer's fine person and intellect: 'Nature bestowed on him a body remarkable in build and structure, and not unworthy of the noble mind it contained',[10] but unlike Vasari he failed to develop the body–mind connection rhetorically to elevate and ennoble the artist and his work. My concern here, however, will be less with the intellectual and literary antecedents for Vasari's notion of the beautiful artist than with its mode of employment, and with its parallels in artistic practice.

Leonardo's celestial endowment was said to be manifest in his looks, but even more in his divine grace of action, leading to power combined with dexterity in various sorts of performance. His movements were graceful, he sang 'divinely' to his improvised playing on the lyre, and he was 'so charming in conversation that he won over the souls of the people'.[11] Part of this grace in performance was the manual dexterity that Vasari presents as one of the mainsprings of Leonardo's art: a facility innate, or quickly self-taught, not resulting from the painstaking study stressed in the *Life* of Raphael. Mind and body were perfectly coordinated, a divine spirit infusing both agent and actions, passing from artist to art.[12] Thus Leonardo's radiant manner could charm one and all, and dispel melancholy.[13] And thus works like the *Last Supper* inspired 'the utmost veneration', and crowds flocked to see a *Madonna and Child with St Anne*, perhaps experiencing something akin to St Anne's emotions as interpreted by Vasari: joy at seeing something both earthly and divine.[14]

Leonardo's incandescent genius may have been unique, but other *Lives*, especially those of Raphael and Parmigianino, repeat this theme of the artist manifesting a divine grace in his person and in his artistic creations. Heaven gave Raphael, appropriately named after an angel, 'graces and rare gifts', among which were 'virtues of soul, together with such grace, diligence, beauty, modesty, and excellent conduct'.[15] A link is implied between the ability of his figures to communicate religious ideals and the moral radiance of his presence, which spread serenity and concord to those around. God was seen as the implanter of Parmigianino's skills as a painter, the evidence being his supremely graceful face and figure 'more like an angel than a man', complemented by 'the finest manner'.[16] His creations mirrored their creator, in their beautiful 'grace' and 'air'.

All this shows Vasari drawing on different strands in contemporary philosophy as well as hagiographical motifs (the saint whose presence calms troubled spirits and tames animals) and the language of religious devotion (the many associations of the word 'grace').[17] Very important, too, was the tradition of treatises on education, courtly manners and feminine beauty, particularly for the notion that physical beauty should be complemented by 'graces', here meaning polished behaviour.[18] Among their other functions, the *Lives* were meant to serve as conduct manuals for painters who sought not just artistic excellence but fame and worldly success, which often meant success in a courtly environment. To shine in such a setting, the artist needed to complement his good looks with skills such as persuasive speech, elegant dress, charming manners, talented singing or music-making, skills similar to those advocated for Castiglione's ideal courtier, male or female. These revealed the artist's intellectual excellence or his talent for creating audible as well as visible beauty.

As we have seen, Leonardo was presented as this sort of courtly artist, in both Milan and France. Rosso's success as courtier was partly enhanced by his 'handsome presence', 'gracious and grave . . . speech', and talent in music and philosophy.[19] Giulio Romano, too, had 'a handsome face, black and laughing eyes', was 'most amiable, of courtly manners, elegant in his dress and dignified conduct'.[20] Parmigianino, with his graceful looks and manners, and skill in lute-playing, had similar potential. But the outstanding example of a handsome artist with social graces was, of course, Raphael: 'Nature created Raphael to excel not only in art but in manners as well'.[21] Vasari evokes his physical presence to register his progress both in terms of artistic success and of social advance. He was innately pleasing, having 'a humane and gentle nature adorned with a gracious affability', together with, as we have seen, 'grace', 'beauty' and excellent conduct.[22] An early Roman self-portrait is described as showing 'a young man with a very modest bearing,

together with a pleasing, fine grace, wearing a black beret'.[23] Later on, though, he became more majestic and magnificent, sweeping from his house to court together with fifty hangers-on, his lifestyle resembling a lord rather than a painter. He embodied grace and he spread grace, dispelling dissension around him and inspiring love, even from animals.[24]

Yet Vasari was cautious of specifically stating that Raphael was very good-looking: praise for his 'grace' – that usefully ambiguous word – always occurs where moral and behavioural qualities, rather than physique or manual dexterity, are dominant concerns. Through rhetorical sleight-of-hand, the reader is made to feel that Raphael *must* have been handsome, and, even more, to sense the maturing of his youthful grace as he encounters new situations and associates. There is an analogy here with the development of his painting style from the *grazia* of his early manner through the *manier gentile* and *bellissima* of his early Roman years to the later *grandezza e maestà* fostered by intelligent study of Michelangelo and the antique.[25] The beautiful artist, then, might be a phenomenon of nature, like Leonardo, or a self-fashioned artefact wrought with much study. That innate talent was insufficient without such study and self-discipline was implicit even in the life of Leonardo, criticized for his fickleness,[26] and absolutely clear in Parmigianino's biography, which was made to serve as an awful warning against abusing God-given gifts. Instead of devising *belle invenzioni*, his obsession with alchemy led him to neglect his work and to sully himself by associating with its base materials and equipment. In what was literally a fall from grace, this angelic beauty let his hair and beard grow long and unkempt, 'almost like a savage'.[27] Again, the motif of the artist as beauty is skilfully adapted to Vasari's purposes: here, the rhetoric of praise and blame.

The *Life* of Parmigianino can introduce the question of how far Vasari's presentations of different types of artist-beauty were shaped not only by literary or philosophical interests, but by artists' own attempts at self-fashioning, self-representation and even at self-reproduction. His idea of the painter as an angelic youth must partly have been influenced by the Vienna *Self-Portrait in a Convex Mirror* (Figure 8.1), undoubtedly the painting he saw in the collection of Pietro Aretino at Arezzo.[28] Allegedly made by the young provincial painter to take with him to Rome in 1524, it served as a sort of superior calling-card, providing simultaneous evidence of his angelic looks and God-given talent. In the lengthy description of its making, Vasari claimed that Parmigianino successfully reproduced what was originally a chance event, the sight of himself in a barber's mirror, using a panel carved to duplicate its convexity. The 'subtleties of art' he claimed Parmigianino were trying to demonstrate seem to be his skill in reproducing authentically the bizarre distortions caused by the curvature of the mirror and the

different light and shade effects, demonstrating a self-effacing style and not the highly individual *bella maniera* he would later develop.

Yet, meant at first sight to seem a work of nature, not of human art, the painting actually celebrates the grace of the painter's face, 'more like an angel than a man', the skill of his hand – that hand so pointedly brought to the foreground in the panel – and also the ingenuity of his *invenzione*, which transforms wood into a mirror, reflecting not the spectator but the angelic artist. Its seeming artlessness might have masked knowingness in other ways. The conceit of the image of a beautiful youth made by chance could have been intended to remind a cultivated audience of papal courtiers of the claim made by an earlier papal servant, Alberti, that painting was invented by another graceful youth, Narcissus, gazing at his own chance reflection: 'What is painting but the act of embracing by means of art the surface of the pool?'[29] However this might be, Parmigianino would surely have been aware that in the Rome of the 1520s, with its Medici Pope and court steeped in a cultured Neoplatonism, his physical beauty might be taken as a mark of divine favour. He would thus have had every incentive to make his features more idealized, regular and more youthful: he looks considerably younger than his approximately twenty years. He may also have adjusted them towards Raphael's facial types, known to him in the *Sistine Madonna* or the *St Cecilia Altarpiece*, not just as a tribute to the older artist's ideal but as a claim to be his spiritual son. These female prototypes might have enhanced a certain androgyny, both befitting an angel and conforming with a taste for beautiful adolescent figures combining male and female characteristics, associated with the influence of Plato.[30] Far from being an ingenuous copying of an image made by chance, the Vienna *Self-Portrait* could well testify to Parmigianino's knowing utilization of his physical endowments not only to announce his presence, but to legitimize his art.

Earlier in Rome, during the 1510s, various stimuli would have encouraged Raphael to direct his always lively interest in portraiture towards experiments in self-representation. Apart from the self-portrait on linen that Dürer sent him, perhaps suggestive of the face of Christ on Veronica's handkerchief,[31] he would probably have been aware of both Venetian and Leonard-esque types of self-portraiture.[32] As none of these quite promoted the 'artist-as-beauty' ideal, more important would have been personal contacts, notably with Castiglione. These would have fostered Raphael's interest in achieving grace in life as well as in art, in fashioning a 'second nature' to add polish to his first – something, perhaps, like Vasari's 'fine ornament of gracious affability'.[33] It is thus tempting to seek self-portraits from the 1510s which celebrate his artistic and social ascendancy and suggest such a polish, and I would follow those scholars who have seen the painting formerly in Cracow (Figure 8.2) as one such work.[34] Datable on grounds of costume to

about 1512–13, it would have been done at a time when Raphael, approaching thirty, could have combined full maturity with boyish, even androgynous, looks, as shown here. With the Stanza della Segnatura frescoes and the *Galatea* behind him, it appropriately projects not the 'modesty' of dress and demeanour of the youth in the *School of Athens*, but a gentlemanly assurance and gracious ease – Castiglione's *sprezzatura*. Neither face nor hands possess special physical refinement, but the figure emanates 'grace' in that the pose is elegantly relaxed, yet suggests potential power, and the sumptuous costume falls with casual ease. There are analogies both with Vasari's presentation of 'Raphael', supremely graceful though not especially good-looking, and his analysis of the artist's contemporary and allegedly best works, such as the S. Maria della Pace *Sibyls*, which combine almost masculine physiques with gracefully flowing contours and draperies. In the ex-Cracow painting, Raphael could have been presenting himself as the literal embodiment of his aesthetic credo, fashioning himself into a work of art as consciously wrought as his other fictive creations – a work which in its turn could have helped inspire another ideal persona, Vasari's 'Raphael'.

Dürer's self-portraits have been very fully studied,[35] so the Munich *Self-Portrait* needs only a brief mention as a special case of the 'artist as beauty', inasmuch as the painter attempted to approach what Vasari called the 'celestial grace' of Christ. This he did by regularizing his features, and stressing those parts which convey intellect and insight, the forehead and the eyes, as would several later sixteenth-century self-portraits, as will be seen. In the Prado *Self-Portrait* of 1494, Dürer had already pioneered the artist-as-assured-and-graceful-gentleman type, which he repeated in the backgrounds of religious works like the *Feast of the Rose Garlands*. Dürer's most brilliant pupil, Hans Baldung Grien, extended the idea in his *St Sebastian Altarpiece*, positioning his own dandified figure such that artist's head and saint's nude body are read together, the artist-as-gentleman merging, somewhat precariously, with the saint-as-beauty.[36]

If Dürer painted the first extant examples of the artist as beauty, Leonardo may have embodied the type twenty years earlier, but we have no records of self-portraits from the 1470s and 1480s when his good looks would have been at their height. This may be part of the deliberate impersonality and veiling of self that he strove for in his writings and in his art, which connects with his many warnings against unconscious self-portrayal.[37] Such an impersonality may be found, in very different ways, in the two drawings thought to be idealized self-portraits done in old age. The Turin drawing both exaggerates his age, only around sixty if usual datings are correct,[38] and submerges his individuality within a type – the brooding old sage with intellectual forehead and penetrating gaze, which, while looking outwards, does not engage with the spectator.

The Windsor example (Figure 8.3),[39] perhaps a copy of an original, represents more of an aged beauty, with its refined features, elegantly curling hair, dignified calm, and projection of a majestic wisdom akin to images of God the Father rather than Christ. Though moved to self-commemoration at this stage of life, Leonardo seems not to have used self-portraiture to advertise his angelic grace or courtly poise when younger, however much he might have been impelled to incorporate his own features in casual drawings or among the bystanders in crowd scenes.

Moving forward to the 1550s we come to the painter who produced more self-portraits than any other sixteenth-century artist and who constituted a special case of an artist as beauty, being a woman. Sofonisba Anguissola's series of self-portraits through the 1550s and 1560s charts her social ascent from modest, though gently-born, adolescent (Vienna) to court lady (Chantilly).[40] The earlier paintings, intended as gifts to influential persons in the hope of future favours, advertise her precocious and exceptional skill while seemingly conforming to a conventional model of a dutiful, chaste daughter. The images accord physically with the current canon of female beauty, with regular features, smooth, pale flesh, rosy cheeks and lips, and high, shining foreheads. If the Althorp painting or one of its variants includes a self-portrait,[41] it adds ivory hands, musical accomplishments, and an implication of chastity through the presence of the servant as chaperone and the 'correctness' of body language. Yet these are neither ingratiating nor conventionally graceful images: they project determination and pride, and paradoxically use standard features of female beauty – a high forehead and large, lustrous eyes – to convey alert observation and insight. Hands do not dangle in elegant passivity but actively create music or paintings. And by normally giving herself a plain, functional dress, few jewels, and a simple hairstyle the artist has moved towards a somewhat masculine ideal, using near androgyny to empower herself,[42] rather than to claim angelic status in a Parmigianinesque fashion.

Vasari's belief that beauty indicated divine grace did not *necessitate* that a major artist be beautiful: his hero, Michelangelo, was described by him in great detail as far from good-looking.[43] Nonetheless, the association of physical comeliness with interior elevation might have been widespread enough to cause unease among artists who had never been handsome or whose looks had faded over time. Dignity and poise of bearing, tasteful dress and courtly manners could achieve a great deal in the absence of a young or superior physique, and several distinguished older artists appear in the pages of the *Lives*. Signorelli was one, as was Jacopo Sansovino, 'sanissimo e gagliardo' at the age of seventy-eight. Francesco Melzi, too, was 'a handsome and courteous old man'.[44] The Windsor drawing of Leonardo

presents a similar ideal of elderly distinction. In contrast, Parmigianino's failure to grow older gracefully might conceivably have been a cause, as well as a consequence, of his obsession with alchemy, if his firm belief in a pseudo-science holding out the promise of eternal youth was in part a response to the fading of his angelic appearance. Raphael may in a sense have been fortunate to die at the peak of both his physical powers and his good looks.

Apart from Sansovino, the beautiful artists discussed did not generate sons to reproduce their looks and perpetuate their skills. They did, however, adopt protégés or designate heirs to continue their memory or their manner, and to share their grace in life as well as in art. This is a theme worked out most comprehensively by Vasari in relation to Raphael. His precursors Francia and Perugino anticipated his grace of manner or of person, though inadequately, while his pupils Giulio Romano and Perino del Vaga success-fully continued his art and his courtly polish. More generally, Raphael's style served as a model for later generations, so that 'the spirit of Raphael' passed into Parmigianino, in his person as well as his graceful style.[45] Leonardo's artistic legacy, including the self-portrait at Windsor, was preserved by the noble and handsome Melzi, 'a lovely child in Leonardo's time, and much loved by him'.[46] The boy Salai, who entered Leonardo's household in the 1490s, was less than successful as a surrogate son and artistic follower but served adequately as a source of inspiration if, as has been often thought, many of the idealized, curly-haired young males from that period increas-ingly incorporate his features.[47] The drawing of two heads in the Uffizi (Popham, no. 141) may contain an autobiographical element, as an idealized image of Leonardo, exaggeratedly aged, confronting an idealised image of Salai – who might also have resembled Leonardo's earlier, beautiful self.

Michelangelo presents another obvious case of an artist attempting to pass on his skills to a beautiful surrogate son. When Michelangelo said he had 'beauty given me at birth' he clearly did not mean that he was physically handsome, and nor did he compensate for this by cultivating easy social manners or wearing fine clothes.[48] Nonetheless, he was enough of a man of his time to interpret the conjunction of nobility of birth, fine looks, and cultivation of Tommaso dei Cavalieri as, literally, God-given. In giving him drawing lessons, the older man demonstrated his desire to create an artist-as-beauty, if he could not be one himself.[49] Significantly, Cavalieri was to be taught the art of drawing, less physical and messy, and thus more courtly, than that of sculpture: Leonardo had denigrated sculpture, as opposed to painting, in these terms.[50] And, as a rare example where heaven's lofty idea was not distorted by nature's accidents, Cavalieri was thought worthy of being portrayed by Michelangelo, according to Vasari.[51] The finished portrait

is lost, but some of the idealised heads seemingly dating from the time when the relationship between the two men was at its most intense may be connected with it. One that seems clearly related to an actually existing model, in my view a young man not a woman, is the head at Windsor (no. 12764), sometimes seen as a preliminary study for Michelangelo's portrait of Cavalieri, and recently claimed to be by Cavalieri himself.[52] Our concern here, though, need only be with Vasari's testimony that Michelangelo presented Cavalieri in idealized antique dress, contemplating a medal, thus paying homage to one who was both his living source of inspiration and his *creato*, a young man who revived antique beauty in his person, and communicated it through his hand.

In this short overview of Cinquecento instances of the artist as beauty, rooted in Vasari's *Lives*, some of the deeper attendant issues have necessarily been sketchily dealt with. Clearly the promotion of the figure of the beautiful artist was closely connected with the Renaissance search for social advancement through the cultivation of a courtly persona, as well as for a more philosophical and religious justification of artists' roles and of artists' selves. The multiple associations of a term such as 'grace', so skilfully exploited by Vasari, are just one indication of this. Important, too, seem to be issues of gender and engendering. In fashioning their own images in self-portraiture (using the term in its broadest sense), artists used themselves as objects and as muses, becoming 'female' matter as well as 'masculine' form, creations as well as creators. Imaginatively transcending the limitations of age or of sex, they projected themselves as wise old sages, or rejuvenated themselves as angels and androgynes. In transmitting their works or, in all senses of the word, their *maniera* to other graceful *creati*, these childless, sometimes homosexual, men became parents – mothers as well as fathers.

The image of the artist as beauty continued to attract seventeenth-century painters, even if the best-known self-portraitist of that age, Rembrandt, usually showed himself as neither beautiful nor gracious. If it is authentic and a self-portrait, Caravaggio's *Narcissus* (Rome, Galleria Nazionale, Palazzo Corsini),[53] can serve as an appropriate commentary by a very self-reflexive painter on Alberti's metaphor for self-regard as the root of artistic creation. However, it is Van Dyck's *Self-Portrait with a Sunflower* of 1633 (Eaton Hall, Cheshire) that can best take up Alberti's floral metaphor and end this paper. In linking himself with the flower that turns to the sun the courtier-artist may not only be indicating his devotion to his royal master, but also suggesting the Renaissance Neoplatonic idea of artistic inspiration from heaven.[54] Both flower and elegant artist, no longer in his first youth, are manifestations on earth of heavenly beauty, though transient ones, unless made immortal in art.

## Notes

I should like to acknowledge the receipt of a grant from the University of Bristol Faculty of Arts Publications Fund to cover the cost of illustrations.

1. Vasari, *Le Vite* . . ., eds Bettarini and Barocchi (Florence 1966–): IV, 15: 'bellezza, grazia e virtù, in una maniera che, dovunque si volge quel tale, ciascuna sua azzione è tanto divina, che lasciandosi dietro tutti gl'altri uomini, manifestamente si fa conoscere per cosa, come ella è, largita da Dio, e non acquistata per arte umana. Questo lo videro gli uomini in Lionardo da Vinci, nel quale oltra la bellezza del corpo, non lodata mai abastanza, era la grazia più che infinita in qualunque sua azzione . . .'

2. *Vite*: III, 639–40, 'tutto grazioso e pulito', 'dolce', 'piacevole', 'cortese'; 581, 'di persona e d'aspetto tanto ben proporzionato, e nella conversazione e nel parlare tanto dolce e piacevole'.

3. *Ibid.*: 590–1.

4. *Vite*: IV, 15–38; 155–215; 473–91; 531–47; V, 55–82, 105–62; VI, 177–88.

5. *Vite*: IV, 15, 'Grandissimi doni si veggono piovere dagli influssi celesti ne' corpi umani'.

6. *Ibid.*: 26, 'quella bellezza e celeste grazia che dovette esser quella de la Divinità incarnata'. See also *Vite*: IV, 175 (life of Raphael) for another explicit linking of physical beauty and divinity.

7. Marsilio Ficino, *Commentarium in Convivium Platonis de Amore*, ed. and trans. Rensi (1992): orazione seconda, ch. I–III, 29–34, orazione quinta, ch. I–VI, 89–90. For Neoplatonic influences on Vasari's book, see most recently Rubin (1995), especially 31, 279, 372ff.

8. In passages in the 'Paragone' Leonardo insists on the power of the painter to create like God, especially in the *Trattato*, 13, ed. Richter, (1939): I, para. 19, and also *Trattato* 12, 19 (Richter: I, paras 13, 23).

9. Paolo Giovio, 'Leonardo Vincii Vita', in Barocchi (1971): I, 7–9. For Giovio's connections with literary and artistic circles and with Vasari see Price Zimmerman (1976): 406–24.

10. Quoted in Koerner (1993): 143.

11. *Vite*: IV, 16, 'canto divinamente all'improviso', and 17, 'era tanta piacevole nella conversazione che tirava a se gl'animi della gente'.

12. *Ibid.*: 15–18, especially in phrases like 'un intelletto tanto divino e maraviglioso' and 'era in quella ingegno infusa tanta grazia da Dio col disegno delle mani sapeva si bene esprimere il suo concetto'.

13. *Ibid.*: 37, 'egli con le splendor dell'aria sua, che bellissima era, raserena ogni animo mesto'.

14. *Ibid.*: 25, 29–30.

15. *Ibid.*: 155–6, 'grazie e più rari doni', 'virtù dell'animo, accompagnate da tanta grazia, studio, bellezza, modestia et ottimo costumi'.

16. *Ibid.*: 535, 'Francesco era di bellissima aria et aveva il volto e l'aspetto grazioso molto e più tosto d'angelo che d'uomo'.

17. See Goldstein (1991): 646–7 for the influence of saints' lives on the *Vite*.

18. For the Vasari's notion of *grazia* as in part influenced by Castiglione, see, as well as Rubin (1995): 52, 302, 376, Blunt (1962): 93–8. For Castiglione's own ideal of *grazia*, see Saccone (1983): 45–68, and on 'grace' or 'graces' advocated for women in the Renaissance, Kelso (1956): 197–200.

19. *Vite*: IV, 473–4, 'di bellissima presenza; il modo del parlar suo era molto grazioso e grave; era bonissimo musico, et aveva ottimi termini di filosofia . . .'.

20. *Vite*: V, 82, 'di bella faccia, con occhio nero et allegro, amorevolissimo, costumato in tutte le sue azzioni . . . e vagi di vestire e vivere onoramente'.

21. *Vite*: IV, 155, 'la natura . . . volle in Raffaello esser vinta dall'arte e dai costume insieme'.

22. *Ibid.*: 155, 'una certa umanità di natura gentile aggiunto un ornamento bellissimo d'una graziata affabilità'.

23. *Ibid.*: 167, 'una testa giovane e d'aspetto molto modesto, acompagnato da una piacevole a buona grazia, con la berretta nera in capo'.

24. *Ibid.*: 210–12.

25. *Ibid.*: 160, 175, as exemplified by the Stanza della Segnatura (166–73) and the Pace *Sibyls* (176–7 and 207).

26. *Ibid.*: 16, where Leonardo is described as 'tanto vario et instabile'.

27. *Ibid.*: 543–5 for the alchemy passages, and his degeneration to being 'quasi un'uomo salvatico'.

28. *Ibid.*: 535–6 for the *Self-Portrait*.

29. *De pictura*: II, 26, 'Quid est enim aliud pingere arte superficiem illam fonti amplecti?', L.B. Alberti, ed. and trans. Grayson (1972): 62–3.

30. See Chastel (1959): 289–98.

31. See Koerner (1993): 95–6 for Dürer's gift to Raphael, which he dates around 1515; and Vasari, *Vite*: IV, 189–90.

32. Through Sebastiano del Piombo he might have been aware of Giorgione's *Self-Portrait as David* and Titian's Doria Gallery *Salome*, where the Baptist's head has been thought a self-portrait (e.g. by Panofsky (1969): 42–7). The self-portrait head by Leonardo in Turin could have been done around the time of the artist's stay in Rome, 1513–16: see below, n.38.

33. See n.22 above.

34. For the ex-Cracow portrait, see Jones and Penny (1983): 171 and plate 180, and Walek (1991). Arguments for its being a self-portrait are based on various seventeenth-century traditions, and on the figure's resemblance to other, better substantiated, self-portraits by Raphael.

35. See Panofsky (1971): 43, as well as Koerner, (1993).

36. For a colour illustration of the painting, now in the Germanisches Nationalmuseum, Nuremberg, see the catalogue of the exhibition *Gothic and Renaissance Art in Nuremberg*, ed. O'Neill and Schultz (1986): 373 and no. 178.

37. Kemp (1976).

38. Turin, Royal Library. It has been dated to 1512–15 by Heydenreich (1954): plate 1, iii and to c.1512 by Popham (1971): no. 154, and Clark (1973): 158–9, who finds it 'remarkably unrevealing'.

39. See most recently Clayton (1996): no. 100.

40. See Buffo (1994): no. 2 and pl. 5; also nos 6, 7, 9, 16, 20.

41. *Ibid.*: pl. 3 and no. 14.

42. See Garrard (1994), especially 580–8, and King (1995), especially 386–91.

43. *Vite*: VI, 121–2.

44. *Vite*: III, 639; VI, 178; IV, 28.

45. Vasari presents this as a matter both of natural affinity, and Parmigianino's conscious striving: 'Lo spirito del qual Raffaello si diceva poi esser passato nel corpo di Francesco, per vedersi quel giovane nell'arte raro e ne' costumi gentile e grazioso come fu Raffaello, e che è più, sentendosi quanto egli s'ingegnava d'immitarle in tutte le cosa, ma sopra tutto nella pittura'; *Vite*: IV, 536.

46. *Vite*: IV, 28, 'che nel tempo di Lionardo era bellissimo fanciullo e molto amato da lui'.

47. For instance, the heads of a youth in the Windsor Royal Library, nos 12557 and 12554 (Popham, (1971): nos 143 and 147); for comments on these and on other related works, see *ibid.*: 39–41; Clark (1973), 58, 71; and Gombrich (1976): 64–5.

48. See Summers (1981): 215ff, and *Vite*: VI, 109ff for Michelangelo's way of life and love of solitude.

49. *Ibid.*: 109–10 for the drawing lessons, an episode recently discussed most fully, with controversial conclusions as to attributions, by Perrig (1991): 75ff.

50. Richter (1939): I, 91, para. 37.

51. *Vite*: VI, 110.

52. Perrig (1991): *loc. cit.*, and as fig. 64. See also Popham and Wilde (1949): no. 434 and fig. 24, as *Head of a Young Woman*.

53. For a summary of critical opinions on the work, see Hibbard (1983): pl. 186, 334.

54. Wark (1956): 52–4; Bruyn and Emmers (1957): 96–7; Brown (1982): 147–9.

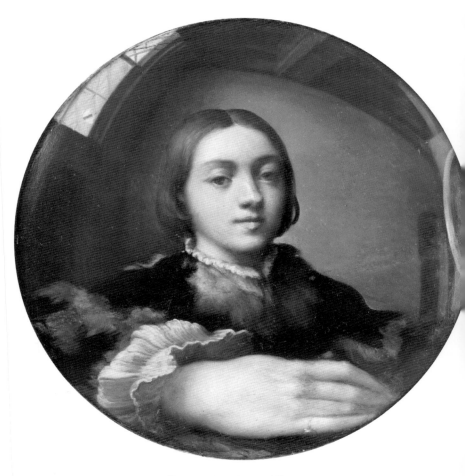

8.1   Francesco Parmigianino, *Self-portrait in a Convex Mirror*

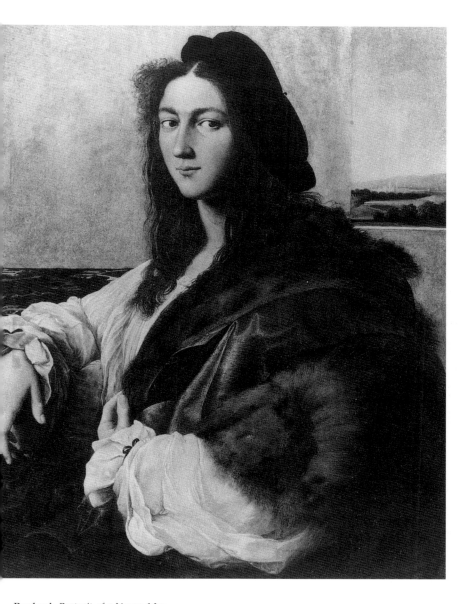

Raphael, *Portrait of a Young Man*

8.3   Copy after Leonardo da Vinci, *Portrait of Leonardo da Vinci*

# 'La più bella e meglio lavorata opera': beauty and good design in Italian Renaissance architecture[1]

*Georgia Clarke*

The issues of beauty and of good design in relation to architecture in Italy in the late fifteenth and early sixteenth century are, of course, both central and of great importance. This paper will highlight various aspects of this topic by examining examples of Renaissance comments and drawings which touch on it. The examples chosen reveal a critical response to architecture by architects and others. This response was often heavily conditioned by ideas about classical architecture, and was based on both built architecture and architectural theory, in particular Vitruvius and Alberti. It was also strongly linked to views on contemporary architecture and good design.

The fundamental components of good design had been delineated by Vitruvius in the famous triad of *firmitas*, *utilitas* and *venustas* (strength/ endurance, utility and beauty).[2] Here beauty was defined as 'when the appearance of the work is pleasing and elegant, and when its members are in due proportion according to correct principles of symmetry'.[3] These ideas were reflected by Alberti in the mid-fifteenth century in his observation that the ancient Italians 'found that grace of form could never be separated or divorced from function and suitability for use'.[4] Alberti took up the triad in stating that 'what we construct should be appropriate to its use, lasting in structure, and graceful and pleasing in appearance'.[5] Alberti's definition of beauty used the term *concinnitas* to express a harmonious proportioning and relationship of individual parts to create an integrated whole.[6] *Concinnitas* can be connected to the Vitruvian idea of *symmetria*, which means a 'commensurability of parts' rather than biaxial symmetry. This concept had also appeared in medieval accounts as *congruentia*.[7]

It is a commonplace that proportion played a central role for Renaissance architects, but just as important, and set in relation to proportion, was 'beauty'. In the early sixteenth-century translation of Vitruvius made by Fabio Calvo for Raphael, the term beauty in the Vitruvian text was expanded

to give equal weight to *gratia*, or elegance.[8] This underlines its position within a Renaissance conception of architecture and design, as Alberti had also emphasized.[9]

Vitruvius and Renaissance texts stressed the importance of durable construction, of well-ordered designs that resulted in convenient and appropriately organized structures, and of a concept of beauty that depended on proportioned members set in relation to one another. Another concept, that of decorum, oversaw these essentials. In an architectural context this was used in the sense of what was right or appropriate to the function and status of a particular building.[10] One early sixteenth-century Vitruvius translation identified it as 'appropriate ornament'.[11] Calvo again includes beauty and elegance in his translation of Vitruvius' passage on decorum, and an annotation to his translation, possibly by Raphael, emphasizes this connection: 'Decorum, beauty and elegance, with which components one persuades in architectural design'.[12] Both decorum and beauty were compromised when architectural elements were used incongruously.[13]

However, these ideas were expressed not only in relation to classical or classicizing architecture.[14] They had appeared in the opinions given c.1487–90 by Leonardo, Bramante and Francesco di Giorgio on the design of the crossing tower, or *tiburio*, of Milan's Gothic cathedral.[15] They argued that it should be built in a Gothic style so that it fitted with the rest of the cathedral. Bramante expressed this most clearly when he stated, in part basing himself on the Vitruvian triad, that 'four characteristics should be taken into consideration, of which the first is strength, the second consistency with the rest of the building, the third, lightness, and the fourth and last, beauty'.[16] That the cathedral, which continued to be built in Gothic style, was admired by non-Milanese well after this period is shown by Andrea Minucci's comment of 1549 that it was made 'in a beautiful manner'.[17]

In contrast to the Milan *tiburio* example of a fitting design being created out of conformity to a style, Pius II in the 1460s had seen no incongruity in having the cathedral in Pienza built with a classicizing main façade and Gothic side elevations and apse.[18] It can be argued that this was a deliberate choice based on his desire for the benefits of a Northern European church design, particularly the effects of light made possible by large, Gothic windows, combined with a suitably dignified façade that drew on the qualities of mass to be found in ancient Roman architecture.[19] His own description of work done at Pienza shows an awareness of Vitruvius and of the concept of appropriate conformity, but this did not necessarily have to be translated into completely classicized buildings.[20] Similarly Cesare Cesariano in his 1521 edition of Vitruvius used local, Milanese buildings, including the Gothic cathedral, to illustrate Vitruvius' ideas.[21]

By the sixteenth century, though, the importance of avoiding jarring stylistic changes in a building had become a guiding principle in the project to construct a façade for S. Petronio in Bologna.[22] There are four surviving drawings made by Peruzzi between 1521 and 1523, of different designs in Gothic style.[23] While Burns has suggested that Peruzzi articulated the façade 'by a classically proportioned order', Peruzzi did not attempt to impose a complete classical solution onto the Gothic church, unlike Palladio fifty years later.[24] Panofsky stated that 'it is hardly to be doubted that Peruzzi's sympathy belonged with his two classical plans rather than to his single "Gothic" one', but it might be argued that such a view attempts to fit early sixteenth-century architects into the straitjacket of Vasarian conformity.[25] However, it was not only architects or those swayed by *campanilismo* (as it might be argued was the case at S. Petronio) who might consider visual harmony more important than building in an 'up-to-date' style. In 1529 the Emperor Charles V expressed concern about the new construction at the Cathedral of Granada in 'modern' or 'Roman' style because it would 'prejudice' the Gothic Capilla Real.[26]

Recently, Tessari has suggested that Peruzzi's interpretation of Gothic architecture in the S. Petronio drawings reveals that he believed that there were in fact elements of continuity between ancient and Gothic styles.[27] There are no condemnatory remarks about Gothic structures among Peruzzi's surviving drawings. His comment on his own drawing of 'modernaccia' (nasty modern style) against one of two proposals for a church portal does not contrast a classical with a Gothic design, rather it criticizes the undermining of the integrity of the piers' articulation by narrative panels in the 'modern' design as opposed to the more architectural solution provided by the use of columns and pilasters in the 'classical' design.[28]

An appreciation of architecture that did not rely solely on the stylistic categories of 'Gothic' and 'classical' can be found in Renaissance accounts,[29] although there is also criticism of architecture on the grounds of style.[30] For example, Antonio de Beatis, accompanying Cardinal Luigi d'Aragona to France in 1517, kept a diary of the journey.[31] In this, as Chastel has pointed out, he never attacked the Gothic structures that he saw as 'barbarous or irregular'.[32] Instead, de Beatis praised or criticized particular buildings and elements in a way that cannot be connected with a straightforwardly Gothic or classical sensibility. A similar attitude, based on awareness of Italian architecture but showing an openness to a range of buildings, can be found in the contemporary diary of an anonymous Milanese.[33] The two French châteaux of Gaillon and Le Verger were praised by these men and others, including Francesco Gonzaga's envoy Jacopo Probo d'Atri, as the most beautiful things that they had ever seen.[34] Yet these buildings retained plenty of 'Gothic' ornament.[35] Ornamentation might or might not be liked, but here

and elsewhere it was often the underlying forms that were criticized or praised, in particular the proportioning of spaces, convenient and ordered plans, and sometimes the relationships of elements to one another.[36]

Therefore, it can be argued that in this period beauty was not necessarily linked to a particular architectural style, that of classicizing architecture. Although by the beginning of the sixteenth century Vitruvius was gaining an increasingly important position in the study of ancient architecture and as a resource for contemporary design, there was still debate about how and on what terms even classical architecture should be judged. Vitruvius was not always seen as the ultimate arbiter. Peruzzi, according to Cellini, 'said many times . . . that Vitruvius had not chosen from the beautiful styles [of ancient architecture] the most beautiful'.[37] That a contemporary indicated that Peruzzi distinguished differences within classical architecture suggests a subtle understanding of ancient architecture and of style on the part of some Renaissance architects and commentators.[38]

Peruzzi's sensitivity to issues of design, his position within the group of architects who in many ways defined Italian Renaissance architecture in the early years of the sixteenth century, and the survival of large numbers of his drawings makes him an illuminating guide in the search for beauty and good design. The annotations on a few of his drawings show this to have been one of his concerns. His contemporary, and sometimes companion in the exploration of Roman antiquities, Antonio da Sangallo the Younger, also annotated drawings and included an occasional aesthetic comment. His buildings show a clear relationship to these researches.

In a number of surviving drawings of Roman antiquities Peruzzi reveals his views through his approach to the remains and by written comments. On UA 631r (Figure 9.1) he draws parts of the Temple of Castor and Pollux in the Forum in Rome.[39] He defines and delineates particular details of the temple such as mouldings, or the fluting of the column, and via measurements expresses the relationship of one part of the building to another. A prominent element of the temple and the drawing is the detail of part of the capital, which was unusual for its decorated abacus and interlinked central volutes. To the drawing Peruzzi adds the comment: 'this is the most beautiful and best-worked piece in Rome'.[40] I think, from the placing of the comment, the arrangement of the drawing and the other elements which are drawn and commented on, that Peruzzi's view connects to various aspects of the temple. The carefully measured parts and their connections to one another suggest the importance of relative relationships, and therefore of *eurythmia* or *concinnitas*, ideas which were also connected to beauty.[41] This is reinforced by a note by the cornice about the lion's head water-spouts: 'for every two coffers [is] a lion's head'.[42] This careful and regular arrangement which highlights the ordered placement of detailing brings to mind the

decorative lions' heads on the cornice of the lower entablature of Peruzzi's Palazzo Massimo alle Colonne, which serve to bind the cornice via vertical accents to the windows in the storey above.[43]

In UA 631r the concentration on the fine sculpting of the intricate capital suggests not only sophisticated design but also a high quality of craftsmanship, a feature which Peruzzi underlines by reference to the work as 'lavorata'. This has the sense of 'designed' and 'worked', which needs to be seen as part of its impact. For example, Antonio da Sangallo the Younger refers to the 'bene lavorato' brickwork of the Tomb of Annia Regilla.[44] This expresses an interest in the technical methods and achievements of past builders also apparent in Giuliano da Sangallo's drawings, and in contemporary buildings, such as work by Raphael and Antonio himself.[45] The use of the word *lavorato* in these contexts suggests that material is enhanced through human intervention and skill, and thus *lavorato* is comparable to the term *artificio*.[46] These terms represent the manifestation of *ingegno*, or skill.[47] Such ideas are to be found in both the private annotations of architects, and also in works that were intended for a less technical and, often, a wider audience. The former papal secretary Paolo Cortesi, in his account of cardinals' palaces published in 1510, argued that a house was rendered 'more elegant through skill than sumptuous through abundant use of marble'.[48] The humanist writer Giovanni Pontano had stated that the dignity of a building depended on its ornament, size, use of outstanding material, and permanence, and stated that nothing could be praised if it had been done without skill.[49] Nevertheless some also warned that there was a danger in relying too much on *ingegno* and a desire for novelty.[50]

The stress on the working of material and craftsmanship is prominent in another of Peruzzi's drawings, UA 633r (Figure 9.2). Here, below a detailed drawing of a marble Pegasus capital inside the Temple of Mars Ultor in the Forum of Augustus, Peruzzi writes: '. . . it was among the well-worked pieces that there were in Rome'.[51] Like the Temple of Castor capital the Temple of Mars Ultor capital is of unusual design and of high quality workmanship. Not only Peruzzi's judgement but also his terminology were passed on to a wider audience through the work of Serlio. In Book III of his architectural treatise, published in 1540, Serlio described this capital as 'very well worked', having included a detailed woodcut in Book IV in 1537.[52]

The quality of material used in a building might also be significant, as it had been in medieval aesthetics.[53] Pontano, when considering the *magnificentia* of palaces, stressed the importance of using expensive materials to match the prestige of the occupant.[54] The deployment of materials was thus connected to appropriateness: a case of decorum. It can be argued that in Peruzzi's drawing of the Pegasus capital the quality of the material had a part to play in the perception of its beauty.

These positive comments on the beauty of ancient architecture can be contrasted with a negative judgement by Peruzzi on the articulation of the ancient 'Nicchione' at Todi as 'Corinthian most barbarous work' (Figure 9.3).[55] Tessari has argued that in this comment Peruzzi objected to the insertion of Corinthian capitals in a Doric structure.[56] I think that Peruzzi was commenting on the rough and ill-proportioned nature of the capitals that act as imposts to the arches of the niches. He may also have been objecting to the fact that the capitals are on the same level as the architrave, or string course, which articulates the niches and wall rather than support-ing it, thus destroying the grammatical logic of these particular architectural members.[57] The comment does not suggest that he was concerned with a supposedly 'correct' hierarchy of the orders, which would have placed the Corinthian above the Doric order whose frieze runs along above the niches, since he does not mention the Doric order or state that this combination was 'barbarous', but rather draws attention to the quality of the Corinthian elements. This is not to say that Tessari's interpretation is necessarily erroneous, but a rigid application of Vitruvian ideas on the hierarchy of the orders was not where Peruzzi's interests lay.[58] In at least one of his own designs Peruzzi 'mixed' elements from the architectural orders, as Serlio pointed out, unsure as to whether this was Peruzzi's invention or something that he had seen in an obscure and otherwise unknown antiquity.[59]

These particular drawings serve as examples of the interests and concerns of Peruzzi in relation not only to his study of ancient remains but also to what he identified in them as *bella*; in particular, ingenuity, careful design, and high quality workmanship. These are distinct aspects, as Antonio da Sangallo the Younger also shows in comments on some of his drawings. Sangallo noted that an unusual or interesting overall design might be worth recording, but would criticize the low quality of execution of architectural or sculptural members.[60] The components of a building were thus differ-entiated, and it is clear that the best works were those that combined both good design and execution. In his own projects Peruzzi goes on to express more overtly other aspects of architectural design which appear, in his view, to be concomitant with beauty. For Peruzzi *firmitas*, *utilitas* and *venustas* are each a necessary link in the chain of good design.

In Peruzzi's series of six surviving designs for a dam, probably on the River Bruna near Siena, beauty still had a role in a context in which endurance and utility were the primary concerns.[61] Peruzzi annotated these drawings quite extensively, explaining their construction and how they would function, and also commenting on the relative merits of the different designs. The most frequent comment is on the strength of the proposed structure, for example on UA 585r 'this way is the strongest of all the other designs'.[62] Peruzzi is not concerned just with the solidity, and therefore

survival, of the dam, or with its purpose of raising and containing the water level, but also in its appearance: thus UA 584r states that 'This way is very strong and beautiful to look at and increases the size of the lake ...'.[63]

The role of beauty in judging the relative merits of a design appears in Peruzzi's comments on two alternative proposals for a courtyard portico in the pre-existing Palazzo Lambertini in Bologna. Peruzzi's justification for recommending the plan which has piers, presumably to support arches, was that 'according to the custom of the good ancients' columns should not support arches and cross vaults together (Figure 9.4).[64] In this he was following the precepts of Alberti.[65] However, in the limited space available in this location Peruzzi considered that piers were too bulky, even though he also provided a variant plan with narrower piers and wider intercolumniations.[66] Another plan, UA 352r (Figure 9.5), has columns instead of piers articulating the portico, but these were intended to support a flat entablature rather than arches.[67] Peruzzi stated that this proposal 'is more suitable for light and beauty', but the most important criterion was that this solution 'is closer to the manner and usage of the good ancients'.[68]

The specific reasons given in the note on UA 352r about this solution show that the 'good design' element of this choice is not just one related to architectural style. The relative slimness of the columns and wider intercolumniations allow more light into the rooms beyond the portico, which is important as the courtyard appears to be their only light source.[69] The drawback in the four-column portico solution is, he writes, that two men could not pass together through the narrow intercolumniations, and he therefore created a slightly larger central opening.[70] The mention of people passing through a colonnade together and the recommendation of a wider central opening recalls Vitruvius' account of the intercolumniations of temple colonnades.[71] Some arrangements of column spacings were too narrow to allow 'matrons ... [to] pass through the intercolumniations with their arms about one another', but the Eustyle system had a wider central intercolumniation which solved this problem.[72] Significantly, Vitruvius identified this arrangement as 'developed with a view to convenience, beauty, and strength'.[73] Peruzzi's comment and solution for the Palazzo Lambertini suggest that this Vitruvian idea may also have been at work in his design of the façade portico of the Palazzo Massimo alle Colonne in Rome where the central opening leading to the entrance door is wider than those on each side.[74]

Peruzzi also pointed out that the four-column solution for the Palazzo Lambertini portico was better since it aligned the intercolumniations with the entrances to the stairs.[75] This correspondence of elements within a design was something that Francesco di Giorgio had considered an essential aspect: 'one of the most excellent elements that a building can have is the agreement

and concordance of each thing'.[76] Precisely the same ideas are to be found in Francesco di Giorgio's and Antonio da Sangallo's corrective responses to the Pantheon in Rome.[77] In particular Sangallo objected to the placing of columns directly in front of niches in the portico, and to the lack of exact correspondence there between columns and echoing pilasters. In the interior he imposed a system of precise vertical relationships between columns, pilasters, aedicules and vault coffering, and thus the vertical alignment of solids above or below voids was avoided.[78]

Sangallo did not justify his corrections by reference to other ancient architectural models as Peruzzi did for the Palazzo Lambertini, but both architects' responses arose out of a profound exploration of ancient buildings connected with a search for satisfactory solutions to contemporary design problems.[79] Peruzzi's proposal of columns supporting a flat entablature for the Lambertini courtyard portico can be seen as an example of bringing to bear criteria about architectural design that relate to 'beauty', to the model of Antiquity, and to a neat and ordered solution to space and articulation using classical architectural orders. All of these are intimately linked rather than being separately applied categories.

Pius II in his commentaries of the 1460s, Cortesi in the early sixteenth century and Vasari in mid-century were among those who praised commodity and utility in design.[80] While they recognized that these reflected the skill and ingenuity of the designer, they often linked such features to beauty. Antonio da Sangallo the Younger's early palace for Melchiore Baldassini, built c.1514/18, stands out as an example of this combination.[81] It is a compact and sophisticated *all'antica* structure in which the order and intelligent simplicity of its proportions and architectural detailing harmonize with the rational arrangement of the plan. It thereby fulfils the Vitruvian triad implicitly. An appreciation of it, in which beauty is clearly connected with quality of design, planning and craftsmanship, is to be found in the description by its tenant, Cardinal Pietro Bembo, in 1544. He stated that it was small, but despite its size it was 'the most beautiful and well-made [palace] in all Rome'.[82]

## Notes

My thanks to Deborah Howard and Joanna Saurin for apposite comments on this paper.

1.   The quotation comes from Baldassare Peruzzi, Gabinetto degli Uffizi, Florence, Disegni di architettura (hereafter UA): 478v.

2.   Vitruvius (1981): I, 3, 2.

3.   Vitruvius (1960): 17; Vitruvius (1981): I, 3, 2: 'venustatis vero, cum fuerit operis species grata et elegans membrorumque commensus iustas habeat symmetriarum ratiocinationes'.

4.   Alberti, eds Rykwert et al. (1988): 158; Alberti, ed. Orlandi (1966): II, 455, 6.3: 'et gratiam formae proinde putabat ab expetita usus commoditate nusquam exclusam aut seiunctam inveniri'.

5. Alberti (1988): 155; Alberti, ed. Orlandi: II, 445: 'uti essent quidem quae adstrueremus ad usum apta, ad perpetuitatem firmissima, ad gratiam et amoenitatem paratissima'. Krautheimer (1971) argued that the very structure of *De re aedificatoria* was built on the Vitruvian triad.

6. Alberti (1988): 420, 421–2; Tavernor (1994): 311–13.

7. On *symmetria*, Weil-Garris and D'Amico (1980): 102 n.28; on *congruentia*, Eco (1986): 28–42, Tavernor (1994): 311 argued that *concinnitas* was not the same as Vitruvian *symmetria*, considering that the latter was formulated on the basis of modular repetition, but I think that the Vitruvian term was broader than that.

8. Fontana and Morachiello (1975): 83 (Vitruvius (1981): I, 3, 2: 'se habbi rispecto e considerazione . . . alla venustà e belleza et alla gratia . . .'. *Belleza* and *gratia* are additions to the text at this point, although later in the passage Vitruvius explained *venustas* more fully. This passage was annotated, perhaps by Raphael, in this translation made for Raphael by Fabio Calvo between 1511 and 1520: 'Quante cose se de[ve] haver rispecto in [or]dinare l'edificii [con] utilitate e beleza'.

9. On Alberti and beauty, e.g. Bialostocki (1964): 13–19; Smith (1992): 46, 80–97.

10. Onians (1988): 36–7, 151, and passim.

11. Vatican Library, Rome, Ms. Ottoboniensis 1653, f.4r, 'Il decoro cioe ornamento conveniente'. This translation has been variously dated in the first two decades of the sixteenth century and is thought to have been produced either in Rome or in a Tuscan context; Clarke (1992): 87.

12. Fontana and Morachiello: 79: 'El decoro, beleza e gratia, con quali parti se induce nell'architettura'.

13. Vitruvius (1981): I, 2, 6; Fontana and Morachiello: 80: again Calvo adds 'bellezza' to the text where Vitruvius only has 'decore', while Caporali (1536): 21r translates 'decore' as 'specie di conveniente bellezza'.

14. Bruschi (1978): 324–5.

15. *Ibid*: 321–86; Panofsky (1955): 192–3.

16. Bruschi (1978): 367: 'quattro cose vi bisogneno, de la quale la prima si è la forteza, la seconda conformità cum el resto de l'edificio, la terza legiereza, la quarta et ultima belleza'. Translation by Schofield (1989): 72. Panofsky (1955): 190–1 connected the idea of 'conformità' to Alberti.

17. Bernardi (1862): 69: 'con bella maniera'. Minucci was born in Serravalle in the north-eastern Veneto, and Panofsky would probably have argued that his artistic sensibilities were influenced by his North Italian origins, see Panofsky (1955): 195; but see below for central Italian comments on Gothic buildings.

18. On Pienza see, for example, Mack (1987).

19. Pius II (1984): II, 551, 552: 'iusserat qui exemplar apud Germanos in Austria vidisset, venustius ea res et luminosius templum reddit'. An example of his early appreciation of this can be seen in his praise of St Giles, Edinburgh, which he saw in 1435, Pius II (1984): I, 48 (my thanks to Deborah Howard for identifying this church for me). For his knowledge of ancient Roman architecture see, for example, Pius' explorations at Tivoli and in the Roman campagna, Pius II (1984): I, 346; II, 693–711.

20. In Mantua in 1459 Pius asked to borrow a copy of Vitruvius, for which Lodovico Gonzaga wrote to Alberti; Borsi (1973): 142. Pius' description of Pienza in the *Commentarii* has various allusions to Vitruvius, e.g. the use of terms such as *simmetrie*, and reference to the idea of *decorum* in his statement about the use of the 'most appropriate' capitals and bases for the palace; Pius II (1984): II, 547.

21. Cesariano (1521): 14r–15v.

22. On the debate that continued into the seventeenth century, see, for example, Panofsky (1957): 196–205; Bernheimer (1954): 263–84; Wittkower (1974): 65–81 (who only identified three drawings); Simoncini (1992): 18ff.; and the recent bibliography in Tessari (1995): 87 n. 86.

23. Bologna, Museo di S. Petronio, 1, 2, 3a, British Museum, London, 1898-3-28-1, Wurm (1984): 127–9, 131.

24. Quotation from H. Burns, in Burns, Boucher and Fairbairn (1975): 241; Palladio designs, 242–4.

25. Panofsky (1955): 198 and n.64. Panofsky identifies Bologna, Museo di S. Petronio, 1 as 'modern', presumably he means *all'antica* and is basing himself on the use of columns to articulate the

façade (although their capital forms are not clear), and two designs as 'Gothic', Bologna, Museo di S. Petronio, 2 (broad piers articulating the façade) and 3a (pilasters articulating the façade, some of which might, in fact, be said to have classical capitals). However, in all of the designs there is a considerable amount of 'Gothic' ornamentation, and splitting them into 'modern' and 'Gothic' is somewhat arbitrary. Panofsky in this essay takes a strongly anti-Gothic stance, arguing that Central Italian architects, in ' "Italy proper" ', from the early fifteenth century onwards conformed to a coherent 'Renaissance' viewpoint that saw 'Gothic' architecture as 'alien and contemptible'. For recent challenges to these views see Trachtenberg (1991): 22–37, especially 33ff. Simoncini ed. (1992): passim; Smith (1992): 58–69.

26. Rosenthal (1961): 18 and doc. 36: '. . . su magestá en que manda que el edificio desta santa iglesia no se haga a lo romano por el perjuyzio de la Capilla Real . . .'.

27. Tessari: 57–9; Simoncini: 20, argues that Peruzzi used a medieval method for composing the façade.

28. British Museum, London, 1848-11-25-12r; Wurm: 159: 'Modernaccia p[er] accomodare le storie'. Designs identified as for the Chapel of S. Giovanni in Siena cathedral.

29. E.g. in 1480 the Florentine Giovanni Ridolfi admired both S. Antonio in Padua and S. Marco and its mosaics in Venice, while a second account from the early sixteenth century, also attributed to Ridolfi, shows that he seemed to prefer the Gothic churches of Venice, SS. Giovanni e Paolo and the Frari, because they were like the Florentine S. Maria Novella and S. Croce: '. . . simigliare le nostre sono . . . piu intese'. Jones (1988): 278, 279–80.

30. E.g. the Neapolitan Pietro Summonte writing to the Venetian Marcantonio Michiel in 1524 described the fifteenth-century work at the Castelnuovo in Naples as not having followed any other design than 'barbarico', and criticized the fact that S. Paolo had been built 'in uso barbarico di opere francese e tedesche' around the remains of the ancient temple of Castor and Pollux; Pane (1975): 69, 70.

31. de Beatis (1905).

32. Chastel (1986): 130–3.

33. Monga (1985): 69, 57, 98. For example, he praised the medieval cathedrals of Amiens and Arras, rating them above Nôtre-Dame in Paris. He considered the early sixteenth-century bell-tower of St Cyr in Nevers to be more beautiful than the Florence campanile. At Blois he preferred the wing built by François I, but it was not necessarily the use of classical ornamentation that he admired, so much as the greater splendour and richness in comparison with the earlier wings.

34. Weiss (1953); Monga: 64–5, 106; Chastel (1986): 90–6.

35. E.g. Weiss: 4–10; Monga: 64–5.

36. E.g. Jacopo Probo d'Atri on Gaillon: 'ben proportionata camera', 'alla quale la grandeza con l'alteza ben corresponde', Weiss (1953): 9, 8, 6. Examples of the criticism of proportions: Ridolfi said that S. Francesco in Milan was 'con pocha proportione', Jones (1988): 268; the Anonymous Milanese stated that English churches were too long and narrow and 'senza proportione', Monga: 84; de Beatis thought the same of Angers cathedral: 'è assai grande ma non bella, per essere in modo de una cappella longa et strecta, senza ale alcune da le bande', de Beatis: 141; Giovanni Battista Gambara, Mantuan envoy, saw Fontainebleau in December 1539 and wrote: 'non mi pare vederli cosa che non habia visto di più belle a Mantova', but disliked the famous Gallery for both its proportions and its paintings: 'una galeria, lunga assai ma troppo stretta, et é dipinta di picture molto brutte . . .', Hamilton Smith (1991): 45; Benvenuto Cellini's criticism of the Porte Dorée, Fontainebleau as 'grande et naine' and thus expressive of the 'mala maniera franciosa', quoted in Hamilton Smith: 45; an early sixteenth-century Florentine account, perhaps also by Ridolfi, thought the exteriors of Venetian palaces beautiful with their marble columns and inlaid stone, but said that the interiors were 'male intese', Jones (1988): 279–80.

37. Cellini (1980): 818: 'molte volte disse . . . che Vitruvio non aveva scelto di queste belle maniere [delle cose antiche] la più bella . . .'.

38. E.g. Cortesi, in Weil-Garris and D'Amico: 76; Raphael's letter to Leo X makes distinctions between different periods and styles of architecture, but does not pick up on changes within Roman architecture, e.g.: 'al tempo degli ultimi imperatori . . . l'architectura . . . edificavasi con la medesima maniera che prima', Golzio (1936): 85–7.

39. Wurm: 458–9. This was on a sheet (UA 631r and UA 478v) which also showed the layout of the three temples relative to the Theatre of Marcellus in the Forum Boarium, and a reconstruction,

with details, of the Temple of Antoninus and Faustina in the Forum Romanum. The Temple of Castor and Pollux was identified here by its popular name of 'tre colonne'. Burns has dated this drawing and UA 633 to between April 1531 and 1535; Burns (1965–66): 246 n.7.

40. 'questa è la più bella e meglio lavorata op[er]a di Roma'.

41. Vitruvius (1981): I, 2, 3: 'Eurythmia est venusta species commodusque'; Vitruvius (1960): 14, 'Eurythmy is beauty and fitness in the adjustments of the members'. E.g. Ms.Ottob. 1653, 4r: 'La eurythmia e uno gratioso aspecto nella compositione de membri'; Fontana and Morachiello: 79, annotation: 'La eurythmia cioè concordantia de tutta l'opara et aparte a parte'. Caporali (1536): 18r, in his commentary on Vitruvius I, 3, 2 discussed beauty as: '. . . una conveniente correspondenza delle cose, atte alla forma di ciascuna cosa da farse'.

42. 'per ogni due lacunarij [é] una testa leonina'.

43. Detail just visible in Frommel (1973): III, 93c.

44. UA 1168r; Bartoli (1914–22): III, fig. 468, 'di matonj bene lavorato'.

45. Pagliara (1991).

46. E.g. Leonardo Bruni letter to Niccolò Niccoli in which he praises the Augustan arch at Rimini as 'sublimis ac magnifice lapide quadrato, et diligenti artificio perpolita . . .', Bruni (1741): I, 76, Bk 3 no.9.

47. E.g. Pius II (1984): 167, on the Gonzaga palace at Revere, which he saw in 1459: 'structura et artificio singulare architecti ostendit ingenium'; cf. the skilful manipulation of materials in ingenious interlocking flat arches that Antonio da Sangallo the Younger draws at the Pieve and S. Francesco in Prato: 'Cosa piu artifitiose per mostrare lo ingegnio del maestro . . .', UA 897r; Giovannoni (1959): fig.38.

48. Weil-Garris and D'Amico: 86, 87: 'artificio concinna magis quam marmorum copia sumptuosa domus'.

49. Pontano (1498): fol. 17r: 'Dignitas . . . his comparatur ornatu, amplitudine, materiae prestantia, operis perennitate, nam sine artificio nihil neque parvum neque magnum laudari recte potest'.

50. E.g. Cortesi, in Weil-Garris and D'Amico: 76; Pietro Summonte writing to Marcantonio Michiel in 1524 criticized fifteenth-century Florentine architects for relying too much on their own *ingegno* and not enough on Alberti's precepts, resulting in 'errore, dico di vera pertinaccia . . . troppa fidanza d'ingegno e presumpzione di trovare cose nuove'; Pane (1975): 69.

51. '. . . era dele ben lavorate op[er]e ch[e] in Roma fussero'. He also notes the marble from which it is made.

52. Serlio (1619): Bk 3, 88v, 'molto ben lavorato'; Bk 4, 184r, this woodcut of the capital was, I think, based directly on Peruzzi's drawing.

53. Eco (1986): 14–15.

54. Pontano (1498): fol. 17v. He criticized Roberto Sanseverino, Prince of Salerno, for the use of poor quality stone where he should have used marble in his palace in Naples. For Pontano cost-cutting was a sign of miserliness and therefore inappropriate for a building which should express the character of its owner. The 'magnificent' man should be thinking of how to make a building as beautiful as possible.

55. UA 402r; Wurm: 67: 'corinthyo op[er]a barbarisma'. Probably drawn in 1518, Tessari (1995): 51.

56. Tessari: 51.

57. He draws a detail of this, marked 'A'.

58. Peruzzi was well aware of Vitruvius and at times used Vitruvian terminology on drawings. Quednau (1987): 413–14.

59. The now-destroyed portal of the Palazzo Fusconi da Norcia in Rome; Serlio (1619): Bk 4, 146v–47r; Quednau (1987): 425.

60. UA 1207v; Giovannoni (1959): fig.41. The unusual design of the Porta Marzia in Perugia is praised: 'i[n]ve[n]zione . . . p[er]ché è variata dalli altri archi triunfali', but the detailing and sculpture condemned: 'tutto e mal fatto di modani e fi[g]lure'. On the same page he comments on a partial cross-section and a plan of S. Angelo in Perugia: 'solo se ne pigli la forma overo invenzione, altro di bono non ci è se non qualche capitello'.

61. On the project and on the technical aspects of Peruzzi's designs, see Adams (1984) who dates them to c.1530.

62. Wurm: 296, 'questo modo e fortissimo infra tucti li altri disegni'.

63. Wurm: 295, 'Questo modo e molto forte e bello di vista e cresce la grandezza del laco . . .'.

64. UA 353r; Wurm: 135: '. . . p[er] che le colo[n]ne tonde secondo el costume delj buonj antiq[ui] no[n] possano tenere archi e crosiera in sieme . . .'.

65. Alberti (1966): II, 643, 7.15.

66. UA 353, flap; Wurm: 136 B.

67. As the portico was actually built. For photographs of this before its destruction at the beginning of the twentieth century, Roversi (1986): 288–9. My thanks to Fabrizio Nevola for bringing these photographs to my attention.

68. UA 352r; Wurm: 134: 'e piu al p[ro]posito p[er] lumj e p[er] bellezza e maxime che glie piu p[ro]pinque ala maniera e uso delj bonj antiquj'. See too Burns (1988): 218, who also places the Palazzo Lambertini design in the context of *firmitas*, *utilitas*, and *venustas*.

69. Peruzzi includes variations on the number of columns and width of intervolumniations too; UA 352 and UA 353, flaps; Wurm: 136 A and B.

70. '. . . ne sono p[er]o tanto angusti li intercolumnij che nelj quattro più strecti no[n] passino comodam[en]te due homjnj al paro e ancora tre no[n] sendo molto inviljppati in veste nuptialj . . .'.

71. Vitruvius (1981): III, 3, 1–8.

72. Vitruvius (1960): 80; Vitruvius (1981): III, 3, 3; III, 3, 6.

73. Vitruvius (1960): 80; Vitruvius (1981): III, 3, 3, 6 'ad usum et ad speciem et ad firmitatem rationes habet explicatas'.

74. For a measured survey plan see Wilson Jones (1988): fig.14.

75. UA 352r: '. . . accompagnano lj vanj dela scala meglio . . .'.

76. Francesco di Giorgio Martini (1967): I, 48: 'una delle più eccellenti parti che l'edifizio avere possa sie la concordanzia e conferenzia di ciascuna cosa'. See too II, 412, on three general rules, in his discussion of temple architecture, that state that elements should align vertically – solids over solids, voids over voids etc. – and that doors should be placed in line with intercolumniations, etc.

77. Buddensieg (1971). Sangallo's drawings are UA 306, 874r and v; Bartoli (1914–22): III, figs. 415, 414. The verso of 874 is entitled 'Riformatione della rito[n]da p[er] ricorregiere li falsi sono in ditto edifitio' and 306 'per la corretione della ritonda'. Buddensieg dates these drawings to c.1535, Buddensieg (1971): 266 n.1. Peruzzi in his section drawing of the Pantheon added a 3/4 pilaster in the vestibule, stating only that 'questo no[n] ve', see Burns (1966): 250.

78. UA 874r; Buddensieg (1971): 266. The terms of Sangallo's description and of his arguments on UA 306 are very close to Francesco di Giorgio's treatise; Francesco di Giorgio Martini (1967), II, 412.

79. On Sangallo and Peruzzi drawings of antiquities, Günther (1988); on ancient and contemporary interests see, for example, Pagliara (1972): 23–47.

80. E.g. Pius II on the stairs and many other details in his Pienza palace, Pius II (1984): 546–56; Cortesi's references to the Cortile del Belvedere in Rome, Weil-Garris and D'Amico: 80, 87; *Vita di Michelozzo* in Vasari (1966–87): III, 230–1, on Palazzo Medici, Florence. His judgement agreed with Filarete's of the 1460s, Filarete (1972): II, 697.

81. Montini (1957); Frommel (1973): II, 23–9; III, 10–14; Portoghesi (1972): 79–82. The date at which the palace was begun is disputed.

82. 'il più bella e meglio fatta che sia in tutta Roma', Redig de Campos (1956): 18.

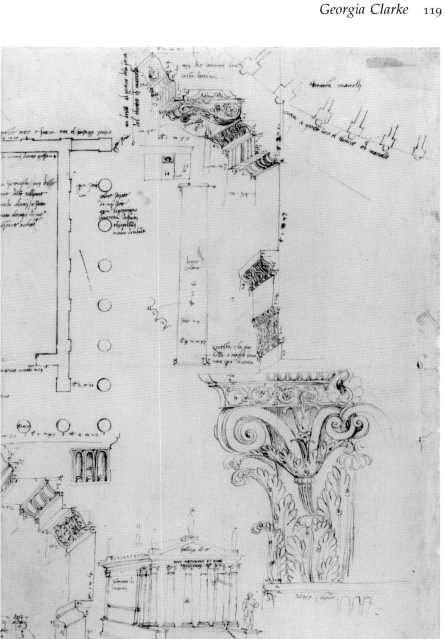

9.1  Baldassare Peruzzi, *Temple of Castor and Pollux*

9.2   Baldassare Peruzzi, *Temple of Mars Ultor*, detail of capital and base

9.3  Baldassare Peruzzi, *I Nicchioni, Todi*

9.4    Anonymous Bolognese and Baldassare Peruzzi, *Palazzo Lambertini*, Bologna, plan

Anonymous Bolognese and Baldassare Peruzzi, *Palazzo Lambertini*, Bologna, plan

# Poetry in motion: beauty in movement and the Renaissance conception of *leggiadrìa*

*Sharon Fermor*

For writers on art in early sixteenth-century Italy the word beauty, or *bellezza*, was either very specific, or very general in its significance. For Ludovico Dolce, invoking a notion of beauty first hinted at by Plato and rarely absent from subsequent art theory, beauty lay in symmetry and proportion in the human body.[1] At the other extreme, for Vasari, *bello/a* usually meant little more than 'pleasing', especially when used in the context of movement. In such instances, it was generally used to denote the sense of pleasure experienced by the viewer from the appropriateness of a painted movement to its narrative and emotional context, and from the artist's observation of decorum. Describing Giotto's frescoes in the Chapel Tosvighi-Spinelli in S. Croce, for example, Vasari writes of the *Presentation in the Temple* as:

... a very beautiful thing, seeing that, besides a great affection that is seen in that old man as he receives Christ, the action of the Child, stretching out his arms in fear of him, and turning in terror towards his mother, could not be more touching or more beautiful.[2]

Here, *bellezza* denotes less a specific quality intrinsic in the Child's movement, than the quality of its effect on the viewer, and the latter's pleasure in the aptness of Giotto's invention. Alternatively, *bello/a* is used by Vasari to emphasize or reinforce another, more specific term, as in *bella grazia* or *bella maniera*.

Neither Dolce's nor Vasari's way of employing *bellezza* is entirely surprising. Following Plato's discussion of beauty, made more concrete in Neoplatonic discussions of the arts, few writers, whether on art or on beauty, entirely rejected the notion that beauty depended on the physical qualities of harmony, proportion and symmetry in the body, however anti-Platonic the overall conception of their writings.[3] Even Vasari admits the importance of proper proportion and harmony in a body, although he discusses this under

the term *misura* – one of his five rules for the production of good art.[4] Nonetheless, as Panofsky has long since pointed out, Platonic and Neo-platonic theories of beauty were in many ways inimical to the practical and prescriptive nature of art theory and criticism as they emerged in fifteenth-century Italy, with their emphasis on empirical observation as the basis for artistic activity.[5] Furthermore, the notion of an ideal beauty, as an absolute standard which also has metaphysical connotations, was not easily reconcil-able with an artistic practice and theory that increasingly valued naturalism and the faithful rendition of appearances. At the same time, while for strategic reasons Vasari may have avoided using *bellezza* in a way that recalled Neoplatonic ideas, he was unable to ascribe to the term an alter-native, equally specific meaning.

The tension between Platonic and Neoplatonic definitions of beauty, and pre-Mannerist art theory and criticism, was particularly acute as regards the description of movement and it is thus understandable that writers on art rarely use *bellezza* to describe the bodily movement. The same is true of the numerous writings on beauty, especially female beauty, which appeared in Italy in the early sixteenth century, and which were more obviously per-meated by Neoplatonic thought, sometimes mediated by the poetry of Dante and Petrarch.[6] Within such writings, the movement of the body was rarely discussed in detail, notable exceptions being Firenzuola and Castiglione. Even here, insofar as movement is discussed in connection with beauty, it is usually in the sense of a general appearance of animation deemed necessary to give a figure a pleasing aspect and convey the impression of life.

In some ways, the Neoplatonic notion of beauty was antithetical to overt physical movement. On the one hand, the ideal of perfect proportion and symmetry in a body was best observed and expressed in a static and balanced body, with limbs and torso undistorted by twists, turns or fore-shortenings. It is therefore of particular interest that one of Vasari's most precise, and also most Platonic, uses of *bellezza* occurs in his description of Michelangelo's *Creation of Adam* on the Sistine Ceiling. Adam's body lies almost motionless, turned slightly towards the viewer to display his ideal proportions; even the position of his outstretched arm seems designed to reveal the perfection of each detail of the arm and hand.

In Vasari's account, Adam's physical beauty or *bellezza* is noted separately from his gesture and position:

He [Michelangelo] then went on . . . to the Creation of Adam, a figure of such a kind, in its beauty, its attitude and in the outlines that he appears as if newly-fashioned by the supreme and first Creator.[7]

Indeed, not only is Vasari's sense of beauty here close to the Neoplatonic ideal of perfect proportion, but his account of Michelangelo's painting of

Adam makes the figure into something approximating the realization of the Divine Idea. The artist is not so much an intermediary between the Idea and the visible form, but a clear, transparent vessel for the implementation of God's design.

Conversely, when discussing the *ignudi* on the Sistine Ceiling Vasari makes clear, if only incidentally, that *bellezza* in relation to movement does not signal one particular type of movement, as he emphasizes precisely the diversity of the figures' actions: here, beauty is used rather to convey pleasingness or the ability to delight:

> And at the present day everyone is amazed who is able to perceive the excellence of the figures . . . which have in them grace and slenderness, being drawn with the beauty of proportion that is seen in beautiful nudes, different in expression and in form, in countenance and in outline, some more slender and some fuller in the members as may also be seen in the beautiful attitudes, which are different, some seated, some turning . . .[8]

The idea, first explicitly stated by Alberti, that the painter's task was to observe the varied movements appropriate to different individuals and their actions was also largely incompatible with a single ideal of beautiful movement. This much is apparent in the later writings of Gian Paolo Lomazzo who, in his *Treatise on the Art of Painting* of 1584, attempted explicitly to discuss movement in relation to Neoplatonic thought. As is well known, for Lomazzo the essence of beauty was contained in the *figura serpentinata* with its upwards, flame-like shape. In the *Idea of the Temple of Painting* of 1590, Lomazzo draws heavily on Florentine Neoplatonism, and especially the writings of Marsilio Ficino for his definition of beauty:

> Finally, the beauty of the body is nothing else than a certain action, liveliness and grace, which shine therein thanks to the influence of the idea, and this influence does not descend into matter unless this [matter] is most fittingly prepared.[9]

As Lomazzo goes on to explain, the beauty that derives from 'liveliness' or animation can only appear in a body already possessing beauty by virtue of its ideal proportions and physical perfection. In the *Treatise on the Art of Painting*, this liveliness is identified with the *figura serpentinata*.[10] Yet Lomazzo's attempts to reconcile his recommendations to painters constantly to observe this form, with his prescription for specific, individual movements are almost entirely unsuccessful from a theoretical point of view. They would also have been difficult to put into practice. In the light of this conflict, it is hardly surprising that many of the figures considered by Vasari to display beauty in their movements have little or no narrative function. Furthermore, figures that are alluded to in terms of *leggiadrìa* are often described as displaying 'poses' or 'attitudes', rather than the more active 'movements' or 'actions'.

There was another dimension to the conflict arising from the pursuit of beauty of movement within the specificity expected of narrative painting, for the system of thinking about the body derived from Plato shared with the Aristotelian tradition the idea that movement was the index of the soul, and of moral and social stature. As such, movement was seen as something to be rigorously controlled and scrupulously observed. While almost all writers on movement stress that rigidity in the body should be avoided, an excess of movement was considered to be far more problematic. Depending on its nature, excessive and uncontrolled movement could indicate a range of different vices, including anger, effeminacy, lack of self-restraint, sycophancy, servility, licentiousness, affectation, untrustworthiness or deceitfulness. Particularly undesirable were sloping, slanting or swaying of the shoulders or hips. Most desirable was an erect but not rigid posture, with the torso held in equilibrium and without sideways movement of the pelvis. Also considered reprehensible were over-free, excitable gestures of the arms.

Considered against this background, identifying a type of movement which expressed or was compatible both with the beauty of perfect proportion, and with that of the virtuous soul, would have been a formidable task and it is quite comprehensible that movement rarely enters into discussions of *bellezza* as strictly defined. Vasari, like other Renaissance writers on art, faced a degree of conflict when discussing movement – between the demands of narrative clarity which required movement clearly to express emotion, and the function of movement, consciously or otherwise, as an index of social and moral states. The vivid expression of emotion or intention through movement may not always have been compatible with contemporary ideals of polite behaviour and their emphasis on self-control and physical restraint.

All this is not to say that Vasari did not have a concept of beauty in movement, or something approximating it. It seems likely, however, that this is signalled not by the term *bellezza* with its Neoplatonic baggage, but by the term *leggiadrìa* – one that was common both in writings on manners and in writings on art. I have discussed elsewhere, and in some detail, the implications of Vasari's use of *leggiadrìa*, and its relation to contemporary writings on manners, and I will therefore address it only briefly here. I have also discussed a number of figures described by Vasari as possessing *leggiadrìa* of movement, most notably the Magdalen in Raphael's *Ecstasy of St Cecilia*, and the figures of Parmigianino, particularly good examples of which are the *Wise and Foolish Virgins* in Sta Maria della Steccata, Parma.[11]

On the basis of these figures, and of contemporary texts, we can say that the essence of *leggiadrìa* resided, firstly, in a movement that was even, measured and controlled, and that avoided any but the most subtle twists and turns of the body. Figures described in these terms, whether in literature

or in art, are characterized by a deportment that is erect and composed, with any curves or bends confined to the movement of the arms, and excluding potentially suggestive movements of the shoulders or hips. It was a kind of movement that combined the gentlest appearance of animation and life with a simplicity indicative of inner virtue. As Firenzuola wrote in his *Dialogue on the Beauties of Women* of 1541:

Leggiadrìa is nothing other than the observation of a tacit law given to you women, by which, in moving, bearing and using both the whole body and the individual limbs, everything should be done with grace, with modesty, with nobility, with measure, and with charm, in such a way that no movement and no action is performed without rule, method, measure or design, but is, as this law dictates, well-ordered, composed, regulated and graceful ...[12]

The element of uprightness or erectness of the body is made additionally clear in Pietro Bembo's *Gli Asolani*, first published in 1505, where Bembo describes the pleasures of watching a loved one:

... singing and dancing in a circle, moving her honest and upright and collected form to the sound of the instruments, now with slow steps showing herself worthy of the greatest reverence, now with exquisite turns, or, pausing to bow, filling, *leggiadrìssima*, with beauty, the entire circle, and when with swifter steps across she is almost like a passing sun, which strikes the eyes of the beholders.[13]

Bembo's description appears particularly appropriate to Parmigianino's Virgins who move with stately ease and upright, but not rigid stance, the measure of their movement and their meticulous control made clear by the amphorae balanced on their heads.

There is, however, another dimension implied in many sixteenth-century uses of *leggiadrìa* – that is, a quality of lightness, of apparent weightlessness in posture or in bearing, whereby a movement appears without effort. Consequently, it is often used in connection with actions involving jumping, or dancing. In his *Book of the Courtier*, for example, completed by 1518, Castiglione writes:

There be some other exercises that may be done both openly and privately, as dancing: and in this I believe the Courtier ought to have a respect, for if he daunceth in the presence of many, and in a place full of people, he must (in my minde) keepe a certaine dignitie, tempered nothwithstanding with a *leggiadra* and airy sweetness of movement.

And for all he feeleth him selfe very nimble and to have time and measure at will, yet let him not enter into that swiftnesse of feet and doubled footinges, that we see are very comely in our Barletta, and peradventure were unseemely for a gentleman.[14]

Here, Castiglione advises the courtier to seek for dignity in dancing, tempered with a *leggiadra ed aerosa dolcezza di movimenti* – a light and airy

sweetness of movement. He should not, however, feel himself so light and agile that he is tempted to displays of virtuosity in jumping, which are inappropriate to a gentleman.

The same connection between *leggiadrìa* and lightness of foot appears, only more eloquently, in Matteo Bandello's *Canzoniere*. Here, the close relationship between *leggiadrìa* and *bellezza* is also made clear. The relationship between *leggiadrìa* and an appearance of virtue, specifically of chastity is likewise made explicit:

> That celestial movement,
> Her foot barely touching the ground,
> The beautiful turn of that golden head,
> Pausing a while so that beauty
> And chastity fall all around:
> Her bearing full of *leggiadrìa*
> Those blessed manners, made in paradise,
> Her noble greetings, her sweet and modest speech.[15]

In this instance *leggiadrìa* of deportment is associated with a step which appears barely to touch the ground, and which produces the effect of a heavenly or celestial movement.

Finally, at the turn of the seventeenth century, Filippo Baldinucci made this aspect of *leggiadrìa* explicit in his *Vocabolario Toscano dell'arte del Disegno*, of 1681:

*Leggiadrìa*: a certain way of carrying the body, so light and agile that the figure appears to move but to have no weight, bearing itself with the greatest possible lightness; it is appropriate for youth, and especially for nymphs and figures of a similar kind.[16]

This combination of an upright, fluid but controlled posture which did not bring into play in any obvious way the mechanics of the body, combined with an appearance of lightness or weightlessness, may account for the importance of *leggiadrìa* within sixteenth-century concepts of ideal or beautiful movement. Within a culture where both movement and the physical body were the sites of some anxiety and conflict, a style of movement or posture which appeared to minimize and contain these, and to lighten, even deny the body's physical mass inevitably occupied an important place.

It is interesting in this respect that, as in Bembo's text, the use of *leggiadrìa* is often accompanied by some reference to physical light. In the case of Bembo, the impression created by the dancing woman is compared to that of the fleeting sun that dazzles the beholder, and there is little doubt that Bembo is drawing here on a Neoplatonic notion of physical light as a sign of the inner light that indicates spiritual grace. The physical lightness of the

woman's movement conveys an inner light and grace that radiate like the sun, and draw the viewer to her. To this extent, *leggiadrìa* in movement becomes a source of one aspect of *bellezza* as conventionally defined – the outer manifestation of an inner radiance or light.

It may also be significant then that some of the most important figures in painting to which Vasari applies the term *leggiadrìa* – Raphael's Magdalen, the figures of Parmigianino, and some of the figures of Beccafumi – make conspicuous use of bright light, not as part of a schematic *chiaroscuro*, or to articulate the body's structure or anatomy, but to create, in a more abstract way, an appearance of light and easy movement, by illuminating the figures' free limbs, or the long lines of their torsos. In terms of musculature and the mechanics of the body this light conceals as much as it reveals, dazzling the eye rather than inviting it to consider the body underneath. It is thus as though, even if at an unconscious level, Vasari is responding to painted light in his reference to lightness of movement. More specifically, the Neoplatonic connotations of light, of which he must certainly have been aware, may have informed his response to these figures as light and graceful in their movement and, by implication, virtuous in their being.

What I am suggesting then is that, in the first half of the sixteenth century, *bellezza* was imbued with Platonic and Neoplatonic associations which were in large measure antithetical to the notion of bodily movement of any specific nature. Accordingly, movement was not generally comprised within definitions of beauty beyond a general idea of a semblance of animation which revealed an inner grace. Likewise, the increasing emphasis in art theory and practice on naturalism and on the observation of individual movements and physical types at times made it difficult for writers to identify a unified ideal of movement, or a concept of beautiful movement which could be realized in practical terms. Writers who did not explicitly draw on Neoplatonic philosophy or writings nonetheless found it difficult to invest the term *bellezza* with an alternative meaning that had any degree of precision, and did not use it of movement in a particularly descriptive or informative way. Furthermore, writers on beauty in whatever context, and whether drawing on a Platonic or an Aristotelian view – or indeed a mixture of the two – inherited an acute ambivalence about movement per se, and an anxiety about excessive movement that made it difficult to identify a notion of beauty in movement.

The notion of *leggiadrìa* probably comes closest to encapsulating a contemporary notion of beautiful movement, and it is often used together with *bellezza* in contemporary texts, with *bellezza* serving primarily as a form of emphasis. It is the only explicitly defined quality of movement that comes close to resolving the conflicts outlined above, combining the necessary elements of composure and restraint with a subtle animation that gives the

figure the requisite appearance of life. The element of lightness and upward movement implied by *leggiadrìa* may also have resonated with the emphasis within the Platonic tradition on movement as a sign of spiritual ascent, or the soul's striving to rise towards the Divine.

Nonetheless, *leggiadrìa* was not a quality that could be considered universally desirable, or as an absolute ideal. Most writers identify it as a quality especially appropriate to the movement of women, or young men. Furthermore, it was not necessarily the type of movement which Vasari himself thought most desirable or most admirable in art, or that which was best suited to displaying the artist's skill in representing motion. In this respect, as has often been observed, Vasari showed a preference for the type of twisting and turning motion that reached its most extreme expression in the *figura serpentinata*, and which he usually denoted by the tern *grazia*. At the same time, he himself recognized that this type of movement could easily be taken to extremes, distorting the body to the point of ugliness or physical impossibility, and he stressed the importance of moderation in this respect, especially in the depiction of religious figures. In the *Life* of Spinello Aretino, for example, he makes clear that *grazia semplice* – that is, a simplicity in movement where the twists and turns are limited and restrained – creates an impression of modesty and holiness:

... it having been something peculiar and natural to Spinello to give to his figures a certain simple grace, which has much of the modest and the saintly, it appears that the figures that he made of Saints, and above all of the Virgin, breathe a certain quality of the saintly and divine.[17]

Conversely, Vasari criticizes Pontormo for the figures in his *Annunciation* in S. Felicità, which he describes as:

... both one and the other twisted in such a way that one can recognize how the bizarre extravagance of that brain of his was never content with anything.[18]

Pontormo's figures are particularly interesting in the context of the present discussion, for while Vasari describes them as 'twisted', the twists and turns of their bodies are almost exclusively confined to the heads and limbs. Their torsos are held as one piece, almost rigid, while their legs bend and cross. For Vasari, not only would this rigidity lack grace, or even *leggiadrìa*, but the positions of the limbs in Pontormo's figures appear to lack logic, and to impede rather than facilitate movement. The Virgin appears unbalanced, as if about to fall, clutching at her reading stand with her feet crossed over: not only does this appear to make further movement difficult, but in all texts on behaviour, and in some writings on art, such as Leonardo's *Notebooks*, crossing the legs was expressly identified as inappropriate for well-bred

women. The angel also appears devoid of potential internal movement, his body a solid block that descends, seemingly without his control. These figures thus display some of the dangers inherent in serpentine movement, with their knotted and contorted limbs, while also illustrating one of the potential pitfalls of *leggiadrìa* – an over-controlled or rigid carriage of the body that makes the figure appear graceless and contrived, and lacking in *bellezza*.

Nonetheless, in comparison to the kind of movement implied by the term *grazia*, *leggiadrìa* had more obvious limits, and the undesirable connotations of an excessively rigid stance – mainly affectation – were less serious than those of excessive movement of the torso or limbs. Thus, from the point of view of both aesthetics and decorum, it was the most pleasing and the least problematic quality defined in the *Lives*. Thus, Ludovico Dolce, writing about movement in his *Dialogue on Painting*, explicitly contrasts poses that show *leggiadrìa* with movements that are forced, strained and 'out of time', making clear the pleasing or delightful quality that *leggiadrìa* has for the viewer, even at the expense of a lack of overt skill in representation:

But these movements [of the body] should not be continuous and in every figure; because men are not always in movement, nor do they move so boldly that they appear like madmen . . . A *leggiadro* pose is often more delightful than one which is forced and lacking in harmony.[19]

## Notes

1. Dolce (1960): 155.

2. '. . . cosa bellissima: perchè, oltre a un grande affetto che si conosce in quel vecchio ricevente Cristo, l'atto del fanciullo, che, avendo paura di lui, porge le braccia e si rivolge tutto timorosetto verso la madre, non può essere ne più affettuoso ne più bello.' Vasari, ed. Milanesi (1878): I, 374; trans. G. de Vere (1912–14): I, 73.

3. On this point see Panofsky (1968) passim, and Barasch (1985) passim.

4. Vasari, ed. Milanesi: IV, 7–8.

5. Panofsky (1968): 47ff.

6. On writings about female beauty see Cropper (1976), and Rogers (1988).

7. 'E così seguito sotto a questo la creazione de Adamo . . . figurato di bellezza, di attitudine e di dintorni, di qualità che e' par fatto di nuovo dal sommo e primo suo Creatore.' Vasari, ed. Milanesi: VII, 180; trans. de Vere: IX, 34.

8. 'Ma stupisca ora ogni uomo, che in quella sa scorger la bontà delle figure . . . che hanno in se grazia e sveltezza, girati con quella bella proporzione che nei belli ignudi si vede . . . differenti d'aria e di forma, cosi nel viso come ne' lineamenti, di aver più sveltezza e grossezza nelle membra, come ancora si puo conoscere nelle bellissime attitudini che differente e' fanno, sedendo e girando . . .' Vasari, ed. Milanesi: VII, 179; trans. de Vere: IX, 33.

9. 'Finalmente la bellezza del corpo non è altro che un certo atto, vivacità e grazia che il lui risplende per lo influsso della sua Idea, il quale non discende nella materia se ella non e attissimamente preparata.' Lomazzo (1974): II, 215; Holt (1982): 85.

10. Summers (1972): 269–301.

11. Fermor (1983): 15–21, and (1993): 129–45, where these figures are also illustrated.

12. 'La leggiadrìa non è altro . . . che una osservanza d'una tacita legge . . . nel muovere, portare, e adoperare cosi tutta la persona insieme, come le membra particolari, con gratia, con modestia, con gentilezza, con misura, con garbo, in guisa che nessuno movimento, nessuna attione sia senza regola, senza modo, senza misura, o senza disegno: ma come ci sforza questa tacita legge, assettata, composta, regolata, gratiosa . . .', Firenzuola (1548), 83r. My translation.

13. '. . . carolando e danzando muovere agli ascoltati tempi degli strumenti la schietta e diritta e raccolta persona, ora con lenti varchi degna di molta reverenza mostrandosi, ora con cari rivolgimenti, o inchinevoli dimore leggiadrissima empiendo tutto il cerchio, e quando con più veloci trapassamenti, quasi un trascorrevole sole, negli occhi de' riguardenti percotendo.' Bembo (1961): 102–3. My translation.

14. 'Sono alcuni altri esercizi che far si possono nel publico e nel privato, come e il danzare; ed a questo estimo io che di debba aver rispetti il cortegiano; perche danzando in presenza di molti ed in loco pieno di populo parmi che se gli convenga servare una certa dignità, temperata pero con leggiadra ed aerosa dolcezza di movimenti; e benchè si senta leggerissimo e che abbia tempo e misura assai, non entri in quelle prestezze de' piedi e duplicati rebattimenti, i quali veggiamo che nel nostro Barletta stanno benissimo e forse in un gentiluom sarian poco convenienti.' Castiglione (1964): 205–6; trans. T. Hoby (1974): 99.

15. 'L'andar celeste, il far che 'l piede tocchi/La terra a pena, il bel girar intorno/Quell'aurea testa, e dar di se soggiorno/Si che bellezza, e castità vi fiocchi:/Il portamento pien di leggiadrìa/Que' santi modi fatti in paradiso,/L'alte accoglienze, il parlar dolce, e schivo.' Bandello (1923): 83–4. My translation.

16. 'Leggiadrìa: un certo portamento della persona . . . cosi leggiero ed agile che pare ch'ella si muova, e quasi non abbia peso, ma leggierissimamente si sostenti; e propria della gioventù, e spezialmente di Ninfe, e simili.' Baldinucci (1681): 82. My translation.

17. '. . . essendo stato proprio e cosa naturale di Spinello dare alle sue figure una certa grazia semplice che ha del modesto e del Santo, pare che le figure che egli fece de' Santi e massimamente della Vergine spirino un non so che di santo e di divino . . .' Vasari, ed. Milanesi: I, 685; trans. de Vere: II, 34.

18. '. . . in modo l'una e l'altra stravolte, che si conosce . . . che la bizzarra stravazanga di quel cervello di niuna cosa non si contentava giammai.' Vasari, ed. Milanesi: VI, 272. My translation.

19. 'Ma queste movenzie non debbono esser continue e in tutte le figure: perchè gli uomini sempre non si muovono; nè fiere sì, che paiono da disperati . . . E spesso più dilettevole un posar leggiadro che uno sforzato e fuori di tempo.' *Op. cit.*: 180. My translation.

# Resplendent vessels: Parmigianino at work in the Steccata

*Mary Vaccaro*

After a long absence from his native town of Parma, Francesco Mazzola (1503–40), better known as il Parmigianino, returned home. He soon under-took several important commissions there, yet seems to have had some difficulty bringing the projects to term. The most notorious episode involves the decoration in the church of S. Maria della Steccata in Parma. His procrastination so incurred the wrath of the local confraternity that he ended up in jail and was then forced to flee to nearby Casalmaggiore, where he died in exile. According to Giorgio Vasari, a consuming obsession with alchemy had led the artist astray. Vasari vividly describes how Parmigianino, once gentle in appearance, turned into a bearded savage with long unruly hair, wasting time over alchemical furnaces when he should instead have been racking his brains to devise beautiful inventions for his brush.[1]

The sheer quantity of extant related preliminary drawings belies Vasari's accusation, however. Parmigianino appears to have spent an extraordinary amount of time devising and reworking beautiful ideas for the Steccata, even if he was slow to translate them into paint. His many designs for the lovely young women in the vault, the so-called Wise and Foolish Virgins, reveal an especially intense preoccupation with the portrayal of female beauty. The inclusion of a self-portrait in one drawing underscores the extent to which these maidens reflect elegant and shifting patterns of his imagination.[2] Through the act of drawing, Parmigianino's pen gradually gave form to the elusive inventions of his mind and shaped a visual poetic of Petrarchan desire. This essay will focus on the Steccata Virgins in order to explore more fully such creative practice.

The details of Parmigianino's ill-fated commission to decorate S. Maria della Steccata are amply documented.[3] In 1531 the confraternity of the newly built church officially enlisted the artist to paint the eastern (main) apse and its coffered barrel vault, along with the soffits of the arches on either side of

the vault and the corresponding frieze and cornices. Parmigianino optimistically promised to complete all the work within eighteen months. Nevertheless, eight years later, he had still not painted the apse, although the rest of the decoration was then complete. The confraternity refused to grant the artist any more indulgence and barred him from further activity in the church; an ensuing legal dispute over the matter drove him out of Parma for good.

The earliest known document for the commission establishes that the apse was to contain a scene of the Coronation of the Virgin, for which Parmigianino supplied at that time a drawing.[4] Most of the document concerns the gilding and installation of metal *rosoni* for the vault coffers.[5] No mention is made of the iconographic nature of the other decoration, however, which may indicate that a firm decorative programme had yet to be envisaged, and perhaps Parmigianino was to be responsible, at least in part, for its development. Book VII of Leon Battista Alberti's *De re aedificatoria* (regarding ornament to sacred buildings) specifically recommends that the spaces in the coffered ceiling of a temple be gracefully adorned through the ingenuity of the painter.[6]

The interstices of the Steccata vault presented a challenge for Parmigianino to display his inventive skill, his ideas evolving slowly over the course of an elaborate design process. Close to a hundred preliminary drawings exist for the vault and soffits alone, and the very range of graphic possibilities explored by the artist therein suggests the extent of his creative liberty. A double-sided sheet in the British Museum indicates that he first thought to insert a number of figured oval medallions between the coffers.[7] Such a solution would have proven illegible *in situ*, given the considerable height of the vault, and Parmigianino eventually opted to adorn the space instead with larger female figures. The British Museum sheet indeed anticipates the change, for traces of the artist's pen may be discerned turning one of the medallions into the ovoid shape of a woman.

The basic compositional idea of three standing maidens with outstretched arms between the coffers finds monumental expression in the Steccata church (Figure 11.1).[8] There, at the base of the vault to either side, dances a triad of young women in the act of exchanging lamps, unlit on the north wall and lit on the south. The soffits contain oval niches with monochrome figures, Adam and Moses flanking the Virgins of the north wall, Eve and Aaron flanking those of the south. The colour scheme is a sumptuous red, blue and gold, with projecting gilt *rosoni* sunk into the blue coffers. Smaller *rosoni*, interspersed with little nude figures, line the vault along the soffits. Patterns of intricate gold latticework fill the upper curve of the soffits. The corresponding area of the coffered vault teems with foliate and animal

motives, and the frieze below the vault, with images of liturgical books and vessels.

Preparatory drawings testify to the degree of attention the artist lavished on every aspect of the project. A sheet in the Metropolitan Museum for two soffit figures, for instance, contains no less than nine studies for Moses and eight for Eve.[9] Such interest in refinement of pose is nowhere more evident than in Parmigianino's many designs for the so-called Wise and Foolish Virgins. These drawings explore changes in movement and stance for the maidens, either singly or in groups of two or three, and often do so with exceeding subtlety. A sheet in the British Museum depicts the young women with baskets on their heads, like *canephoroi* in some ancient ritual procession.[10] The central maiden is shown frontally, while those flanking her face inward. The far-left figure holds hands with the central maiden, who, in turn, exchanges a basket with another maiden on the far right; a large vessel rests on the ground between the first and central maiden. A design at Chatsworth arranges the poses in a slightly different way.[11] All the maidens hold hands and bear amphorae (instead of baskets) on their heads. Neither drawing includes the lamps that appear in the final painted version.

The preparatory designs for the Steccata maidens cannot be placed in any definitive chronological sequence, but bespeak nonetheless the ongoing efforts of Parmigianino's pen to describe and perfect his beautiful inventions. Some sheets show all the maidens frontally, while, in other designs, the outer maidens face the middle figure. Still other drawings investigate more minute changes, regarding, for example, which of the maidens' arms should be raised to support the container atop their heads and which should instead be laterally extended.[12] Parmigianino thus gradually choreographed a dance of consummate elegance. Movement flows seamlessly from one beautiful woman to the next, from one arabesque of classicizing drapery to the next. The sinuous poses of the two outer women mirror and reverse each other, and enframe the measured *contrapposto* of the central attendant. Each triad of maidens, with its intricate harmony of interlaced poses, moreover, seems to invite comparison with the Three Graces, personifying every aspect of grace, charm and splendour.[13]

At some evidently later stage Parmigianino introduced the lamps that are found in the painting. The exchange of lamps allowed for a refined portrayal of the maidens' hands, at the same time modulating and punctuating the horizontal rhythm of their outstretched arms. The attribute of lamps also permitted an association with the biblical parable of the Wise and Foolish Virgins, who accompany a bride to her groom's house (Matthew 25:1–13). The five Foolish Virgins failed to bring sufficient oil for their lamps and missed the arrival of the groom when they went to buy more oil, whereas the five Wise Virgins, prudently equipped with oil in jars, were allowed access to

the wedding banquet. The story, used extensively in the liturgy of virgin martyrs, inspired patristic readings about the triumphant relation of chaste virgins to the Bridegroom Christ and His Bride and Mother Mary.[14]

The Steccata maidens number six not ten, and since the preparatory drawings suggest that Parmigianino did not originally have such a Christian gloss in mind, many scholars have discounted the religious importance of the decoration. According to a recent monograph, the late addition of lamps serves as 'indication of the cavalier attitude shown by the artist toward theology throughout the work, and indeed throughout most of his career.'[15] Does the apparent absence of a rigid iconographic programme necessarily expose Parmigianino's purely aesthetic intentions? If painting was indeed comparable to poetry – the Horatian simile already a commonplace in Renaissance art theory – might not the artist be expected to formulate a decorative scheme with poetic grace and invent meaning in new ways? Finally, how might such visual beauty function as sacred content? The large amphora filled with white lilies atop each maiden's head is often recognized as a formal quotation of Raphael's statuesque water carrier in the *Fire in the Borgo*. The iconographic and poetic implications of Parmigianino's visual analogy of woman to vessel, to vases and to lamps, deserve further consideration, however, especially in light of an altarpiece on which the artist was working at the time.

Parmigianino painted the altarpiece commonly known as the *Madonna dal collo lungo*, or *Madonna of the Long Neck*, for a local noblewoman named Elena Baiardi to decorate her chapel in the Servite church of Parma.[16] As with the Steccata project, this commission met with delay and was ultimately left unfinished. And, as with the Steccata, many extant preparatory drawings attest to the protracted imaginative process whereby the artist explored a range of alternatives for his thematic charge.[17] What began as a fairly standard *sacra conversazione* of the enthroned Madonna and Child with saints eventually turned into a quite unconventional picture. Parmigianino not only modified the compositional and spatial relation of the figures, but also added a vase. Vasari notes that the vase is a crystal urn, in which glitters ('riluce') a cross contemplated by the Virgin.[18]

This urn with its elongated neck relates in shape and colour to the body and drapery of the Virgin Mary. The analogy of the Virgin to a vessel figures importantly in Marian religious celebration, such as the Litany of Loreto.[19] In Parmigianino's image, the angel proffers an urn, marked with a cross, and looks toward the Virgin, who, in turn, regards the sleeping Infant across her lap. The vase thus serves as a metaphor for the beautiful Madonna, that pristine receptacle of the Incarnation destined for the future Passion. Significantly, Parmigianino did not begin with the idea of the Virgin as vessel, but seems to have developed the conceit through the act of drawing.[20]

Notwithstanding its precise iconographic function, the vase in the *Madonna of the Long Neck* operates in broader social and poetic terms. Elizabeth Cropper has connected the vase imagery of this picture to contemporary treatises of beauty, notably that by Agnolo Firenzuola.[21] Firenzuola's comparison of vases to female body types is itself a topos with ancient origins.[22] According to Cropper, moreover, the construct of loveliness found in both Parmigianino's Madonna and Firenzuola's treatise reflects the Petrarchan descriptive tradition that enjoyed cultural currency in the sixteenth century. Such poetic convention finds its biblical precedent in the voluptuous language of the Song of Songs, or Canticles, used to exalt the beauty of the Bride in all her parts. In Christian exegesis, the Bride of this Old Testament epithalamium came to be equated with the Virgin Mary, and the Bridegroom with Christ.[23] Petrarch's *Canzoniere* indeed culminates with his ode to the beautiful Virgin, at once 'madre, figliuola et sposa'.[24]

A more specific connection exists between *Petrarchismo* and Parmigianino's image, however, since the father of the patron in this case actually wrote Petrarchan poetry. It seems most likely that the artist would have been familiar with Andrea Baiardi's poems, in which the major topos of female beauty is the very feature he chose here to emphasize, the neck.[25] The painter created a visual poetic of desire no less compelling than the words of Andrea Baiardi, or even those of Petrarch. Parmigianino's Madonna is the Bride of Canticles, a composite of perfect body parts, and her physical beauty makes absolute religious sense. Indeed, her neck, epitomizing her loveliness in general, steals the beholder's thoughts with urgency and entices with the promise of divine love.

Designs for the Steccata vault similarly elucidate the artist's definition and exploration of content through form, his hand searching to render the beautiful inventions of his mind. A sheet in Modena, though now much ruined, exemplifies the process: its recto contains ideas for the framing of the coffers, the words 'querza lauro palme/ rose' in Parmigianino's writing next to bundles of foliage and acorns.[26] Such coincidence of word and image invites us to entertain the possibility of meaning in the Steccata ornament. The verso (Figure 11.2) suggests a still more evocative relation of word to image: lines of Petrarch's poetry read 'Nova beleza in abito Gentile/ volsel mio core ala morosa schiera', and share the page with sketches of the Steccata Virgins.[27] The verse testifies to Parmigianino's interest in Petrarchan poetry and provides an interpretative framework with which to understand better the Steccata project. Indeed, the maidens themselves embody a 'nova beleza in abito gentile', capable of turning the heart toward their amorous ranks.

Ludovico Dolce's dialogue on painting credits Parmigianino with the ability to endow a 'certa vaghezza alle cose sue' that makes the beholder fall

in love.[28] The quality of *vaghezza*, loosely translatable as charm, implies a beauty that inspires the beholder to wander in thought, to become a desirous vagabond.[29] The word *vagare* also appears in the context of the creative process in the sixteenth century. When Giovanni Bellini declined to paint a picture for Isabella d'Este, he did so, according to Pietro Bembo, because he did not like to be given detailed instructions and preferred instead to allow his imagination to wander at will in his paintings ('di sempre vagare a sua voglia nelle pitture'), thereby arriving at the most appropriate composition.[30] Might not Parmigianino's drawings represent a comparable inventive means, his hand wandering to describe an idea of female beauty so seductive as to invite the viewer, and even the artist himself, to wander and fall in love? A drawing at Windsor, for example, records the sustained, almost automatic movement of his pen as it generated one lovely profile after another for a Steccata maiden.[31]

Through the act of drawing, the artist devised and reworked elusive inventions for the Steccata Virgins, moving from one idea to the next and back again. These concepts, classicizing as well as Christian, work together in a rich accretion of lyric meaning. The earliest designs indicate that these figures began as maidens with either baskets or amphorae on their heads. Basket carriers, or *canephoroi*, in the religious festivals of antiquity were, by definition, chaste nubile virgins, closely identified with wedding ritual.[32] Parmigianino eventually added the lamps that gave the attendants a Christian identity as the Wise and Foolish Virgins, part of the wedding ceremony of Christ and His Bride. The artist was not illustrating a specific story, however, but shaping instead an evocative dance of 'nova beleza in abito gentile'.[33] Such physical beauty makes religious sense, for the delicate movements of the Virgins' bodies, so painstakingly choreographed by Parmigianino, connote their inner virtue.[34]

Moreover, light figures importantly in this poetic construct; besides the lamps held by the Virgins, imagery of luminous containers appears in the decoration that runs beneath the vault and soffits. The frieze below the coffered vault to either side depicts an elaborately wrought metal vessel at its centre, surrounded by church books and liturgical paraphernalia. The vessel on the north wall (Figure 11.3) issues clear white light, literally illuminating the open books before it, whereas that on the south wall, quite different in appearance, contains glowing coals. Furthermore, each section of the frieze beneath the soffits shows other metal vessels emanating bursts of light (Figure 11.4).[35] This varied treatment of vessels and light merits further study, and the artist's putative interest in alchemy may offer some explanation, though likely not a definitive one.[36]

Perhaps more useful interpretative clues are to be found in terms of the Marian dedication and civic importance of the Steccata church and,

particularly, the social function of its confraternity. This confraternity was responsible for the selection of poor nubile but honorable virgins in Parma, the allotment of their dowries and arrangement of their marriages. Every year, on the feast of the Anunciation, twenty young women dressed in white solemnly entered the church of the Steccata in order to receive a bag containing dowry monies.[37] Such ritualistic use of space would have had its lyrical counterpoint in the dance of the painted Virgins above, in the light and wisdom revealed by sundry vessels in the vault. No gold or silver vessel was more dear to God, however, as Saint Jerome reminds, than the temple of a virgin's body.[38]

Parmigianino's lovely bridal attendants are themselves strongly modelled with directional light from the east, for they were to have served merely as a prelude to his decoration of the eastern apse. There, we recall, the artist had intended to show the Coronation of the Virgin by Christ, her Son and Bridegroom, and he had submitted from the beginning a related design of the scene.[39] If his drawings for the vault are any indication, he probably would have reworked many times his visualizations of that wisest of virgins, the ultimate and most resplendent of all vessels. Alas, he was not granted more time to do so.[40] We are left therefore to imagine just how the continual wandering of his mind and pen might have envisaged the Virgin Mary, and if such invention would have been so dazzling as to rival in brilliance even Petrarch's words: 'Beautiful Virgin who, clothed with the sun and crowned with stars,/ so pleased the highest Sun/ that in you He hid His light . . . . Wise Virgin, one of the number of blessed wise virgins,/ rather the first,/ and with the brightest lamp.'[41]

## Notes

1.  Vasari, Le vite . . . ed. Milanesi: V, especially 231–2. On the possible role of alchemy in Parmigianino's art, see Fagiolo Dell'Arco (1970). Contrast Grasman (1985) and Moffitt (1988).

2.  Popham (1971): no. 719 r. (plate 343). For the drawings connected with the Steccata project, see Popham: I, 22–5 and 101–3, plates 309–44, and below.

3.  For the documents, see dall'Acqua (1982). A useful summary of the commission is found in Freedberg (1950): 189–97.

4.  The undated informal agreement, evidently preliminary to the official notarial act of 10 May 1531, is transcribed in its entirety by dall'Acqua (1982): 137: '. . . pingere la nichia cioè l'cubo over volta de la dita chapela grande et farli como hanno prepose una inchoronatione et observando la meta del desegno qualo ano visto . . .'. This drawing appears to be lost. Regarding the extant studies for the Coronation, see Popham: I, 25–6.

5.  Gilt rosoni were thus intended from the beginning to decorate the coffered vault, and the repeated reference to 'lacunari' and 'rose' in the document suggests this aspect of the decoration to have been a priority for the patrons. The presence of coffered vaults accords with the overall classicizing architectural language found in the Steccata, although the particular insistence on gilt rosoni may require further explanation, perhaps in terms of the Marian dedication of the site. For the architecture of the Steccata, see Adorni (1982).

6.  L.B. Alberti, De re aedificatoria, Book VII, 15. The treatise appears to have had broad impact on the architecture of the Steccata (see Adorni, 1982). Parmigianino's friend the local architect

Damiano Pieti (the same who repeatedly interceded on his behalf during conflicts with the Steccata confraternity) was translating *De re aedificatoria* at the time that the painter was working on the Steccata project, and Parmigianino would therefore likely have been familiar with the passage under discussion. Book VII, 15 also contains ancient recipes for gilding, which would presumably have interested the artist given his role in the gilding of the Steccata *rosoni*.

7. Popham (1971): no. 228 r. and v. (plates 312–13).

8. For illustrations of the vault in all its breathtaking detail, see Ghidiglia Quintavalle (1970).

9. Popham (1971): no. 301 r. and v. (plate 330).

10. Popham (1971): no. 229 r. (plate 314).

11. Popham (1971): no. 718 r. (plate 316).

12. Compare, in particular, Popham (1971): nos 451, 663, 719r., 450, and 514. Essentially the same configuration of maidens appears on both sides of the Steccata vault, which suggests reliance on a common cartoon. The Virgins of the south and north walls differ in terms of their lamps (lit or not), drapery colours and facial expressions (furrowed brow or not). On stylistic differences in the maidens and the possibility of shop intervention, see Freedberg (1950): 193–5.

13. Statuary groups of the Three Graces or ancient reliefs of dancing maidens (e.g. the Borghese Dancers) likely provided an important visual source for Parmigianino's maidens, as did the mural paintings of Raphael and especially Correggio (e.g. the variously posed soffit figures in the Parma Duomo).

14. For the parable and its liturgical and iconographic tradition, see Körkel-Hinkforth (1994): especially 17–31, with previous bibliography.

15. Gould (1994): 133. Compare Freedberg (1950): 97, and Popham (1971): I, 24.

16. For the commission, see Freedberg (1950): 186–9 (plates 80–3), and Vaccaro, forthcoming. A document of 1534, commonly thought to be the contract for the painting, does not provide information about the subject matter to be depicted.

17. Popham (1971): I, 25–6, and plates 345–60. See also Ekserdjian (1984) and di Giampaolo (1983–84).

18. Vasari, ed. Milanesi: V, 231. The cross, though now much abraded, is still visible in the original.

19. For Mary as vase, see *Summa aurea* . . . (1866): XIII, cols 410–25.

20. Related drawings depict, for instance, the Christ Child proffering the vase to the Madonna, or the angel raising the Child with the vase, or the angel pointing to a cross on the vase. Compare, for example, Popham (1971): nos 509, 454, 383 and 26.

21. Cropper (1976).

22. The dialogue *Hippias Major*, thought to be by Plato in the Renaissance, relates the elegant forms of vases and women to absolute beauty. See Rowland (1994): esp. 95–6.

23. Regarding the exegetical tradition, see Matter (1990) with previous bibliography. For the relation of the *Madonna of the Long Neck* to Canticles, though her interpretation differs from mine, see Davitt Asmus (1977): 114–82.

24. See the parallel English and Italian texts in Petrarch, ed. Durling (1976): no. 366, 578–9, line 46.

25. The only printed edition of Baiardi's poems (ed. F. Fogliazzi, Milan, 1756) is partial and problematic. I am currently revising for publication a paper entitled 'Figuring the Beautiful in Renaissance Parma', presented at the 1995 Renaissance Society of America meeting, which relates Parmigianino's art to Andrea Baiardi and the Petrarchan tradition in Parma.

26. Popham (1971): I, 115–16 (no. 284, plates 317–18). For the transcriptions, see related entry in Bentini ed. (1989): 74–7. All of these plants are Marian symbols (cf. Levi D'Ancona, 1977).

27. These lines (which have to my knowledge not been hitherto identified) derive from a poem by Petrarch excluded from his definitive edition of the *Rimesparse*. The matter will be discussed in my forthcoming study on Parmigianino and Petrarchism.

28. Dolce, ed. Roskill (1968): 182–3. On Dolce, Petrarchan desire and visual subjectivity in Renaissance art, see now Cropper (1994).

29. Firenzuola, ed. Fantini (1802): I, 54–6. On *vaghezza*, see Sohm (1995): esp. 768–73.

30. The letter is transcribed in Gaye ed. (1840): II, 71–3.

31. Popham (1971): no. 668 r. (plate 423).

32. For *canephoroi*, see Lissarrague (1995).

33. The fact that the Steccata Virgins do not agree in number with the biblical parable, or that the lamps were introduced late in the creative process, need not be problematic. The attribute can function as a generic sign in the depiction of Christian virgins (cf. Durandus' *Rationale divinorum officiorum*, I.15, a book that actually appears among the books and liturgical vessels in Parmigianino's frieze on the south wall).

34. For *leggiadria* in dance and moral comportment, see Fermor (1993).

35. See reproductions in Ghidiglia Quintavalle (1970): plates 104–16, and Fornari Schianchi ed. (1991): esp. 7–15. The books surrounding the vessel in the centre of the south frieze are mostly closed.

36. See, for example, Fagiolo Dell'Arco (1970): 48–53. His suggestion that the alchemical nature of Parmigianino's imagery in the Steccata caused his troubles with the confraternity, however, is untenable. The decorative scheme evidently pleased the confraternity, since contracts for the other vaults specify that Parmigianino's example be followed.

37. See Marocchi (1982), with an illuminated decree of 1518 showing a procession of young women in receipt of dowry (16), and dall'Acqua (1984): 160–6.

38. St Jerome *Letters* . . . (1893): letter 22.23 to the virgin Eustochium, also including references to the Wise and Foolish Virgins. For this famous letter and Jerome's importance in the Renaissance, see Rice (1985).

39. See n.4 above.

40. By 1539, its patience completely exhausted, the confraternity debarred Parmigianino from the project and looked to Giulio Romano to paint the apse. In 1540, only months before his death, and exiled in Casalmaggiore, Parmigianino wrote to Giulio to dissuade him from taking the commission; the desperate letter indicates Parmigianino's vain hopes to resume work in the Steccata.

41. Petrarch, ed. Durling (1976): no. 366, lines 1–3 and 14–16. On the common liturgical tradition associating Mary with light and wisdom, see Catta (1961).

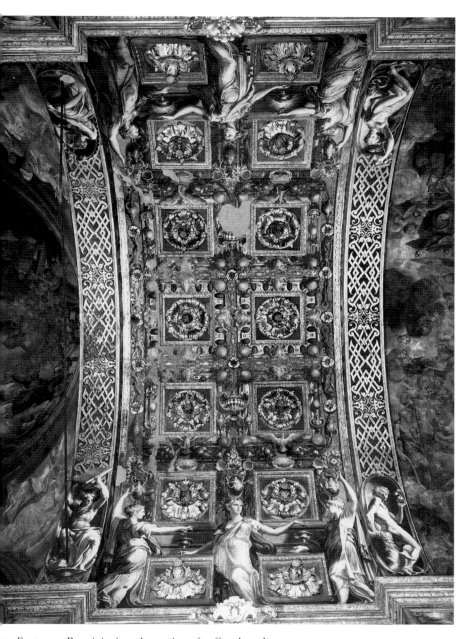

1   Francesco Parmigianino, decoration of coffered vault

11.2   Francesco Parmigianino, drawing for the Steccata Virgins

11.3  Francesco Parmigianino, frieze below coffered vault, detail

11.4    Francesco Parmigianino, frieze below soffit, detail

# Michelangelo's Christian neoplatonic aesthetic of beauty in his early *oeuvre*: the *nuditas virtualis* image

*Joanne Snow-Smith*

In his *De amore* (the *Commentary on Plato's Symposium on Love*) Marsilio Ficino states that God is the totality of goodness and that beauty is the reflected splendour of the divine countenance.[1] To the Christian Neoplatonists of the Renaissance, God was beauty and the source of beauty. God's image is man. Therefore, the ideally beautiful man is the closest approximation of God on this earth. From this follows that in the process of creating a beautiful work of art a concept must first be formed in the mind and then translated into visible terms. Michelangelo was knowledgeable in the Christian Neoplatonic theory of the time. He believed that the spirit of classical art inspired and guided the formation of the concept of beauty in the mind.[2]

Michelangelo's work appears to support this belief. His internal contemplation of the desire for the fruition of beauty resulted in the new style of idealization and perfection of form found within his early *oeuvre*. His emphasis on the depiction of the male nude shows his conviction that the nude figure is more noble than anything that might clothe it, a conviction evincing the Christian Neoplatonic belief in the beauty of man as a reflection of God. Thus, he embraces the symbolic meaning of nudity as *nuditas virtualis*, a state of innocence. Through Bertoldo di Giovanni, Michelangelo came to know Lorenzo de' Medici and the philosophers of the Platonic academy of Florence which had been founded there in 1463 by Cosimo de' Medici. His obsession with the study of classical sculpture began while he studied in Lorenzo's Giardino di S. Marco, and it was here also that the young artist came under the spell of the Neoplatonic philosophy of the humanists Marsilio Ficino, Pico della Mirandola and Angelo Poliziano.[3]

These Renaissance humanists saw no conflict between the newly rediscovered wisdom of the ancient world and the authority of the Church. As Kristeller points out, 'Though Platonic philosophy has its own authority and tradition, it is in no way opposed to Christian doctrine and tradition', as

there is an 'intimate affinity of Platonism with the Mosaic and the Christian doctrines which to Ficino and his fellow humanists fulfils a mission necessary to the divine scheme of world history.'[4] These Neoplatonists wished to fuse pagan idealism with Christian doctrine, to give expression to what Jacob Burckhardt terms 'the reconciliation of the spirit of antiquity with that of Christianity'.[5] Nowhere is this reconciliation between the Church and the pagan world more explicit than in Michelangelo's early work. As Panofsky has pointed out, Michelangelo's poetry is full of 'Platonic' conceptions, as are his paintings and sculpture.[6] Michelangelo was familiar with the *Commentary* by Cristoforo Landino in which every line of Dante's *Divina Commedia* is interpreted in Neoplatonic terms. 'Among his contemporaries', Panofsky continues, 'the artist was the only one who adopted Neoplatonism . . . as a metaphysical justification of his own self.' Antique art, centred on the concept of a noble human mind in an ideal body, provided convincing models for him to emulate. As Plato explains in the *Timaeus*, the ideal of beauty, one form of truth, is governed by reason evident in its system of measurement and proportion.[7] This Ideal Man by his heroic and divine virtue raises himself above the level of common beings and is an example for them. The principal concern of this classicism in art is always with the *ideal* in form as well as in content: it approaches the idea of Platonic love in its purest sense.

The internal contemplation of the desire for the fruition of beauty, as defined by Ficino in his *De amore*, which ultimately results in the luminous and all-embracing beauty reached at the state of divine love,[8] is apparent in Michelangelo's new idealization and perfection of form in the St Peter's *Pietà* of 1499.[9] A majestic serenity gives a poignancy of extreme power to the intimacy of the relationship between the Mother, the compassionate and meditative *Mater Salvatoris*, and her dead Son. Michelangelo here reached the goal of externalizing 'divine love'. The sculptural perfection and beauty of the human body of Christ, covered only by a narrow loincloth, becomes Michelangelo's image of God on this earth.[10]

With the nude figure of *David*, sculpted in Florence between 1501–04, Michelangelo proclaimed forcefully his fervent belief in the *nuditas virtualis*. While earlier Renaissance artists, following the Bible, had represented David as a young boy, Michelangelo portrays him as a youthful adult male much as the ancient Greeks, followed by the Romans, had portrayed Hercules. For Michelangelo, David is a hero with no shame in his nudity, for he is in a state of innocence, poised in readiness to defend good over evil. In the powerful stance and the beauty of the delineation of the musculature, one can see reflections of the *Dioscuri* which he certainly saw in Rome and which since the beginning of the fifteenth century had been considered the most important prototypes for the depiction of the male nude figure.[11] However,

Michelangelo's statue is not an artistic imitation of an antique model but a new manifestation of masculine strength as the symbol of spiritual strength. Since early Christian times, David had been considered as a 'type' of Christ, and the story of David and Goliath was understood more widely as symbolizing the victory of right over wrong.[12]

Michelangelo conceived his *David* as a nude, reflecting the ancient philosophy that nothing in the human body is disgraceful either by sight or name.[13] In Chapter 4 of Speech V of the *Commentary on Plato's Symposium on Love*, Ficino makes clear the merit of the beauty of the body when he writes that 'the soul is prepared for the body by its own nature, that is both a spirit and a mirror, as it were, next to God, a mirror in which the image of the divine countenance is reflected.'[14] In Speech VI he enlarges on the importance of the beauty of a man: '. . . We do not hesitate to call it the beautiful, the good, the blessed, and a god'.[15] Within this same speech, Ficino talks about the nudity of the body as 'Love which wanders *without cover* and naked' [his emphasis], and continues that 'the beauty of the body ought to be a road by which we begin to ascend to higher beauty'.[16] He expands on this theme in Chapter 18 entitled: 'How the soul is raised from the beauty of the body to the beauty of God'.

In 1505 Michelangelo was summoned to Rome by Julius II to begin the tomb of the Pope, a project which the artist approached with sublime joy. However, in 1508 the Pope's interest turned towards the repainting of the Sistine Chapel ceiling, which Michelangelo reluctantly began on 10 May 1508 and which would totally consume him for the next four years.[17] Three hundred and forty-three sculptural figures were to act out the theme of the *Salus Mundi*, the Salvation of the World. The Sistine Ceiling, with its three-dimensional figures, manifests explicitly the Christian Neoplatonic concept of beauty expressed through the influence of antique sculpture. This Neoplatonic enfleshment of physical beauty of the nude human figure reflects, as a mirror, the glorified image of God. Nowhere is this more powerfully expressed than in the well-known scene of the *Creation of Adam*. The body of Adam in its *nuditas virtualis* state of beauty is receiving the incarnation of a soul; that is, the transcendence of spirit through the power of God. For the Renaissance Neoplatonists, as Michael Allen has indicated, 'beauty was raised to the status of being the highest artistic and even moral and intellectual abstraction'.[18]

That for Michelangelo nudity could have conveyed absence of original sin is clear when we consider Michelangelo's statue of the *Risen Christ* (Figure 12.1). In the contract of 14 June 1514, it was specifically requested that the statue be lifesize, nude and standing cradling the Cross in one arm.[19] The statue was finally placed next to the left choir pier of S. Maria sopra Minerva on 19 October 1521. It is not known if the unusual request for the figure of

Christ to be portrayed completely nude was the desire of the patrons (Bernardo Cencio, Canon of St Peter's, Mario Scappuccio and Metello Vari) to symbolize the Resurrected Christ, or if it was a concession to Michelangelo's own artistic preferences. In the portrayal of this nude figure Michelangelo depicts the Saviour as a classically beautiful Greek god, whose perfection in all bodily parts reflects Christ's purity and His victory over sin; truly as an image of God. Leo Steinberg explains that '. . . Christ's necessary exemption from genital shame follows from the theological definition of shame as the penalty of Original Sin'.[20] Therefore, the word *pudenda* (shameful parts) would be a wrong designation when applied to Christ for the word derives from the Latin *pudere*, to feel or cause shame. Michelangelo's *Risen Christ* was one of the most admired works in the sixteenth century: Vasari called it a 'figura mirabilissima'. It remained unclothed until at least 1546, and in 1588 it was draped with an apron loincloth. It is reported that sometime before 1638, a monk, acting out of religious compunction, mutilated the penis underneath. The loincloth was restored in 1735 and more recently in 1933.[21]

The philosophical and artistic aspects of Michelangelo's works were dramatically augmented by newly accessible, or newly discovered, antique sculptures such as the *Apollo Belvedere*, the *Laocoön*, and the *Belvedere Torso*. Michelangelo was particularly drawn to the latter, with its exaggerated musculature and twisting, restless counterpoise. Reflections of the *Belvedere Torso*, which Michelangelo called his 'master', became a constant in his works. Through the study of the *Laocoön* and the *Torso* he was reintroduced to the classical idea of the *figura serpentinata*, a calculated construction of the movement of the body to obtain the maximum of torsion in the minimum of space, giving an ecstatic quality to the figures symbolizing an externalization of the spirituality of the soul.[22] This spiritual quality of ecstasy called 'divine fury', considered nearest to grace and engendered by the Hellenistic *figura serpentinata*, is embodied by Michelangelo in his *nuditas virtualis* figures, in paint and in marble. The power of the *figura serpentinata* to express invisible human passions through its pyramidal composition and flame-like proportions satisfied Michelangelo's artistic needs to convey his own deepest emotions.

Classical writers had proposed that men's souls are indicated in the expressions of the face and movements of the body, as in counter-position, strictly analogous to the *figura serpentinata* in sculpture. To the Renaissance Neoplatonists a parallel Christian meaning, which had its roots in the mystical and transcendental religious timbre of early Eastern Christianity, was also inherent within this figural motif. With the renewal of Neoplatonism in the later fifteenth and early sixteenth centuries, there came a strengthening of the appeal of the *Celestial Hierarchy*, written c. AD 500 by the

so-called Dionysius the Areopagite, whose writings achieved enormous esteem.[23] For example, his works became a favourite theological authority for Giles of Viterbo,[24] a member of the College of Cardinals and a mystical and spiritual support for writers of the Augustinian and Franciscan Orders.[25] Two years before his death in 1499, Marsilio Ficino made a new translation of the works of Dionysius the Areopagite, and they thus entered into the lexicon of Renaissance philosophy.[26] The Renaissance belief in the concept of light metaphysics took form with the guidance of the *Celestial Hierarchy*. Light had long been associated with God from pagan to Christian times, Christ Himself saying 'I am the Light of the World [*Ego sum lux mundi*]: He that follows me shall not walk in darkness, but shall have the light of life' (John 8:12); but it was Dionysius the Areopagite who codified the belief of the place of light in God's world. Radiant light, he wrote, emanates from God, is imparted to the heavenly angels, who in turn impart intelligible light one to another in descending order, that is, through the celestial hierarchy, to the mind of man. With the aid of angels, man is able successfully to ascend to the hierarchy to the divine light, that is, God. This may come about through the action of divine love considered by Dionysius as the 'divine madness', an ecstatic motion in which the divinity leads and conserves all in every manner while it enraptures the soul. He wrote that 'the motion of the divinity is spiral (winding) in its steadfast procession and fecund rest.'[27] The unlimitedness of the divine, he continues, is best imagined through fire, and in the *Celestial Hierarchy* he explained that 'for the sensible fire is, so to speak, in everything and passes unmingled through everything . . . it is invisible displaying its own majesty to the materials receiving it . . . it is energetic, powerful, and manifesting itself suddenly . . . by a sort of seeking . . .'[28] While it is nearly impossible to transform an intellectual concept of such magnitude into physical reality, Michelangelo in his use of the *figura serpentinata* has achieved it. This symbolic externalization of the spirituality of the soul through the flame-like spiralling movement of the human body is very pronounced in many of the *ignudi*, the twenty nude youths on the Sistine Ceiling.

During 1513–14 Michelangelo carved the so-called *Dying Captive* (Figure 12.2) and the *Rebellious Captive* (Figure 12.3), to accompany other *Captives* and figures of *Victories* on the first level of the second project for the Julius II tomb.[29] I believe that the *Captives* form part of a moral allegory of the immortality of the soul.[30] In the *Dying Captive*, Michelangelo implied both the Neoplatonic concept of the ascent of the lower soul from a physical life of struggle and suffering and the Christian doctrine of the imprisonment of the soul by the bonds of sin. Through the subtle movement of the figure, he has suggested the divine aspect of the human soul attempting to break these bonds and ascend to Heaven. The human body conveys the Platonic idea of

beauty and reveals the creativity of the Christian God. The shame of the human condition is suggested not by the nude body but by the symbolic use of fetters which have bound it to the terrestrial world. This becomes quite evident with the inclusion at the base of the rough-hewn image of an ape, a Christian symbol of the licentious and prurient lower nature of humanity, a metaphor perhaps derived from the early Christian text *Physiologus*, where the ape is portrayed as wicked but also as prone to imitation.[31] In the Renaissance the ape was recognized as a negative caricature of Man's own distorted, ignoble self and as an image associated with vice and sin in general. Often it was used as a personification of lust or vanity and shown holding a mirror in which the sinful soul of humanity was reflected.

It was also occasionally used as an emblem of the arts of painting and sculpture inasmuch as they were based on imitation, and several scholars have been inclined to interpret Michelangelo's inclusion of an ape in this way.[32] However, I propose that the ape, whose name from early times became a pejorative epithet and a symbol of malice and physical ugliness, plays a pivotal rôle in the iconographic meaning of this statue. Its ugliness suggests the evil from which the figure attempts to extricate itself, according to Platonic conceptions linking physical and moral states. Michelangelo had already categorically demonstrated this belief in the fresco of the *Fall of Man* and *Expulsion from Paradise* on the Sistine Ceiling. Before the Expulsion Adam and Eve are shown as physically beautiful; afterwards they are agonized figures, heavier, older and lacking in youthful beauty. In keeping with its sepulchral setting the *Dying Captive* has been given the meaning of the *Eros funèbre*, an image often identified with the winged Thanatos, the Greek gentle genius of death. During the Hellenistic and Roman periods, standing statues of the Sleeping Eros or Somnus, the genius of sleep, were incorporated within a funerary context. The main stylistic and iconographic characteristics of this popular theme appear in a Roman second-century AD *Sleeping Eros* now in the Ashmolean Museum, Oxford (Figure 12.4). The winged nude allegorical figure leans on an inverted torch indicative of the end of life, in an attitude of mourning or sleep; the bow and arrow, symbolic of terrestrial pain-inflicting activities, lean against his right leg. Images of death are barely distinguishable from Eros, and the conflation of these personifications may explain the countless representations in Roman sepulchral art in which death appears as communion with a god through love, as, for example, Psyche and Eros, Endymion and Diana, and Ganymede and Zeus.[33] This love of a god for a mortal was understood to mean that death constituted a deified love through which the mortal was able to attain eternal happiness, a notion set forth in the Renaissance in the so-called *Chaldean Oracles*.[34]

One of the fundamental doctrines of Christianity from the earliest period is the belief that all those who die in the love of God enjoy eternally the face-to-face vision of God: the soul and God are united in an act of love, resulting in a perfect and unceasing joy.[35] To the early Christians, salvation could only come through God's *agape*, the creative and redemptive outpouring of God's love. Inevitably this Christian *agape* became confounded with the creative Eros, deriving from Plato's *Symposium*. The Platonic belief that man could return to the unity of the One through divine contemplation of love as beauty became fused with the Christian belief in salvation through grace during the Florentine Renaissance. Chastel notes that as 'Eros and *Agape* join forces, man struggles up from the sensory towards the intelligible and so retrieves his unity'.[36] It is precisely this struggle of the *Dying Captive*, attempting to return to his first innocent state, the *nuditas virtualis*, in the heavenly realm that Michelangelo has been able to externalize into marble. The figure is not sleeping, but is attempting to reach the hypostatic union with the Godhead through the death of the mortal body. This image of the divine aspect of the human soul would indeed have represented the hope of the Church for its late Vicar of Christ on Earth.

In the *Rebellious Captive*, completed at about the same time, we are faced with a totally different figural style. The pathos of the *Laocoön* seems to pervade the statue, while the massive musculature of the body clearly reflects Michelangelo's continuing emulation of the *Belvedere Torso*. Nowhere is the fury of the flame-like twisting figure so compelling as in this *Rebellious Captive*. The sculptor is able to make visible artistically the dramatic struggle as the soul attempts to spiral upward, like fire. Here he has found the vehicle to express his mystical interpretation of light as an upward flame seeking the divine light, as theorized in Dionysius the Areopagite's *Celestial Hierarchy*. The ecstatic torsion of the *figura serpentinata* explicitly suggests the same torsion of the soul. However, within this statue we seem to feel a polarity between the spirit and the human form. It shows the passion of the soul which cannot free itself from the licentious sins of this mortal life. Michelangelo has created an image not of the surrender of the body to the soul, as in the *Dying Captive*, but of the conflict of the soul as it fights desperately with the body. With an expression of despair and supplication, the *Captive* lifts his head upward as if to seek compassion and clemency from the Godhead as he fights against the funerary bonds of death symbolized by the flat, narrow band across his chest. Motzkin has pointed out that the bands evident on both *Captives* were meant to reflect symbolically the bandages used for swathing the dead, a specifically Christian symbol.[37]

Unusually among Michelangelo's male figures, the *Rebellious Captive* is not completely nude since he wears a loincloth secured by a strap. This raises the question as to why the genitalia are covered in this case. The terrestrial

manifestation of pure love which the human soul bears towards God, called *amor divinus* by Ficino and the Neoplatonists, was in opposition to the vulgar or concupiscent concept of love connected by Plato in the *Symposium* with the earthly Aphrodite, which governs the sensual passions of the body.[38] This Platonic emphasis placed on the sensual nature of the body as the lower or sinful was carried over explicitly by the early Christian theologians.[39] The early Church believed that dangers in this human passage through life towards God resulted in two wounds of the soul: the *intellectus*, subject to the wound of ignorance; and the *affectus*, subject to concupiscence.[40] These were regarded together as hereditary results of the fall in Adam's children, but concupiscence was so tightly interwoven with the doctrine of original sin that it was considered by many as both the sin and its consequence for future generations. Michelangelo's *Rebellious Captive* represents this struggle against the bonds of concupiscence as his genitalia are condemned as 'shameful parts' by being covered by a loincloth.[41] The figure may be an allegory of the tortures caused by intemperate physical love, symbolizing the agonies of hedonistic sensual passion which enslave and debase the soul.

Michelangelo had originally planned a series of female Victories to counter the theme of the Captives, but at a later date the plan was changed to show two male Victory groups.[42] Only the *Victory*, of about 1521–3, now in the Palazzo Vecchio (Figure 12.5) was executed. Several credible theories have been set forth for the meaning of this *Victory*, but I should like to propose a new one based on Michelangelo's choice of the beautiful serpentine figure subduing its physical opposite. The *Victory* can be connected with the *Rebellious Captive*, although the violent psychomachy against evil and the world has here been resolved and the *Victory* has won its own 'conflict of the soul with the body'. I believe that in the *concetto* for this group Michelangelo returned to the literary images of the Greek *sophrosyne* (Latin *temperantia*), a complex category of myth intended to 'sophronize' men by instilling wisdom and prudence through warnings and examples.[43] In the early fifth-century AD text of the *Psychomachia* by Prudentius, two of the images of the seven major virtues and vices represented important facets of the Greek *sophrosyne*, also commonly found in its Latin representatives: *Pudicitia* (chastity) and its moral combatant *Libido* (lust or lechery). In the Renaissance the emphasis was usually placed on the image of the triumphal victory of virtue rather than on the actual battle itself, as had been seen in medieval representations. It is this victory that Michelangelo has represented in his *Victory* group. The youthful, beautiful figure of the *Victory* symbolizes the Platonic concept of beauty as the reflected splendour of God and of the human body as the image of God. In a marginal note on this subject in a poem of Cristoforo Landino, Marsilio Ficino makes clear that beauty denotes

good and ugliness evil, 'for since love is a desire stricken by beauty, it loves beauty and takes pleasure in beautiful sights. Whatever is good is beautiful, and everything evil is ugly. Thus love enjoys the good and avoids the evil.'[44] Ugliness was often characterized by old age, and Michelangelo has drawn a strong contrast between the youthful, spiralling nude figure of the victor and the twisted, crouching figure of the vanquished. He is an old man with roughly chiselled head and body, clothed in armour and chlamys, his arms tied behind his back in an attitude of debasement. In my view Michelangelo has depicted the figure of *Victory* as a *pancratiast*, the victor in the brutal athletic contest known as the *Pancratium* which was part of the famous Games held at Olympia.[45] Michelangelo's compositional scheme apparently reflects a scene often depicted on ancient Greek vases, the harsh ending of the contest marked by the triumphant pose of the *pancratiast* mastering his opponent in the so-called 'all-in wrestling'.[46] Extraordinary toughness was required to withstand this ordeal, and it is the moment of triumph that becomes Michelangelo's vehicle of expression in his *Victory* in which good has triumphed over evil in the ultimate battle of the human soul in its duality, the celestial and the terrestrial. The victory is complete, but evidence of the *furor amatorius*, the expression of truly Platonic, all-pervasive and all-effacing passion, is evident in the *figura serpentinata*, the externalization of the forces inherent within the relentless struggle. It would certainly reflect the victory of the purified soul overcoming sin in its journey towards God, a victory intended to reflect also that of the soul of Pope Julius II at his death.

In his early works Michelangelo reconciled a Christian ascetic sensibility with the sensuous beauty of the pagan Olympian deities. But in his later sculptural images, the physical beauty of the human body is replaced by a beauty of profound religious spirituality. In Michelangelo's creative corpus we can perhaps trace his own personal 'journey of the Soul to God'. Starting with the Christian Neoplatonic concept of the perfect beauty of the nude male body, as in the figure of Christ in the St Peter's *Pietà*, he concluded six days before his death with the dematerialization of the physical body of Christ in his Rondanini *Pietà*. The radical carving of the mutilated statue seems to reflect Michelangelo's 'ardente desio' to achieve a symbolic hypostatic union with the moribund Jesus, recalling his words when he first began to carve this work: 'Oh! Flesh, Blood and Wood, supreme pain, Through you must I suffer my agony'.[47] As the forms of the Son and Mother spiral upward with the delicacy of incense, Michelangelo has manifested the final expression of his life-long journey to break the bonds of this earthly realm and return to the celestial realm of the Godhead, reflecting his words, 'Al cielo aspiro'.

## Notes

1. Ficino, trans. Jayne (1985): 88–90.

2. Even a partial list of the pertinent material on Michelangelo is too enormous to present. However, I should like to mention several: Murray (1984); Hibbard (1974); de Tolnay et al. (1965); Poeschke (1996); Hartt (1984); Salvini (1976); Condivi (1976); Wilde (1978); Clements (1961); Richmond (1992); Summers (1981); and de Vecchi (1991); this last is particularly recommended for its plates.

3. For a cogent discussion of this philosophy, see Kristeller (1980): 1–68.

4. Kristeller (1943): 23–9.

5. Burckhardt (1965): 384–5. For a study on the artistic expressions of this reconciliation of Christian doctrine and Florentine Neoplatonic thought in the late fifteenth century, see Snow-Smith (1993): passim.

6. Panofsky (1939): 178–80.

7. Plato, (1985); *Timaeus*, trans. Jowett, passim, 87a–92c.

8. Ficino (1985): passim.

9. For discussion of the development of this sculptural image see Schiller (1972): II, 178–81. For a study of the early works of Michelangelo in Rome, including photographs of this *Pietà*, see Hirst (1994): 10–81.

10. Hall (1979): 82. See also Steinberg (1983): 131–3 and Dixon (1994): 10–13.

11. For a discussion of the influence of these important statues on Renaissance artists, see Pogány-Balás (1980): 7–11, plates 251–63.

12. Hall: 92–3.

13. Steinberg: 20–1.

14. Ficino (1985): 94.

15. *Ibid.*: 108–9.

16. *Ibid.*: 124.

17. The literature on the Ceiling is vast, but Richmond (1992) is recommended; see also Hibbard (1974): 57–96.

18. Allen (1984): 188–9.

19. Poeschke (1996): 99–101.

20. Steinberg (1983): 17, n. 17. For a different interpretation of the exposition of the nude body of Christ, see Bynum (1986).

21. Poeschke: 100–1.

22. For this, see Summers (1972).

23. For a discussion of the influence of these writings during the Renaissance, see Stinger (1985): 164–5.

24. O'Malley (1968): V, 58.

25. On the extent of this association during the sixteenth century, see de Andrés (1958–59): 12.

26. Kristeller (1980): 92.

27. Pseudo-Dionysius the Areopagite (1980): 68–9.

28. Quoted in *ibid.*: 69. In a letter to Bernardo Bembo Ficino graphically reflects this same meaning of divine fire: 'Oh, generous flames of our heart! Illumine us, we beg, shed your light on us and fire us, so that we inwardly blaze with the love of Your light, that is, truth and wisdom. This alone, Almighty God, is to truly know You . . .'; see Ficino, *The Letters* . . . (1975–81): I, 190–1, Letter 123.

29. For the history of this ill-fated monument, see Poeschke: 89–99. The name 'Slaves' is commonly applied to these statues today, but its use only dates to the nineteenth century. They were first identified as *prigioni* (prisoners) in Michelangelo's appeal to Pope Paul III of 20 July 1542; see Poeschke: 95.

30. For a different interpretation as well as a review of several earlier ones, see Motzkin (1992): 207–28. For other interpretations, see also Poeschke (1996): 87–98.

31. Biedermann (1994): 14–16.

32. For example, see Pope-Hennessy (1963): 30–1.

33. Wind (1968): 157–60.

34. 'As there are many kinds of death, this one is the most highly approved and commended both by the sages of antiquity and by the authority of the Bible: when those . . . yearning for God and desiring to be conjoined with him (which cannot be achieved in this prison of the flesh) are carried away to heaven and freed from the body by a death which is the profoundest sleep; in which manner Paul desired to die when he said: I long to be dissolved and be with Christ . . .'; *Conclusiones . . . de intelligentia dietorom Zoroastris et expositorom eius Caldaeorom* no. 7, quoted in *ibid*.: 154.

35. See, for example, Brandt (1962): 243.

36. Chastel (1969): 64.

37. Motzkin (1992): 216–17.

38. *Symposium*, trans. Joyce, M., in Plato, *Collected Dialogues* (1985): 180 b.

39. Saint Augustine, for example, states: '. . . the road is provided by one (Christ) who is himself both God and man. As God, he is the goal; as man, he is the way.' Augustine, trans. Bettenson (1972): 694–5.

40. For a discussion of these two 'wounds' together with artistic images, see Snow-Smith (1989), 159–69.

41. See n. 20 above.

42. On the complicated problem of dating this statue and for previous interpretations, see Pope-Hennessy (1963): 323–4, and Poeschke: 101–2.

43. For an extensive study on this important genre, see North (1979): chaps 1 and 4.

44. Landino (1939): 162. Also quoted in Ficino (1985): 61.

45. For a discussion of the *Pancratium* and the early Games, which began in 776 BC and were actually religious in origin, see Robinson (1948): 58–9. See also Hale (1970): 75–7, 202–7.

46. For an illustration from a Greek vase of a scene depicting a bout of the 'all-in wrestling', the *Pancratium*, see Robinson: plate IV.

47. For a history of the transformations of this statuary group, see Poeschke: 120–2.

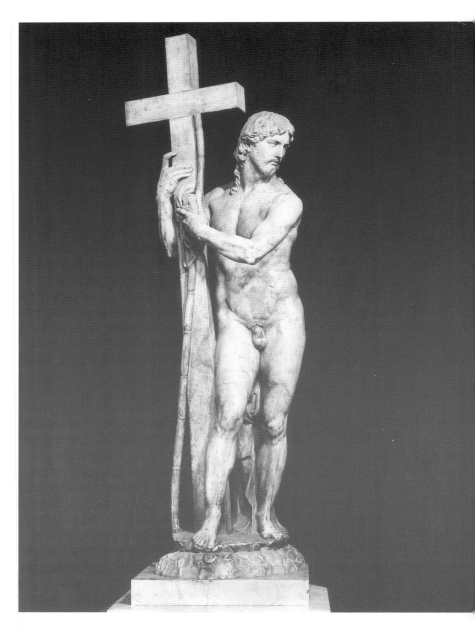

12.1   Michelangelo, *Risen Christ*

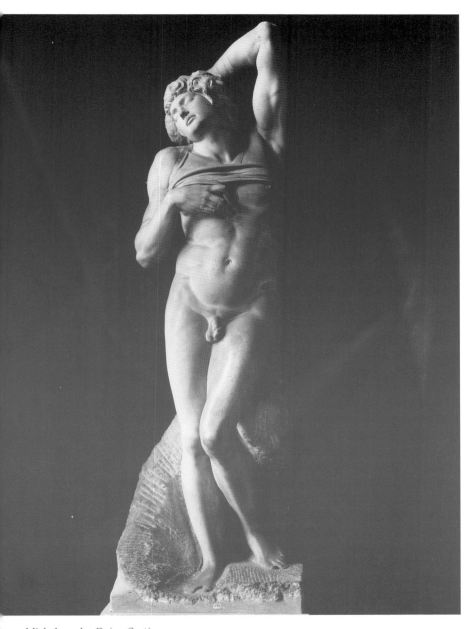

2.2   Michelangelo, *Dying Captive*

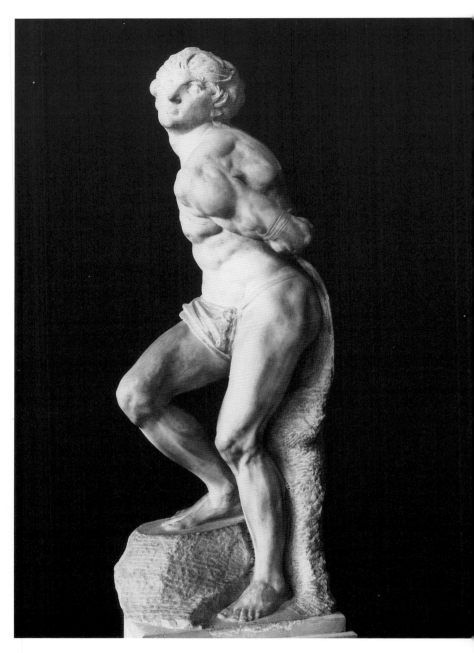

12.3   Michelangelo, *Rebellious Captive*

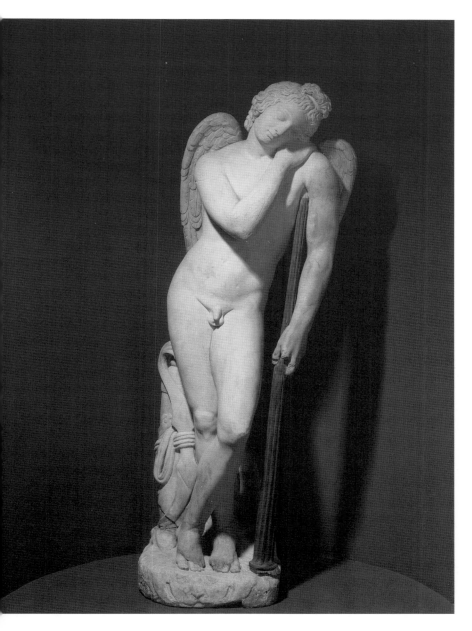

*Sleeping Eros*, second-century A.D. Roman copy of an earlier prototype

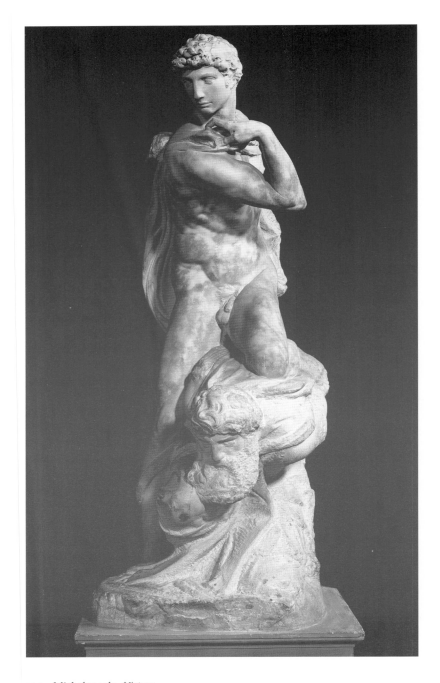

12.5   Michelangelo, *Victory*

# Venetian glass and Renaissance self-fashioning

*Paul Hills*

In seeking to define 'concepts of beauty in Renaissance art', priority is given to *concept*, that is, the result of a mental act of conceiving a notion or idea.[1] The implication is that what has first been conceived will then be in some fashion embodied in a work of art. In framing the topic thus, the ghost of the Aristotelian priority of form over matter still haunts us: what intellect conceives as form, craft obediently forges in matter. A dualism ingrained in humanist language is hard to escape, so we search for apposite texts to define the Renaissance concept of beauty, then trace their manifestation in visual art.

It is one thing to point to a theoretical position that was widely held, quite another to accept it on its own terms as an explanation. What if we start with the artefacts and the changing technology of their production? Instead of taking Renaissance discourse on art at face value, accepting the ontological priority of a concept of beauty, we might focus on the give-and-take, the dynamic interplay, between social practices and technological possibility. Following the lead of economic historian Richard Goldthwaite, we might examine how the increased production and differentiation of goods in the Renaissance – particularly luxury goods for domestic use – sharpened and refined aesthetic sensitivity.[2] The market is a driving force, creating differentiation and proliferation of goods. Such is the case with Renaissance maiolica. In this paper the focus is on another of the most successful developments in luxury manufactures of Renaissance Italy, Venetian table glass.

The novel social practice of using glass vessels in upper-class circles produces behavioural difference, and hence discrimination. Without denying entirely the force of concepts of beauty, as formulated in theoretical texts or in poetry, I would argue that beauty – *id quod visum placet* – is refined, developed, differentiated within the social sphere. Concepts may be more

significant in accounting for the reception of the work of art of artefact – *post facto* – rather than in their production. The remarkable technologies of Murano glass embodied beauty, made it intimately apprehensible to the sense of sight and touch, in ways that were influential in the secularization of ideals of grace and beauty which took place in the Early Modern period. I will argue also that the aesthetic awareness brought about by making or using glass is reflected and refracted in distinctive ways in the paintings of Titian and Tintoretto.

The fact that Renaissance table glass is little known to students of art history is indicative of the bias in favour of the fine arts, and of *images* rather than *objects*, which remains entrenched within the discipline, whether traditional or 'new'. Histories of Renaissance art in Venice omit discussion of glass,[3] and today's exhibition visitors are invited to believe that the 'genius' or 'glory' of Venice resided almost entirely in painting. For contemporaries things were different: Venetian glass was one of the Republic's most sought-after manufactures.

In the fifteenth century the glass-blowers of Murano, the *fiolarii*, showed great technical ingenuity in counterfeiting objects in more precious materials.[4] The most skilled masters were diversifying their products to create a varied range extending from the absolutely transparent to the perfectly opaque, with degrees of translucency between. Angelo Barovier (d.1461) is credited with the perfection of clear glass with great surface brilliance, known as *cristallo* because it matched the highly prized transparency of rock-crystal. At the same time, in the mid-fifteenth century, an opaque glass, later called *lattimo* because of its milk-white appearance, was achieved.[5] *Lattimo* seems to have provided the means whereby highly valued Oriental white porcelain would be counterfeited in glass.[6]

Alongside the transparency of *cristallo* and the opacity of *lattimo* there were, by the second half of the fifteenth century, many distinctions of colour. A deep violet-blue glass, *turchino*, as well as a lighter blue, was achieved by using cobalt oxide (referred to in fifteenth-century Venice as *zaffera*). These blues, translucent greens and purples, and a more opaque aquamarine, were much used in goblets. In addition to glass that was coloured throughout the vessel, enamelling colours onto clear glass was revived and refined. In the 1490s a new technique for achieving translucent rose-reds, referred to in documents as *rosechiero*, was introduced to Murano.[7] The manifold effects achieved by layering gave scope to a new range of luxury products, which in turn refined the discrimination of the princes and patrician classes who could afford them. The Venetians successfully revived the Roman techniques of gold sandwich-glass and millefiori. Typically in sandwich-glass a layer of granulated gold is placed between a disc of aubergine glass and clear *cristallo*; during firing the granular gilding is slightly stretched, so that in the

finished vessel one sees through clear glass a speckled membrane of granulated gold floating on a translucent purple. In millefiori cross-sections of multicoloured canes are embedded like 'a thousand flowers' in a glass vessel. The density of the canes varies. Sometimes, as in a bowl of c.1500 in the Victoria and Albert Museum, patches of colour drift in the clear glass like shells stirred by the current of a stream (Figure 13.1). Twisting and turning of the canes, stretching their star patterns, blurring some, leaving others sharp, is initiated in the marvering (the rolling of the molten gather on the smooth surface of the marver) and fulfilled, as it were, in the blowing. In other millefiori vessels, such as a bottle in the British Museum, the canes are more densely packed.[8] In all cases the appearance of the vessel changes according to the lighting or angle a glass is held at, therefore rewarding the owner or bearer with an intimate experience of changing sensations of colour. Tilt a vessel one way, it appears predominantly opaque; turn it another, it shifts towards transparency.

To our eyes, jaded by bright colours, there is something rather kitsch about millefiori, and we may deduce that even around 1500 its rather obvious *belleza di colore* was fine for beads, paternosters and gewgaws – *conterie* as they were called – but never quite as serious or as *signorile* as another, related invention of the Venetians, the imitation in glass of veined hardstones or *pietre dure*. These imitations were known collectively as *vetri calcedonii*, chalcedony glass, although they counterfeited not only the colour and veining of chalcedony but also agates and oriental jaspers (Figure 13.2). In 1475 the Florentine Filippo Strozzi sent an agent to Venice to buy 'vetri calcedonii e porciellane'; and the agent duly bought eleven chalcedony glass vases.[9] Antonio Neri, whose *L'Arte Vetraria*, published in 1612, is the first detailed account of glassmaking, praises *calcedonio* as an art that surpasses nature. He says it is 'none other than a gathering of almost all the colours, and *scherzi*, which can be made in glass, not a common thing' – *cosa non vulgare*.[10] That term, *scherzo*, at once playful and musical, repeated several times by Neri, aptly characterizes the joyful release of colour in such glass from the responsibilities of representation, from the bounding by outline or *lineamenti*.

Despite these extraordinary achievements, the student of art history is more likely to know that Isabella d'Este was keen to acquire a painting by Giovanni Bellini than that she bought Murano glass; or that the Emperor Philip II commissioned a series of *poesie* from Titian, than that he possessed sixty-five examples of a novelty of the Murano furnaces, ice-glass or *vetro a ghiaccio*, in his palace, El Pardo.[11] Philip was buying the very best in Venetian painting and the very latest invention in glass. His eye would certainly not have missed the carafe of *cristallo* glass placed so emblematically in the

centre of a painting about transgression by sight, Titian's *Diana and Actaeon*.[12]

Another piece of glass is at the centre of an earlier canvas, the *Bacchanal of the Andrians*, painted for Alfonso d'Este, where a man holds up a *cristallo* ewer, revealing the red wine which is the source of the Andrian's joy.[13] While it has often been pointed out that by his mastery of oil glazes Titian has matched the transparency of glass and the translucency of wine, it is less often realized that the painting demonstrates the lightness for which Venetian glass was celebrated. Seemingly dancing, the man can hold the ewer aloft with effortless *sprezzatura*, in telling antithesis to the servant, exiting left, who is bent by the weight of an antique krater. Such a *contrapposto* of the lightness of modern glass drinking vessels against the weight of metal and pottery receptacles becomes a commonplace of Venetian feasting scenes.

The lightness of Venetian glass is due to two factors: it is lower in lead content than northern glass, and the composition of the frit allowed it to be blown and manipulated into thinner membranes. To produce such glass, the master glassmaker needed great dexterity in blowing, rotating on the pontil and in manipulating. Venetian technology, especially in the arts of fire, was one of the marvels foreign visitors came to see. They inspected the Arsenal and made the trip to the furnaces at Murano. As the diarist Marin Sanudo records, a visit to the furnaces was part of the protocol for foreign dignitaries; the Queen of France was taken there in 1502, the Duke of Urbino in 1532.[14] Prospective patrons visited Murano not just to see glass, but to see it being made: to marvel at the performing skill of the glass-blower. As if in recognition that the mastery of rhythm and grace displayed by the master glassmakers was akin to that of a courtier – therefore raising their families into a higher social class – Venetian patricians were permitted to marry the daughters of master glassmakers, without forfeiting their noble rank, a unique exemption from the ban on intermarriage with the offspring of manual workers.[15]

The performance of production acted as rehearsal for reception and use. When a wine glass was purchased and put to use, the control and poise exercised by the glassmaker was translated into another rhythm which became the self-conscious property of the bearer of the glass. Sixteenth-century Venetian glass was primarily a luxury export to the courts of Italy and Europe. Its success lay in the way it met the needs and fuelled the desires of an élite searching for ever greater degrees of refinement and grace. For the glassmaker, success in the market for luxury goods – worldly goods to fill the domestic spaces of palaces – depended upon multiplying the range of objects by differentiating their functions. The evolution of drinking vessels illustrates this market-led proliferation of novel forms. No longer will a

beaker do: the wine glass in *cristallo* must be developed to display the colour of wine and the social grace of the drinker.

The cultivation of manners was the obsession of a sixteenth-century ruling élite anxious to distance itself from anything that might bear the taint of brutish effort. The evolution of the wine glass fits in here as an accessory to self-fashioning. By extending the stems, broadening the bowls into shallow saucer shapes, and rendering the glass ever thinner and lighter, the Murano masters produced glasses that directed attention to maintaining the vertical – any tilt would spill the wine. The long-stemmed wine glasses have a poise and balance that is like an extension to the body, engaging the awareness in those who wielded them of their own poise. In some examples of balustered glasses the insertion of a blue stem between colourless foot and bowl achieved a floating lightness, an on-tip-toe quality (Figure 13.3). The awesome fragility of luxury table-glass added to its value as sign of difference, setting apart those who could handle it with delicacy from the vulgar drinkers who knocked about taverns with heavy tankards. Since neither glass nor maiolica were intrinsically expensive compared to tableware in silver, owning and using glass was more a statement about manners than about wealth. And the refinement of forms, rather than simply reflecting refinement of behaviour, did much to induce it. As such it was something that could be taught, so when a servant or slave, such as the black page in the left foreground of Veronese's *Feast at Cana*, proffers a brimming *tazza*, his poise and evident concentration function as a sign of exclusive training.[16] It is easy to see how the bearable lightness of the Venetian wine glass accorded with widespread aristocratic ideals of civility, with the cultivation of *sprezzatura*, and the particular lightness and ease of deportment often associated with the term *leggiadrìa*.[17]

If Veronese's paintings reflect this aesthetic based on social differentiation, those of Titian and Tintoretto modulate it in ways that are rather less obvious, bringing out what Theodor Adorno has characterized as the negative complement of any ideal of beauty.[18] In his long life Titian would have witnessed many developments in styles of glass. On Alfonso d'Este's instructions he had investigated the furnaces at Murano and submitted a clay model for vessels.[19] In his maturity and old age he was sufficiently wealthy to have possessed quality glass; no doubt it graced his table at the musical soirées held at Biri Grande, his house that looked across the lagoon towards Murano. By the middle of the century he would have seen ice-glass, the Murano invention which Philip II purchased so avidly.

Ice-glass is made by plunging the vessel after it has been blown, before annealing or cooling, into cold water, an immersion which causes the glass to crinkle or frost. In addition, splinters of glass may be scattered on the marver, and the cylinder of glass rolled on it so it picks them up on its

viscous surface. Further blowing or stretching will expand the pattern without smoothing away the seemingly haphazard roughness of the surface. As a result the apparent rotundity of the vessel is compromised and curiously flattened (Figure 13.4). On the face of it, given the triumphant achievement of perfect transparency in *cristallo*, as well as the rarified elegance of Venetian glass, ice-glass is a surprising about-turn.

I would like to suggest that ice-glass offers an analogue to what Titian does in his later paintings, such as the *Crowning with Thorns*, in Munich, or the *Diana and Callisto*, in Edinburgh (Figure 13.5), where the modelling function of light is in tension with the surface scintillation of impastoed white lead.[20] Like the crinkles in the ice-glass, the staccato rhythm in Titian's brush-strokes is wilful, partially obliterating the translucencies of glaze by the opacities of scumble, and threatening the integrity of volumes. To plunge a hot glass into water introduces into the manufacture a hazardous device, whereby the artefact is marked by the randomness of natural process: Titian, with his loaded brush, enlists comparable risk – a willed suspension of total control. And just as it is hard to look *at* the markings in ice-glass because they do not represent anything and therefore resist conceptual purchase, so Titian's rough impasto defers judgement and keeps attention in flux. It was pre-eminently princely patrons, such as Philip II, who were building grottoes and buying ice-glass, who became attuned to this wild artifice. For the sophisticated, roughness had become a necessary relief after polish.

Titian's younger rival, Jacopo Tintoretto, worked primarily for Venetian patrons – patricians and cittadini, the state and the *Scuole*. His work traces a different trajectory in its glassy similes. When he was in his teens, in the 1530s, the major innovation in Murano glass lay in the embedding of white canes in the vitreous matrix. *Vetro a fili*, or filigree glass, soon became diversified, with the canes twisted into spirals, *a retorti*, or flattened into broader white traces, *a fili*. The standing cup with cover in the British Museum (Figure 13.6) combines both.[21]

In filigree glass, white lines do not circumscribe forms or describe high-lights. In the standing cup the white *fili* encircle volumes without fixing them, suggesting airy nothings. Unlike highlights in painting, such whites do not imply a source of light or situate the beholder. *Vetro a fili* duplicates and repeats itself from every angle; unlike vessels with figurative decoration, they have no front and no back. To contemplate a vase or *tazza* in *vetro a fili* is to be reminded of eternity by a pattern that circles on and on. Nothing could be further from the perspectival, spatially orienting quality of line as *disegno*.

In Tintoretto's *Finding of the Body of St Mark*, in the Brera (Figure 13.7), there is a comparable release of line and light from any indexical relation to a viewing subject. Here too, white lines spiral in space without binding

volumes as contours. Tintoretto's white drawing with the brush on a dark ground, insouciant of tonal gradation, ravels the distant and the near. Though there is a perspectival scaffold (with the vanishing point over the outstretched hand of St Mark) the dynamism of the space is curvilinear.

In later paintings, such as the backgrounds to the *Baptism of Christ* and the *Adoration of the Magi* in the Scuola Grande di San Rocco, this spinning of a skein of white brush-strokes becomes even more daring.[22] These are analogous to the *tratti* that Boschini – seventeenth-century champion of Venetian *colorito*, and dealer in glass – will describe.[23] In many Murano goblets with canes placed vertically, a swirl in the pattern arises quite naturally from the necessity of spinning the glass while it is still ductile.[24] The twist of the canes moves round the essential symmetry of the goblet, just as Tintoretto's brush-stroke moves round the concealed symmetry of the human body. To such a comparison it might be objected that the delicate precision in filigree glass is poles apart from Tintoretto's hectic vigour, his *prestezza*. True, but it is noteworthy that Venetian glass vessels were peculiarly susceptible to changing shape during firing; on enamelled bowls, for instance, dots painted as circles are stretched to ellipses during rotation. In Tintoretto's backgrounds, the bodies are not so much *non finito* as held in suspension.

The trickery of photographs is to render differences of scale invisible by equalizing the graspable intimacy of glass and the vastness of Tintoretto's canvases, thereby luring us into false comparisons. But if we recall Ridolfi's description of Tintoretto's miniature stage, with its model figures draped in scraps of cloth, then it may not be so far-fetched to conceive of the painter moving from the rotation of an object in the hand, clay model or glass, to the larger world conjured by his brush.[25]

Rotation is of the essence. Recent studies have stressed that although Copernicus's demonstration of a heliocentric universe achieved definitive expression in the 1540s, it had little impact on astronomy before the very end of the sixteenth century. In arguing that the earth goes round the sun, Copernicus not only displaced the earth from its central position, but also set it into motion.[26] At the level of consciousness of the reading public, to which Tintoretto belonged, it was the setting of the earth spinning which was unsettling. For Tintoretto's friend, the proto-journalist Anton Francesco Doni, the image of the turning world was emblematic of the restlessness that afflicted all spheres of life in mid-sixteenth-century Italy.[27]

In this context, working for patrons who were less secure than Titian's, Tintoretto launched his representations of an expanded universe, in which man's position is decentred and motion never-ending. In the ceiling painting in the Scuola di San Rocco, *Moses Striking Water from the Rock*, God rolls in propelled on the ghost of a transparent orb, while below the fountain of water from the rock falls in an array of white arcs like the canes in filigree

glass.[28] Presence, which in High Renaissance art had been embodied in the figure, is now equally made manifest in the mobility of air and water.

If Titian deconstructed the beauty of the crystal-clear by matching the wilful interference with perspicuity evident in contemporary ice-glass, Tintoretto discovered in the transparent far from comforting suggestions of impermanence, mobility and evanescence. By studying glass as object and metaphor we may apprehend a shift from the spiritual to the mundane underpinning concepts of beauty. The secularization of the transparent or clear opened up a perilous void: by the end of the sixteenth century proud man has begun to fear for his glassy essence.[29]

In the Bible imagery of glass occurs most frequently in the Apocalypse, where the Heavenly Jerusalem is described as 'pure gold, like unto clear glass' – *aurum mundum simile vitro mundo*. And again, 'the streets of the city were pure gold, as it were transparent glass'.[30] To dull minds such imagery makes no sense, for gold is not transparent, however much it may shine like glass; but of course St John's imagery is moral, for gold and glass are being held up as symbols of the absolutely pure, immaculate. In the Vulgate it is the Latin for pure or clear, *mundus, mundum*, which carries the rhythm – *aurum mundum, simile vitro mundo*. In Latin the same word, *mundus*, means both pure or clean, *and* the world, the universe, the heavens; and in Italian *mondo* again combines both meanings.

In the Middle Ages the *claritas* of lustre, particularly gold, outshone the *claritas* of transparency. Significantly, glass chalices were banned by Papal Bull.[31] But by the sixteenth century, with the flood of bullion from the New World, gold was becoming devalued. Anton Doni caustically remarked that it should be returned to the earth whence it came.[32] The Renaissance turn from gold to transparency as ruling metaphor took up imagery latent within the Christian tradition – and threatened to invert it. By Titian's death and Tintoretto's old age, the perspicuity of the world was truly becoming mundane, infiltrated by secular values associated not only with the courtier's wine glass but also with the alchemist's retort and the pharmacist's urinal. Transparency, once the symbol of the divinely ordered heavens and key concept of beauty, becomes kin to the fragile, the insubstantial, the perilous.

> The world's a bubble; and the life of man
> Less than a span

Francis Bacon will write, probably as early as the 1590s.[33]

It was an Italian poet, Torquato Tasso, who discerned how the social practices of his countrymen, their desire for luxury goods, had tarnished a spiritual ideal of beauty. After a trip to France, he wrote to the Duke of Ferrara:

The great number of glass windows, coloured and with figures, are worthy of admiration and praise, as much for the vivacity of colour as for the design and artifice of the figures. In this respect the French offer a rebuke to the Italians. Whereas for us the art of glass is esteemed for the style and delights it affords to those who drink; for them it is employed as an ornament of the churches of God and of the conduct of religion.[34]

## Notes

1. 'Concepts of Beauty in Renaissance Art' was the title of the section of the conference of the Association of Art Historians at which the paper was delivered.

2. Goldthwaite (1993; 1989). Many passages in (1993) illuminate this topic.

3. True of the excellent book by Huse and Wolters (1990).

4. The most accessible survey is Tait (1979); the most richly documented is Zecchin (1990).

5. Clarke (1974).

6. Tait (1979): 95.

7. Zecchin: III, 84.

8. Tait: cat. 163, with plate.

9. Spallanzani (1978): 164–6 (document 23).

10. Neri, ed. R. Barovier Mentasti (1980): 34 (ch. XXXVII).

11. Zecchin: II, 235; Tait: 94.

12. Collection of the Duke of Sutherland, on loan to the National Gallery of Scotland; Hope (1980): plate XXVII.

13. In the Prado; Hope (1980): plate XII.

14. Zecchin: II, 233–4, lists these and other visits to Murano.

15. Tait: 10.

16. Halbert ed. (1992): plates 170 and 173.

17. For *leggiadria* see Fermor (1993).

18. Adorno, trans. C. Lenhardt (1984): esp. Ch. 3.

19. Campori (1874); discussed by Fehl (1991): 359, n. 95.

20. Hope: fig. 65 (*Crowning with Thorns*) and plate XXXI (*Diana and Callisto* in colour).

21. On *vetro a fili* see Tait: 49–50; the BM Cup is cat. 94.

22. Pallucchini and Rossi (1982): figs 450 and 451, 454 and 456.

23. E.g. *La carta del navegar pitoresco* (1660): 300, '. . . el colorito/Contien in sì la machia, e insieme el trato'; for commentary see Sohm (1991).

24. E.g. Tait: cat. 155.

25. Ridolfi, ed. D. Von Hadeln (1924): II, 15.

26. North (1994): 285.

27. Grendler (1969): 95–6.

28. Pallucchini and Rossi: fig. 432.

29. Of course most Renaissance imagery using the word 'glass', including Shakespeare's and George Herbert's, refers to mirrors rather than to glass vessels.

30. *Revelation*: 21, v.18 and 21.

31. Thorpe (1949): 78.

32. Grendler: 88. For the relation between money and civility in the Renaissance, see Hale: 372–92.

33. Jones (1991): 697, 'probably written 1592–8'. For the symbolism of bubbles c.1600 see Wittkower (1977): 159–66.

34. Tasso (1935): 569; cited by E. Castelnuovo in *La Grande Vetrata di San Giovanni e Paolo* (1982): 13–14.

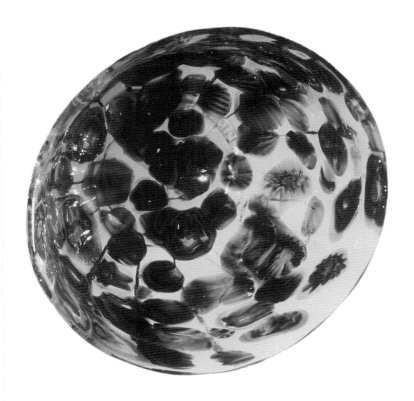

13.1  Bowl in millefiore-glass; Venetian, c.1500

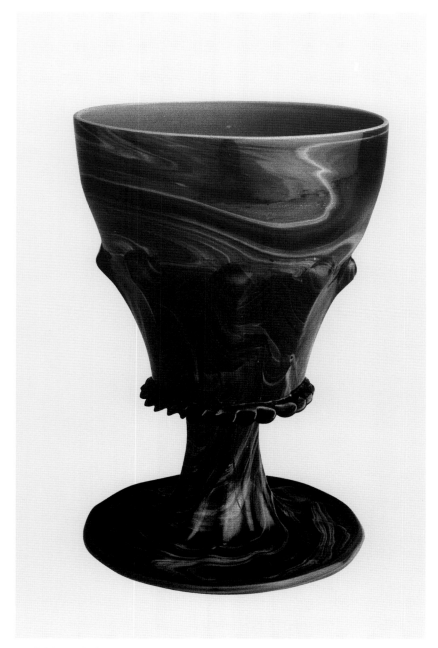

13.2   Goblet in chalcedony glass; Venetian, c.1480 (18 cm high)

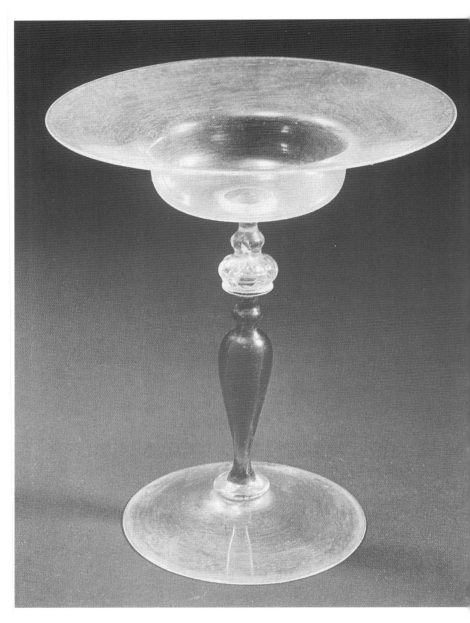

13.3   *Cristallo* wine glass with blue baluster stem; Venetian, mid-16th century

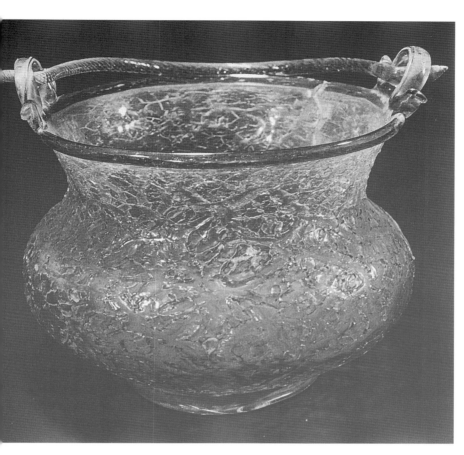

4   Bucket in ice-glass; Venetian, late 16th century

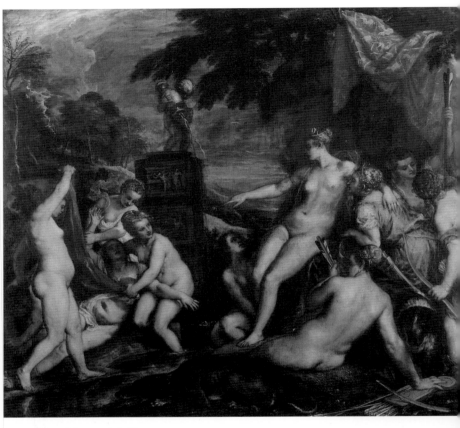

13.5   Titian, *Diana and Callisto*

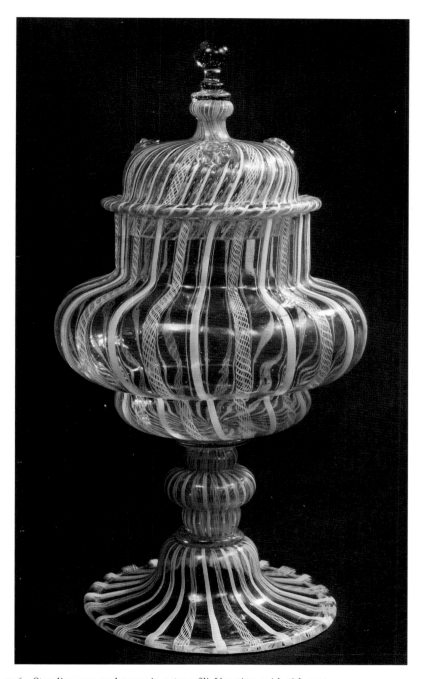

13.6 Standing cup and cover in *vetro a fili*; Venetian, mid-16th century

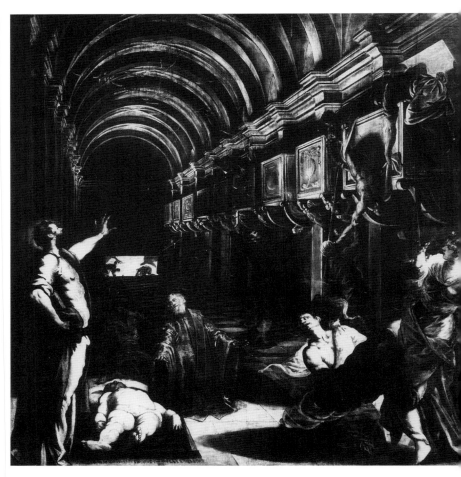

13.7   Jacopo Tintoretto, *The Finding of the Body of St Mark*

# Vasari's interpretation of female beauty

*Liana De Girolami Cheney*

As a Mannerist painter, Giorgio Vasari (1511–74) considered himself to be not merely an artisan but a writer, an art collector, and an aesthetician as well. Vasari's ambitions culminated in his writing of *The Lives of the Most Excellent Painters, Sculptors, and Architects* (*Le Vite dei più eccellenti pittori, scultori e architetti*), the first edition of which appeared in 1550; a second, enlarged and revised, containing woodcut portraits of the artists, appeared in 1568.[1]

Vasari's *Lives* consists of two components: biographies and prefaces. In writing the biographies, Vasari discusses stylistic qualities and techniques of art.[2] In the Prefaces (*Proemi*) he not only establishes the historical scheme for his writing of the biographies but also defines the criteria he applied in the selection of the 'most excellent' artists and the standards by which their works were judged (Preface I, 7).

Vasari's criteria for assessing art accorded with conventional standards in sixteenth-century taste. He embodied the aesthetic judgement of his time in the criteria he used to evaluate individual works of art. Qualities he applauded were: technical proficiency especially in drawing; good composition; imitation of nature; variety and invention; and adherence to the classical art of ancient Rome. He felt that such qualities must be attained with beauty and grace of style, which meant that the work must appear to have been executed with masterful ease. He emphasized that a magical, godlike quality (genius) is the essential quality of great art. He assumed that artists' individual achievements were essentially manifestations of their own peculiar genius. But genius itself – and with it, major changes in style and technique – could be explained only by invoking the intervention of divine forces: 'To save us from such great errors ... the Most Benign Ruler of Heaven turned his eyes clemently to earth ... and consented to send down a Spirit ...'[3] Vasari's theory of genius or divine intervention to explain the

execution of works of exemplary merit particularly applies to the artist's perception of feminine beauty and its function in the integrity of artistic expression.

Within this framework, this study considers the following: Vasari's concept of beauty as advanced in the Prefaces of the *Lives*; its Quattrocento and Cinquecento literary and philosophical sources; and its artistic embodiment in his painting *The Toilet of Venus* of 1558 (Figure 14.1) and the pendant painting of *The Bacchanal* of 1558 (Figure 14.2).[4]

In his Third Preface of the *Lives*, Vasari defines his theory of beauty in terms of the laws of design as consisting of *regola, ordine, misura, disegno e maniera* (rule, order, proportion, design, and manner).[5] He further states:

Design is the imitation of the most beautiful things in nature, used for the creation of all figures whether in sculpture or painting; and this quality depends on the ability of the artist's hand and mind to reproduce what he sees with his eyes accurately and correctly onto paper or a panel or whatever flat surface he may be using. The same applies to works of relief in sculpture. And then the artist achieves the highest perfection of style or *maniera* by copying the most beautiful things in nature and combining the most perfect members, hands, head, torso, and legs, to produce the finest possible figure as a model for use in all his works; this is how he achieves what we know as fine style or *maniera*. (Preface III, 35).

Vasari's aesthetic (the word aesthetic derives from the Greek *aisthesis* – sensation) is concerned with the nature of the beautiful as it exists in art or in art and nature as well as with the physicality and spirituality of beauty.[6] For Vasari, physicality of beauty is perceived in the painted image and his spirituality of beauty is reflected in the evocation of the visual experience. His philosophy of art depends upon the philosophical and poetic tradition of the Quattrocento and Cinquecento, in short the Italian Renaissance restatement of Neoplatonism. In accordance with the Neoplatonic theory of beauty, Vasari understands beauty to be a divine creation: 'He [God] fashioned the first forms of painting and sculpture in the sublime grace of created things'.[7] Consequently, he refers to beauty as symmetry and proportion of form and associates the beautiful with Plotinus's concept of radiance or splendour, an element that results from the quality of unity inherent in the object.

Correspondingly, Vasari absorbs from Ficino's *Commentary on Plato's Symposium on Love*, 'the ancient Greek philosopher's definition of beauty as "the splendour of *divine goodness* present everywhere", and of personal beauty as "the expression of an interior moral goodness"' as well as Ficino's explanation of beauty as 'a process of ascent from sensual cognition of earthly beauty to the apprehension of the immortal ideal of beauty itself'.[8] By appropriating from Ficino the interconnection between love and beauty, Vasari also embraces his notion that the essence of beauty consists in proportion, that is, the ancient doctrine of the symmetrical and pleasant

relationship of individual parts. According to Vasari, the origin of beauty derives from order and proportion (*la bellezza nasce da ordine e proporzione*), and at times he relates the concept of beauty to goodness (*bellezza e bontà*).[9] Obviously, Vasari is following Marsilio Ficino; in the *Symposium*, Ficino discusses how many things are required to create a beautiful body, such as arrangement (meaning the distance between parts), proportion (meaning quantity), and aspect (meaning shape and colour). He further analyses how in their proportioning the parts have their natural positions: 'that the ears be in their place, and the eyes and nose, etc., and that the eyes be at equal distances near the nose ... the proportion of the parts ... preserves the proper proportions of the whole body'.[10]

Thus, Vasari's aesthetic derives jointly from the classical conception of physical beauty and from the Neoplatonic notion of spiritual beauty. That is to say, the classical concept of beauty meant for Vasari a beautiful image created from the combination of parts of the body arranged commensurately and proportionately as a whole, as represented in his paintings of *The Studio of Zeuxis* (1548) in his house at Arezzo, and *The Studio of Apelles* (1560) in his house in Florence.[11] In contrast, the Neoplatonic spiritual beauty meant for Vasari the manifestation of vivacity, radiance and grace in the image perceived through reason and sight in order to move the human soul and delight the spirit, as illustrated in his *Toilet of Venus* (Figure 14.1).[12]

Vasari deliberately selects the image of Venus as the manifestation of his theory of beauty following not only the Neoplatonic philosophy but also the literary tradition of Cinquecento treatises on love and beauty such as Mario Equicola, Leone Ebreo, Benedetto Varchi and Agostino Nifo. These literary treatises on love refer to the concept of beauty: for example, Mario Equicola in *Libro di natura d'amore* (Venice, 1525) questions what is beauty (*che cosa é bellezza?*). In this book, Equicola agrees with the ancients (Plato, Virgil, and Ovid) that the image of the goddess Venus embodies beauty (*calos* is Greek for 'beauty', and can also mean 'beautiful' in Latin) and that her perfect proportions (Cicero) delight the viewer.[13] Furthermore, in *Dialoghi d'amore* (Rome, 1535), Leone Ebreo defines beauty in terms of delighting the spirit (*la bellezza che dillettando l'animo ... il muove ad amare*).[14] Benedetto Varchi, too, commented on the concept of beauty and grace in relation to love in his *Lezioni sull'Amore* (1540), for the poet Leone Orsino: 'la bellezza non è altro che una certa grazia, la quale diletta l'animo di chiunche la vede e conosce, e dilettando lo muove a desiderare di goderla con unione, cioè lo muove ad amarla.' In this passage Varchi paraphrases Ebreo's concept of delight. Varchi continues his definition of beauty by stressing the interconnection between beauty (*bellezza*) and grace (*grazia*) in this manner: 'che cosa sia bellezza e che cosa sia grazia; e questo non si puo sapere con miglior modo e più sicuro e certo mezzo, che mediante la definizione loro.'[15] Likewise,

Agostino Nifo in *Del bello. Il bello è nella natura* (Lyon, 1549), discusses the quality of beauty; however, in his definition he adds the Aristotelian concept of subjectivity, thus for Nifo beauty is judged in terms of relativity – if a young woman is confronted with beasts, she is beautiful, but ugly when compared with goddesses.[16] These Cinquecento treatises on love were inspired, in turn, by the philosophical discourses on love by Marsilio Ficino, such as his *De amore* or *Sopra lo amore* (On Love, 1474) and *Commentary on Plato's Symposium on Love.*[17]

Moreover, Quattrocento and Cinquecento poets such as Baldesar Castiglione, Angelo Poliziano and Pietro Bembo adhere to Petrarch's and Dante's models of female beauty, such as Laura and Beatrice, and assimilated the poets' Neoplatonic aesthetics.[18] For them, a beautiful female image reflected a 'celestial beauty which leads the poet or philosopher upward to the experience of divine or heavenly beauty'.[19] Correspondingly, Agnolo Firenzuola, in his book on *On the Beauty of Women* (1548) declares:

A beautiful woman is the most beautiful object one can admire, and beauty is the greatest gift God bestowed on His human creatures. And so, through her virtue we direct our souls to contemplation, and through contemplation to the desire for heavenly things.[20]

Furthermore, according to Vasari beauty must contain *grazia* and *maniera*, an allusion to the art of grace and sensual appeal, as it was represented in the art of antiquity, reiterated in the Renaissance, and executed by Raphael. When Vasari writes about the ancient painters who achieved beauty in their imagery, he particularly refers to Apelles. In the Second Preface, for example, Vasari mentions 'Apelles, who produced beautiful work which was perfect in every detail and could not possibly have been improved on; for this artist not only painted superb forms and gestures but also depicted the emotions and passions of the spirit' (Preface II, 23). Similarly in the Third Preface, he judges Raphael's art as the manifestation of beauty: 'the most graceful of all was Raphael of Urbino, who studied what had been achieved by both the ancient and the modern masters, selected the best qualities from all their works, and by this means so enhanced the art of painting that it equalled the faultless perfection of the figures painted in the ancient world by Apelles and Zeuxis, and might even be said to surpass them were it possible to compare his work with theirs' (Preface III, 32).

Vasari continues to explain how beauty can be manifest by several aesthetic qualities and visual elements, among which he included 'spontaneity which enables the artist to enhance his work by adding innumerable inventive details and, as it were, a pervasive beauty to what is merely artistically correct' (Preface II, 203). He goes on to include softness, unity and chiaroscuro techniques (Preface I, 1) as well as the inclusion of ornamenta-

tion with the abundance of beautiful clothes, imaginative details, and charming colours (Preface III, 30). The biographer cites other examples of artists who created beautiful forms, such as Leonardo who showed in his paintings 'beauty true to life' in 'figures that moved and breathed' (Preface III, 32), and Parmigianino who painted his figures with 'beauty and grace' (Preface III, 33).[21]

For Vasari, when artists returned to consider nature, in imitation or emulation of their ancient forbears, a rebirth occurred in the arts. Renaissance artists first imitated nature, then equalled nature, and finally surpassed nature. Fidelity to nature meant artists mastering 'naturalism' in the rational representation of perspective, foreshortening, chiaroscuro and the knowledge of anatomy, 'pleasing both the eye and the mind, creating a beautiful form'.[22]

By improving on nature, Vasari suggests, Italian Renaissance artists corrected nature's imperfections by working with the canons of proportion, by selecting the best aspects of nature, and by achieving graceful or idealized beauty. When artists surpassed nature, according to Vasari, they responded to their *concetto* (conceit), to produce an idea or image of beauty, partly innate in the mind of the artist (*invenzione*) and partly derived from previous study of nature and art (*imitazione*). Therefore, Vasari's concept of beauty derives from two principles: the ideational, a *concetto* to create an image of beauty, and the realistic, a current idea about how an image of beauty can be conceived. Vasari's *The Toilet of Venus* visually represents his theory of beauty.[23]

Fascinated with the subject of beauty and love embodied in the image of Venus, Vasari depicted her in the theme of the Toilet of Venus in several media: in a large cartoon, in a stained glass window, and in three paintings. The large cartoon is lost at present but an elaborate description of its imagery is recorded in a letter from Vasari to Niccolò Vespucci:

A seated, nude Venus surrounded by the Three Graces: one while kneeling holds a mirror; another with artistry braids her hair with pearls and corals in order to beautify Venus; another pours, with an emerald crystal vase, perfumed clear water in a mother-of-pearl conch for her bath. Eros, holding a bow and arrows, sleeps, reclining on Venus' garment. Other Cupids encircle the group while covering them and the landscape with roses and flowers. The ground is filled with stones; through their cracks flows water. Doves and swans taste this water. Hidden in the trees and bushes a satyr contemplates the beautiful Venus with the three Graces. His lascivious attitude, expressed by his open, wild eyes, and implied lust gesture was highly praised by Pope Clement who suggested that I paint a picture based on this drawing.[24]

The stained glass window was executed by Gualtieri d'Anversa in 1558 probably after Vasari's cartoon design for the Scrittoio di Calliope at the

Palazzo Vecchio in Florence. The paintings were commissioned by Cardinal Ippolito de' Medici (1532), by Jacopo Capponi (1559) – both these paintings are now lost – and by Luca Torrigiani (1558, Figure 14.1).[25] The stained glass window has a similar composition to Luca Torrigiani's painting, probably because both versions draw from the cartoon design. In Torrigiani's painting of *The Toilet of Venus*, Vasari portrays Venus being dressed and adorned by the Three Graces (*Charites* in Greek or *Gratiae* in Latin) with numerous attributes of roses, myrtle and a pair of doves, alluding to spiritual as well as erotic love.[26]

By selecting and depicting the classical subject of Venus beautifying herself, admiring herself in the mirror, and posing for the viewer's gaze and arousal, Vasari has addressed the physicality of an image embodying his aesthetic of female beauty. By suggesting she personifies both Love and Lust he alludes to astrological traditions, and by including emblematic references to both Vanity and Prudence he adds Christian qualities.[27] Thus he manifests his assimilation of Renaissance Neoplatonism – the Christianization of pagan myths or the secularization of Christian religion.

Since antiquity the image of Venus has been defined in terms of physical beauty. In ancient Latin, the word Venus (*phosphorous*) means *the luminous one*. This appellation alludes to Venus as both planet and goddess.[28] Therefore, the classical representations depict her holding a mirror (*speculum*) for reflecting her beauty, alluding to Venus magically linked to her reflection or life source, as in the Roman mosaic of the third century AD at the Musée Nationale du Bardo in Tunisia.

For the Platonist philosophers (Plato, Plotinus and Ficino) the planetary gods and goddesses represented poetic analogies of celestial and psychological functions. They described the operational principles of action, heart and mind, that is to say, the psyche, in which emotions, instincts and thought orbit the luminaries of the self and ego. Therefore, as a female symbol, Venus assumes the female planetary aspect associated with Luna (Moon), sensualism. For example, Venus as a planet or sphere expresses the active instinctual desire for pleasure and love, because 'Love was born on the birthday of Venus'.[29] It rules the arts, as illustrated in the *De Sphaera*, an Italian illuminated manuscript of the fifteenth century, in the Biblioteca Estense in Modena. Here Venus is depicted holding a mirror, nude, with flowers and jewellery; she controls the heavens with the zodiac signs of Libra and Taurus, and rules on earth over the aspects related to the arts and love.[30] Vasari endows his Venus in *The Toilet of Venus* with these ancient cosmological, philosophical and psychological implications.

In Vasari's *The Toilet of Venus*, the accompaniment of the Three Graces, as handmaiden to Venus, accords with the writings of Horace (*Odes*: I, 3) and Seneca (*De beneficiis*: I, 3). For Horace, the Graces are usually depicted as

semi-clothed because they are 'free of deceit'; and for Seneca, the Graces were partially clothed with exposed breasts because 'benefits want to be seen'. The Graces' dual character is associated with Venus's cosmic nature – planet and goddess – and derives from their personification in antiquity. In the Greek period the Charities personified grace, charm and beauty and were named Aglaia (meaning Splendour), Euphrosyne (Mirth), and Thalia (Abundance) and during the Roman era the *Gratiae* were a symbol of gratitude – Castitas (Chastity), Voluptas (Pleasure), and Pulchritudo (Beauty). Vasari's inclusion of the Graces adds yet another dimension to the symbolism of Venus, providing a moral basis for her actions such as decorum.

In Vasari's painting Venus gazes at her reflection in the mirror. The mirror, in Christian symbolism, is the conventional attribute of truth and is traditionally carried by a personification of Prudence. Venus's action takes place at the same time as one of the Graces pours water, an action alluding to another virtue, the personification of Temperance. The other two Graces who assist Venus in her beautification, connote through their actions yet another virtue – Charity, which is inherent in their name 'Charities'. Thus the visual bond that exists between Venus and the Graces in the painting alludes to and reinforces the spiritual aspects of Christian or Neoplatonic 'sacred love'. For Vasari, then, the Graces represent Beauty, Love and Pleasure as well as Giving, Receiving and Requiting.

At this point one might ask: What is the specific meaning of Vasari's rendition of Venus? Is she to be viewed as the planetary Venus or as the personification of a Virtue such as Chaste Love, Truth (*Veritas*) or Prudence (*Prudentia*)? Or does she represent a personification of Vice, such as *Vanitas* or *Luxuria*? Or is she meant to symbolize one of the five senses, such as Sight? Vasari's *oeuvre* as well as his aesthetic reflects his eclectic nature in perceiving and conceiving art; therefore, even though paradoxically, Vasari's conceit for the image of Venus combines a mixture of significations alluding to symbols of virtue as well as vice. In addition, the use of the mirror as an attribute of the sense of Sight can imply two perceptions: the viewer's perception of Venus as young and beautiful, and Venus's intimation of her future age and ugliness reflected in the mirror. The eye of the viewer becomes the mirror of present life whereas Venus's mirror becomes the mirror of her past. Although viewers see in the painting the present beauty and future ugliness of Venus, they are seduced by the now, the narcissistic exhibition of her body (*Luxuria* and *Vanitas*). Conversely, Venus is reminded by the mirror's reflection of the transience of life and truth of her nature: 'I am who I am' (Exodus 3:14).

With the recent discovery of *The Bacchanal* (Figure 14.2), the pendant painting to *The Toilet of Venus* (Figure 14.1), a voyeuristic interpretation is

maybe further suggested. For the Luca Torrigiani commission Vasari perhaps decided to produce two paintings based on his cartoon designs – *The Toilet of Venus* and *The Bacchanal*. In the drawing studies for the Bacchanal painting, and in the painting itself, the 'lascivious' satyr is included, assisting the intoxicated Silenus or stealing grapes and libations for himself. In the painting of *The Bacchanal*, the Three Graces, who attended and completed the toilet of Venus, can be seen now as Maenads dancing at the music performed with tambourines and recorders by the nymphs, fauns and satyrs in the Dionysiac forest. Unlike Venus's beautiful attendants, Bacchus's escorts can be seen as wild beasts from the forest, such as wild horses, lions, tigers, or panthers and rams, and as symbols of fertility, since they were held sacred to him. Bacchus's companions and worshippers, intoxicated with the nectar of grapes provided by Bacchus during a drinking contest, crown and decorate their god with wreaths of laurel, ivy and grape leaves.

The young, effeminate, idealized body of Bacchus contrasts with the ageing, coarse and muscular body of Silenus and the satyrs. Vasari in representing Bacchus as an image of male beauty relies on Pliny's and Vitruvius's theory of human proportions[31] as well as on Ficino's description *On a painting of Love* where, according to the poet Agathon, Love is personified by a young, tender, agile, well-proportioned and glowing man.[32] From Vasari's perspective, then, the beautiful depiction of Bacchus expands his theory of beauty to include the male body as well as the female body (Venus), and both images of beauty reflect a conceit of love.

These pendant paintings show parallelism of poses, gestures, colouration and movement. However, although Venus and Bacchus are facing each other, they do not gaze at each other: they are both self-absorbed in their individual preparations for their thirst, as Venus actively adorns herself and Bacchus passively indulges in his revelry.[33] Familiar with the legend of the liaison between Venus and Bacchus, which resulted in Priapus, Vasari created with these two paintings a theatrical scene where the viewer, with humour, visually connects their actions and with pleasure anticipates a passionate conclusion. Has Vasari created a Mannerist conceit?

In contrast to the cartoon's description, the painting of *The Toilet of Venus* excludes the voyeuristic satyr; however, Vasari has cleverly replaced him with the pendant painting or the viewer. This *maniera* conceit or teasing technique fits in well with the *maniera* spirit of joviality and self-absorption. On the one level the gazing action may appear to be fortuitous and puerile, with the viewer or satyr ogling the beautiful naked woman; on another level, the narcissistic behaviour of Venus regarding herself in the mirror can be seen as an allusion to her vanity, thereby manifesting the temporal world. Obviously, the reflected image in the mirror ought to be of a beautiful, voluptuous and ageless woman. However, on careful observation, the reflec-

tion reveals an ageing and homely woman. Is Vasari tantalizing the viewer again? Is he conveying the paradox of the Neoplatonic aesthetic, as well as his own? Does he, like the Renaissance Neoplatonists, attempt the reconciliation of pagan myths and attitudes reinforced by Christian religion and beliefs? Can feminine beauty be both sensual and spiritual? Vasari, again, allows the viewer to speculate and adjudicate!

As we know from the eloquent discussions in the writings of Freedberg, Friedländer, Pinelli, Shearman and Smyth, Cinquecento artists and theorists used the term *maniera* to denote a surpassing skill in aesthetic achievements of beauty or *grazia*.[34] Mannerist painters, such as Vasari, on the other hand, associated beauty with the nudes they created for contemplation, their flowing forms enlivened by a vibrantly sensual handling of colour and line. Cinquecento styles sought to formalize and intellectualize these qualities of beauty in order to create images infused with artificiality as well as sophistication – in short, to achieve a Vasarian concept of beauty.

In summary, Vasari chooses the image of Venus because she symbolizes both intellectual and physical powers. As a planet she rules over the arts. In turn he, Vasari, as an artist and creator is ruled by her planetary force. As a female the goddess displays her beauty, and the artist, as man, is bewitched by her physical beauty.

## Notes

I want to express my sincere gratitude to Professors Elizabeth Cropper, Mary Rogers, and Francis Ames-Lewis, for their invaluable comments.

1.  I have used the Italian version of Vasari, ed. Milanesi (1878–85), and an English version, Vasari, trans. Bull (1971).

2.  For studies and excellent bibliographies on Vasari and his technique of art, see Vasari (1960); Panichi (1991); and LeMollé (1988).

3.  Cochrane (1985): 402, and Vasari, ed. Milanesi: Preface, I, 7.

4.  See catalogue entry of Ewald and Markova (1994). The Gerini collection was recorded in the drawings of Ranieri Allegranti and subsequently in the engravings of Lorenzo Lorenzi and Ferdinando Gregori in 1786; included among the engravings were these two paintings by Vasari. (See Plates III and IV in Corti (1981)). Catherine Monbeig-Goguel has identified several preparatory drawings for these paintings in the Louvre and in the Uffizi; see Monbeig-Goguel (1972): 172–3, Plate 222, and Uffizi drawings nos 620 F and 641 F.

5.  See Vasari ed. Milanesi: Preface, III, 35 for a definition of these terms, and Mirollo (1984): 10–14. Obviously, Vasari is following Marsilio Ficino; see Ficino trans. Jayne (1985): 93–5 and Vestra (1986): 178.

6.  Wiener (1974): 510–12; Ficino trans. Jayne: 89–91; and Vestra: 179–80.

7.  Vasari, ed. Milanesi: Preface I, 93.

8.  Ficino, trans. Jayne: 90. Ficino explains how Beauty is the splendour of the divine countenance (89–91); Vestra: 185 and Cheney (1993): 32–4.

9.  Vasari ed. Milanesi: VII, 710 and V, 386.

10.  Ficino, trans. Jayne: 93–5.

11.  Cheney (1989): 97–120; and Jacobs (1984).

12.  Panofsky (1968): 129–41.

13.  See Rocchi (1976) and P. Barocchi, 'Bellezza e Grazia', in Barocchi, ed. (1971–7): I, 1613–27.

14.  Ebreo (1535): 226–8 and Ebreo, ed. and trans. Friedberg-Seeley (1937): 298ff and 327ff.

15.  Cited in Barocchi, 'Bellezza e Grazia': 1672.

16.  Nifo (1549): XV–XX, 15–20.

17.  Lorenzetti (1922) and Nelson (1933).

18.  See Baldesar Castiglione (1527): Chapters XXVI and XXVIII of Book I; in Barocchi, 'Bellezza e Grazia': 1609–1708; Baldacci (1957); Zorzi Pugliese (1986); and Rogers (1988).

19.  Wiener (1974): III, 508.

20.  For the theory of female beauty in Italian Renaissance art, see Cropper (1976); Cropper (1986); Rogers (1988): 47–87; and Agnolo Firenzuola, ed. and trans. Eisenbichler and Murray (1992).

21.  Cropper (1976): 374–94; and Cropper (1995).

22.  Vasari, ed. Milanesi: Preface III, 8.

23.  Panofsky (1968): 71–9. For a clear study on Vasari's concept of nature and an extensive bibliography on this subject, see Mirollo (1984): 8.

24.  Frey (1923): I, 2, 3, and 8.

25.  See n. 4.

26.  For illustrations of the Three Graces in art, see Reid, ed. (1993): 475–80; for the *Toilet of Venus*, see 13–44.

27.  In representing the ambiguity of Vanity and Prudence, who both traditionally are shown looking into a mirror, Vasari may have referred to Michelangelo's drawing of the *Allegory of Prudence* in the British Museum, London; see Barolsky (1994): 10, fig. 5.

28.  Ficino, trans. Jayne: 116–17.

29.  *Ibid.*: 120. Ficino elaborated further on the nature of love as well as of the passions, stating: 'Love follows and worships Venus and is seized by a desire for the beautiful, since Venus herself is very beautiful'.

30.  Nesle (1985): 134–5.

31.  Vitruvius, ed. and trans. Morgan (1960): III, I, 3; and Pliny, ed. and trans. Jex-Blake and Sellers (1976): VII, 77. See also Panofsky (1955): 89–99.

32.  Ficino, trans. Jayne: 95–6. See Rousselle (1993) 5–23 for a discussion on the bodies of men, and 24–46 on the bodies of women.

33.  Otto (1986): 176 for a discussion on the sensual affair between Aphrodite (Venus) and Dionysus (Bacchus).

34.  See Smyth (1992) for a complete bibliography on this topic; Pinelli (1993) and Cheney, ed. (1997) for an historical discussion of Mannerism and *maniera*.

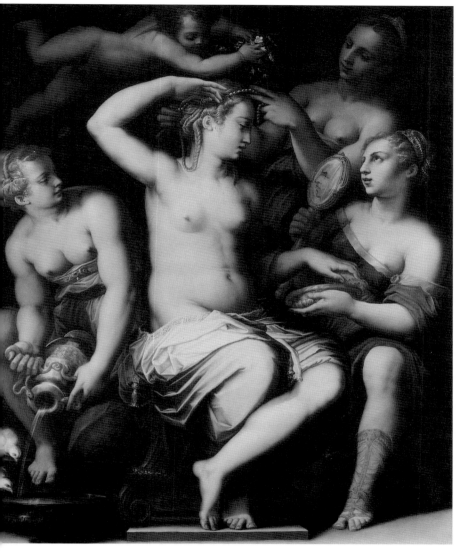

Giorgio Vasari, *The Toilet of Venus*

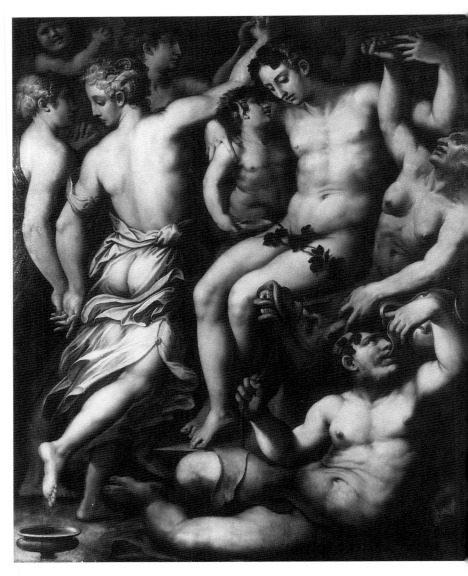

14.2   Giorgio Vasari, *The Bacchanal*

# The notion of beauty in Francesco Bocchi's
*Bellezze della città di Fiorenza*, I

*Thomas Frangenberg*

This paper is divided into two parts. The first will survey the notion of beauty in the two works that were the most important sources of Francesco Bocchi's art theory: Giorgio Vasari's *Lives*, published in 1550 and reprinted in a vastly enlarged edition in 1568, and Raffaele Borghini's *Riposo* of 1584. Furthermore, Bocchi's approach to the term beauty in his treatise on Donatello's *St George*, written in 1571 and published in 1584, will be studied. The second part will address the understanding of beauty emerging from an analysis of Bocchi's guide to Florence, the *Bellezze*, of 1591.

Beauty is not a term given particular weight in Vasari's art theory. In the introduction to the third part of the *Lives*,[1] Vasari uses the word 'bello' above all in his characterization of the achievements of the second period, largely coinciding with the fifteenth century, which for Vasari was still far from the artistic perfection attained in his own lifetime. In his explanation of the progress in the arts of design during the Quattrocento, Vasari maintains that

*Disegno* entailed, to imitate in all figures, be they sculpted or painted, what is most beautiful in nature. . . . . Manner became most beautiful because it became customary to portray the most beautiful things frequently, and [to take] hands, heads, bodies or legs from the most beautiful objects, to put them together, and to make a figure of all these beauties as well as one could, and to employ [this figure] for all figures in every work; therefore it is called a beautiful manner.[2]

It is hard to avoid the impression that Vasari's repetitive use of the word 'beautiful' damns with faint praise. This impression is reinforced by his further statements that the second period had not yet attained 'a grace that exceeds measure', and 'this graceful and subtle ease that appears between the seen and the unseen'.[3]

Vasari does not explicitly say that graceful works of art will be beautiful, but he implies as much in his assertion that by the standards of the third period art must have 'a certain beauty ... extended into every minute thing'.[4] The fact that Vasari qualifies beauty in this context as 'a certain beauty' suggests that the schematic characterization of beauty in the Aristotelian tradition, as correspondence between the parts,[5] loses some of its relevance in an art practice fundamentally 'exceeding measure'. Furthermore, it is relevant that Vasari here applies the notion of beauty to the small details of the art work. A marginalization of beauty is even clearer in a later section of this text. As further elements not yet available to artists of the second period, Vasari adduces 'the quantity of beautiful garments, the variety of so many bizarre things', and 'the loveliness of the colours', among others.[6] In a work of art possessing grace, beauty may impose itself on the viewer's attention as little more than sartorial accomplishment.

The notion of beauty plays a similarly modest role in Raffaele Borghini's *Riposo*, a work in the form of four dialogues between four Florentine gentlemen. Writing for a lay audience exemplified by the interlocutors, Borghini seeks to provide non-artists with the kind of artistic vocabulary they require. Borghini considers talking about art as an art form in its own right. Whereas the last two dialogues provide the reader with historical information, the first two address questions of art theory. Borghini defines five terms which provide the interlocutors with criteria to judge individual art works: invention, disposition, postures, limbs, and colours (*inventione, dispositione, attitudini, membri, colori*).[7] In the gentlemen's discussions, the five terms give direction to almost everything they say. The section on invention stresses appropriateness and, in particular, the avoidance of sensual imagery in ecclesiastical settings. Such concerns lead to a discussion of Bronzino's *Resurrection of Christ* in SS. Annunziata, Florence.

Talking about the Resurrection, interjected Michelozzo, reminded me of a panel by Bronzino in the Annunziata, depicting this mystery. Let us please not talk of it, responded Vecchietti, because there is so lascivious an angel that it is shameful. If I had this beautiful figure in my house, said Michelozzo, I would esteem it greatly, and I would highly regard it as one of the most delicate and soft figures that one can find. . . .[8]

The tension of this discussion derives from the opposed requirements of iconography and artistic appreciation; these lead to mutually exclusive evaluations of the picture. Among the terms employed, that of the beautiful is the least specific and therefore the least useful, referring only to the pleasing appearance of the figure.

The first text of art theory written in Florence to give considerable weight to the discussion of beauty is Vincenzo Danti's *Trattato delle perfette pro-*

*porzioni* of 1567.[9] To a large extent, this text expounds the Aristotelian definitions of the beautiful as the correspondence between and appropriateness of the members of the body.[10] Danti's treatise appears to have had little or no impact on Francesco Bocchi. Likewise, Benedetto Varchi's philosophical disquisition, his *Libro della beltà e grazia*, one of the most multi-faceted analyses of beauty to have been written in Florence during the sixteenth century,[11] appears to have left no mark on Bocchi's thought.

Whereas in Bocchi's early art-theoretical writings, such as orations in praise of Michelangelo and Andrea del Sarto,[12] the term beauty does not play a significant role, he accords a place of honour to beauty in two of his most important later writings.

The *Eccellenza del San Giorgio di Donatello* follows the conventions of encomiastic literature. The emphasis on beauty in this context is not surprising; in encomia of both people and cities, praise for their beauty is commonplace.[13] In Bocchi's text, beauty is one of three qualities singled out for praise. The treatise is subdivided into three chapters, each devoted to the discussion of a quality of the statue: its *costume* (loosely translatable as 'character'), its liveliness, and its beauty. Bocchi's focus on these three terms suggests that his source is a specific treatise on rhetoric. The terms are very close to three of the seven 'ideae' (that is, styles) defined in the *Rhetoric* of Hermogenes of Tarsus, a work widely read in the sixteenth century.[14] Bocchi's dependence on Hermogenes, and his debt to the tradition of eulogistic literature, go a long way towards explaining his departure from the terminology of Vasari and Borghini.

In the *Eccellenza* Bocchi defines beauty in Aristotelian terms, as the proportionality of the parts of the object. The importance to Bocchi of the Aristotelian definition of beauty is illustrated by the fact that even grace, and the reverence accorded to beautiful objects, are subsumed under the effects of proportionality:

This beauty seems to be a certain unity and a measured appropriateness, for which purpose every part, all devised perfectly with regard to the other[s], produces a graceful sight, and beauty – as it must – leads to great honour, its eternal companion.[15]

What Bocchi has to say about beauty, beyond this definition, is similarly interesting. Bocchi maintains that in human works true beauty is inseparable from perfection – a perfection so hard to achieve, and therefore rare, that it must be considered a miracle when it is found in a work of art.[16] This claim cannot be fully understood without bearing the rhetorical intentions of the text in mind. In a work attempting to demonstrate the excellence of a single statue, it is sensible to claim that beauty is attained only rarely. We shall find that beauty is portrayed as less rare in the *Bellezze*.

Some of Bocchi's most interesting thinking is concerned with how the perfection of a work can be established beyond doubt. Whereas the literary tradition provides sufficient evidence for the existence of antique works of complete perfection, the worth of contemporary works is much more difficult to assess:

> Because this matter is too obscure and difficult for human judgement to judge without error, I would not dare to mention many [beautiful works] of our own age, if men of letters and experts, and the nobility of the works [themselves] did not attest to the fact that in the city of Florence there nevertheless are some [works] which must be granted this lofty title of beauty.[17]

The individual viewer's judgement about contemporary art thus depends upon a consensus, based both on the theoretical and practical expertise of members of the same society. Only in the light of this consensus can the 'nobility of the works' be evaluated.

In encountering individual works, it is helpful and avoids confusion that only one of the senses, that of sight, is involved.[18] Even in the use of just one sense, however, there are qualitative differences between individual viewers:

> The more one's perception is subtle and discerning, the more one recognizes beauty and perfection, looking at all the parts of the St George, one by one.[19]

The particular, perhaps excessive acuity of mind and readiness to criticize which Bocchi observes among his fellow Florentines[20] can thus offer a further indication that complete perfection does exist. Since Donatello's sculpture is seen by so many discerning viewers, and not the smallest imperfection has ever been found, one may be certain that the work deserves nothing but praise.

The notion that artistic perfection is as much the fruit of the artist's labour as the result of the consensus reached in a society with a sophisticated visual culture is very close to the emphasis on laymen's judgement of art works found in Vincenzo Borghini's Selva di notizie.[21] This manuscript was written for the Accademia del Disegno in the mid-1560s, and appears to have had some circulation in Florence. It was certainly known to Raffaele Borghini, and perhaps also to Bocchi. Vincenzo Borghini argues that the judgement arrived at by all viewers in conjunction leads to 'universal perfection', that is, a perfection acknowledged in all its aspects. In Bocchi's Eccellenza, the consensus of all viewers is given a similar heuristic value.

The Florentine art works that Bocchi in the Eccellenza deems perfect are no more than four: Michelangelo's Night in the Medici Chapel, the Madonna del Sacco by Andrea del Sarto, the cupola of Florence Cathedral, and Donatello's St George.[22]

Whereas the *Eccellenza* is a text in praise of one work, the *Bellezze della città di Fiorenza*, the first modern guide-book to any city, is written in praise of the entire city of Florence.[23] Bocchi's text is intended to benefit visitors 'who take pleasure in coming to know such noble works of art'.[24] With Borghini's *Riposo*, the *Bellezze* is one of the earliest art-theoretical texts specifically addressing an audience of non-artists. Furthermore, the *Bellezze* is a novel enterprise in forming a new synthesis of periegetic and encomiastic literature.

As we have seen, the emphasis on beauty in Bocchi's encomia accords with the tradition of this literary genre. In particular, in eulogies of cities emphasis on their beauty is common. Several sixteenth-century texts in praise of cities use the word 'beauties' in their title, establishing beauty as a quality comprehensively expressing the respective city's merit. A short encomium of Florence, written by Bernardino da Firenze in c.1500, is called *Le bellezze et chasati di Firenze*.[25] Later in the sixteenth century, the word 'bellezze' appears in the titles of encomia of Genoa (1583)[26] and Verona (1586).[27]

Of such encomia, Bocchi's is the first text to superimpose the praise of the city on the literary format of a guide to the buildings and art works of the city. The *Bellezze* derives its structure from the itineraries devised by Bocchi, rather than from headings such as 'public and private buildings', 'important families' or 'festivals', subjects usually discussed in individual chapters in sixteenth-century encomia of cities.

In making beauty the focus of his discussion, and in employing beauty as a category comprehensively expressive of Florentine achievement, Bocchi writes a guide that in some respects seems alien to twentieth-century readers. When following each one of the itineraries devised by Bocchi, the user of Bocchi's guide not only comes to know the beauties within the city, but at the same time is engaged in assembling visual evidence in support of the nobility of Florence.

To point to the rarity of positive qualities in the object of praise would contradict the conventions of encomiastic literature. Thus, in striking contrast with the very short list of works accorded perfect beauty in the *Eccellenza*, Bocchi claims in the *Bellezze* that Florence harbours an abundance of beauties. Beauty and the beautiful are referred to extremely frequently throughout the text.

Because of the rhetorical purpose of the notion of beauty in the *Bellezze* it is crucial to Bocchi to enable the viewer to apprehend the manifestations of beauty. Bocchi aims to make the notion of beauty a useful intellectual tool in the context of the visual exploration of the city, and in art criticism.

In the *Bellezze* Bocchi develops some themes that he had first addressed in the *Eccellenza*. In the dedication to Grand Duchess Christina of Lorraine,

Bocchi returns to the question of how beauty can be identified. He points out that his book may be particularly pleasurable to the Grand Duchess: she can better grasp the 'beauties scattered in this most flourishing city' because of her uncommon understanding and wise judgement.[28]

The assertion that beauty is 'scattered' over the city entails that not everything in Florence is beautiful; in fact, Bocchi's first itinerary starts with several buildings that he admits are not particularly beautiful.[29] Characteristically, Bocchi names his book *The Beauties of Florence*, not *Beautiful Florence*, as one would probably expect today. There is no instance in which the term beautiful is unambiguously applied to the city in its entirety. Even when Bocchi writes that through the arts of design 'cities rise to the most superb beauty',[30] and Florence rose to such beauty that it astounds everybody,[31] he appears to refer to the cumulative effect of numerous individual instances of beauty. When Bocchi characterizes the city as a whole, he calls it noble, not beautiful.[32]

Since beauty is localized, the degree to which one is able to find and perceive instances of beauty depends on the intellectual preparation of each viewer, and the assistance upon which one draws. All readers, and in particular a mind as lofty as that of the Grand Duchess, will benefit from Bocchi's text.

Like Vasari and Borghini, Bocchi has at his disposal a rich and subtle vocabulary to define and describe artistic accomplishments, and we learn a great deal about Bocchi's understanding of beauty when we consider the terms he pairs beauty with. Splendour and artistic quality, for example, are portrayed as manifestations of the beauty of the Salviati Chapel in S. Marco.[33] Bocchi's notion of beauty is greatly more subtle and diversified than his Aristotelian definition of beauty in the *Eccellenza* suggests.

In the *Bellezze* no less than in the *Eccellenza*, Bocchi portrays the greatest beauty as fullness of perfection. In his description of the Casino di S. Marco, Bocchi writes:

The palace was designed by Bernardo Buontalenti, a man of outlandish and exquisite talent, as one can tell from the elegant windows, from the chambers and the state rooms, all judiciously accommodated, and from the mastery displayed in the doors; but the main entrance overlooking the street is wonderfully beautiful.[34]

As conclusion to a series of comments on aspects of the artistic quality of this building, the beauty attained in one particular detail is presented as the crowning achievement. Only visitors able to distinguish the beautiful from the neutral, and the exceptionally beautiful from the merely beautiful, will, in Bocchi's eyes, be able to grasp fully the merit of Florence and the Florentines.

# Notes

1. Vasari, eds Beltarini and Barocchi (1966–87): IV, 3–13.

2. 'Il disegno fu lo imitare il più bello della natura in tutte le figure, così scolpite come dipinte. . . . La maniera venne poi la più bella dall'aver messo in uso il frequente ritrarre le cose più belle, e da quel più bello, o mani o teste o corpi o gambe, aggiugnerle insieme e fare una figura di tutte quelle bellezze che più si poteva, e metterla in uso in ogni opera per tutte le figure, che per questo si dice esser bella maniera.' *Ibid.*: IV, 4; for a recent and somewhat problematic discussion of Vasari's introduction to the third part of the *Lives* see Sohm (1995): 759–808, esp. 761–73. The attribution of the historical prefaces of the *Lives* to Vasari has recently been questioned in Hope (1995): 11.

3. '. . . una grazia che eccedesse la misura'; 'quella facilità graziosa e dolce che apparisce fra 'l vedi e non vedi'; Vasari (1966–87): IV, 5.

4. '. . . una certa bellezza continuata in ogni minima cosa'; *ibid.*

5. See Grassi (1962): 140–3.

6. '. . . la copia de'belli abiti, la varietà di tante biz[z]arrie, la vaghezza de'colori'; Vasari (1966–87): IV, 5.

7. Borghini (1584, reprinted 1967): I, 52. On this work see Frangenberg (1990): 77–102 and *ad indicem*, with earlier literature.

8. 'L'haver parlato della Resurettione, soggiunse il Michelozzo, mi ha fatto ricordare d'una tavola del Bronzino nella Nuntiata dimostrante tal misterio. Digratia non ne parliamo, replicò il Vecchietto, perche vi è un Agnelo tanto lascivo, che è cosa disconvenevole. S'io havessi cotesta bella figura in casa, disse il Michelozzo, io la estimerei molto, e ne terrei gran conto per una delle piu dilicate, e morbide figure, che veder si possano. . . .' Borghini (1584): I, 116.

9. Danti, in Barocchi (1960–2): I, 207–69; see Davis (1982): 63–84.

10. These chapters of the treatise also in Barocchi (1971–7): II, 1682–90.

11. See Barocchi (1960–2): I, 83–91. Barocchi (*ibid.*: 310) states that this text was probably written after Varchi's return to Florence in 1543. See also Mendelsohn (1982): 19, 130, 134.

12. See Williams (1989): 111–39; Frangenberg (1990): 69–76 *passim*.

13. E.g. see Marcus Fabius Quintilianus, *Institutionis oratoriae libri XII*: III, 7, 12 and 27.

14. See Frangenberg (1990): 124–5.

15. 'Questa bellezza pare che sia una certa unità e una misurata convenevolezza, a cui, come a suo fine, ogni sua parte, ciascuna per rispetto dell'altra ottimamente divisata, fa di sè vista graziosa e, per quello ordinata, adopera non senza molto onore, che a lei è sempre in compagnia.' Bocchi, in Barocchi (1960–2): III, 125–94, esp. 169.

16. Barocchi (1960–2): III, 171.

17. 'Dell'età nostra non già prenderei ardire di nominarne molte, perocché è la cosa troppo più oscura e malagevole, che il giudizio umano la possa senza errore giudicare, se già gli uomini letterati et intendenti e la nobiltà delle opere non ci facesse fede, che nella città di Firenze alcune ce ne ha tuttavia, le quali con questo gran titolo di bellezza si deono nominare.' *Ibid.*: 178.

18. *Ibid.*: 186.

19. 'Ma quanto più l'altrui avvedimento è sottile e discreto, riguardando ad una ad una tutte le parti del San Giorgio, tanto bellezza maggiore e maggiore perfezzione vi conosce.' *Ibid.*

20. '. . . gli ingegni fiorentini, per avventura troppo più acuti nel giudicare e troppo più severi che queste simili cose non richieggono'; *Ibid.* A similar opinion is expressed by Vincenzo Borghini; see Bottari and Ticozzi (1822–5): I, 243: the Florentines have 'buon occhio e cattiva lingua'.

21. V. Borghini, 'Selva di notizie', the manuscript in the Kunsthistorisches Institut, Florence; large sections published in Barocchi (1971–7): I, 611–73, esp. 629; see Frangenberg (1990): 55–8.

22. Barocchi (1960–2): III, 178–9.

23. Bocchi (1591, reprinted 1971). The extraordinary interest of this book was pointed out in Schlosser Magnino (1977): *ad indicem*; see also Frangenberg (1990): 130–47.

24. '. . . coloro, che di conoscere sì nobili artifizii si dilettano'; Bocchi (1591): sig. 3r.

25. Bernardino da Firenze, n.d.; see Frangenberg (1994): 41–64, 44.

26. B. Paschetti, *Le bellezze di Genova, dialogo nel quale si ragiona del sito della città, degli huomini illustri e delle donne similmente, con altre cose notabili*, Genoa 1583, cited after Schlosser Magnino (1977): 576.

27. Valerini (1586). The title of a further encomium of Florence, dating from the early seventeenth century, is a further indication of the importance of beauty in the praise of cities, even though in this instance the title may be inspired by Bocchi's book: *Opera nuova delle bellezze, e grandezze della città di Firenze narrate da un forestiero a' suoi amici essendo ritornato a casa sua*, Lucca n.d.; a *terminus post quem* for this pamphlet is provided by a reference (sig. A iv r) to the equestrian statue on the Piazza SS Annunziata, a work by Giambologna unveiled in 1608; see Avery (1987): 258.

28. 'Ma più che à tutti per questo affare à V.[ostra] A.[ltezza] S.[erenissima] puote essere di diletto; la quale si come più intende, così col suo savio avviso delle bellezze sparse in questa città fioritissima potrà fare maggiore acquisto.' Bocchi (1591): sig. 3 v.

29. *Ibid.*: 4–5.

30. '. . . sormontano le città alla più sovrana bellezza'; *Ibid.*: 2.

31. *Ibid.*: 3.

32. E.g. *Ibid.*: 1.

33. *Ibid.*: 8.

34. 'Il disegno di questo palazzo è di Bernardo Buontalenti, huomo di peregrino ingegno, & raro come si vede nelle finestre, che sono leggiadre, nelle camere, & nelle Sale adagiate con savio avviso, nelle porte, che sono artifiziose, ma quella, che è principale in su la strada, è bella à maraviglia.' *Ibid.*: 7.

# The notion of beauty in Francesco Bocchi's
## *Bellezze della città di Fiorenza*, II

*Robert Williams*

In the *Bellezze*, Bocchi uses the terms *bello*, *bellissimo* and *bellezza* a great many times and in many ways; sometimes his usage seems to denote something specific and carefully considered, at times it seems very casual, even wilfully indiscriminate. This set of words occurs most frequently in relation to parts of the body as represented in paintings and sculptures: faces, hands and feet. They are occasionally used to describe a figure as a whole, not infrequently to describe the motion of a figure when it is especially graceful or expressive. Sometimes they are used to refer to parts or aspects of a picture: the treatment of drapery, an architectural setting or landscape background may be beautiful; the handling of paint over the whole surface of a picture or its colouring (*colorito*) may also be characterized in this way. Though Bocchi was, as we have already seen, familiar with the tradition that understood beauty as a relation between parts to one another and to the whole, and though he sometimes uses the term climactically, as a quality toward which all other qualities contribute, he most often uses the set of terms based on the adjective *bello* to refer to parts; beauty seems to be a feature of details, something ornamental.

Yet the use of the word *bellezza* in the title of the book suggests that everything Bocchi discusses is in some way exemplary of beauty, that beauty is not ornamental, but essential; not casual, but the very substance of discussion. The book is framed rhetorically, as panegyric, an extended praise of the city of Florence, and all the individual beauties enumerated are signs or demonstrations of the city's *virtù* – its power, but also its worth or integrity in a spiritual or moral sense. This becomes clear in Bocchi's long and careful inventories of relics kept in the most important churches, which, taken together, serve to demonstrate the deep piety of the Florentine people – the fact that they possess the virtue of faith. Bocchi's discussion of charitable institutions such as the Ospedale degli Innocenti or S. Maria

Nuova – with statistics regarding their capital endowments, the number of beds, the number of carers and so on – are likewise offered as proofs of the fact that Florentines possess the virtues of charity and civic responsibility. The larger thematic frame for Bocchi's consideration of art is also apparent in descriptions of customs such as the various horse races or annual football tournament, displays of competitive energy reflective of the virility, hence *virtù*, of the city's male population.

Bocchi's description of the soccer tournament that took place in the Piazza S. Croce each spring is worth considering in detail:

These youths, strong of limb, agile of body and of noble blood, gather in the square every afternoon, two hours before sunset . . . Taking off all the clothing that would hinder their movements, they proceed to compete as energetically and as skilfully as the game requires. Fifty-four young men are selected and divided into two teams: they make an incredibly beautiful sight in their speed and agility of body, exerting themselves to the utmost in the flower of their youth. Each side competes fiercely, as if it were an army, and from all parts of the city gentlemen come to watch, along with many children, so that the spectacle as a whole is lovely and very cheerful, both for the many incidents that occur in the game and for the most noble quality of the onlookers.[1]

Here, beauty is a feature of the motion of living figures – as it often is of painted ones – and the qualities of energy and agility produce it. At the same time, the spectacle as a whole is lovely to witness, largely because the competitors and audience are noble – because it reflects, in other words, upon a deeper quality of the Florentine people.

Though it may seem as remote from the issue of beauty as are the virtues of faith or charity, the concept of nobility provides another important context for Bocchi's consideration of Florentine art. The nobility of Florence was also something that needed to be demonstrated. As a mercantile and republican society, Florence had always been subject to the condescension of those for whom nobility in the feudal sense – titles, lineage, territory, wealth – was an important criterion of legitimacy. By the beginning of the fifteenth century, Florentines had developed a political ideology that justified a rejection of such standards in favour of others – individual initiative, *virtù*, public service, genius.[2] With the end of the Republic and the establishment of the Ducal regime, this ideology was subjected to curious pressure; Duke Cosimo was concerned to preserve it even while undermining the social and political structures that had led to its evolution, and appropriating for himself many of the prerogatives of a feudal lord.[3]

In the decades around mid-century, Cosimo was involved in a conflict with the d'Este Dukes of Ferrara over precedence at the imperial and papal courts, a case which was really a struggle for status between the ruling families, but which came to be argued in terms of the relative nobility of the

two cities. The Ferrarese upheld the feudal ideal, while the Florentines fell back on what might be called the civic or republican one. Though the issue was legally resolved when Cosimo was made Grand Duke of Tuscany in 1569, the rivalry between the two cultural ideals persisted into the following decades. A large quantity of polemical literature was generated: on the Florentine side, it featured inventories of accomplished men, of palaces – so many demonstrations of the virtue of magnanimity – of churches, demonstrations of faith, and of charitable institutions as demonstrations of charity.[4] Bocchi's book, despite its emphasis on the visual arts, is a contribution to this literature: artists were often listed among the accomplished men. His book might even be thought of as a response to the view of the Ferrarese poet Tasso that Florence was not a particularly beautiful city, rich in beautiful buildings, as was, say, Paris.[5]

Though Bocchi often treats beauty as if it were a matter of ornament, there is another and contrary notion that runs through his text. In the essay on Donatello's *St George*, he had compared the beauty of the statue with that of Michelangelo's work. Of Michelangelo he says: 'Neither his pictures nor his sculptures are encumbered with ornaments; there is no place in them for anything frivolous, nor for any trivial pleasure, but only for profundity of design, deep understanding, and vast knowledge, so that the souls of viewers, nourished on this exalted food, are filled with exalted thoughts.'[6] This emphasis on the austerity of Michelangelo's works had been anticipated in an important passage added to the second edition of Vasari's *Lives*, where the *Last Judgement* is defended against the criticism that its artifice is extravagant and indecorous with a digression that emphasizes rather its seriousness and avoidance of ornament. Michelangelo is said to be 'standing firm always in the profundity of art'.[7] His outstanding quality is described in terms of a variation on the topos of *puro sanza ornato*, the idea that purity or essential integrity needs no embellishment.[8]

This theme is developed in several places in the *Bellezze*. One is the discussion of Michelangelo's windows on the *pianterreno* of the Medici Palace:

There is no ornament around the windows, nor any extraneous charm, but the simplicity of the components suggests that every most lovely grace and all the rarest beauty have been poured forth from Michelangelo's mind. One cannot express with words how wonderful these windows are, and how much they are admired by every expert. For just as women are already fully adorned who, content with their natural beauty, disdain all extraneous ornament, so too these windows are esteemed to be stupendously beautiful because they do not distract by foreign artifice, but glory in their simplicity – wonderful beyond all beauty.[9]

The notion that the highest kind of art involves an apparent artlessness was a commonplace, of course; here it is overlaid with the idea that the highest

kind of beauty involves a retreat from the overt display of ornament, and thus has the effect of pointing instead toward something still more exalted, a more recondite integrity.

This theme is most strikingly stated in Bocchi's discussion of the cupola of Florence cathedral:

This structure is no less beautiful and elegant than it is strong and sturdy. Just as human beauty departs from an unhealthy body and joins itself to a healthy one with strong bonds, in like manner this wonderful building would be less beautiful if it were not also strong. Because beauty is closely linked to strength, the greatest artists and experts cannot decide whether this building excels more in its strength or its beauty. Two hundred and ninety years have already passed, with great diversity of weather: it has withstood floods, felt perilous earthquakes, been battered by rain, exposed to changes of humidity; it has been hit by furious winds and wild bolts of lightning. Still, it has always remained invincible and bold, and has never changed. However beautiful the interior and the exterior may be, one can nevertheless rightly say *quaeque latent meliora puta* (that which is hidden is better still).[10]

Beauty reveals a hidden quality, here an essential integrity, strength, that – given the importance of the cathedral – makes manifest, in turn, the virtue of the Florentine people. The idea of beauty as something relating to an inner quality is also found in the discussion of the Laurentian Library, where the architecture is said to function like a beautiful body, containing the *animo gentile* of learning preserved in the books housed there.[11]

Already in the essay on the *St George*, Bocchi had made a fascinating parallel between the beauty of the statue and that of the cupola, a passage that deserves to be quoted at length:

Beauty has a great and strong affinity with strength and sturdiness. Composed simply, without ornament, but rich in natural qualities, it makes strength pleasing to the sight. Many were the ideas which the various architects proposed who wished to complete the cupola of our cathedral, but only one was true, simple and natural: namely, that strong in its nature, graceful to the sight, beautiful in every part with respect to itself, it should be useful to the people who would occupy it and well-ordered with regard to the divine services performed there.[12]

Knowledgeable artists, Bocchi goes on to say, cannot decide whether the cupola's strength or its beauty is its more salient quality; the two qualities seem to compete one with another for primacy, and this same relation of qualities is also found in Donatello's figure of St George.[13]

Another indication of the moral resonance of this conception of beauty is found in a funeral oration for Duke Cosimo by a Florentine intellectual, Bernardo Davanzati, whom Bocchi knew:

He was patient in listening and polite in responding, plain in his dress and in his diet, like those who seek to maintain majesty in their deeds and bearing rather than

seeking it in clothes and banquets. So it is that great artists, when making their best figures, pay little attention to ornaments, while others give great attention to elaborate coiffures, to beautiful leggings, and other such embellishments. Not able to make their pictures beautiful, they make them rich – as Apelles said to one of his students who had made a picture of Helen adorned with much gold.[14]

Here, life imitates art: Cosimo is like the cupola, or the *St George*, or the *Last Judgement*. If the aesthetic is grounded in the moral, the moral is also grounded in the aesthetic.

On the one hand, the notion of beauty presented in the *Bellezze* seems to anticipate the modern idea of the aesthetic as a distinct and autonomous realm: by describing the city and its works of art as a visual spectacle, offering them as objects of a particular kind of interest, Bocchi implies the adequacy of such interest to them, and thus a certain degree of self-sufficiency or autonomy or inner logic to the mode of viewing he recommends. As we have seen, however, beauty is also the sign of something else, a higher integrity or perfection that is not visible and that cannot be characterized in the limited way implied by the term aesthetic. I have suggested that it might be more adequately characterized as moral or spiritual, but also that such a characterization is not entirely satisfying either. Whatever it may be for Bocchi, the aesthetic is not yet the aesthetic in the modern philosophical sense: it is still not perfectly distinguished from other realms, cognition on the one hand, morality on the other.

I would propose that the tension between these senses of the term is resolved if we recognize that, for Bocchi, the perception of beauty requires an act of objectification. Parts are said to be beautiful when seen in relation to wholes; wholes become parts when seen in relation to larger wholes. Visual objectification in general might be understood as a part, one function in relation to other functions and faculties of mind. It would be going too far to say that Bocchi believed beauty itself to be constituted in the act of objectification – he believed that it is already present in the things in the world that we admire – but its perception, and the benefit we derive from it, occurs in the context of human perception generally, of judgement and action – the entire fabric of human concerns. The objectification necessary to perceive it is what provides beauty with its moral ground.

The ability to objectify is a highly developed skill, and one of Bocchi's aims is to offer instruction in it: the *Bellezze* is not only about what to look at, but how to look. In isolating viewing the way it does – the particular kind of interest, of excitement, of pleasure, that viewing affords – but also reintegrating viewing in the larger fabric of human interests, the *Bellezze* can be said to construct or reconstitute viewing as a cultural practice. It is worth concluding with the observation that Bocchi's understanding of this practice is

bound up with his activity as orator and his understanding of the importance of eloquence generally. Naming things is also an act of objectification, even when the things named are subjective responses, and this helps to explain the importance Bocchi attaches to the way in which beauty reveals what is hidden, makes manifest qualities that we can identify and that serve as points of reference for future thought, discussion and action.

## Notes

1. 'Quelli, che di forze sono robusti, & destri di persona, di giovenile età, di sangue nobile, due hore prima, che il Sole tramonti, . . . ogni giorno fanno adunanza in questa piazza, & spogliandosi le veste, che impediscono l'attegiar la persona, come chiede il giuoco del pallone, con fierezza più destra, che pensar si possa, si esercitano. Perche scelto un numero di LIIII giovani eletti, & divisi in due parti, è incredibile à dire, quanto facciano bella vista nella velocità, & nella destrezza del corpo; & nel fiore dell'età usando maggiore sforzo, che si puote, come sembra l'una parte, & l'altra, che combatta, come è usanza tra due eserciti, con gran fierezza. Da tutte le parti della Città concorrono gentilhuomini à vedere, & fanciuletti di picciola età: onde si fa una frequenza vaga, & di molta letizia per li accidenti varii, che ad hora, ad hora nel giuoco intervengono, & per la qualità de gli huomini nobilissima.' Bocchi (1591): 146–7.

2. For a recent overview of this process, see Donati (1988).

3. For a summary discussion of this process, with further bibliography, see: Williams (forthcoming).

4. Examples include: Paolo Mini, *Difesa della città di Fiorenza* (Lyon, 1577); expanded and republished as Mini (1593); Bastiano de' Rossi (1584); Luca Ferrini, 'Discorso della nobiltà di Firenze ancor che sia mercantile', in Poccianti (1589): 17–46.

5. In a letter to Count Ercole de' Contrari of 1572, Tasso compares France and Italy in general, and leaves Florence conspicuously missing from a discussion of Italian cities which, by their beauty, might compare favourably to Paris. Tasso (1965): V, 725–47, esp. 742–5.

6. 'Non sono le sue statue, né le pitture parimente, involte in ornamenti; non vi ha luogo cosa frivola né diletto leggiere, ma gravità di disegno, profonda intelligenza e savio avviso in ogni affare, che, poiché hanno preso l'animo altrui, pascono quello di cibo orrevole, e di savio pensiero lo reiempiono.' Bocchi (1584): 189.

7. Vasari (1966–87): VI, 69: '. . . stando saldo sempre nella profundità dell'arte . . .'

8. On this theme, see Baxandall (1972): 122–3; Wohl (1993).

9. 'Intorno non ci è ornamento, né vaghezza esteriore: ma nella semplicità de' membri pare, che dal senno del Buonarroto sia piovuta ogni grazia più vaga, & ogni più rara bellezza: ne con parole si puote exprimere, quanto siano maravigliose, & da ogni huomo intendente ammirate. Perche si come le donne assai sono ornate, che contente della bellezza naturale sprezzano ogni ornamento esteriore: Così di stupenda bellezza sono stimate queste finestre, le quali senza fermargli di artifizio straniero in sua semplicità risplendono mirabilmente sopra ogni bellezza.' Bocchi (1591): 10.

10. 'Per lo che non meno è bella questa macchina, & leggiadra, che forte, & gagliarda: Et si come l'humana bellezza dal corpo, che è infermo, si dilegua, & con quello, che è sano, quasi con forte nodo è congiunta: Così questa mirabil fabbrica, se non fosse gagliarda, meno in lei rilucerebbe quell'eccessiva bellezza, la quale legata, & stretta con estrema fortezza, fa star pensosi i sommi artefici, & i piu intendenti huomini, che nel mirarla ad hora, ad hora non sanno ancor discernere, se più sia ella gagliarda, o da altra parte in bellezza si avanzi. Già sono passati dugento novanta anni con grandissima diversità di tempi, & ha provate inondazioni di acque, ha sentiti ruinosi tremoti, è stata travagliata da tempi piovosi, da variazione di secco, di humido, da venti furiosi: è stata scossa da folgori impetuose: ma invitta, & franca ha conservato sempre l'esser suo senza cambiarsi, & quantunque dentro, & di fuori sia bella, come si vede, non senza ragione di lei tuttavia si puote dire: *quaeque latent, meliora puta*.' *Ibid.*: 17.

11. *Ibid.*: 285.

12. 'Ha la bellezza con quello che è forte e gagliardo stretta e grande amistà, e composta con semplice ragione, senza ornamento, ma ricca di naturali arredi, rende vista piacevole in sua

fortezza. Molte erano le ragioni che proponevano molti maestri, quando si dovea voltare la cupola del nostro duomo et innalzarla; ma una era la ragione vera, semplice e naturale, et in un modo senza più: che, forte in sua natura, leggiadro in vista, bello in ogni parte verso di sé, dovea essere utile all'uomo che dentro ci dovea dimorare, e per li divini uffizii opportunamente ordinato.' Bocchi (1584): 189.

13. A passage at the beginning of Alberti's dialogue, *Della Tranquillità dell'animo*, indicates that this way of considering the Cathedral as a synthesis of opposing qualities was already well-established. 'E certo questo tempio ha in sè grazia e maiestà: e quello ch'io spesso considerai, mi diletta ch'io veggo in questo tempio iunto insieme una gracilità vezzosa con una sodezza robusta e piena, tale che da una parte ogni suo membro pare posto ad amenità, e dall'altra parte compreendo che ogni cosa qui è fatta e offirmata a perpetuità.' Alberti, ed. Grayson (1996): II, 107. The passage is cited and discussed in Smith (1992): 5–6.

14. 'Era patiente nell'udire, grato nel rispondere, semplice nel vestire e di vivande splendide non curante, come quegli che ritenendo ne' fatti, e nell'aspetto la maestà, non la cercava ne gli abiti, e nelle mense. Così avviene a i grandi artefici che facendo lor figure ottime, non troppo curano gl'ornamenti, dove gl'altri molto studiano in trecce, in biondelle, in bei calzari, e fregi, e non potendo lor pitture far belle le fanno ricche, si come dice Apelle a quel suo discepolo che haveva dipinto Elena ornato di molto oro.' *Oratione delle laudi del S. Cosimo de' Medici . . .*, ms. BAV, Barb. lat. 3963, f. 24; cited by Quiviger (1989): 164.

# Bibliography

## Primary sources

Alberti, Leon Battista. *Della Pittura*. L. Mallé, ed. Florence, 1950.
———— *L'Architettura (De re aedificatoria)*. G. Orlandi, ed. 2 vols, Milan, 1966.
———— *Opere volgari*. C. Grayson, ed. 2 vols, Bari, 1960–73.
———— *I libri della famiglia*. R. Romano and A. Tenenti, eds. Turin, 1969.
———— *Leon Battista Alberti On Painting and On Sculpture*. C. Grayson, ed. and trans. London, 1972.
———— *On the Art of Building in Ten Books*. J. Rykwert, N. Leach and R. Tavernor, eds and trans. Cambridge and London, 1988.
Anon. *Opera nuova delle bellezze, e grandezze della città di Firenze narrate da un forestiero a' suoi amici essendo ritornato a casa sua*. Lucca, n.d.
———— 'Vita di Leon Battista Alberti', in L.B. Alberti, *Opere Volgare*, A. Bonucci, ed. 3 vols, Florence, 1843–49, I, LXXXIX–CXIX.
Aquinas, St Thomas. *Summa theologiae*. Cambridge, 1964–81.
Aristotle. *The Nicomachean Ethics*. H. Rackham, trans. (Loeb Classical Library). London and New York, 1926.
———— *The Nicomachean Ethics*. J.A.K. Thomson, trans. London, 1955.
Augustine, St. *Concerning the City of God against the Pagans*. H. Bettenson, trans. London, 1972.
Baiardi, A. *Rime del Cavaliere Andrea Bajardi*. F. Fogliazzi, ed. Milan, 1756.
Baldinucci, Filippo. *Vocabolario Toscano dell'Arte del Disegno*. Florence, 1681.
Bandello, Matteo. *Il Canzoniere*. F. Picco, ed. Turin, 1923.
Barocchi, P., ed. *Trattati d'arte del Cinquecento, fra Manierismo e Controriforma*. 3 vols, Bari, 1960–2.
———— *Scritti d'arte del Cinquecento*. 3 vols, Milan and Naples. 1971–7.
Bembo, Pietro. 'Gli Asolani', in *Pietro Bembo. Opere in Volgare*. M. Marti, ed. Florence, 1961.
Boccaccio, Giovanni. *Decamerone*. V. Branca, ed. 3 vols, Florence, 1966.

Bocchi, Francesco. *Eccellenza della statua del San Giorgio di Donatello scultore fiorentino posta nella facciata di fuori d'Or San Michele . . . dove si tratta del costume, della vivacità e della bellezza di detta statua.* Florence, 1584; in P. Barocchi, ed. (1960–2): III, 125–94.

———— *Le bellezze della città di Fiorenza, dove à pieno di pittura, di scultura, di sacri tempii, di palazzi i più notabili artifizii, et più preziosi si contengono.* Florence, 1591; reprint edition with introduction by J. Shearman. Farnborough, 1971.

Borghini, Raffaello. *Il Riposo.* Florence, 1584; facsimile edition, M. Rosci ed. 2 vols, Milan, 1967.

Boschini, Marco. *La carta del navegar pitoresco.* Venice, 1660. A. Pallucchini, ed. Venice and Rome, 1966.

Bruni, Leonardo. *Epistolarum.* L. Mehus, ed. 2 vols, Florence, 1741.

Caporali, Giovanni Battista. *Con il suo commento e figure Vetruvio in volgar lingua.* Perugia, 1536.

Castiglione, Baldesar. *Il Cortegiano.* Venice, 1527.

Castiglione, Baldassare. *Il Libro del Cortegiano.* B. Maier, ed. Turin, 1964.

———— *Il libro del Cortegiano.* E. Bonora, ed. Milan, 1972–81.

———— *The Book of the Courtier.* T. Hoby, trans. (1561). London and New York, 1975.

Cellini, Benvenuto. 'Dell'architettura', in *Opere di Benvenuto Cellini.* G.G. Ferrero, ed. Turin, 1980, 813–21.

Cennini, Cennino. *The Craftsman's Handbook. 'Il Libro dell'Arte'.* D.V. Thompson, ed. and trans. New Haven, CT, 1933.

Cesariano, Cesare. *Di Lucio Vitruvio Pollione de architectura libri decem traducti de latino in volgare affigurati, commentati . . .* Como, 1521.

Cicero, Marcus Tullius. *De Officiis.* W. Miller, ed. and trans. (Loeb Classical Library). London and Cambridge, Mass, 1975.

Condivi, Ascanio. *The Life of Michelangelo.* H. Wohl, ed., A.S. Wohl, trans. Baton Rouge, Louisiana, 1976.

Danti, Vincenzo. *Il primo libro del trattato delle perfette proporzioni di tutte le cose che imitare e ritrarre si possano con l'arte del disegno.* Florence, 1567; in P. Barocchi, ed. (1960–2): I, 207–69.

da Firenze, Bernardino. *Le bellezze et chasati di Firenze.* Florence, n.d. (c. 1500).

da Hollanda, Francisco. *Four Dialogues on Painting.* A.F.G. Bell, ed. and trans. Oxford, 1928.

da Vinci, Leonardo. *Treatise on Painting.* A.P. McMahon, ed. and trans. 2 vols, Princeton, NJ, 1956.

———— *Leonardo on painting.* M. Kemp and M. Walker, eds and trans. New Haven, CT, and London, 1989.

degli Arienti, Giovanni Sabadino. 'De triumphis religionis . . .', in W.L. Gundersheimer (1972).

de Beatis, Antonio. *Die Reise des Kardinals Luigi d'Aragona durch Deutschland, die Niederlande, Frankreich und Oberitalien, 1517–18.* L. Pastor, ed. Freiburg im Breisgau, 1905.

della Casa, Giovanni. *Galateo ovvero de'costumi.* C. Milanini, ed. Milan, 1977.

de'Crescenzi, Piero. *De Agricultura Vulgare.* Venice, 1495.

de'Rossi, Bastiano. *Lettera . . . nella quale si ragiona di Torquato Tasso . . .* Florence, 1585.

di Benedetto, A., ed. *Prose di Giovanni della Casa e altri trattatisti cinquecenteschi del comportamento.* Turin, 1970

Dionysius the Areopagite. *Mystical Theology and the Celestial Hierarchies.* Editors of the Shrine of Wisdom, trans. Godalming, 1965.

Dolce, Ludovico. *Dialogo della Pittura.* Venice, 1557; in P. Barocchi, ed. (1960–2): I, 141–206.

——— 'Dialogo della pittura intitolato l'Aretino', in M. Roskill (1968).

Ebreo, Leone. *Dialoghi d'amore.* Rome, 1535.

——— *The Philosophy of Love (Dialoghi d'amore).* F. Friedberg-Seeley and J. H. Barnes, eds and trans. London, 1937.

Equicola, Mario. *Libro di natura d'amore.* Venice, 1525.

Fiamma, Galvano. *Opusculum de rebus gestis ab Azone, Luchino et Johanne Vicecomitibus ab anno MCCCXXVIII usque ad annum MCCCXLII.* C. Castiglioni, ed., in *Rerum Italicarum Scriptores,* L.A. Muratori, ed. 2nd ed., Bologna, 1938, 12 (4).

Ficino, Marsilio. *De amore* or *Sopra lo amore.* Florence, 1474.

——— *Platonis opera omnia.* Lyons, 1548.

——— *Opera omnia.* Basel, 1561.

——— *Theologiae platonicae, de immortalitate animorum.* R. Marcel, ed. and trans. 3 vols, Paris, 1964–70.

——— *The Letters of Marsilio Ficino.* Members of the Language Department of the School of Economic Science, trans. 3 vols, London, 1975–1981.

——— *Commentary on Plato's Symposium on Love (In convivium Platonis de amore commentarium).* S. Jayne, trans. 2nd revised edn., Dallas, Texas, 1985.

——— *Commentarium in Convivium Platonis de Amore.* G. Rensi, ed. and trans., as *Marsilio Ficino sopra lo Amore.* Milan, 1992.

Filarete (Antonio di Piero Averlino). *Filarete's Treatise on Architecture, Being the Treatise by Antonio di Piero Averlino, known as Filarete.* J.R. Spencer, trans. 2 vols, New Haven, CT, and London, 1965.

——— *Trattato di architettura.* A. M. Finoli and L. Grassi, eds. 2 vols, Milan, 1972.

Firenzuola, Agnolo. 'Dialogo delle Bellezze delle Donne', in *Prose di M. Agnolo Firenzuola Fiorentino*. Florence, 1548.

―――― 'Del dialogo del Firenzuola fiorentino della bellezza delle donne intitolato Celso. Discorso Primo', in *Opere di Messer Agnolo Firenzuola fiorentino*, P.-L. Fantini, ed. 4 vols, Florence, 1763: I, 249–328.

―――― 'Dialogo delle bellezze delle donne' (1542), in *Opere di Messer Agnolo Firenzuola*, P.-L. Fantini, ed. 2 vols, Milan, 1802: I, 1–97.

―――― *On the Beauty of Women*. K. Eisenbichler and J. Murray, eds and trans. Philadelphia, PA, 1992.

Gauricus, Pomponius. *De sculptura*. A. Chastel and R. Klein, eds. Geneva, 1969.

Ghiberti, Lorenzo. *I commentari*. O. Morisani, ed. Naples, 1947.

Giovio, Paolo. 'Leonardi Vincii Vita', in P. Barocchi, ed. (1971–7): I, 7–9.

Gottifredi, Bartolomeo. 'Specchio d'Amore', in A. di Benedetto, ed. (1970): 577–631.

Jerome, St. *St Jerome: Letters and Select Works, A Select Library of Nicene and Post-Nicene Fathers of the Church*. 2d. ser., VI. New York, 1893.

Landino, Cristoforo. *Carmina omnia*. A. Perosa, ed. Florence, 1939.

Liutprand, Cremonensis Episcopi. 'Relatio de Legatione Constantinopolitana (968)', in *Patrologiae . . . omnium SS.Patrum, doctorum scriptorumque ecclesiasticorum . . .* J.P. Migne, ed, CXXXVI. Paris, 1881.

Lomazzo, Giovanni Paolo. 'Trattato dell'arte della pittura, scoltura ed architettura' (1584), in *Gian Paolo Lomazzo. Scritti sulle arti*. R.P. Ciardi, ed. 2 vols, Florence, 1974: II.

―――― *Idea dello Tempio della Pittura*. R. Klein, ed. 2 vols, Florence, 1974.

Luther, Martin. *Martin Luthers Werke. Kritische Gesamtausgabe*. Weimar, 1883–.

Manetti, Gianozzo. 'Vita Nicolai V Summi Pontificis auctore Jannotio Manetto Florentino nunc primum prodit ex manuscripto codice florentino', in *Rerum Italicarum Scriptores ab anno aerae Christianae quingentesimo ad millesimumquingentesimum, quorum potissima pars nunc primum in lucem prodit ex Ambrosianae, Estensis, aliarumque insignium bibliothecarum codicibus*. L.A. Muratori, ed. Milan, 1734: 3(2), cols 905–960.

Martini, Francesco di Giorgio. *Trattati di Architettura, Ingegneria e Arte Militare*. C. Maltese, ed. 2 vols, Milan, 1967.

Mini, Paolo. *Discorso della nobiltà di Firenze e de' fiorentini*. Florence, 1593.

Neri, Antonio. *L'Arte Vetraria* (1612). R. Barovier Mentasti, ed. Milan, 1980.

Nifo, Agostino. *Del bello. Il bello è nella natura*. Lyon, 1549.

Palmieri, Matteo. *Della Vita Civile*. G. Belloni, ed. Florence, 1982.

Petrarch, Francesco. *Petrarch's Lyric Poems: The "Rime Sparse" and Other Lyrics*. R.M. Durling, ed. and trans. Cambridge, Mass, 1976.

Piccolomini, Alessandro. 'Instituzion Morale', in A. di Benedetto, ed. (1970): 507–69.

––––––– 'Raffaella, o Dialogo de la bella Creanza de le Donne de lo Stordito intronato', in A. di Benedetto, ed. (1970): 431–506.

Pius II. *Aeneas Silvius Piccolomini (Pius II), The Goodli History of the Ladye Lucres of Scene and of her Lover Eurialus*. E.J. Morrall, ed. (Early English Text Society). Oxford, 1996.

––––––– *Commentarii rerum memorabilium que temporibus suis contigerunt*. A. van Heck, ed. 2 vols, Vatican City, 1984.

Plato. *The Collected Dialogues Including the Letters*. E. Hamilton and H. Cairns, eds (Bollingen Series LXXI). Princeton, NJ, 1985.

Pliny the Elder. *The Elder Pliny's Chapters on The History of Art*. E. Sellers and K. Jex-Blake, eds and trans. Chicago, Ill, 1976.

Poccianti, Michele, *Vite de' sette beati fiorentini fondatori dello Sacro Ordine de'servi*. Florence, 1589.

Pontano, Giovanni. *De magnificentia*. Naples, 1498.

––––––– *I trattati delle virtù sociali: De Liberalitate, De Beneficentia, De Magnificentia, De Splendore, De Conviventia*. F. Tateo, ed. Rome, 1965.

Pseudo-Dionysius the Areopagite. *The Divine Names and Mystical Theology*. J.D. Jones, trans. Milwaukee, Wisconsin, 1980.

Ridolfi, Carlo. *Le maraviglie dell'arte*. D. von Hadeln, ed. Berlin, 1914.

Sansovino, Francesco. 'Ragionamento di messer Francesco Sansovino nel qual s'insegna a' giovani la bella arte d'amore', in A. di Benedetto, ed. (1970): 639–672.

Serlio, Sebastiano. *Tutte l'opere d'architettura, et prospettiva*. Venice, 1619; reprint Ridgewood, NJ, 1964.

Spagnoli, Battista. *The Eclogues of Baptista Mantuanus*. W. P. Mustard, ed. Baltimore, MD, 1911.

Strozzi, Alessandra Macinghi degli. *Lettere di una gentildonna fiorentina del secolo xv . . . .* C. Guasti, ed. Florence, 1877.

Suetonius. *Works*. J.C. Rolfe, trans. (The Loeb Classical Library). London and New York, 1914.

*Summa aurea de laudibus beatissimae Virginis Mariae*. J.P. Migne, ed. Paris, 1866.

Tasso, Torquato. *Prose*. F. Flora, ed. Milan, 1935.

––––––– Torquato. *Opere*. B. Maier, ed. 5 vols, Milan, 1965.

Valerini, Adriano. *Le bellezze di Verona, nuovo ragionamento . . . nel quale con brevità si tratta di tutte le cose notabili della città*. Verona, 1586. G.P. Marchi, ed. Verona, 1974.

Varchi, Benedetto. *Lezioni sull'Amore*. Florence, 1540.

Vasari, Giorgio. *Le Vite de'più eccellenti pittori, scultori ed architettori*. Florence, 1568. G. Milanesi, ed. 9 vols, Florence, 1878–85.

———— *Lives of the Most Eminent Painters, Sculptors and Architects.*
G. de Vere, trans. 10 vols, London, 1912–14.
———— *Vasari on Technique.* L.E. Maclehose, ed. and trans. London 1907 and
New York, 1960.
———— *Le vite de' più eccellenti pittori, scultori, e architettori (nelle redazione del
1550 e 1568).* R. Bettarini and P. Barocchi, eds. 6 vols, Florence and
Verona, 1966–87.
———— *The Lives of the Most Excellent Painters, Sculptors, and Architects.*
G. Bull, trans. Harmondsworth, 1971.
Vitruvius. *Ten Books on Architecture.* M.H. Morgan, trans. New York, 1960.
———— *De architectura libri decem.* C. Fensterbuch, ed. Darmstadt, 1981.
von Strassburg, Gottfried. *Tristan.* A.T. Hatto, ed. and trans. London, 1967.
———— *Tristan.* R. Bechstein and P. Ganz, eds. Wiesbaden, 1978.
Wimpheling, Jakob. *Epithoma rerum Germanicarum usque ad nostra tempora.*
Strassburg, 1505.

**Secondary literature**

Ackerman, J.S. *The Architecture of Michelangelo.* Harmondsworth, 1986.
Adams, N. 'Architecture for Fish: The Sienese Dam on the Bruna. River-
Structures and Designs, 1468–ca.1530'. *Technology and Culture*, 25, 1984:
768–97.
Adler, K. and M. Pointon, eds. *The Body Imaged. The Human Form and Visual
Culture since the Renaissance.* Cambridge, 1993.
Adorni, B., ed. *Santa Maria della Steccata a Parma.* Parma, 1982.
———— 'L'archittetura', in B. Adorni, ed. (1982): 41–98.
Adorno, T. *Aesthetic Theory.* C. Lenhardt, trans. London, 1984.
Allen, M.J.B. *The Platonism of Marsilio Ficino: A Study of his Phaedrus
Commentary, Its Sources and Genesis.* Berkeley and Los Angeles, Calif,
1984.
———— *Icastes: Marsilio Ficino's Interpretation of Plato's 'Sophist'.* Berkeley and
Los Angeles, Calif, and Oxford, 1989.
Ames-Lewis, F., ed. *The Early Medici and their Artists.* London, 1995.
Avery, C. *Giambologna. The Complete Sculpture.* Oxford, 1987.
Baer, C. *Die italienischen Bau- und Ornamentsformen in der Augsburger Kunst
zu Beginn des 16. Jahrhunderts.* Frankfurt-am-Main, 1993.
Baldacci, L., ed. *Il petrarchismo italiano nel '500.* Milan and Naples, 1957.
———— 'Gli *Asolani* del Bembo e Venere celeste', in L. Baldacci, ed. (1957):
107–110.
Barasch, M. *Light and Color in the Italian Renaissance Theory of Art.* New
York, 1978.

—— *Theories of Art from Plato to Winckelmann*. New York and London, 1985.

Barolsky, P. *The Faun in the Garden*. University Park, PA, 1994.

Bartoli, A. *I Monumenti di Roma nei disegni degli Uffizi di Firenze*, 6 vols, Rome, 1914–22.

Baxandall, M. *Giotto and the Orators*. Oxford, 1971.

—— *Painting and Experience in Fifteenth-Century Italy*. Oxford, 1972.

—— *The Limewood Sculptors of Renaissance Germany*. New Haven, CT, and London, 1980.

Bentini, J., ed. *Disegni della Galleria Estense di Modena*. Modena, 1989.

Bernardi, J. 'Descrizione di un viaggio fatto nel 1549 da Venezia a Parigi di Andrea Minucci, arcivescovo di Zara'. *Miscellanea di storia italiana*, 1, 1862: 49–103.

Bernheimer, R. 'Gothic Survival and Revival in Bologna', *Art Bulletin*, 36, 1954: 263–84.

Bialostocki, J. 'The Power of Beauty. A Utopian Idea of Leon Battista Alberti', in W. Lotz and L.L. Müller, eds (1964): 13–19.

Biedermann, H. *Dictionary of Symbolism: Cultural Icons and the Meanings Behind Them*. J. Hulbert, trans. New York, 1994.

Bloch, R.H. and F. Ferguson, eds. *Misogyny, Misandry, and Misanthropy*. Berkeley and Los Angeles, Calif, 1989.

Blunt, A. *Artistic Theory in Italy 1450–1600*. Oxford, 1962.

Bober, P.P. and R. Rubinstein. *Renaissance Artists and Antique Sculpture: A Handbook of Sources*. Oxford, 1986.

Bolgar, R.R., ed. *Classical Influences in European Culture AD 500–1500*. Cambridge, 1971.

Borsi, F. *Leon Battista Alberti. Opera completa*. Milan, 1973.

Bottari, G. and S. Ticozzi, eds. *Raccolta di lettere sulla pittura, scultura ed architettura*. 8 vols, Milan, 1822–5.

Botter, M. *Affreschi decorativi di antiche case trivigiane: del XII al XV secolo*. Treviso, 1979.

Brandt, G. *Catholicism*. New York, 1982.

Brinkmann, H. *Zu Wesen und Form Mittelalterlicher Dichtung*. Halle, 1928.

Brown, C. *Van Dyck*. Oxford, 1982.

Brown, R. G. 'The Politics of Magnificence in Ferrara 1450–1505: a study in the socio-political implications of Renaissance spectacle', Ph.D. thesis (unpublished), University of Edinburgh, 1982.

Bruschi, A., C. Maltese, M. Tafuri and R. Bonelli, eds. *Scritti rinascimentali di architettura*. Milan, 1978.

Bruschi, A. 'I pareri sul tiburio del duomo di Milano. Leonardo, Bramante, Francesco di Giorgio', in A. Bruschi, C. Maltese, M. Tafuri and R. Bonelli, eds (1978): 321–86.

Bruyn, J. and J.A. Emmers. 'The Sunflower Again'. *Burlington Magazine*, 1957: 96–97.

Buddensieg, T. 'Criticism and Praise of the Pantheon in the Renaissance', in R.R. Bolgar, ed. (1971): 259–67.

Buffo, P. *Sofonisba Anguissola e le sue sorelle* [exhibition catalogue], Cremona, 1994.

Burckhardt, J. *The Civilization of the Renaissance in Italy.* 2 vols, New York, 1958.

Burke, P. *The Italian Renaissance: Culture and Society.* Cambridge, 1986.

Burns, H. 'A Peruzzi Drawing in Ferrara'. *Mitteilungen des Kunsthistorischen Institutes in Florenz*, 12, 1965–66: 245–70.

Burns, H., B. Boucher and L. Fairbairn, eds. *Andrea Palladio 1508–1580: The Portico and the Farmyard* [exhibition catalogue] London, 1975.

Burns, H. 'Baldassare Peruzzi and Sixteenth Century Architectural Theory', in J. Guillaume, ed. (1988): 207–26.

Bynum, C. 'The Body of Christ in the Later Middle Ages: A Reply to Leo Steinberg'. *Renaissance Quarterly*, 39, 1986: 3.

Cämmerer, M., ed. *Kunst des Cinquecento in der Toskana.* Munich, 1994.

Campori, G. 'Tiziano e gli Estensi'. *Nuova Antologia*, 27, 1874: 571–620.

Canuti, F. *Il Perugino.* Siena, 1931.

Catta, E. 'Sedes Sapientiae', in H. Du Manoir, ed. (1961): VI, 689–866.

Ceci, G. 'Il Palazzo dei Sanseverino, Principi di Salerno'. *Napoli nobilissima*, 8 (6), 1898: 81–85.

Chandler, S.B. 'The life and literary works of Giovanni Sabadino degli Arienti'. Ph.D. thesis (unpublished), University of London, 1952.

Chastel, A. *Marsile Ficin e l'art.* Geneva and Lille, 1954.

———— *Art et Humanisme à Florence au temps de Laurent le Magnifique.* Paris, 1959.

———— *The Myth of the Renaissance – 1420–1520.* Geneva, 1969.

———— *Le cardinal Louis d'Aragon. Un voyageur princier de la Renaissance.* Paris, 1986.

Cheney, L. De G. 'Vasari's Depiction of Pliny's Histories', in *Exploration in Renaissance Culture*, 15, 1989: 97–120.

———— *Botticelli's Neoplatonic Images.* Potomac, MD, 1993.

Cheney, L. De G., ed. *Readings in Italian Mannerism.* New York and London, 1997.

Christensen, C.C. 'Luther's Theology and the uses of religious art'. *Lutheran Quarterly*, 22, 1970: 147–65.

Cittadella, L. N. *Notizie relative a Ferrara, per la maggior parte inedite, ricavate da documenti ed illustrate.* Ferrara, 1864.

Clark, K. 'Leonardo and the Antique', in C.D. O'Malley, ed. (1969): 1–34.

———— *The Nude: A Study in Ideal Form.* Princeton, NJ, 1972.

———— *Leonardo da Vinci*. Harmondsworth, 1973.

Clarke, G. 'Italian Renaissance Urban Domestic Architecture: The Influence of Antiquity'. Ph.D. thesis (unpublished), University of London, 1992.

Clarke, T.H. '*Lattimo* – a group of Venetian glass enamelled on an opaque-white ground'. *Journal of Glass Studies*, XVI, 1974: 22–56.

Clayton, M. *Leonardo da Vinci: one hundred drawings from the collection of Her Majesty the Queen* [exhibition catalogue, Queen's Gallery, Buckingham Palace]. London, 1996.

Clements, R.J. *Michelangelo's Theory of Art*. New York, 1961.

Clough, C., ed. *Cultural Aspects of the Italian Renaissance: essays in honour of Paul Oskar Kristeller*. Manchester, 1976.

Cochrane, E. *Historians and Historiography in the Italian Renaissance*. Chicago, Ill, 1985.

Corti, L. et al., eds. *Giorgio Vasari: Principi, letterati e artisti nelle carte di Giorgio Vasari*. Florence, 1981

Cropper, E. 'On Beautiful Women. Parmigianino, *Petrarchismo*, and the Vernacular Style'. *Art Bulletin*, 58(3), 1976: 374–95.

———— 'The Beauty of Women: Problems in the Rhetoric of Female Portraiture', in M.W. Ferguson, M. Quilligan and N.J. Vickers, eds (1986): 175–90.

———— 'The Place of Beauty in the High Renaissance and its Displacement in the History of Art', in A. Vos, ed. (1995): 159–205.

Curtius, E.R. *European Literature and the Latin Middle Ages*. London, 1979.

dall'Acqua, M. 'Il Parmigianino alla Steccata, documentazione', in B. Adorni, ed. (1982): 137–50.

———— *Correggio e il suo tempo*. Parma, 1984.

Daly Davis, M. 'Beyond the "Primo libro" of Vincenzo Danti's "Trattato delle perfette proporzioni" '. *Mitteilungen des Kunsthistorischen Institutes in Florenz*, 26, 1982: 63–84.

d'Amico, J. F. *Renaissance Humanism in Papal Rome: Humanists and Churchmen on the Eve of the Reformation*. Baltimore, MD, and London, 1983.

Davitt Asmus, U. *Corpus Quasi Vas: Beiträge zur Ikonographie der italienischen Renaissance*. Berlin, 1977.

de Andrés, G. 'El Greco y los Agustinos'. *Revista del Colegio de Alfonso XII*, 1958–59, 12.

de Bièvre, E. 'The urban subconscious: the art of Delft and Leiden'. *Art History*, 18, 1995: 222–52.

Dempsey, C. Review of Summers, D. *Michelangelo and the Language of Art*. Princeton, NJ, 1981, in *Burlington Magazine*, 125, 1983: 624–7.

———— *The Portrayal of Love: Botticelli's 'Primavera' and Humanist Culture at the Time of Lorenzo the Magnificent*. Princeton, NJ, and Oxford, 1992.

Denley, P. and C. Elam, eds. *Florence and Italy. Renaissance Studies in Honour of Nicolai Rubinstein.* London, 1988.

de Tolnay, C., et al. *The Complete Work of Michelangelo,* 2 vols. London, 1966.

de Vecchi, P. *Michelangelo.* A. Campbell, trans. New York, 1991.

di Giampaolo, M. 'Quattro studi del Parmigianino per la "Madonna dal collo lungo" '. *Prospettiva,* 33–36, 1983–84: 180–2.

Dixon, J. W. *The Christ of Michelangelo: An Essay on Carnal Spirituality.* Atlanta, Georgia, 1994.

Donati, C. *L'Idea della nobiltà in Italia.* Rome and Bari, 1988.

Duffy, E. *The Stripping of the Altars. Traditional Religion in England, 1400–1580.* New Haven, CT, and London, 1992.

Du Manoir, H., ed. *Maria. Etudes sur la Sante Vierge.* 9 vols, Paris, 1961.

Dunkerton, J., S. Foister, D. Gordon, and N. Penny, *Giotto to Dürer: Early Renaissance Painting in the National Gallery.* New Haven, CT, and London, 1991.

Eco, U. *Art and Beauty in the Middle Ages.* New Haven, CT, and London, 1986.

Ehrismann, O. *Ehre und Mut. Aventiure und Minne. Höfische Wortgeschichten aus den Mittelalter.* Munich, 1995.

Eisenbichler, K. and O. Zorzi Pugliese, eds. *Ficino and Renaissance Neoplatonism.* Toronto, 1986.

Ekserdjian, D. 'Parmigianino's first idea for the *Madonna of the Long Neck'. Burlington Magazine,* 126, 1984: 424–9.

Ewald, G. 'La Toeletta di Venere', in L. Corti et al. eds. (1981): 74–5.

Fagiolo Dell'Arco, M. *Il Parmigianino, un saggio sull'ermetismo nel Cinquecento.* Rome, 1970.

———— and M.L. Madonna, eds. *Baldassare Peruzzi: pittura, scena, e architettura nel Cinquecento.* Rome, 1987.

Fehl, P. *Decorum and Wit: the Poetry of Venetian Painting.* Vienna, 1991.

Ferguson, M.W., M. Quilligan and N.J. Vickers, eds. *Rewriting the Renaissance: The Discourses of Sexual Difference in Early Modern Europe.* Chicago, Ill, and London, 1986.

Fermor, S. 'On the Description of Movement in Vasari's *Lives'. Acts of the XXV International Art History Congress.* 4 vols, Vienna, 1983: II, 15–21.

———— 'Movement and Gender in sixteenth-century Italian painting', in K. Adler and M. Pointon, eds (1993): 129–45.

Fontana, V. and P. Morachiello. *Vitruvio e Raffaello: Il 'De architettura' di Vitruvio nella traduzione inedita di Fabio Calvo ravennate.* Rome, 1975.

Forde, G.O. 'When the Gods Fail: Martin Luther's Critique of Mysticism', in C. Lindberg, ed. (1984): 15–26.

Fornari Schianchi, L., ed. *'Per uso del santificare et adornare'. Gli arredi di Santa Maria della Steccata*. Parma, 1991.

Frangenberg, T. *Der Betrachter. Studien zur florentinischen Kunstliteratur des 16. Jahrhunderts*. Berlin, 1990.

––––––– 'Chorographies of Florence. The Use of City Views and City Plans in the Sixteenth Century'. *Imago Mundi*, 46, 1994: 41–64.

Fraser Jenkins, A. D. 'Cosimo de' Medici's patronage of architecture and the theory of magnificence'. *Journal of the Warburg and Courtauld Institutes*, 33, 1970: 162–70.

Frati, L. 'Notizie biografiche di Gio. Battista Refrigerio'. *Giornale storico della letteratura italiana*, 12, 1888: 325–350.

Freedberg, D. *The Power of Images. Studies in the History and Theory of Response*. Chicago, 1989.

Freedberg, S.J. *Parmigianino: His Works in Painting*. Cambridge, Mass, 1950.

Frey, K. *Der Literarische Nachlass Giorgio Vasaris*. Munich, 1923.

Frommel, C.L. *Der römische Palastbau der Hochrenaissance*. 3 vols, Tübingen, 1973.

Garin, E. *Italian Humanism: Philosophy and Civic Life in the Renaissance*. P. Munz, trans. Oxford, 1965.

Garrard, M. 'Here's looking at me: Sofonisba Anguissola and the Problem of the Woman Artist'. *Renaissance Quarterly*, 47, 1994: 556–622.

Gaye, G., ed. *Carteggio inedito d'artisti*. Florence, 1840.

Gennari, G. 'La "Domus jocunditatis" a Bentivoglio, con nuovi documenti'. *Strenna storica bolognese*, 7, 1957: 173–8.

Ghidiglia Quintavalle, A. *Gli ultimi affreschi del Parmigianino*. Parma, 1970.

Giovannoni, G. *Antonio da Sangallo il Giovane*. Rome, 1959.

Goldthwaite, R. 'The economic and social world of Italian Renaissance Maiolica'. *Renaissance Quarterly*, 42, 1989: 1–32.

––––––– *Wealth and the Demand for Art in Italy 1300–1600*. Baltimore, MD, and London, 1993.

Goldstein, C. 'Rhetoric and Art History in the Italian Renaissance'. *Art Bulletin*, 73, 1991: 641–52.

Golzio, V. *Raffaello nei documenti*. Vatican City, 1936.

Gombrich, E.H. 'Alberto Avogadro's Descriptions of the Badia of Fiesole and of the Villa of Careggi'. *Italia Medioevale e Umanistica*, 5, 1962: 217–29.

––––––– *Symbolic Images. Studies in the Art of the Renaissance*. London, 1972.

––––––– 'Botticelli's Mythologies', in Gombrich (1972): 31–81.

––––––– *The Heritage of Apelles*. Oxford, 1976.

––––––– *Norm and Form: Studies in the Art of the Renaissance*. Oxford, 1978.

––––––– 'The Early Medici as Patrons of Art', in Gombrich (1978): 35–57.

Gould, C. *Parmigianino*. New York and London, 1994.

Grasman, E. 'L'alchimista Parmigianino nelle *Vite* del Vasari'. *Mededelingen van het Nederlands Institut te Rome*, 46, 1985: 87–102.

Grassi, E. *Die Theorie des Schönen in der Antike*. Cologne, 1962.

Green, L. 'Galvano Fiamma, Azzone Visconti and the revival of the classical theory of magnificence'. *Journal of the Warburg and Courtauld Institutes*, 53, 1990: 98–113.

Grendler, P.F. *Critics of the Italian World*. Madison and Milwaukee, Wisconsin, and London, 1969.

Guillaume, J., ed. *Les Traités d'architecture de la Renaissance*. Paris, 1988.

—— *Les Chantiers de la Renaissance. Actes des colloques tenus à Tours en 1983–1984*. Paris, 1991.

Gundersheimer, W.L. *Art and Life at the Court of Ercole I d'Este: The 'De triumphis religionis' of Giovanni Sabadino degli Arienti* (Travaux d'humanisme et renaissance, 127). Geneva, 1972.

—— 'The patronage of Ercole I d'Este'. *Journal of Medieval and Renaissance Studies*, 6 (1), 1976: 1–18.

Günther, H. *Das Studium der antiken Architektur in den Zeichnungen der Hochrenaissance*. Tübingen, 1988.

Habert, J., ed. *Les Noces de Cana de Veronèse*. Paris, 1992.

Hale, J. *The Civilization of Europe in the Renaissance*. London, 1993.

Hale, W.H. *Ancient Greece*. New York, 1970.

Hall, J. *Dictionary of Subjects and Symbols in Art*. New York, 1979.

Hamilton Smith, M. 'La première description de Fontainebleau'. *Revue de l'Art*, 91, 1991: 44–6.

Hanning, R.W. and D. Rosand, eds. *Castiglione: Ideal and Real in Renaissance Culture*. New Haven, CT, and London, 1983.

Hartt, F. *Michelangelo*. New York, 1964.

Herlihy, D. and Klapisch-Zuber, C. *Tuscans and their families*. New Haven, CT, and London, 1985.

Hess, D. *Das Gothaer Liebespaar. Ein Ungleiches Höfischer Minne*. Frankfurt-am-Main, 1996.

Heydenreich, L. *Leonardo da Vinci*. 2 vols, London, New York and Basel, 1954.

Hibbard, H. *Michelangelo*. New York, 1974.

—— *Caravaggio*. London, 1983.

Hirst, M. *The Young Michelangelo: The Artist in Rome, 1496–1501*. London, 1994.

Holt, E., ed. *A Documentary History of Art. vol. II. Michelangelo and the Mannerists*. Princeton, NJ, 1982.

Hope, C. *Titian*. London, 1980.

—— 'Can we trust Vasari?' Review of P. Rubin, *Giorgio Vasari: Art and History*, New Haven, CT, and London 1995, in *The New York Review of Books*, 42(15), 1995: 10–13.

Huse, N. and W. Wolters. *The Art of Renaissance Venice*. Chicago, Ill, 1990.

Jacobs, F. 'Vasari's Vision of the History of Painting: Frescoes in the Casa Vasari, Florence'. *Art Bulletin*, 66, 1984: 399–416.

James, C. *Giovanni Sabadino degli Arienti: a literary career* (Istituto Nazionale di Studi sul Rinascimento, *Quaderni di "Rinascimento"*, 32). Florence, 1996.

Janson, H.W. 'The image "made by chance" in Renaissance thought', in M. Meiss, ed. (1961): 254–66.

Jones, E. *The New Oxford Book of Sixteenth Century Verse*. Oxford, 1991.

Jones, P.J. 'The Travel Notes of an Apprentice Florentine Statesman, Giovanni di Tommaso Ridolfi', in P. Denley and C. Elam, eds. (1988): 263–80.

Jones, R. and N. Penny. *Raphael*. London and New Haven, CT, 1983.

Kelso, R. *Doctrine for the Lady of the Renaissance*, Urbana, Ill, 1956.

Kemp, M. ' "Ogni dipintore dipinge se": a neoplatonic echo in Leonardo's art theory?', in C. Clough, ed. (1976): 311–23.

—— *Leonardo da Vinci: the Marvellous Works of Nature and Man*. London, 1981.

Kerrigan, W. and G. Braden, *The Idea of the Renaissance*. Baltimore, MD, and London, 1989.

Keuls, E.C. *Plato and Greek Painting*. Leiden, 1978.

Kidwell, C. *Pontano: Poet & Prime Minister*. London, 1991.

King, C. 'Looking a sight: sixteenth-century portraits of women artists'. *Zeitschrift für Kunstgeschichte*, 58, 1995: 381–406.

Klibansky, R. *The Continuity of the Platonic Tradition during the Middle Ages*. London, 1949.

Koerner, J.L. *The Moment of Self-portraiture in German Renaissance Art*. Chicago, Ill, 1993.

Kolb, B., and I.Q. Whishaw. *Fundamentals of human neuropsychology*. New York, 1996.

Körkel-Hinkforth, R. *Die Parabel von den Klugen und Törichten Jungfrauen*. Frankfurt-am-Main, 1994.

Krämer, G. 'Jörg Breu der Ältere als Maler und Protestant', in *Welt im Umbruch. Augsburg zwischen Renaissance und Barok*. 3 vols, Augsburg, 1980: III, 115–33.

Krautheimer, R. *Studies in Early Christian, Medieval and Renaissance Art*. London, 1971.

—— 'Alberti and Vitruvius', in Krautheimer (1971): 323–32.

Kristeller, P. O. *The Philosophy of Marsilio Ficino*. V. Conant, trans. New York, 1943.

—— *Renaissance Thought and the Arts: Collected Essays*. Princeton, NJ, 1980.

Kruse, J. 'Hunting, magnificence and the court of Leo X'. *Renaissance Studies*, 7(3), 1993: 243–57.

LeMollé, R. *Georges Vasari et le vocabulaire de la critique d'art dans les 'Vite'*. Grenoble, 1988.

Levi D'Ancona, M. *The Garden of the Renaissance: Botanical Symbolism in Italian Painting*. Florence, 1977.

Lichtenstein, J. 'Making up Representation: The Risks of Femininity', in R.H. Bloch and F. Ferguson, eds (1989): 77–87.

Lindberg, C., ed. *Piety, Politics and Ethics: Reformation Studies in Honor of George Wolfgang Forell*. Kirksville, Missouri, 1984.

Lissarrague, F. 'Women, Boxes, Containers: Some Signs and Metaphors', in E. Reeder, ed. (1995): 91–101.

Lotz, W. and L.L. Müller, eds. *Studien zu toskanischen Kunst. Festschrift für L.H. Heydenreich*. Ansbach, 1964

Lorenzetti, P. *La bellezza e l'amore nei trattati del cinquecento*. Pisa, 1922.

McFarland, D. *Animal behaviour*. Burnt Mill, 1992.

Mack, C.R. *Pienza. The Creation of a Renaissance City*. Ithaca, NY, and London, 1987.

Malagù, U. *Ville e 'delizie' del Ferrarese*. Ferrara, 1972.

Manca, J. *The Art of Ercole de' Roberti*. Cambridge, 1992.

Markova, V. 'Un "Baccanale" ritrovato di Giorgio Vasari, proveniente dalla Galleria Gerini', in M. Cämmerer, ed. (1994): 237–41.

Marocchi, A. 'La chiesa della Steccata nella storia', in B. Adorni, ed. (1982): 16–23.

Marrow, J. *Passion Iconography in Northern European Art of the late Middle Ages and Early Renaissance: A Study of the Transformation of Sacred Metaphor into Descriptive Narrative* (Ars Neerlandica 1). Kortrijk, 1979.

Matter, E.A. *The Voice of My Beloved: The Song of Songs in Western Medieval Christianity*. Philadelphia, PA, 1990.

Meiss, M., ed. *De artibus opuscula XL: Essays in Honor of Erwin Panofsky*. New York, 1961.

Mendelsohn, L. *Paragoni. Benedetto Varchi's 'Due Lezzioni' and Cinquecento Art Theory*. Ann Arbor, Michigan, 1982.

Menz, C. *Das Frühwerk Jörg Breus des Älteren*. Augsburg, 1982.

Millon, H.A., ed. *Studies in Italian Art and Architecture 15th through 18th Centuries* (Memoirs of the American Academy in Rome 35). Cambridge, Mass, 1980.

Mirollo, J. V. *Mannerism and Renaissance Poetry*. New Haven, CT, 1984.

Moffitt, J. ' "Painters Born Under Saturn": The Physiological Explanation'. *Art History*, 11, 1988: 195–216.

Monbeig-Goguel, C. *Vasari et son temps, Dessins Italiens du Musée du Louvre*. Paris, 1972.

Monga, L., ed. *Un mercante di Milano in Europa. Diario di viaggio del primo '500*. Milan, 1985.

Montini, R.U. 'Palazzo Baldassini restaurato'. *Studi romani*, 5, 1957: 39–56.

Morrall, R. A. 'Jörg Breu the Elder. Reformation and Renaissance in sixteenth century Augsburg', Ph.D. thesis (unpublished), University of London, 1996.

Mottola Molfino, A. and M. Natale, eds. *Le Muse e il Principe: Arte di corte nel Rinascimento padano*. 2 vols, Modena, 1991.

Motzkin, E. 'Michelangelo's Slaves in the Louvre'. *Gazette des Beaux-Arts*, 120, 1992: 207–28.

Moxey, K.P.F. 'The Master E.S. and the Folly of Love'. *Simiolus*, 11, 1980: 125–48.

––––––– 'Das Ritterideal und der Hausbuchmeister', in *Vom Leben im späten Mittelalter. Der Hausbuchmeister oder Meister des Amsterdamer Kabinetts* [exhibition catalogue] Frankfurt-am-Main, 1985: 39–51.

Murray, L. *Michelangelo: His Life, Work and Times*. London, 1984.

Nelson, J. *The Renaissance Theory of Love*. Florence, 1933.

Nesle, S. de M. *Astrology: History, Symbols, and Signs*. Rochester, VT, 1985.

North, H. F. *From Myth to Icon: Reflections of Greek Ethical Doctrine in Literature and Art*. Ithaca, NY, and London, 1979.

North, J. *The Fontana History of Astronomy and Cosmology*. London, 1994.

O'Malley, C.D., ed. *Leonardo's Legacy, an International Symposium*. Berkeley and Los Angeles, Calif, 1969.

O'Malley, J. W. *Giles of Viterbo on Church and Reform. A Study in Renaissance Thought* (Studies in Medieval and Renaissance Thought, V). Leiden, 1968.

Onians, J. *Bearers of Meaning*. Princeton, NJ, 1988.

O'Neill, J.P. and E. Schulz. *Gothic and Renaissance Art in Nuremberg 1300–1550* [exhibition catalogue] Munich and New York, 1986.

Otto, W. F. *Dionysus: Myth and Cult*. Dallas, Texas, 1986.

Pagliara, P.N. 'La attività edilizia di Antonio da Sangallo il Giovane. Il confronto tra gli studi sull'antico e la letteratura vitruviana'. *Controspazio*, 4(2), 1972: 3–47.

––––––– 'Raffaello e la rinascita delle tecniche antiche', in J. Guillaume, ed. (1991): 51–69.

Pallucchini, R. and P. Rossi. *Tintoretto. Le opere sacre e profane*. Milan, 1982.

Pane, R. *Architettura del Rinascimenti in Napoli*. 2 vols, Naples, 1937.

––––––– *Il Rinascimento nell'Italia meridionale*. 2 vols, Milan, 1975.

Panichi, R. *La tecnica dell'arte negli scritti di Giorgio Vasari.* Florence, 1991.

Panofsky, E. *Studies in Iconology: Humanistic Themes in the Art of the Renaissance.* Oxford, 1939.

────── *Meaning in the Visual Arts.* New York, 1955.

────── 'The History of the Theory of Human Proportions as a Reflection of the History of Styles', in Panofsky (1955): 89–99.

────── 'The First Page of Giorgio Vasari's "Libro". A Study on the Gothic Style in the Judgement of the Italian Renaissance', in Panofsky (1955): 169–225.

────── *Idea. A Concept in Art Theory.* Columbia, SC, New York, San Francisco, Calif, and London, 1968.

────── *Problems in Titian, mostly iconographic.* London and New York, 1969.

────── *The Life and Art of Albrecht Dürer,* 4th ed. Princeton, NJ, 1971.

Parronchi, A. 'Sul "Della statua" Albertiano'. *Paragone* IX (117), 1959: 3–29.

Pedretti, C. *Leonardo da Vinci on Painting, a Lost Book.* London, 1965.

Perrig, A. *Michelangelo's drawings: the science of attribution.* New Haven, CT, and London, 1991.

Pinelli, A. *La bella maniera: artisti del Cinquecento fra regola e licenza.* Turin, 1993.

Poeschke, J. *Michelangelo and his World: Sculpture of the Renaissance.* R. Stockman, trans. New York, 1996.

Pogány-Balás, E. *The Influence of Rome's Antique Monumental Sculptures on the Great Masters of the Renaissance.* Á. Debreczeni, trans. Budapest, 1980.

Pope-Hennessy, J. *Italian High Renaissance and Baroque Sculpture.* London, 1963.

────── *Paolo Uccello.* London, 1969.

Popham, A.E. and J. Wilde. *The Italian Drawings of the 15th and 16th centuries in the Collection of His Majesty the King at Windsor Castle.* London, 1949.

Popham, A.E. *Catalogue of the Drawings of Parmigianino.* 3 vols, New Haven, CT, and London, 1971.

────── *The Drawings of Leonardo da Vinci,* 2nd ed. London, 1971.

Portoghesi, P. *Rome of the Renaissance.* London, 1972.

Price Zimmerman, T.C. , 'Paolo Giovio and the evolution of Renaissance art criticism', in C. Clough, ed. (1976): 406–24.

Quednau, R. 'Aemulatio veterum. Lo studio e la recezione dell'antichità in Peruzzi e Raffaello', in M. Fagiolo Dell'Arco and M.L. Madonna, eds (1987): 399–431.

Quiviger, F. 'Aspects of the Exegesis and Criticism of Italian Art, c.1540–c.1600'. Ph.D. thesis (unpublished), University of London, 1989.

Redig de Campos, D. 'Notizia su Palazzo Baldassini'. *Bollettino del Centro di Studi per la Storia dell'Architettura*, 10, 1956: 3–22.

Reeder, E., ed. *Pandora: Women in Classical Greece*. Princeton, NJ, 1995.

Reid, J. D., ed. *The Oxford Guide to Classical Mythology in the Arts: 1300–1990s*. Oxford and New York, 1993.

Rice, Jr., E.F. *Saint Jerome in the Renaissance*. Baltimore, MD, and London, 1985.

Richmond, R. *Michelangelo and the Creation of the Sistine Ceiling*. London, 1992.

Richter, J.P. *The Literary Works of Leonardo da Vinci*. London, New York and Toronto, 1939.

Robinson, C.E. *Hellas: A Short History of Ancient Greece*. New York, 1948.

Rocchi, I. 'Per una nuova cronologia e valutazione del *Libro di natura de amore* di Mario Equicola'. *Giornale storico della letteratura italiana*, 153, 1976: 566–85.

Rogers, M. 'The decorum of women's beauty: Trissino, Firenzuola, Luigini and the representation of women in sixteenth-century painting'. *Renaissance Studies*, 2(1), 1988: 47–89.

Rosenberg, C. M. 'Notes on the Borsian Addition to the Palazzo Schifanoia'. *Musei Ferraresi: Bollettino annuale*, 3, 1973: 32–42.

——— 'The Iconography of the Sala degli Stucchi in the Palazzo Schifanoia in Ferrara'. *Art Bulletin*, 61, 1979: 377–84.

Rosenthal, E.E. *The Cathedral of Granada. A Study in the Spanish Renaissance*. Princeton, NJ, 1961.

Roskill, M. *Dolce's 'Aretino' and Venetian Art Theory of the Cinquecento*. New York, 1968.

Rousselle, A. *Porneia: On Desire and The Body in Antiquity*. Oxford, 1993.

Roversi, G. *Palazzi e case nobili del '500 a Bologna*. Bologna, 1986.

Rowland, I. 'Raphael, Angelo Colucci, and the Genesis of the Architectural Orders'. *Art Bulletin*, 76, 1994: 81–104.

Rubin P. *Giorgio Vasari: Art and History*. New Haven, CT, and London, 1995.

——— 'Magnificence and the Medici', in F. Ames-Lewis, ed. (1995): 37–49.

Rykwert, J. and A. Engel, eds. *Leon Battista Alberti* [exhibition catalogue] Milan, 1994.

Saccone, E. '*Grazia, sprezzatura, affettazione* in the *Courtier*', in R.W. Hanning and D. Rosand, eds (1983): 45–68.

Salvini, R. *Michelangelo*. C. Atthill, trans. New York, 1981.

Schiller, G. *Iconography of Christian Art*. J. Seligman, trans. 2 vols, London, 1972.

Schlosser Magnino, J. *La letteratura artistica. Manuale delle fonti della storia dell'arte moderna*. Florence, 1977.

Schofield, R. 'Amadeo, Bramante and Leonardo and the tiburio of Milan Cathedral'. *Achademia Leonardi Vinci*, 2, 1989: 68–100.

Scribner, R.W. 'Popular Piety and Modes of Visual Perception in Late Medieval and Reformation Germany'. *Journal of Religious History*, 15, 1989: 448–69.

Seznec, J. *The Survival of the Pagan Gods: The Mythological Tradition and its Place in Renaissance Humanism and Art*. B.F. Sessions, trans. (Bollingen Series XXXVIII). Princeton, NJ, 1972.

Shearman, J. *Only Connect . . ., Art and the Spectator in the Italian Renaissance*. Princeton, NJ, 1992.

Shell, J. and G. Sironi. 'Salaì and Leonardo's legacy'. *Burlington Magazine*, 133, 1991: 95–108.

Shepherd, R. 'Giovanni Sabadino degli Arienti, Ercole I d'Este and the decoration of the Italian Renaissance court'. *Renaissance Studies*, 9, 1995: 18–57.

Signorini, R. *Opus hoc tenue: la Camera Dipinta di Andrea Mantegna: Lettura storica iconografica iconologica*. Mantua, 1985.

Simoncini, G. ed. *La tradizione medievale nell'architettura italiana dal XV al XVIII secolo*. Florence, 1992.

Simoncini, G. 'La persistenza del gotico dopo il Medioevo: periodizzazione ed orientamenti figurativi', in G. Simoncini, ed. (1992): 1–50.

Smith, C. *Architecture and the Culture of Early Humanism. Aesthetics, Ethics and Eloquence 1400–1470*. Oxford, 1992.

Smyth, C. H. *Mannerism and Maniera*. Vienna, 1992.

Snow-Smith, J. 'Brunelleschi's Competition Panel: the Spinario and the Sin of Heresy', *Gazette des Beaux-Arts*, 113, 1989, 159–69.

———— *The 'Primavera' of Sandro Botticelli: A Neoplatonic Interpretation*. New York and Bern, 1993.

Sohm, P. *Pittoresco*. Cambridge, 1991.

———— 'Gendered Style in Italian Art Criticism from Michelangelo to Malvasia'. *Renaissance Quarterly*, 48, 1995: 759–808.

Spallanzani, M. *Ceramiche orientali a Firenze nel Rinascimento*. Florence, 1978.

Steinberg, L. *The Sexuality of Christ in Renaissance Art and in Modern Oblivion*. New York, 1983.

Stinger, C. L. *The Renaissance in Rome*. Bloomington, Indiana, 1985.

Summers, D. 'Maniera and Movement: the Figura Serpentinata'. *Art Quarterly*, 35, 1972: 269–301.

———— 'Contrapposto: Style and Meaning in Renaissance Art'. *Art Bulletin*, 59, 1977: 336–61.

———— *Michelangelo and the Language of Art*. Princeton, NJ, 1981.

Tait, H., ed. *The Golden Age of Venetian Glass* [exhibition catalogue, British Museum]. London, 1979.

Tavernor, R. 'Concinnitas, o la formulazione della bellezza', in
    J. Rykwert and A. Engel, eds (1994): 300–15.
Tessari, C. *Baldassare Peruzzi. Il progetto dell'antico*. Milan, 1995.
Thorpe, W.A. *English Glass*. London, 1949.
Trachtenberg, M. 'Gothic/Italian "Gothic": Towards a Redefinition'. *Journal
    of the Society of Architectural Historians*, 50, 1991: 22–37.
Trinkaus, C. *In Our Image and Likeness*. 2 vols, London, 1970.
Tuohy, T. *Herculean Ferrara: Ercole d'Este (1471–1505) and the Invention of a
    Ducal Capital*. Cambridge, 1996.
Vaccaro, M. 'Dutiful Widows: Female Patronage and Two Marian
    Altarpieces by Parmigianino', in D. Wilkins and S. Reiss, eds.
    (forthcoming).
Valcanover, F., et al. *Pittura murale esterno nel Veneto: Venezia e provincia*.
    Venice, 1991.
Varese, R. 'La vera facciata di Schifanoia'. *Critica d'arte*, ns 43, 1978: 44–66.
Varese, R., ed. *Atlante di Schifanoia*. Modena, 1989.
Varese, R. 'Il sistema delle "delizie" e lo "studiolo" di Belfiore', in eds
    A. Mottola Molfino and M. Natale (1991): 2: *Saggi*, 187–201.
Vekeman, H. and J. Müller Hofstede, eds. *Wort und Bild in der
    niederländischen Kunst und Literatur des 16. und 17. Jahrhunderts*.
    Erfstadt, 1984.
Venturi, A. 'L'arte ferrarese nel periodo d'Ercole I d'Este', *Atti e memorie
    della R. Deputazione di storia patria per le provincie di Romagna*, Ser. 3 (6),
    1887–9: 91–119 and 350–422, and Ser. 3 (7), 1887–9: 368–412.
Vestra, L. 'Love and Beauty in Ficino and Plotinus', in K. Eisenbichler and
    O. Zorzi Pugliese, eds (1986): 177–90.
Vignau-Wilberg, T. 'Höfische Minne und Bürgermoral in der Graphik um
    1500', in H. Vekeman and J. Müller Hofstede, eds (1984): 43–52.
Visser Travagli, A. M. *Palazzo Schifanoia e Palazzina Marfisa a Ferrara*. Milan,
    1994.
Vos, A., ed. *Place and Displacement in the Renaissance*. Binghampton, NY,
    1995.
Walek, J. 'The Czartoryski "Portrait of a Youth" by Raphael'. *Artibus et
    Historiae*, 24, 1991: 201–25.
Wark, R.R. 'A Shorter Notice on Van Dyck's "Self-Portrait with a
    Sunflower" '. *Burlington Magazine*, 98, 1956: 52–4.
Weil-Garris, K. and J.F. D'Amico. 'The Renaissance Cardinal's Ideal Palace:
    A Chapter from Cortesi's *De cardinalatu*', in H.A. Millon ed. (1980):
    45–123.
Weiss, R. 'The Castle of Gaillon in 1509–10', *Journal of the Warburg and
    Courtauld Institutes*, 16, 1953: 1–12.
Wiener, P. P., ed. *Dictionary of the History of Ideas*. New York, 1974.

Wilde, J. *Michelangelo*. Oxford, 1978.

Wilkins, D. and S. Reiss, eds. *Beyond Isabella: Secular Women Patrons of Art in Renaissance Italy* (forthcoming).

Williams, R. 'A Treatise by Francesco Bocchi in Praise of Andrea del Sarto'. *Journal of the Warburg and Courtauld Institutes*, 52, 1989: 111–39.

────── 'The Sala Grande in the Palazzo Vecchio and the Precedence Controversy between Florence and Ferrara', in *Vasari's Florence*, Cambridge (forthcoming).

Wilson Jones, M. 'Palazzo Massimo and Baldassare Peruzzi's Approach to Architectural Design'. *Architectural History*, 41, 1988: 59–87.

Wind, E. *Pagan Mysteries in the Renaissance*. New York, 1968.

Wittkower, R. *Gothic versus Classic*. London, 1974.

────── *Allegory and the Migration of Symbols*. London, 1977.

────── 'Death and Resurrection in a Picture by Marten de Vos', in R. Wittkower (1977): 159–66.

Wohl, H. ' "Puro sanza ornato": Masaccio, Cristoforo Landino and Leonardo'. *Journal of the Warburg and Courtauld Institutes*, 56, 1993: 256–60.

Wölfflin, H. *Classic art*. P. and L. Murray, trans. London, 1952.

Wurm, H. *Baldassare Peruzzi Architekturzeichnungen*. Tübingen, 1984.

Zecchin, L. *Vetro e Vetrai di Murano*. 3 vols, Venice, 1990.

Zevi, B. *Biagio Rossetti, architetto ferrarese: il primo urbanista moderno europeo*. Milan, 1960.

Zöllner, F. 'Leonardo's portrait of Mona Lisa del Giocondo'. *Gazette des Beaux-Arts*, 121, 1993: 115–38.

Zorzi Pugliese, O. 'Variants on Ficino's *De amore*: The Hymns to Love by Benivieni and Castiglione', in K. Eisenbichler and O. Zorzi Pugliese eds (1986): 113–21.

# Index

Page references in *italic* type indicate illustrations.